A HISTORY
OF SCULPTURE

A HISTORY OF
SCULPTURE

BY

GEORGE HENRY CHASE, Ph.D. 1874-
JOHN E. HUDSON PROFESSOR OF ARCHÆOLOGY, HARVARD UNIVERSITY

AND

CHANDLER RATHFON POST, Ph.D.
PROFESSOR OF GREEK AND OF FINE ARTS, HARVARD UNIVERSITY

ILLUSTRATED

GREENWOOD PRESS, PUBLISHERS
WESTPORT, CONNECTICUT

Copyright 1925, 1953 by Harper & Brothers

Originally published in 1925
by Harper & Brothers, Publishers, New York and London

Reprinted with the permission
of Harper & Row, Publishers, New York

First Greenwood Reprinting 1971

Library of Congress Catalogue Card Number 72-138105

ISBN 0-8371-5681-5

Printed in the United States of America

CONTENTS

CHAPTER PAGE

PREFACE ix

I. INTRODUCTION 1

II. EGYPTIAN SCULPTURE 15

III. MESOPOTAMIAN SCULPTURE 34

IV. GREEK SCULPTURE: THE ARCHAIC PERIOD 52

V. GREEK SCULPTURE: THE FIFTH CENTURY 81

VI. GREEK SCULPTURE: THE FOURTH CENTURY 112

VII. GREEK SCULPTURE AFTER ALEXANDER 128

VIII. ROMAN SCULPTURE 151

IX. THE SCULPTURE OF THE FIRST MILLENNIUM, A.D. 169

X. THE MIDDLE AGES 190

XI. THE RENAISSANCE 295

XII. THE BAROQUE AND THE ROCOCO 371

XIII. NEOCLASSICISM 418

XIV. MODERN SCULPTURE 433

XV. THE SCULPTURE OF THE ORIENT 528

GLOSSARY 549

INDEX OF SCULPTORS 551

INDEX OF MONUMENTS AND PLACES 557

ILLUSTRATIONS

On page 557 will be found an INDEX TO MONU-
MENTS AND PLACES. Those marked by an as-
terisk (*) indicate an illustration in the text.

PREFACE

In accordance with the principles adopted for Harper's Fine Arts Series, the writers of this brief history have tried to present a concise account of the development of the art of sculpture from the earliest times to the present day, with reference especially to recent discoveries and discussions. The first chapter was written in collaboration, Chapters II to VIII by Mr. Chase, and Chapters IX to XV by Mr. Post, but both have read and revised the whole book. Mr. Post's chapters are, in the main, an abridgment, with the necessary alterations, of his larger work, "A History of European and American Sculpture"; but many sections, such as those upon Early Christian art, upon the Spanish Romanesque, and upon the early Belgian and the German baroque, have been rewritten in accordance with the most recent criticism or with changes in his own point of view, and in a large number of other cases, for the same reasons, single statements have been modified. Some new material, also, has been added, especially for modern sculpture, and an attempt has been made to achieve a somewhat clearer and more logical arrangement. Mr. Chase's treatment of Greek and Roman sculpture in Chapters IV to VIII, on the other hand, is, in general, an expansion of the briefer sketch contained in his "Greek and Roman Sculpture in American Collections."

To the many owners of copyright who have granted permission to use photographs or other material, the authors wish to express their appreciation and thanks. They are especially indebted to the Directors of the Fogg Art Museum of Harvard University for many courtesies and constant help.

G. H. C.
C. R. P.

A HISTORY
OF SCULPTURE

A HISTORY
OF SCULPTURE

CHAPTER I

INTRODUCTION

The palæolithic period. The history of sculpture, if the phrase is interpreted in its widest meaning, begins at a very early date. Even the men of the earlier age of stone, the so-called palæolithic period, carved small figures out of stone and bone and decorated the horn and bone handles of their weapons and implements with figures of men and animals, sometimes carved in relief, sometimes merely scratched with incised lines. On the walls of the caves in which they found refuge during the long winters of the quarternary period, they engraved and painted remarkably lifelike representations of the animals with which they were familiar, such as the mammoth, the reindeer, and the bison. The most striking figures of this sort have been found in caves in and near the Pyrenees, in southern France and northern Spain; and in one of them, quite recently, a group of two bisons modelled in clay was discovered. In all these works of palæolithic man, the outstanding quality is the intense realism with which the figures are treated. There are many productions of inferior craftsmen, but the best of the sculptures display a skill in catching characteristic forms and movements which shows that the makers deserve to be called artists, no less than the professional sculptors of later days. But these memorials of primitive man, interesting as they are, can only be briefly mentioned here. The race that produced them appears to have been almost, if not entirely, overwhelmed by the geologi-

1

cal changes that mark the end of the quaternary period
(about 8,000 to 10,000 B.C., according to the latest dates
suggested by geologists), and there is no evidence that any of
the knowledge which they had gained was transmitted to
those who came after them. Their high attainments in the
field of art remain a curious and isolated phenomenon in the
history of human progress.

The neolithic period. Continuity of artistic development.
One of the most noteworthy features of the succeeding, neo-
lithic stage of culture is the almost complete absence of works
of sculpture. The men of this age attained remarkable skill
in chipping and polishing stone implements and in ornament-
ing them with patterns. But their rare attempts at repre-
senting men and animals in stone or clay are of the crudest
sort, and only serve to emphasize their inferiority in this
respect to their predecessors. Not until the knowledge of
copper and bronze made possible the employment of better
cutting instruments do we find an improvement in the sculp-
tor's art. From that time on, a steady progress can be traced,
and the art was never again wholly lost. It had its great
periods and its periods of depression, when artists seem to
have lost almost all that had been gained; but after the
beginning of the bronze age the tradition was never com-
pletely broken, and in Europe, at least, from the time when
the Greeks first essayed sculpture to the present day, the
style of one period grew out of that of another in a continuous
and uninterrupted evolution. To trace these developments
and to show the relations between the products of different
countries and different civilizations is the purpose of the
present book.

Materials of sculpture. Before we undertake this task
it will be helpful to define somewhat more clearly the mean-
ing of the term sculpture and to discuss the materials
with which the sculptor works, his methods and processes,
and the different kinds of sculpture that he produces. When
one speaks of sculpture, the image that most naturally occurs
to the mind is a statue or group in marble or bronze or a
relief in one or the other of these materials. But it should
be emphasized at the outset that these are by no means the

only materials in which sculpture can be conceived and executed. Many kinds of stone besides marble are not infrequently employed, both softer stones, such as limestone and sandstone, and harder varieties, such as granite, basalt, diorite, serpentine, and porphyry. With the exception of Italy, the countless monuments of the Romanesque and Gothic periods were regularly carved in the common stone of the region in which each chanced to be situated. Not only bronze, but iron, copper, lead, and other metals are sometimes used, and statuettes, at least, of gold and silver are not uncommon. Wood has been popular as a medium at many epochs, especially during the late Gothic period. Ivory has been called into service particularly for the minor arts, and in Byzantine and Carolingian sculpture the small ivories constitute the chief surviving objects for study. The greatest works of the ancient Greek sculptors were often built up of gold and ivory attached to a frame of wood and metal, with precious stones for the eyes and for other details. Stucco, a plaster consisting of lime, sand, and finely-crushed marble, was occasionally applied by the Romans to the sculptural adornment of architecture, and has been utilized sporadically ever since. With the rest of the Roman heritage, it was cultivated especially in the Renaissance and attained the height of its vogue everywhere in the baroque of the seventeenth century. Terracotta has at almost all times been a favorite material, because of the facility with which it can be handled and with which changes can be made in the finished work. By the Greeks it was usually decorated with paint, but by others its original reddish-brown surface has not seldom been kept intact; during the fifteenth century, at Florence, the Della Robbia family evolved a delightful method of glazing it over with shining enamel of different colors. Here and there more exotic materials have been forced to do duty. Wax is frequently used for the first sketch, but it has sometimes, for one reason or another, been retained even for the completed product; lacquer has naturally appealed to the Japanese. The modern struggle for novelty has now and then suggested even stranger materials, and the Futurists have brought this tendency to its culmination

by employing for their sculptural compositions the actual substances and objects that they desire to represent.

The tools. Where the materials are so various, it is obvious that methods of work must vary correspondingly. Workers in different materials naturally employ different tools, and the same sculptor will change his tools and his methods according to the material with which he is dealing. Of all plastic substances, clay is the most easily worked. A statue or a relief of terracotta is simply moulded by the hands of the maker, perhaps with the aid of a modelling stick or a spatula, colored and glazed (if color and glaze are used), and fired. The sculptor in wood must have utilized at all times the familiar instruments of the trade, saws and hammers, chisels and gouges of various sorts. For marble and other stones, except in so far as machinery has been introduced in modern times, the tools of today are largely the same as those which were employed in antiquity—pointed hammers and drills, curved chisels, claw chisels, and files for rubbing down and finishing. The softer classes of stone can often be cut with saws or knife-like instruments, and ancient statues sometimes show the use of tools of this kind.

The modern process of making a marble statue or relief. In connection with the technique of working in marble and similar materials, there are a number of interesting details which have been much discussed.[1] The general practice for marble statues and reliefs, since at least the beginning of the sixteenth century, has been, with some exceptions, the following. Having first made a small sketch in clay or wax, the sculptor then builds up a full-sized model in clay. From this a cast is commonly taken in plaster or some other durable material. On the cast a number of points, or *puntelli*, are marked. These are next transferred mechanically to a block of marble, and holes are drilled into the block to the depth required to arrive at corresponding points on what is ultimately to be the statue or relief. Then the marble is cut away until the inner *puntelli* are reached, and the work is

[1] The succeeding paragraphs on processes and polychromy apply to western art; no attempt has been made in this book to discuss the technical methods of oriental sculpture.

complete except for the finishing touches. All the transference from the model to the stone is commonly left to assistants, and even the finishing touches are sometimes entrusted to their hands. For the transference, the assistants ordinarily resort to the mechanical device known as the pointing-machine. Thus the artist often has no direct and personal contact with the marble that bears his signature, and at best the work of his hands is confined to adding the finishing touches. Such a method is certainly open to grave objections, and many critics see in it one reason for the mechanical character and lack of warmth and of vitality in so much modern sculpture.

Processes in earlier periods. It is frequently pointed out that the sculptors of antiquity and the Middle Ages did not work in this way, but attacked the stone directly and carved their figures in a "fine frenzy" of inspiration. This statement, however, cannot be taken too literally, at least for the ancient period. In Greek sculpture there is little evidence for the use of *puntelli* until a comparatively late period, and even then the small number employed suggests that they served rather as general guides for the sculptor than as a means of producing a mechanically exact copy. But all this does not prove that some sort of model was not frequently employed, even in the great period of Greek art, and indeed for elaborate decorative compositions it would seem that a series of models would be necessary if the artist was to gain a clear idea of the total effect of his groups. Probably these models would be only small sketches; but on the whole it must be said that the evidence in regard to the methods of ancient sculptors is inconclusive. In any case, even if in some instances the full-sized model intervened, the transfer to marble was made by the master himself or at least by an assistant who truly deserved the name of artist. The mediæval sculptor worked directly on the stone from a drawing or at most a small model. If the commission included a large group of sculptures on a church or a monument, the master would not have time to do all the execution himself; and his collaborators used his drawings as starting-points, revealing an æsthetic sense as keen as that of their Greek

predecessors. Donatello and at least a large number of other
Italians in the first century of the Renaissance continued the
Gothic practice of hewing the stone without constructing a
full-sized model. The modern intervention of the large model
began to become general in the next century, the sixteenth;
but Michael Angelo constituted a brilliant exception to this
custom of his day. The principal objection to the modern
practice is that so much of the task is entrusted to helpers who
are uninspired. If the sculptor himself undertakes the final
work on his marble statue, beginning at a point where the
statue is still so incomplete that slight modifications are
feasible, it is possible that he can make his figure express his
personality almost as successfully as by any other method.
The creation of a masterpiece depends primarily on the qual-
ities of the artist, not on the methods he employs. The artist
of slight ability may be dominated by a method; the great
artist is a master by force of genius, and methods with him
are but means to ends.

Polychromy. Another question that has been much mooted
in recent years is the propriety of coloring statues and reliefs.
It is now generally admitted that, broadly speaking, until
the beginning of the sixteenth century after Christ, poly-
chromy was usually applied to sculpture. Among the Greeks
the art of polychromy was so fully developed that uncolored
works were quite exceptional. Even during the Hellenistic
period and under the Roman empire, the application of color
was not uncommon. Ancient statues in hard stone, to be sure,
which can be highly polished, were frequently uncolored,
but in the case of other sorts of stone and of other materials
it seems to be proved that at least partial polychromy en-
livened the surfaces. The practice continued until the end
of the Middle Ages, but began to be abandoned in the Renais-
sance, partly because the ancient works which were ex-
cavated and which the sculptors of that period imitated had
lost their polychromy. Since the beginning of the sixteenth
century colored sculpture in stone has been a rare phe-
nomenon, and we have become so accustomed to the associa-
tion of white or gray with works of sculpture that polychromy
seems to many little less than barbaric. Those who admire

polychromy in certain kinds of sculpture, such as wood-carvings or the terracottas of the Della Robbia, still find themselves unable to admit its beauty in marble or other stone. The difficulty lies partly in the fact that the false and tawdry modern attempts, in restorations or original work, to reproduce ancient and mediæval polychromy and the faded and dirty tones into which the few remnants of old color on mediæval statuary have now degenerated are calculated to give to the uninitiated a derogatory conception of the practice in general. The taste and skill with which color was employed on statuary in antiquity, in the Middle Ages, and here and there in other periods must be reserved for later discussion; but it should be stressed at once that ordinarily the pigment was applied in so thin a layer that the texture of the surface of the stone or even of the wood was preserved and thus the sculptural quality was not sacrificed. The ancient bronzes were frequently and the mediæval bronzes regularly gilded, but there was often also an elaborate ornamentation by the inlay of other metals and enamels. The vacillations of modern art have resulted, sporadically but never very successfully, in rather artificial efforts to resuscitate polychromy, even when the sculpture is not intended for a modern imitation of a mediæval church.

Ancient methods for bronze. The methods by which bronze statues were made in antiquity can be determined to some extent by a study of extant examples, but many details of the processes are obscure. Small statuettes have at all times been cast solid in moulds of stone or sand or some other material. But statues of larger size cannot be cast solid because of the great amount of metal required and the danger of cracking as the metal cools. The great weight of large statues of solid bronze is a further objection. There are preserved a number of primitive statues which were built up with plates of beaten bronze or copper soldered or riveted together or fastened to a framework. But this method never produces very satisfactory results. Very early, therefore, in the history of sculpture, the method of hollow casting was developed. Two Greek sculptors of Samos, Rhoecus and Theodorus, who lived in the sixth century B.C., are said to have invented

hollow casting, but the tradition probably means no more than that they introduced into Greece an art which had long been practised in Egypt, for there are many hollow Egyptian statues of bronze which considerably antedate the time of these two masters. The exact methods of the Egyptian workmen are unknown, but they probably resembled the method which is called the *cire perdue* process and which continued in general favor until about the middle of the eighteenth century after Christ.

The "cire perdue" process. To produce a statue by this method the artist first makes a full-sized clay model. From this model is constructed a piece-mould of plaster; at the present day, when the *cire perdue* process is used, the mould is usually of gelatine, except in the case of larger bronzes. The mould is then carefully lined with a layer of wax, which thus takes the exact form of the intended statue and is given the thickness (ordinarily from ⅜ to ⅝ of an inch) desired in the finished bronze; and the whole centre of the wax-lined mould is filled with a core of fire-proof material. The piece-mould is now removed (not to be used again, unless it is necessary to start from the beginning for a new casting), and the last refinements of modelling are bestowed upon the wax surface. Another solid (not piece) mould is now built around the core with the attached wax, and small bronze rods are driven through this mould into the core in order that during the casting they may be kept in their relative positions to each other. Tubes are inserted in the mould at intervals to carry the molten metal. The whole is next heated over a fire, the wax melts and runs out, and molten bronze is let into the narrow space between the mould and the core. Lastly the mould is broken off, the core raked out, the bronze rods filed off the cast, and the statue is ready for polishing and finishing. The wax-covered image is sometimes obtained in other ways. After the piece-mould is complete, a plaster cast may be taken from it and pared down until a space is left equivalent to that required for the bronze. Or, no piece-mould at all is constructed: the core is first built up until it has roughly the shape of the completed statue; and it is then covered with a layer of wax in which the surface

modelling is carefully executed. In both of these methods, the process of casting, after the wax model is obtained, is the same as in the first instance. The disadvantage of the last method is that no piece-mould is made and preserved as a starting point for subsequent castings, in case the first trial fails; but, nevertheless, such evidence as there is suggests that it was this method which was employed by the ancients.

Modern methods for bronze. The revival of an interest in processes and in technical perfection, which began towards the end of the nineteenth century, has brought with it a partial resuscitation of the fine old method of *cire perdue;* but for the century and a half previous to that date, save occasionally for large figures, its position had been usurped by the process of a sand mould, or sometimes, in the last fifty years, by the galvanic method of electrotype deposit. The sand process corresponds to the second kind of *cire perdue* method. A mould in sections and a core are made from moist sand, a layer of the core, as thick as the desired bronze, is removed, and the molten metal introduced between the core and mould. For the electrotype method, a mould of gutta-percha, of some other material, or even of very hard plaster is coated with plumbago or black lead. It is then placed in a bath, where the metal is electrolytically deposited into it to the requisite thickness; and eventually the mould is broken away. After the casting, if the bronze is not to be gilded, it is either left with its native tone or given a patina of some shade of brown, green, or gray through staining with acid.

Bronze reliefs. In antiquity reliefs of bronze were produced by beating out plates of the metal on wooden or stone cores or by beating up the bronze from behind and incising details with a sharp tool. Since at least as early as the ninth century after Christ, bronze reliefs have usually been cast after the same fashion as statues; and inasmuch as in the first century of the Renaissance the norm for reliefs in all materials was set by the common bronze examples, a highly pictorial treatment of relief with a deep perspective of landscape was evolved and has never since lost its vogue except in cases where the admiration for ancient art has been very potent, as in the neoclassic epoch. Because the starting-

point for the clay model from which the casting was
done was the background, from which, by adding piece upon
piece, the relief was gradually built up, a deep perspective
was the natural result. In antiquity the process of beating
out bronze reliefs rendered it difficult to give to the foremost
figures the height of projection that was essential if there
were to be a large number of other planes behind; and in
any case it was not the bronze but the stone reliefs that set
the standard. In these, the ancients naturally did not wish
to remove any more material than was necessary and worked
from without inward, so that they did not tend to evolve a
deep background. Reliefs of clay they stamped from moulds,
and these moulds they could not recess to any great degree
if they wanted them to be effective in stamping.

 Classifications. Various terms are employed to designate
different kinds of sculpture. Free-standing figures are often
referred to as "sculpture in the round," to distinguish them
from "sculpture in relief," in which the figures are not com-
pletely worked out in three dimensions but are attached to a
background. High relief (or *alto rilievo, haut relief*) is re-
lief in which the forms project decidedly from the back-
ground and approach, in appearance, figures in the round.
Low relief (or *basso rilievo, bas relief*) is relief in which the
forms emerge but little from the background. Donatello
evolved a *very* low sort of relief, the depressed and shadowy
outlines of which often vanish into the background. Called
by the Italians *rilievo schiacciato* (or *stiacciato*), "squashed
relief," it was much cultivated in the fifteenth century and
has sometimes been imitated in later times, particularly by
those sculptors who in the nineteenth century once more
turned with enthusiasm to reproducing the style of the
Renaissance. Relief that is neither exactly high nor low is
occasionally called middle relief (*mezzo rilievo*).

 On the ground of the purpose for which sculpture is
planned, other convenient distinctions may be made. The
term decorative sculpture is often applied to works that are
planned in relation to a larger whole; most relief sculpture
falls into this class, as well as figures in the round that are
to be placed on buildings or set up in public places as parts of

a general scheme. In such works the relation to the whole composition exercises a marked influence on the sculptor's conception and execution. Statues or groups that are not planned with regard to a larger whole are often called free or substantive sculpture, and here the master's imagination is conditioned to a lesser degree, except in so far as he has to take into account the setting for his work. It often happens that the number of examples of free sculpture that have survived from a given period of antiquity is small or that these are badly preserved; but since in the great periods, at least, decorative sculpture followed closely the progress of free sculpture and was executed by distinguished artists, it may safely be used by the critic as a basis for his judgment. From the beginning of Christian art to the end of the Middle Ages, sculpture was chiefly employed to decorate churches, ecclesiastical furniture, civil and domestic buildings, and tombs. There were always, however, a certain number of free-standing statues of sacred personages, especially of the Virgin, and occasion was found also for a few separate portraits; in the last century of the Middle Ages, the fifteenth, detached devotional figures acquired a greater vogue. Yet it was only the dawning cult of art for art's sake in the Renaissance that permanently restored substantive sculpture to the popularity that it had enjoyed among the Greeks and the Romans.

BIBLIOGRAPHICAL NOTE

The history of sculpture is traced, in connection with architecture, painting, and the minor arts, in all general histories of art. Among these, S. Reinach's *Apollo, an Illustrated Manual of the History of Art throughout the Ages*, New York, 1907, is undoubtedly the best brief outline that has yet been written. For a somewhat fuller account, accurate, enlightened, and up-to-date, the following works may be recommended: K. Woermann's *Geschichte der Kunst aller Zeiten und Völker*, Leipzig, first edition, 3 vols., 1900-1911; second edition completed through Vol. V, 1915-20; A. Springer's *Handbuch der Kunstgeschichte*, Leipzig, 5 vols., frequently revised; and the second volume (in two parts) of P. Albert Kuhn's *Allgemeine Kunst-Geschichte*, Einsiedeln, 1909. E. Faure's *Histoire de l'Art*, Paris, 4 vols., 1921, 1922 (now

appearing in an English translation, New York) contains much interesting criticism and will be helpful to the student who already has some knowledge. Useful brief accounts of the history of sculpture are A. Marquand and A. L. Frothingham's *Text-Book of the History of Sculpture,* New York, 1899, and H. N. Fowler's *History of Sculpture,* New York, 1916.

By far the best lexicon of the artists of all times, absolutely indispensable to the student, is the *Allgemeines Lexikon der bildenden Künstler,* edited by U. Thieme and F. Becker, including now 16 volumes and having reached Heub- in the alphabet, Leipzig, 1907——; the encyclopædic articles are by the most eminent specialists of all countries, and each is accompanied by an exhaustive bibliography. Despite the great achievements of research and criticism in the last twenty years, H. A. Müller and H. W. Singer's *Allgemeines Künstler-Lexikon,* Frankfort on the Main, 1895-1905, still has value, particularly for the sections of the alphabet not yet covered by Thieme and Becker. For French sculpture from the Middle Ages to the present day, Stanislas Lami's four *Dictionnaires,* Paris, 1898-1921, are sources for biographical data and catalogues of works.

The most ambitious attempt to trace the history of ancient art in detail is G. Perrot and C. Chipiez's *Histoire de l'art dans l'antiquité,* of which 10 volumes have appeared, Paris, 1882-1914. C. Picard's *La sculpture antique des origines à Phidias,* Paris, 1923, traces the development of sculpture from the beginnings to the time of the great Greek masters, and is noteworthy for its clear presentation of recent discoveries and theories and for its excellent bibliographies. The best general history of modern art (if "modern" be understood in its broadest sense) is the *Histoire de l'art depuis les premiers temps jusqu' à nos jours,* Paris, 1905——, edited by A. Michel and written by the leading French scholars in collaboration; it has now been completed through 7½ volumes (each volume in two parts) and carries the reader through the first half of the eighteenth century.

The most monumental history of Italian art is A. Venturi's *Storia dell'arte italiana,* now numbering eight volumes (the seventh volume in four parts) and covering the subject through the painting, sculpture, and architecture of the fifteenth century, Milan, 1900-23; the achievement is valuable not only for its mature scholarship and wealth of illustrations, but also for its penetrating and brilliantly phrased characterizations. W. C. Water's *Italian Sculptors,* London, 1911, is a convenient and moderately good dictionary of the plastic masters of Italy in the

mediæval, Renaissance, and baroque periods. C. Ricci's *Art in Northern Italy*, 1911, is more intelligent in its condensation than some of the other handbooks of the *Ars Una* series (all published at New York in English). These other manuals, nevertheless, are the most satisfactory short histories of the art of the respective countries: L. Hourticq, *Art in France*, 1911; M. Rooses, *Art in Flanders*, 1914; W. Armstrong, *Art in Great Britain and Ireland*, 1909; and M. Dieulafoy, *Art in Spain and Portugal*, 1913. L. Gonse's *La sculpture française depuis le XIV*e *siècle*, Paris, 1895, is too superficial to be of much service. W. Bode's *Geschichte der deutschen Plastik*, on the other hand, though published as long ago as 1887, at Berlin, still needs to be consulted. The volumes of G. Dehio's *Handbuch der deutschen Kunst-denkmäler*, Berlin, 1906-14, constitute a full, scientific, and convenient catalogue of the monuments of art throughout Germany. E. Marchal, in *La sculpture et les chefs-d'œuvre de l'orfèvrerie belges*, Brussels, 1895, has provided a copious source-book, including the whole history of plastic art in Belgium almost to the present day. *Belgische Kunstdenkmäler*, edited by P. Clemen, Munich, 1923, comprises a series of authoritative articles· by various scholars on many phases of Flemish art. L. Cloquet, in *Les artistes wallons*, Brussels, 1913, and R. Dupierreux, in *La sculpture wallone*, Brussels, 1914, present summary treatments of the district of Belgium implied in the titles. A standard work on Dutch art is G. Galland's *Geschichte der holländischen Baukunst und Bildnerei*, Frankfort on the Main, 1890; A. Pit's *La sculpture hollandaise au Musée Nationale d'Amsterdam*, Amsterdam, 1902, touches illuminatingly upon the different periods. For Spain, P. Lafond's *La sculpture espagnole*, Paris, 1908, though all-inclusive, is too much a mere catalogue; A. F. Calvert's *Sculpture in Spain*, New York, 1912, is too light. The monumental works on the subject are M. Dieulafoy's *La statuaire polychrome en Espagne*, Paris, 1908, and E. Serrano Fatigati's *Escultura en Madrid*, Madrid, 1912. L. Taft's *History of American Sculpture*, second edition, New York, 1924, has become a classic.

The best large collections of photographic reproductions are: Brunn-Bruckmann-Arndt, *Denkmäler griechischer und römischer Sculptur*, 685 plates, Munich, 1888—— (beginning with plate 501, elaborate discussions accompany the plates) and *Griechische und römische Porträts*, Munich, 1891——; P. Vitry and G. Brière, *Documents de sculpture française* (Middle Ages, Renaissance, and modern times), Paris, 1906——; J. J. van Ysendyck, *Docu-*

ments classés de l'art dans les Pays-Bas, Antwerp, 1880-1889; and
G. Dehio and G. von Bezold, *Die Denkmäler der deutschen
Bildhauerkunst,* Berlin, 1905——.

For the processes of sculpture, the following works may be
consulted: G. Baldwin Brown, *Vasari on Technique,* London,
1907; E. Lanteri, *Modelling,* London, 1904; A. Toft, *Modelling
and Sculpture,* Philadelphia, 1911.

CHAPTER II

EGYPTIAN SCULPTURE

Among the nations of antiquity, the Egyptians first developed an important national art. Modern research has modified our ideas of the enormous age of the Egyptian monuments and has shown that in the valley of the Tigris and the Euphrates a significant civilization developed almost, if not quite, as early as in the valley of the Nile. But of the early art of the Mesopotamian region, comparatively few monuments have been preserved, and the Egyptian artists clearly attained a high degree of skill before those of Babylonia and Chaldæa, so that a history of sculpture naturally begins with Egypt.

The civilization that arose and flourished in the Nile valley in ancient times maintained itself for many centuries and was little affected by that of other nations. Indeed, Egypt has always been a country which absorbed invading tribes, so that, in the case of Egyptian sculpture, more clearly than in that of other races, it is possible to trace the influences by which the art was moulded and under which it developed. Such influences are, in general, the physical features of the country, its political history, and the character and the beliefs of the people, especially their religious beliefs. To such influences we shall constantly refer as we consider the products of different regions.

Physical conditions. Ancient Egypt, in a strict sense, comprised only a part of the valley of the Nile, namely, the region north of the First Cataract, the last 550 miles of the river's course, including the Delta. The physical conditions of this district favored the development of a great civilization. The warm and almost rainless climate and the fertility of the soil, constantly enriched by an annual deposit of silt from the inundation, made it possible for men to obtain the

necessities of life with comparatively little labor; the river afforded an easy means of communication between the different parts of the country; and the deserts beyond the cliffs that bound the valley on either side served as natural defenses against enemies. On the other hand, the physical environment exercised in some ways an unfavorable influence. The very ease with which the necessities of life were gained reacted to the disadvantage of the dwellers in this fortunate valley, and the isolation and the constant physical and climatic conditions are at least partially responsible for the conservatism that is so marked in the character of the ancient Egyptians. Even in antiquity, the name of Egypt was synonymous with all that was fixed and unchanging.

Political history. The history of ancient Egypt is made up of alternating periods of strength and weakness, as the country was united and controlled by powerful Pharaohs, or disrupted by internal dissension or foreign invasion. Following a system devised by the priest Manetho, who in the third century B.C. wrote a history of Egypt, it is customary to arrange the rulers, from the beginning of the historic period (about 3400 B.C.) to the conquest of the country by Alexander the Great in 330 B.C., in thirty groups or Dynasties. Modern writers, furthermore, commonly distinguish four great "periods of power," called respectively The Old Kingdom (Dyn. III-VI, about 2980-2475 B.C.), The Middle Kingdom (Dyn. XI and XII, about 2160-1788 B.C.), The Empire (Dyn. XVIII-XX, about 1580-1090 B.C.), and The Saïte Period (Dyn. XXVI, 663-525 B.C.). It is these periods of power with which we have principally to do in any discussion of Egyptian art. The important periods in the history of sculpture (and of architecture and painting as well) were the same as the important periods in the political history, for it was the Pharaohs and the officers of their courts who undertook the erection and decoration of mighty temples dedicated to the gods, or of elaborate tombs for the preservation of their own bodies and for the ceremonies that were thought essential to the attainment of life after death.

Religious beliefs. It is no exaggeration to say that almost all Egyptian sculpture was inspired, in one way or another,

by religion. Both in work in the round and in work in relief, figures of the gods and figures of the Pharaohs, who were regarded as gods on earth and were at the head of the state religion, play a prominent part, and the temples of the gods formed one of the two types of monuments (temples and tombs) that were most elaborately adorned with sculpture. Most important of all is the curious form of the Egyptian belief in the life after death. Briefly stated, this was as follows: Man, after death, consisted of several parts: there was the body; the *ka*, or double, conceived as an exact replica of the body, but without material substance; the *ba*, or soul, often represented as a bird with a human head; and the *khu*, or "luminous," a sort of spark from the divine fire, closely connected with the *ba*. Of these, as the Egyptian believed, the body and the *ka* remained in the tomb; the *ba* and the *khu* went forth to associate with the gods. For the attainment of immortality, it was necessary that all four elements should be preserved, the body and the *ka* by the preservation of the actual body, the soul and the "luminous" by the prayers and offerings of later generations. This belief led to many important developments in sculpture. As the *ka* was thought of as closely associated with the body, it became customary to place in the tombs portrait statues of the dead, so that, if the body were accidentally destroyed, the *ka* might still have a presentment of the living man with which he could consort, as if he might be deceived into continuing his existence. Since the *ka* had need, in his life in the tomb, of the beings who had surrounded the man while he was among the living, statues or statuettes of his wife, his children, and his servants were placed in the tomb, along with the portrait statues of the occupant. As the bringing of offerings and prayers in perpetuity must necessarily be a doubtful matter, the offerings came to be represented in relief on the walls. Gradually the scope of these reliefs was extended; beginning with the representation of food, the Egyptians came to picture all the processes of the preparation of food, and finally many other scenes from daily life.

The Prehistoric Age (before 3400 B.C.) and the Archaic Period (c. 3400-2980 B.C.). Of the first rude beginnings of

Egyptian art in the prehistoric age the excavations of the last
forty years have given us a fairly definite idea. Small statu-
ettes of wood, ivory, and stone, and even some larger statues,
together with crude reliefs, show that already the craftsmen
of Egypt had attacked the problem of representing the forms
they saw about them. The succeeding archaic period of the
I and II Dynasties (sometimes called the Thinite period, from
Thinis, the capital) was a time of rapid development. Some
of the products of this age, especially the stelæ, or grave-
stones, set up over the tombs of the Pharaohs, and tablets of
schist, of which the purpose is uncertain, exhibit in their
reliefs a delicacy of treatment rarely surpassed in later days.

*The Old Kingdom (Dyn. III-VI, about 2980-2475 B.C.).
The School of Memphis.* The first great flowering of
Egyptian art, however, took place during the Old Kingdom,
or, as it is sometimes called, the Memphite period. At
this time, Memphis was the capital, and from the graveyard
of Memphis, the great necropolis that extends for many
miles along the edge of the desert to the west and the south-
west of Cairo, almost all the preserved monuments of Old
Kingdom sculpture have been recovered. The richest find-
ing places have been the so-called mastabas, flat-topped
tombs built for the great nobles. From these have come
many statues of the occupants of the tombs, their families,
and their servants, as well as great quantities of reliefs repre-
senting almost every aspect of Egyptian life. The ruins of
the temples, also, built by the Pharaohs in connection with
the pyramids in which they were buried, have yielded im-
portant representations of the rulers. The largest collection
of these works is in the great museum at Cairo, but many
have passed to other countries. In America, both the Metro-
politan Museum in New York and the Museum of Fine Arts
in Boston possess fine examples from the Old Kingdom.

The Sheikh-el-Beled. What strikes one most forcibly in
any collection of Old Kingdom sculpture is the marked realis-
tic tendency. This is especially noticeable in figures drawn
from the middle and lower classes. In these the endeavor of
the artist was clearly to create, so far as lay in his power, a
counterfeit of the living model. The most famous of all

statues of this period, the Sheikh-el-Beled (Fig. 1), brings vividly before us the type of the successful "self-made" man. The very name of the figure is a tribute to the skill of the maker. It means Village Chief, and was given to the statue by the Arab workmen who found it, because, when it came out of the sand, it looked so much like the chief of their village that they all with one accord cried out "Sheikh-el-Beled," and Sheikh-el-Beled it has been called ever since. It represents a man in middle life, who clearly had not denied himself the pleasures of eating and drinking. The fleshy, stocky form, with the loin-cloth as the only garment, is admirably rendered, especially when one remembers that what we have is only the wooden core of the figure. As it stood originally, the surface was concealed by a covering of linen and plaster, in which, no doubt, some details were added, and the whole was painted. But the most remarkable feature,

FIG. 1—THE SHEIKH-EL-BELED.
MUSEUM, CAIRO

after all, is the head, with its wonderful suggestion of self-satisfied well-being. Here, clearly, we have a faithful portrait. The ideals of the artist are best shown, perhaps, by the fact

that the eyes are formed by two pieces of white quartz and the pupils by bits of rock crystal, with a polished wooden nail at the centre. In spite of more recent discoveries, the Sheikh-el-Beled still remains one of the great masterpieces of the Old Kingdom.

The Seated Scribe in the Louvre. Very similar in spirit, though less skilful in execution, is the Seated Scribe in the

FIG. 2—SEATED SCRIBE. LOUVRE, PARIS.
(PHOTO. GIRAUDON)

Louvre (Fig. 2), one of the finest examples of the large group of figures of servants and slaves that have come from the tombs of the Old Kingdom. This figure is of limestone and retains many traces of the paint with which it was covered. Ready to take his master's dictation, he sits erect and alert. The posture, obviously, made difficulties for the sculptor; the legs are abnormally heavy, a n d each foot has only three toes. But the upper body shows careful study, with its flabby breast muscles and well-rendered collar bones; and the face was evidently studied from life.

Statues of the Pharaohs. A rather different ideal appears in the figures of the Pharaohs, in which we can trace an attempt to pass beyond the facts of nature, that is, to idealize. The reason is probably to be found in the conception of the ruler as a superhuman being, a descendant of the gods and their representative on earth. In the wonderfully preserved group now in the Museum of Fine Arts, Boston (Fig. 3), the faces doubtless reflect those of Menkure, the builder of the Third Pyramid at Gizeh, and his queen. But it is hardly likely that the faces of the originals displayed such great regularity of feature or so few wrinkles and other in-

dividual peculiarities; and the fixed smile is probably meant
to suggest not only the gracious rulers of the land, but also
superior beings, less subject than ordinary mortals to the
troubles and griefs of actual human existence. These
suspicions are confirmed by other portraits of the Pharaohs of
the Old Kingdom, such as
the great diorite Khafre in
the Museum at Cairo and
the Great Sphinx at Gizeh,
which is now generally rec-
ognized as another repre-
sentation of this Pharaoh,
the builder of the Second
Pyramid. Such portraits
differ considerably from one
another and obviously were
based on different originals,
but all have in common the
regular features, the smooth
cheeks, and the fixed smile.
These are also found in
many statues of the Egyp-
tian deities.

Characteristics of Mem-
phite sculpture. In the
masterpieces of the Mem-
phite school, we see the best
that the sculptors of the
Old Kingdom accomplished.
Many other statues of the

FIG. 3—MENKURE AND HIS QUEEN.
MUSEUM OF FINE ARTS, BOSTON

period, naturally, are less impressive, being the work of less
skilful artists or of local schools, remote from the centre
of greatest activity. But any period should be judged by
its best productions rather than by those of inferior merit,
and the less successful statues betray the same ideal as those
of the great masters, namely, the faithful reproduction of the
subjects represented. Details of the body are often neglected
or badly rendered, but in the faces, at least, the attempt at
portraiture is always obvious. In the statues of the great

nobles, as in those of the Pharaohs, we often suspect a slurring over of details, in an attempt to suggest the dignity and reserve that were evidently regarded as proper to the ruling caste. And throughout the production of the Memphite school, there is a tendency to what may be called suavity, that is, to smoothness and roundness of surface. But these idealizing tendencies are slight, at best, and never go so far as to obscure the portrait character of the work as a whole.

The law of frontality. One noteworthy feature of these statues is the comparatively small number of poses represented. The figures are almost all either standing or seated, and there is strict observance of what has come to be called the "law of frontality." A plumb line dropped from the centre of the forehead would divide the figure in all cases into two equal parts. Arms and legs may be differently placed on the two sides, but there is no bending to right or to left, and the head always faces straight forward. The result is the stiffness of pose which is a marked feature of Egyptian work in the round.

Polychromy. Another persistent feature is the use of color. Statues in softer materials, like wood or limestone, were apparently completely covered with paint; those made of harder stones or of bronze usually show some traces of color. The system was a conventional one. The flesh of men was regularly painted a dark red, that of women, light yellow; the drapery is usually white; hair and wigs are black; and all these colors, together with blue and green, were applied to diadems, necklaces, and other pieces of jewelry. The result, in the rare instances where the color is well preserved, is a brilliant polychromy, which greatly enhances the lifelike effect.

Relief sculpture. The reliefs of the Old Kingdom that have been preserved come almost exclusively from the elaborately decorated chapels of the tombs. The walls were commonly divided from bottom to top into a series of narrow fields, and in these were carved many scenes from Egyptian life, especially the bringing of offerings to the dead, the production of food, and games and sports of many kinds (Fig. 4).

Sometimes each field is occupied by a single subject; but not infrequently, by a convention which is common in the early art of many regions and which is sometimes called the continuous method of narration, more subjects than one are represented in the same field. The relief is commonly kept very low, with figures rising only slightly from the background. A peculiarly Egyptian type is what is often called "sunk relief"; in this, each figure is worked in low relief at the bottom of a sinking in the stone (see Fig. 9 for an example from a later period). The workmanship is sometimes hasty,

FIG. 4—RELIEFS FROM A TOMB-CHAMBER. MUSEUM OF FINE ARTS, BOSTON

but the best of the reliefs are executed with great care and produce a charming decorative effect. This is much enhanced by the delicate and harmonious colors with which all were originally covered and which sometimes are remarkably well preserved. Closer inspection reveals many peculiarities in composition and in drawing. The principal figure in any scene is usually larger in scale than others. The individual figures regularly have the head in profile, with eye in front view, shoulders in front view, legs in profile, and body in a sort of three-quarters, tapering down to make the transition from the shoulders to the legs. Hands, too, are usually awkwardly rendered, with all the fingers displayed, and

similar tendencies appear in the feet. The result is a certain stiffness and unnaturalness, which we recognize at once as characteristic of Egyptian reliefs and which justifies the adjective "conventional," so often applied to them. Yet it is a striking tribute to the skill of the Egyptian sculptors that their conventional methods of representation detract little, if at all, from the pleasure one feels in the clear, graceful outlines, the delicate, rounded surfaces, and the pictures of Egyptian life. Even the conventional rendering of nature, by which water becomes a blue wash covered with zigzag black lines, and plants and trees are drawn with pattern-like regularity, has a distinct decorative value and in the actual reliefs is much less disturbing than might be imagined from a description.

The Middle Kingdom (Dyn. XI and XII, about 2160-1788 B.C.). The First Theban School. The period of disintegration which followed the Sixth Dynasty has left but few monuments and those of no great importance. It was brought to an end by princes of Thebes in Upper Egypt, who once more established a strong central power and founded what is commonly called the Middle Kingdom. The Theban Pharaohs organized their government along feudal lines, giving to the local chiefs who acknowledged their sway more authority than they had enjoyed during the Old Kingdom. One result of this policy is that a number of local schools or groups of artists, working in different parts of the country for the great nobles, can be distinguished, sometimes with considerable clearness. The most important group, naturally, is made up of the men who worked for the rulers and who are conveniently called the First Theban School. We have a few early works of this group, which, although they are inferior in execution to the best products of the Old Kingdom, show a certain crude power and considerable originality. But with the firm establishment of the Theban rule, the men of the Theban School began to imitate the earlier artists of Memphis, so that most of the work of this period continues the traditions of the Old Kingdom. There are some slight differences. In the statues of the Pharaohs of the Middle Kingdom, the heads seem usually less idealized than

those of the earlier kings and give an effect of more faithful portraiture (Fig. 5); in reliefs, the figures are carved a little higher, and there are rare instances of less conventional poses, suggesting a certain independence. But for the most part, the Theban artists, after they began to imitate the

FIG. 5—SESOSTRIS I. MUSEUM, CAIRO

mannerisms of the Memphites, remained their faithful followers.

The Empire (Dyn. XVIII-XX, about 1580-1090 B.C.). The Second Theban School. The First Theban period was succeeded by two centuries of confusion, from which few records have survived. The weakening of the central power

was apparently followed by many struggles among the
nobles, which so distracted the country that it fell an easy
prey to foreign invaders called the Hyksos. They ruled
Egypt for about a century, but were finally expelled by the
princes of Thebes, who once more established a strong central
government. Unlike their predecessors, the rulers of the
Second Theban period aimed to destroy the power of the
nobles. The local chiefs were largely exterminated, and their

FIG. 6—COLOSSI OF RAMSES II. ABU SIMBEL

lands reverted to the crown. The form of government thus
established was clearly imperial in character, and the period,
therefore, is commonly called the Empire. This was the
most brilliant age in the whole history of Egypt. By a series
of successful wars, the great Pharaohs of the XVIII Dynasty
extended their sway, not only over all the neighboring regions
of northeastern Africa, but also over a large part of western
Asia, and most of the conquered regions were held for many
years, though not without frequent struggles. With the
tribute from this mighty empire, the kings built many tem-
ples, partly for the worship of the gods, partly as adjuncts to

their own tombs, for the worship of the Pharaohs after death. All the temples were adorned with statues and reliefs, and the tombs themselves, for which the favorite type was now the "rock-cut" tomb, hollowed out of the cliffs, were elaborately decorated with reliefs and paintings. Of the quantities of richly embellished furniture and utensils deposited in these burial places the recently discovered tomb of Tutankhamen h a s furnished a remarkable illustration.

Round sculpture: Colossal statues. The great activity in building and the enormous scale on which many of the structures of the Empire were planned are responsible for some of the changes that we can see in the sculpture of the time. Colossal statues, o f t e n many times life-size, became more common, no doubt because figures of smaller size would have seemed out of scale with the walls and columns near which they were set up. This tendency, to be sure, was no new thing, for the

FIG. 7—HEAD FROM A STATUE OF HARMHEB. MUSEUM, CAIRO

love of the colossal was inherent in the Egyptian character, as the Great Sphinx and some other early figures show, but it was undoubtedly encouraged by the large scale of the buildings of the Empire. The most famous examples that have survived in anything like good preservation are four seated figures of Ramses II, carved out of the cliff in front of a rock-cut temple at Abu Simbel in Nubia (Fig. 6). These are more than sixty-five feet in height. The tendency

to somewhat slenderer proportions, also, appears in many figures of the Empire, and may possibly again be due to the scale of the buildings with which they were associated. At the same time, it is noticeable that for their types, in general, the sculptors of the Empire went back to earlier times for inspiration. The statues of the Second Theban period are regularly either standing or seated figures, posed like those of the Memphite and the First Theban schools. The portraits of the Pharaohs, though most of them are rather common-

FIG. 8—SETI I IN BATTLE. KARNAK

place, sometimes show remarkable skill in characterization (Fig. 7), and there is the same tendency as in earlier times to concentrate attention on the heads and to slur over details of the bodies.

Reliefs. The reliefs of the Empire, in many cases, betray careless execution, as if the maker were pressed for time or felt that on the great surface to be decorated, careful work would not be appreciated. In temple reliefs, naturally, the figures are frequently much larger than those of earlier date. The scheme of division into horizontal bands is often given

up and figures are scattered promiscuously over the wall (Fig. 8). For the figures themselves, the same disturbing conventions continued in use, but in the best work, just as in earlier days, the delicacy of the details makes us almost forget the disregard of actual conditions in nature (Fig. 9).

FIG. 9—SETI I MAKING OFFERINGS TO THE GODS. ABYDOS

The reign of Ikhnaton (about 1375-1358 B.C.). Almost the only break with tradition during the period of the Empire is furnished by a series of works from the reign of Amenhotep IV, or, as he called himself, Ikhnaton. This king is famous as a religious reformer, who tried to introduce a monotheistic worship of the sun as the supreme god, in place of the estab-

lished system. The statues and reliefs of his time differ from the mass of Egyptian works in that they show a more naturalistic rendering of the human figure (Fig. 10), with long, sharp face, small neck, protruding belly, and thin legs. Apparently, these traits are those of Ikhnaton himself, and were introduced into other figures out of flattery to the monarch. Perhaps they are merely characteristic of a local school at Akhetaton (the modern Tell el-Amarna), where Ikhnaton, deserting Thebes, built a new capital. At any rate, the tendency towards greater naturalism was only a passing fashion. It had little effect on later works, in which the sculptors returned to the older types.

FIG. 10—IKHNATON AND HIS QUEEN. NEW MUSEUM, BERLIN. (FROM VON BISSING, "DENKMÄLER ÄGYPTISCHER SCULPTUR," PL. 83)

Saïte Period (Dyn. XXVI, 663-525 B.C.) The Egyptian Renaissance. The XXI to the XXV Dynasties mark another period of disintegration, conveniently called the Period of Foreign Domination. The Pharaohs of this time, whose control rarely extended beyond Egypt and Nubia and sometimes embraced only parts of those districts, were often not native Egyptians at all but foreigners; and at the end of the period, all Egypt was for a short time included in the Assyrian empire. From these troubled years, considerable numbers of statues and reliefs are preserved, for the most part inferior to those of the Empire, but occasionally of such merit as to show that something of the Empire tradition survived. A new era dawned with the expulsion of the Assyrian garrisons by Psamtik I, prince of Saïs in the Delta, who gained control over the whole country. Under the Saïte rulers, there appears to have been a real revival, both in literature

and in art, and the Saïte period is often called the Egyptian Renaissance. The name is justified by the monuments of the time, since the attempt to imitate earlier works is everywhere apparent. It was especially the art of the Old Kingdom which appealed most strongly to the Saïte artists, with the result that in their statues we find again the realistic tendency of the first dynasties. But the Saïte sculptors went further than their models, and the heads of this period often exhibit remarkable skill in the rendering of distinctive traits (Fig. 11). Especially marked is the care expended on the bony structure of the skull and the wrinkles of the skin. At the same time, the bodies are carved in the ancient manner, and rarely show any individual peculiarities.

FIG. 11—PORTRAIT HEAD OF THE SAÏTE PERIOD. MUSEUM OF FINE ARTS, BOSTON

Reliefs. In reliefs, the figures are once more arranged in horizontal bands and executed with all the purity of line and delicacy of the Old Kingdom. Among the interesting relics of Saïte art are the "sculptor's models"—small pieces of limestone, carved with figures in various stages of completeness, or with a single head, or hand, or foot, or a single animal—examples of which are to be found in almost every collection. These were clearly used in the instruction of young artists, and are often remarkable for their fine detail. They emphasize once more the persistence of traditional methods which is such a marked feature of all Egyptian art. Evidently, at this time, the copying of established forms was regarded as the ideal method of training a sculptor, and the study of nature, without which the highest development in any art is impossible, was sadly neglected.

Later Egyptian sculpture. The Saïte period represents the last important phase of Egyptian sculpture, although many monuments are preserved from the succeeding ages of Persian, Greek, and Roman rule. After the conquest by Alexander, a certain amount of Greek influence can sometimes be seen in statues and reliefs. But, in general, the Egyptian remained true to his ideals. Even in work of the Roman age, the intention to follow the ancient models is clear, though the execution is usually far inferior to that of earlier times.

General character of Egyptian sculpture. The most striking quality of Egyptian sculpture is its unchanging character. The types for seated and standing statues and for figures in relief established during the Old Kingdom continued in use, with only slight variations, throughout the later periods. The persistence of types is the more significant in view of the very great skill which the Egyptian sculptors obviously possessed. They did not hesitate to attack the hardest materials, such as granite, basalt, and serpentine. Their power of observation is shown in the very successful characterization which distinguishes their portrait heads, in their rendering of the physical peculiarities and un-Egyptian dress of foreigners, and in their remarkably lifelike representation of animals. It is possible, of course, that the unchanging nature of the types is due, as has often been suggested, to the conservatism and aversion to novelty characteristic of the ancient Egyptians. But a much more reasonable explanation is that the types continued in use because they satisfied the sculptors and their patrons and really expressed the ideals of the Egyptians in regard to what is fitting in sculpture.

Influence of Egyptian sculpture. That these Egyptian ideals did not greatly appeal to other races is not surprising. The Egyptian style was rarely followed by sculptors of other lands, and almost always as a matter of conscious imitation. The Phœnicians frequently copied Egyptian types for small figures in bronze or ivory or clay, or for the decoration of bronze and silver bowls and other utensils. These, together with small figures and utensils of Egyptian manufacture, were carried by Phœnician merchants to all the lands

around the Mediterranean, and occasionally inspired emulation in regions remote from Egypt. There are some evidences of Egyptian influence in the earliest Greek sculpture, as we shall see, and Egyptian forms were imitated not infrequently in the Roman age. But, for the most part, the Egyptian style remained peculiar to the inhabitants of the Nile valley, and, except for certain decorative patterns, especially those derived from the lotus, had little effect on the art of other peoples.

BIBLIOGRAPHICAL NOTE

Although it was published in 1882, the chapter on Egyptian sculpture in the first volume of Perrot and Chipiez's elaborate *Histoire de l'art dans l'antiquité* is still one of the best discussions of the subject. (The English translation by W. Armstrong was published under the title *Art in Egypt,* in 2 vols., London, 1883.) G. Maspero's *Manual of Egyptian Archæology,* New York, 6th ed., 1914, contains a brief historical account; his *Art in Egypt,* New York, 1912 (*Ars Una* series), lists many more monuments and attempts to distinguish the work of local schools. Hedwig Fechheimer's *Die Plastik der Ægypter,* Berlin, 2d ed., 1922, is an interesting endeavor, with many excellent illustrations, to evaluate Egyptian sculpture from an æsthetic point of view.

The earliest monuments are conveniently brought together in J. Capart's *Primitive Art in Egypt,* London, 1905. L. Borchardt's *Kunstwerke aus dem Museum,* Cairo, 1912, publishes in 50 plates, with a brief text, many of the treasures of the great museum in Cairo. F. W. von Bissing's *Denkmäler ägyptischer Sculptur,* Munich, 1914, with 150 plates and explanatory text, is similar in character, but laid out on broader lines. J. Capart's *L'art égyptien,* Brussels, 2 vols., 1909, 1911, provides in a cheaper form reproductions of a large number of monuments, with excellent bibliographical references.

The best political history of Egypt is J. H. Breasted's *History of Egypt from the Earliest Times to the Persian Conquest,* New York, 2d ed., 1909.

CHAPTER III

MESOPOTAMIAN SCULPTURE

While the Egyptian sculptors of the Old Kingdom were working out the forms which were modified, but never abandoned, by their successors, another civilization, destined to exercise a greater influence on the art of later times, was developing in the valley of the Tigris and the Euphrates, the district which is most conveniently called Mesopotamia.

Physical environment. Mesopotamia seems, in many ways, a less favorable region for the evolution of a great civilization than Egypt. At the present day, a large part of the country is a desert. But this is due to the neglect of the elaborate system of canals by which, in antiquity, the waters of the rivers were regulated. Herodotus and other writers mention the fertility of the land in ancient times, and show that its prosperity was largely due to agriculture. Commerce, too, played its part, for through this valley runs one of the oldest trade routes of the world, connecting the eastern shore of the Mediterranean and Asia Minor with India and the Far East.

For the development of sculpture, the conditions clearly were less advantageous than in Egypt. The lower part of the valley, the ancient Babylonia and Chaldæa, is a great alluvial plain, with no stone and no trees of any size except the palm, the wood of which is small and fibrous. In this district, therefore, the materials for sculpture had always to be imported. In the upper valley of the Tigris, where the Assyrian power developed, there are deposits of limestone and alabaster, and forests of oak, pine, cypress, and beech cover the nearby hills. But the limestone and alabaster cannot be quarried easily except in slabs, and the Assyrians never developed carving in wood. Mesopotamian sculpture, there-

fore, is mostly sculpture in relief, though figures in the round are sometimes found, often made of very hard imported stone.

Political history. *The Early Babylonian Period (about 3000-1275 B.C.).* The dominant tribes in Mesopotamia during most of the historical period were Semitic, but it is clear that much of their culture was derived from a non-Semitic people called the Sumerians, who occupied the lower part of the valley before the coming of the Semites. Thanks to the system of writing which the Sumerians invented—the so-called cuneiform system, named from its wedge-shaped characters—a good deal is known about the history of Babylonia. As early as 3000 B.C., there were flourishing cities, some Sumerian, some Semitic. We have records of wars between the cities and with the Elamites on the east; of "dynasties" in different cities, which gained control over the whole district or large parts of it; and of occasional expeditions to the north and the west, sometimes as far as the Syrian coast. Ultimately, about 2100 B.C., the leadership fell to the Semitic city of Babylon, which thenceforth remained the most important centre in the lower valley, and for several centuries was the capital of a powerful kingdom.

Assyrian Ascendancy (about 1275-607 B.C.). During the second millennium, the supremacy of Babylon was challenged by a new power in the upper valley of the Tigris, the kingdom of the Assyrians. As early as 1650, the Assyrians succeeded in asserting their independence, and about 1275, they even conquered Babylon itself. With this event, Assyria, rather than Babylonia, became the dominant district, although the Assyrian control was not maintained uninterruptedly. The period of greatest Assyrian power was from 885 to 626, when a succession of strong rulers brought most of western Asia, and even Egypt for a short time, under their sway. The most important of these rulers, from whose palaces the greater part of the Assyrian sculpture that we have has been recovered, were Ashurnasirpal (885-860), Sargon II (722-705), Sennacherib (705-681), and Ashurbanipal (668-626).

Later Babylonian Period (607-538 B.C.). The wars by which the Assyrian monarchs conquered and controlled their

empire were waged with the utmost cruelty. Revolts against them were frequent, and at last their empire was destroyed by a revolt of the Babylonians in alliance with the Medes. In 607, Nineveh, the later capital of Assyria, was taken and utterly destroyed, and Babylon once more became, for a few years, mistress of the valley. The most important king of this time was the famous Nebuchadnezzar (604-561), who rebuilt Babylon on a splendid scale. But under his successor, the city was captured by Cyrus, and the Babylonian kingdom was absorbed into the Persian Empire.

Religious beliefs. The religious beliefs of the Mesopotamian peoples did not exercise so powerful an influence on their art as did those of the Egyptians. Figures of the gods, often distinguished from human beings by the addition of wings, are frequent in their reliefs, but usually associated with representations of the rulers. Belief in the life after death led to no development of elaborate tombs. Most Mesopotamian sculpture comes from the palaces of the kings and is devoted to the glorification of the rulers.

Early Babylonian Period (about 3000-1275 B.C.). Round sculpture. The most important group of early sculptures that has yet been recovered from Babylonia comes from the mound of Tello, the site of the Sumerian city of Lagash. The group includes a number of statues of Gudea, who was priest-king, or *patesi*, of Lagash about 2450 B.C. There are several headless bodies and a number of heads, only one of which, curiously enough, could be fitted to any of the bodies (Fig. 12). The material is diorite, a hard, volcanic stone, which must have been imported. Certain disturbing traits are at once obvious—the over large head, the squat, heavy proportions, the inscription which covers most of the robe, the badly carved feet and ankles, the conventional rendering of the eyebrows as a pair of perfectly regular sinkings, with scratched oblique lines to indicate the separate hairs. But other features show that this is by no means the work of a primitive artist. The muscles of the right arm are rendered with approximate correctness, the shape of the eye is carefully studied, and the little pads of flesh at the corners of the mouth give to the face a lifelikeness that com-

pares favorably with the best Egyptian achievements of the Old Kingdom. An even more favorable impression of the sculptors of Lagash is gained from one of the headless figures, which represents Gudea with a tablet on his knees, on which

FIG. 12—GUDEA. LOUVRE, PARIS. (FROM CROS, "NOUVELLES FOUILLES DE TELLO," PL. 1)

is worked out a plan for a building. In this, the proportions are much better, and the details of hands and feet show painstaking effort.

Reliefs. The Vulture Stele. The mound of Tello has yielded numerous fragments of early reliefs, all, unfortunately, badly mutilated. The most interesting come from the

so-called Vulture Stele, on which was recorded the victory of Eannatum, an early *patesi* of Lagash (about 2900 B.C.),

FIG. 13—STELE OF NARÂM-SIN. LOUVRE, PARIS

over the neighboring city of Umma.[1] Many events of the campaign are pictured—Eannatum leading his troops into battle, the burial of the dead under a tumulus of earth,

[1] Cf. De Sarzec, *Découverts en Chaldée*, pls. 3 and 4.

vultures carrying off the heads of slain enemies, as well as Ningirsu, the god of Lagash, holding a net filled with bodies of the men of Umma. The execution is careful, and in spite of certain awkwardnesses of drawing, the reliefs tell their story with remarkable vividness.

The Stele of Narâm-Sin. Much better for study, because better preserved, is the Stele of Narâm-Sin, found some years ago on the site of Susa, where it had been carried from Babylonia by an Elamite king (Fig. 13). It is an irregular block of limestone, something over six feet high, set up originally about 2600 B.C. by Narâm-Sin, king of the Semitic city of Agade, to commemorate his victories. The king is represented as he marches over hilly, wooded country at the head of his victorious army. The hills are suggested by a great cone in the upper part of the relief and by irregular ground lines under the feet of the king and his soldiers; a single tree symbolizes the forests. Before the king are his enemies, some dead, others dying, others holding up their hands in supplication, while above appear the stars that "fought in their courses" for Narâm-Sin. Many of the conventions of early relief, such as we found in the products of Egyptian sculptors, are noticeable here—the arrangement of the figures one above another with no regard to relations in nature, the representation of the king as larger than the rest, the contorted forms with legs in profile, shoulders in front view, and eye in front view when the head is in profile. Several traits, however, recall the statues from Tello. The poses of the figures are vigorous and full of life; the muscles are heavy, the shoulders broad and square; and a long inscription is carved across the face of the relief. The whole seems to be the work of a sculptor who aimed to reproduce life as he saw it, and to suggest, to the best of his ability, the power of the king, his master.

Assyrian Ascendancy (*about 1275-607 B.C.*). From the later centuries of the Early Babylonian period, very little sculpture has been preserved, and from the earlier years of the Assyrian ascendancy, also, comparatively few works are known. It is not until we reach the reign of Ashurnasirpal (885-860 B.C.) that we have a large number of monuments

for study. Then, for nearly three centuries, the palaces of
the Assyrian monarchs furnish plentiful material for tracing
the history of Assyrian sculpture.

Round sculpture. The statue of Ashurnasirpal. The best
example of Assyrian sculpture in the round is the almost

perfectly preserved figure
of Ashurnasirpal found in
the ruins of his palace by
Sir Henry Layard (Fig.
14). The contrast between
this statue and the seated
figures of Gudea is surpris-
ing. Such naturalness as
was attained by the artists
of the earlier period is en-
tirely gone, and in its place
we find a highly conven-
tional manner of represent-
ing the human body. Ashur-
nasirpal stands stiffly erect,
dressed in a heavy robe. In
this there is no attempt to
render the folds of the
material; only the heavy
fringes seem to have inter-
ested the sculptor. In those
parts of the body that are
not concealed by the robe,
the forms are remarkably
lifeless. The right arm is
almost cylindrical in sec-
tion, with little or no sug-
gestion of the muscles, the
toes are hardly more than

FIG. 14—ASHURNASIRPAL. BRITISH MU-
SEUM, LONDON. (PHOTO. MANSELL)

projecting knobs. But it is in the face that the conventional
character of the work is most evident. The large eyes are as
exaggerated in size as those of the early heads from Tello,
and with their projecting masses are even more unnatural.
The eyebrows are rendered by sinkings. Cheeks and chin

are covered by a heavy heard, treated in vertical bands, with oblique hatchings alternating with small squares decorated in regular, spiral curls. The features are markedly Semitic, with a strongly arched, aquiline nose. There is, perhaps, a certain suggestion of power in this heavy, immobile figure, but as a work of sculpture it falls far below the statues from Tello. The other Assyrian statues that have been preserved show the same qualities.

Relief sculpture. For the study of Assyrian sculpture in relief, our material is abundant. Most of it comes from the palaces of the kings, no less than seven of which have been discovered in the mounds that mark the site of Nineveh and other Assyrian cities. The reliefs, carved in alabaster or limestone, were used as a revetment along the base of the mud-brick walls of the more important apartments and about the doorways. The technique, for the most part, is low relief.

Guardian monsters and animals. There is, however, one group of monuments that may be called high relief, or better, perhaps, a sort of compromise between high relief and sculpture in the round, namely, the figures of monsters and animals which were frequently placed about the entrances of the palaces. These stand out boldly from the slabs in which they are cut, but present a further peculiarity in that the relief is carried around the edge of the slab. The commonest types are monsters, with the body of a bull or a lion, the wings of a bird, and the head of a man (Fig. 15). They were conceived, no doubt, as guardians of the king's residence, powerful beings combining the strength of the bull or the lion with the swiftness of the eagle and the intelligence of man, an idea not unlike that of the cherubim of Jewish tradition. In them the conventionality that we noted in the statue of Ashurnasirpal is even more in evidence. The faces are carved in the same manner as the face of the king. The great muscles of the legs are simply outlined by deep grooves. The feathers of the wings and the flocks of hair along the belly are pattern-like in their regularity. But the most remarkable departure from nature is that each of the monsters has five legs. The sculptor has tried, in a way that is common in early and primitive art, to combine two aspects

of the same figure. Seen from the front, as the visitor approached the palace, the guardian genius was to appear to be standing quietly; as the visitor passed through the portal, the monster was to seem to be advancing; and so, behind the two firmly planted forelegs, a third foreleg was carved.

FIG. 15—GUARDIAN MONSTER FROM THE PALACE OF ASHURNASIRPAL. BRITISH MUSEUM, LONDON. (PHOTO. MANSELL)

Even where the guardian is not a monster, but a lion, the fifth leg almost always appears.

Historical reliefs. The great mass of Assyrian sculpture is in low relief, carved by the simple process of drawing the figures on the stone and cutting away the background. Here again, as in Assyrian round sculpture, the style is more con-

ventional than in the work of the Early Babylonian period.
There are, however, some variations between the reliefs from
different reigns, and we can trace a certain development, cul-
minating in the reliefs of Ashurbanipal. One common trait,
which these reliefs share with those of Egypt, is the com-
bination of successive scenes in a single composition.

Reliefs of Ashurnasirpal (885-860 B.C.). The earliest
large series of reliefs is that from the palace of Ashurnasirpal.

FIG. 16—ASHURNASIRPAL AND A PROTECTING DEITY. BRITISH MUSEUM,
LONDON. (PHOTO. MANSELL)

The subjects represented are those most frequent in the
palace reliefs, namely, fighting and hunting. Figure 16 is
taken from one of the hunting scenes, and represents the king,
equipped with a bow and two arrows and attended by a
protecting deity. In the heads, eye and hair and beard are
rendered in the same unnatural forms as in the Assyrian
statues; and although the heavy muscles of the forearm are
suggested with some approach to correctness, the bared left
leg of the god betrays only too clearly the sculptor's disre-
gard of anatomical relations and dependence on conventional

methods. His principal interest seems to have been in the heavy fringes of the robe and other details of costume; it is noteworthy that the inscription, which is carved straight across the relief, is not allowed to interfere with the working out of the fringe.

Such reliefs as these, in which no attempt is made to suggest the setting of the figures, are the most successful that the sculptors of Ashurnasirpal's reign produced. In most cases, when they undertook to portray more complicated action, they fell into the same difficulties as their contemporaries in Egypt, and evolved a purely conventional method of suggesting relations in space (Fig. 17). The lower part of

FIG. 17—FUGITIVES SWIMMING TO A FORTRESS. FROM THE PALACE OF ASHURNASIRPAL. BRITISH MUSEUM, LONDON. (PHOTO. MANSELL)

the field seems to have been thought of as nearer to the spectator than the upper, but the figures in the upper portion are no smaller than those of the lower, and nowhere is there evidence of any knowledge of the perspective. Hilly country is indicated by groups of triangular projections; water, by wavy grooves; the battlements of a city are no taller than the Assyrians who attack them. The artists of Ashurnasirpal apparently realized their inability to render complicated scenes successfully, and rarely introduced details of landscape unless these were demanded by the subject. This is true, also, of most of the work produced during the reigns of the other kings of the ninth and the eighth centuries.

Reliefs of Sargon II (722-705 B.C.). The most important reliefs of the eighth century are those from the palace of Sargon II at Khorsabad, in which there is some advance over earlier work (Fig. 18). The human figures are not quite so squat and heavy; hair and beard are rendered a little more naturally; the eyes are not completely in front view, although they are not correctly foreshortened; and the inscriptions no longer run completely across the figures.

Reliefs of Sennacherib (705-681 B.C.). In the reliefs of Sennacherib, further changes appear. The sculptors of this reign seem to revel in details of landscape, and because of

FIG. 18—RELIEF FROM THE PALACE OF SARGON II. LOUVRE, PARIS.
(PHOTO. GIRAUDON)

this their reliefs are often called "picturesque," in the sense that they introduce details more proper to painting than to sculpture. Most of the reliefs from Sennacherib's palace are devoted to his victorious campaigns, but one interesting series represents the building of the palace itself. A single slab from this series (Fig. 19) will serve to illustrate the tendencies of the time. The subject is the transportation of building materials on the Tigris. The essential features are the river and the two boats loaded with stone, but to these the sculptor has added many details—the trees along the nearer bank, the fish in the stream, and two fishermen riding on inflated skins, with fish-baskets on their backs. The whole is a sort of elaborate picture-writing, which tells the story with

absolute clearness, but practically without regard to relations in nature.

Reliefs of Ashurbanipal (668-626 B.C.). The tendency to picturesqueness was only temporary. In the reliefs from the palace of Ashurbanipal, there is a return to the simpler manner (Fig. 20). These reliefs are unquestionably the best that the artists of Assyria produced. With the exception of the eyes, the figures are, in general, correctly drawn in

FIG. 19—TRANSPORTATION OF BUILDING MATERIALS. BRITISH MUSEUM, LONDON. (PHOTO. MANSELL)

profile, and the forms, though still heavy, are somewhat more graceful than those of earlier times. The patterns on the robes and the details of harness and other equipment are carved with the utmost care and with no little feeling for decorative effect. But it is above all to the skilful representation of animals that this series owes its fame. In the great hunting scenes that form the subjects of many of Ashurbanipal's reliefs, horses and dogs, wild asses and lions are carved with remarkable dexterity and bear witness

FIG. 20—ASHURBANIPAL HUNTING. BRITISH MUSEUM, LONDON.
(PHOTO. MANSELL)

to developed powers of observation. A single specimen,
but one that is generally regarded as the masterpiece of

FIG. 21—THE WOUNDED LIONESS. BRITISH MUSEUM, LONDON. (PHOTO.
MANSELL)

Assyrian sculpture, the Wounded Lioness (Fig. 21), will serve
to show the high quality. The figure is only one of many,
a mere detail in one of the great hunting scenes. The lioness

has been struck by three arrows, one of which has severed the spinal cord and paralyzed her hind quarters. Yet even in this condition, she tries to pull herself forward and fight on. One may cavil at the attachment of the forelegs and the pattern-like rendering of the flowing blood, but no one can deny that the whole is instinct with life. The wrinkled muzzle, the mouth, open in a snarl of rage and pain, and the

FIG. 22—RELIEFS ON THE GATE OF ISHTAR. BABYLON. (FROM KOLDEWEY, "DAS ISCHTAR-TOR IN BABYLON," PL. 27)

useless legs dragging along the ground show the hand of an artist worthy to rank with the great masters of animal sculpture of all ages.

Later Babylonian Period (607-538 B.C.). From literary accounts it is clear that the later Babylonian period witnessed a renaissance of art in Babylon. The city, as it was rebuilt by Nebuchadnezzar, is spoken of with admiration by many later writers. As yet, we have comparatively few monuments

to confirm their glowing accounts. The most important relics of sculpture are the figures of animals and monsters that formed the decoration of the Ishtar Gate and the so-called Processional Street (Fig. 22). These are worked out in clay bricks, enamelled in brilliant colors. Some of the figures are flat, but others are modelled in low relief. The modelling is somewhat more formal than in the best animal reliefs of Ashurbanipal, but not more so than is appropriate in decorative figures of this sort, and the whole series produces a favorable impression of the skill of the artists of the Neo-Babylonian period.

Use of color. The reliefs in enamelled brick suggest that color may have been used on Mesopotamian works in stone, and this suggestion is confirmed by the reports of Layard and other explorers who saw the stones as they were taken from the ground. Their statements show that in some instances, at least, details like the hair of the figures and the harnesses of horses were picked out in color. But all traces of paint have now disappeared, and it is impossible to gain an exact idea of this feature of the work. It is reasonably sure, however, that color was not so extensively employed as an adjunct to sculpture as it was in Egypt.

General character of Mesopotamian sculpture. Taken as a whole, Mesopotamian sculpture is heavy and monotonous. Its types and its range of subjects are much more restricted than those of Egyptian art. Throughout the centuries of their activity, the Mesopotamian sculptors adhered to the single type of heavily draped figure, with fixed, unsmiling countenance, and devoted themselves almost exclusively to the glorification of the sovereign. Female figures are almost non-existent in their works, and distinctions between different races or classes in society were rarely attempted. In its force and vigor, this art reflects the character of the race that produced it, but it lacks grace and delicacy, just as the people themselves seem to have been deficient in those qualities. Only in the representation of animals does it attain anything approaching greatness.

Influence of Mesopotamian sculpture. Although the products of the Mesopotamian sculptors are not so pleasing to

our eyes as those of the Egyptians, they exercised a much more powerful influence on the art of other nations. The numerous monuments of early sculpture that have been found in Asia Minor—works of Hittite, Phrygian, and Lydian artists—are almost all conceived in Mesopotamian forms. There are, to be sure, early works of Hittite sculpture, such as the rock-cut reliefs at Boghaz-Keui, which were carved before the Hittites came into close relations with the peoples of the Euphrates valley and which show greater independence. But with this exception, the forms evolved by the sculptors of Mesopotamia appear to have dominated the art of Asia Minor until the development of Greek art in Ionia in the sixth century. In Syria, we find a similar state of affairs. The few monuments of Phœnician sculpture that are known suggest Mesopotamian inspiration; and Assyrian *motifs,* no less than types derived from Egypt, were used by the Phœnician craftsmen and, through the Phœnician merchants, transmitted to the west. The early sculpture of Cyprus, which was colonized by the Phœnicians, and which, at one time (about 709-705 B.C.), acknowledged the suzerainty of the Assyrian kings, was largely derived from Assyrian models.[1]

But it is not only towards the west that the influence of Mesopotamian sculpture can be traced. It is no less evident in Persia, where the monuments of the great Persian kings continue the traditions of Babylonia and Assyria. The reliefs from the tombs of the kings near Persepolis, as well as those from the palaces of Xerxes and Artaxerxes at Persepolis and Susa, were clearly inspired by the reliefs of the Mesopotamian monarchs. In some respects, especially in attempts to render the folds of garments more naturally, the Persian reliefs mark an advance, which is, no doubt, to be attributed to contact with Greek art. But the heavily draped, impassive figures

[1] After the conquest of Cyprus by Amasis, a Pharaoh of the Saïte period, Egyptian influence is very evident in Cypriote sculpture. Later still, the influence of Greek art can be seen. But the products of the Cypriote sculptors almost universally suffer from stiffness and conventionality, and sometimes from careless workmanship. Their interest is more archæological than æsthetic. The great Cesnola Collection of Cypriote antiquities in the Metropolitan Museum in New York contains many remarkable examples of Cypriote sculpture.

are essentially Mesopotamian, and prove, once more, the powerful influence exerted by Mesopotamian art on the art of other peoples.

BIBLIOGRAPHICAL NOTE

The discussion of Mesopotamian sculpture in Perrot and Chipiez's *Histoire de l'art dans l'antiquité*, Vol. II, 1884 (English translation in two volumes, London, 1884) is accurate and very fully illustrated. For a more concise statement, P. S. P. Handcock's *Mesopotamian Archæology*, New York, 1912, or E. Babelon's *Manual of Oriental Archæology*, New York, new edition, 1906, may be consulted. B. Meissner's *Grundzüge der babylonisch-assyrischen Plastik*, Leipzig, 1915, is useful especially for its full treatment of the early monuments. The history of the discoveries in Mesopotamia is interestingly recounted in H. V. Hilprecht's *Explorations in Bible Lands*, Philadelphia, 1903. Among the writings of the early explorers, A. H. Layard's *Nineveh and its Remains,* London, 2 vols., 1849, may be heartily recommended. E. de Sarzec's *Découverts en Chaldée*, Paris, 1884——, contains an account of the early monuments found at Tello, with excellent plates. The best political history is R. W. Rogers's *History of Babylonia and Assyria,* New York, 6th ed., 2 vols., 1915. M. Jastrow's *The Civilization of Babylonia and Assyria*, Philadelphia, 1915, is an authoritative work on the culture of the Mesopotamian peoples.

The history of art in other districts of western Asia is most fully treated in Vols. III-V of Perrot and Chipiez's *Histoire:* Vol. III, Phénicie, Cypre, 1885; Vol. IV, Sardaigne, Syrie, Cappodoce, 1887; Vol. V, Phrygie, Lydie et Carie, Lycie, 1890. (All of these are available in English translations.) Babelon's *Manual of Oriental Archæology* contains chapters on the art of Persia, as well as on the art of Mesopotamia. For the art of the Hittites, J. Garstang's *The Land of the Hittites*, London, 1910, is useful. An excellent introduction to the history of Cypriote art is furnished by J. L. Myres's *Handbook of the Cesnola Collection of Antiquities*, New York, 1915.

CHAPTER IV

GREEK SCULPTURE: THE ARCHAIC PERIOD

The prehistoric "Ægean" age (about 3000-1100 B.C.).
Civilization in Greece was long believed to have developed much later than in Egypt and in Mesopotamia. But the explorations begun by Schliemann and continued by a whole company of later explorers during the past fifty years have shown that between 3000 and 1100 B.C., roughly, there sprang up and flourished in the lands around the Ægean Sea a civilization of remarkable brilliancy, which is now generally called the Ægean civilization. The people among whom this culture arose were very surely not Greeks. The Greek-speaking tribes apparently came in during the latter part of the Ægean period, and it was through the fusion of the prehistoric stock and the Greek tribes that the Greek people of historic times came into being.

The discovery of the prehistoric civilization in Greece was one of the great surprises of exploration in the nineteenth century, and more recent excavations have only increased the wonder of modern critics at the stage of culture reached by the Ægean peoples. Their kings, who were probably also priests, lived in palaces, often of great extent, and these have preserved many fragments of elaborate wall-paintings and of vessels of gold, silver, bronze, stone, and clay. The most impressive example is the "Palace of Minos" excavated by Sir Arthur Evans at Cnossus in Crete. The graves of the dead have yielded many well-preserved specimens of weapons, utensils, and jewelry, which prove a high development of all the minor arts.

Sculpture in the prehistoric age. Curiously enough, in spite of these many witnesses to the taste and skill of the prehistoric people, very little sculpture on a large scale has

been found on the Ægean sites. In the famous circle of
graves at Mycenæ, Schliemann discovered several sculptured
tombstones, but the crude drawing and the flat relief with
sharp edges show that these are the work of sculptors of

FIG. 23—THE LION GATE. MYCENÆ

very slight ability. A more favorable impression is gained
from the well-known Lion Relief over the principal gateway
to the citadel of Mycenæ (Fig. 23). The pose of the lions
is somewhat stiff, and the forelegs are badly attached to the
bodies, but the modelling of the bodies themselves will bear
comparison with all but the very best animal sculpture of

Egypt and Assyria; and when the heads, which were separately carved and attached, were in place, the lions must have been impressive guardians of the portal. The date of this relief is probably about 1400 B.C.

FIG. 24—SNAKE GODDESS. MUSEUM OF FINE ARTS, BOSTON

Sculpture on a small scale. The reliefs from Mycenæ are all that we have of large sculpture from the prehistoric age of Greece. But on a smaller scale, the artists of the Ægean period have left us many admirable works, both in the round and in relief. The two ivory "Divers" from Cnossus,[1] which are more probably to be interpreted as acrobats turning somersaults, are rightly praised for their vigorous action and exact details; and the figures of a Snake Goddess and her votary from the same site,[2] though less fine in detail, also show considerable skill in modelling. These are made of terracotta, with a vitreous glaze. But the finest example of a figure in the round that has yet been found is the gold and ivory Snake Goddess acquired by the Museum of Fine Arts in Boston in 1914 (Fig. 24). It is said to have come from Crete, and both style and workmanship make such an origin

[1] Cf. *Annual of the British School in Athens*, VIII, pls. 2 and 3.
[2] *Annual of the British School in Athens*, IX, p. 75, fig. 54; Evans, *The Palace of Minos*, pp. 500 ff. and Frontispiece.

practically certain, and date the figure about 1600 B.C. Although only 6½ inches high, the statuette creates an impression of great dignity. The pose, with the shoulders thrown far back and the head proudly erect, is one that is found in other small figures and is common in the wall-paintings of the prehistoric age. The flounced skirt and the low-cut bodice, with a very small waist confined by a broad girdle, are also characteristic of the female figures of this period. What most distinguishes the Boston figure from others, however, is the remarkably successful carving of the head. Even in the small scale in which he worked, the maker succeeded in giving to the face the same suggestion of dignity and pride of race that he attained in the pose. The individuality, too, in the shape of the nose and the slightly irregular mouth make one suspect that this is no creation of the artist's fancy but a portrait of an individual. Such figures certainly suggest that the neglect of larger sculpture in the prehistoric age can hardly be attributed to lack of skill. Rather, we are forced to conclude that the beliefs and customs of the people prevented the creation of larger works, or at least, did not favor it. The reason is, perhaps, of no great importance. The fact is that sculpture on a large scale was hardly cultivated at all during the prehistoric period.

The Dark Ages (about 1100-700 B.C.). The Ægean culture came to an end about 1100 B.C., probably as a result of the struggles caused by the intrusion of new Greek tribes. There followed several centuries of confusion and upheaval, the history of which is still so obscure that the period is often called the Dark Ages. For the evolution of sculpture, this period is of no direct importance. What little evidence there is suggests that such sculpture as was produced consisted of crude images of wood, and these have all perished. But indirectly the Dark Ages exercised no little influence on the development of Greek art. In the struggle to gain possession of the land, the Hellenic tribes experienced their first great awakening, and entered upon that career of intelligent inquiry into the universe and its meaning which rapidly made them the intellectual leaders of the ancient world. The

Iliad and the *Odyssey*, which were, perhaps, based on events incident to the struggle for the land, were the first fruits of this awakening. In them, the characters of the gods were fixed for all later ages, a fact of great significance for the development of art; and one cannot but suspect that in many ways the national character was profoundly affected by contact with the earlier inhabitants and by the new environment.

Physical conditions in Greece. To argue, as some writers have done, that the whole splendid development of literature and art in Greece was due primarily to the fact that the Greeks inhabited a country broken up into small districts by mountains and deeply indented by the sea is undoubtedly to exaggerate the importance of the physical environment. But it cannot be denied that these conditions exerted a powerful influence. The small districts favored the development of small city-states, and these fostered in their citizens a love of freedom and a sense of individual importance such as had been unknown to the inhabitants of the great monarchies of the East. The sea furnished an easy means of communication among the separate states, with the islands of the Ægean, and with the colonies that were planted for purposes of trade in many places on the shores of the Mediterranean and the Black Sea. The maritime trade thus established brought the Greeks into contact with other nations, from whom they learned many things, among them technical processes in the arts. Finally—a minor point—there can be no doubt that the general use of marble for architecture and sculpture in Greece was largely due to the fact that the mountains of the mainland and the Ægean islands contain large and easily accessible deposits of this material.

Political history. The political history of the Greeks was closely bound up with their physical environment. The emphasis on the individual and the love of liberty which were fostered by the city-states led in almost all cases to some form of democratic government, in which every citizen had a share; and patriotism, which in the older monarchies had usually meant loyalty to the sovereign, came in Greece to mean loyalty to the state. It is true that the Greek view of liberty and of patriotism was a limited one. Only

Greeks, to the Greek mind, were naturally entitled to liberty; all other races were *barbaroi* and might properly be enslaved. Greek patriotism was strictly local; it rarely rose to the conception of loyalty to a union of states. But, with these limitations, the Greeks were the first race in history to emphasize the importance of personal and civic liberty and to develop a high sense of patriotism.

Religious beliefs. In Greek religion, the most striking features are the multiplicity of gods and heroes to whom worship was paid, and the fact that almost all these divine beings were conceived in human form, only more powerful and more beautiful than ordinary mortals. To represent these divinities, therefore, the sculptor had only to create the loveliest human forms he could imagine. Moreover, around these gods and heroes, the Greek imagination wove a mass of stories and myths so beautiful that they have become a part of the heritage of all later ages; and in these the sculptor found many subjects ready to his hand. Another important phase of Greek religion is the close association of athletic games with the worship of the gods. At the great festivals at Olympia, Delphi, Corinth, Nemea, and other places, the Greek sculptors enjoyed unrivalled opportunities for the study of the human figure; and the custom of erecting statues and groups to commemorate victories in the games brought them many commissions and powerfully affected the development of their art.

Civic and religious character of Greek art. All these influences combined to make Greek art essentially religious and civic in character. The noblest buildings in every Greek city, upon which architects, sculptors, and painters lavished all their resources, were the temples of the gods. But these temples were the offerings of the whole people, expressing their patriotic pride in the city of which they formed a part and their devotion to the gods who protected it. Next to the temples, the most important buildings, which also were often adorned with sculpture and painting, were the public offices, colonnades for the transaction of business, theatres, music halls, and other structures for public use. And for the precincts of the gods and the squares and streets of the cities,

sculptors were called upon to create many single figures, groups, and reliefs, both by the state and by private individuals.

Importance of the individual artist. One result of the Greek emphasis on the individual was that the artists of Greece, unlike those of the oriental monarchies, usually signed their works, and that, in the later centuries of Greek civilization, a whole literature devoted to the history of art sprang up. We hear of books on the lives of individual artists, on the masterpieces of art, on proportion and similar subjects, very like the great literature of art in modern times. Although all these books have perished, excerpts from them are preserved in a number of later works, especially the great encyclopædia called the *Naturalis Historia,* written by Pliny the Elder in the first century after Christ. Next to Pliny, the most important ancient writer for the student of Greek sculpture is Pausanias, whose *Description of Greece,* written in the second century after Christ, is full of references to the works of the Greek masters. All these literary compositions are helpful in determining the authorship of statues that otherwise could not be assigned to their makers, and the history of Greek sculpture gains enormously in interest from the personal note that the literary accounts supply. In Greece, for the first time in the history of sculpture, we meet with artists who stand out as individuals.

Oriental influence. The first preserved monuments of sculpture that can properly be called Greek are not earlier than the last quarter of the seventh century. It was not until that time, apparently, that conditions became sufficiently settled in the Ægean area to bring about the production of large works in stone. The problem whether these earliest works were created under the influence of the older arts of Egypt and Mesopotamia or were independent in origin has been much debated. Especially since the discovery of the monuments of the Ægean civilization, there has been a tendency to discredit the theory of "oriental influence" on the beginnings of Greek art. But the older theory cannot easily be rejected. The break between the prehistoric and the historic civilizations in Greece makes it highly improb-

able that much of the artistic tradition of the Ægean age survived; the seventh century was certainly a time of increasingly close relations between Greece and the East; and, most important of all, the earliest monuments themselves give evidence, as we shall see, of the influence of foreign models. It is no discredit to the Greeks that their development was inspired, in its beginnings, by the art of older nations. Their great merit is that they rapidly outgrew the formulæ of oriental art, and far surpassed their predecessors.

Archaic Period (*about 625-480 B.C.*). The years from about 625 to the great Persian invasion of 480 are usually called the Archaic Period. This was a time of rapid intellectual development, when the problems of popular government were being threshed out. Many of the Greek states passed through the stage of "tyranny," the rule of a single powerful man or family. Such "tyrannies," in many cases, proved favorable to the development of art, since the tyrants tried to gain favor by beautifying the cities they controlled. At the same time, commercial relations expanded rapidly, producing the material prosperity that seems necessary to any great artistic development. In the field of literature, the period is marked by the beginnings of lyric and dramatic poetry, philosophy, and history.

Early types. The earliest Greek statues that we possess, those made before the middle of the sixth century, fall into a few well-defined categories. Four types can be readily distinguished: (1) the nude, standing male type, consisting of the figures commonly called "Apollos"; (2) the standing female type, regularly draped; (3) the draped seated type, in which there is little distinction between male and female figures; (4) the winged flying figure. To these some critics would add a fifth type, the nondescript draped standing figure.

The Nicandra statue. Of the nondescript draped type the so-called Nicandra statue from Delos (Fig. 25) is an excellent example. This figure, identified by an inscription on the left side as an offering made to Artemis by a Naxian woman, Nicandra, is regarded by many as the earliest extant large Greek statue. Certainly it is one of the crudest. It probably

represents Artemis, though it is possible that it was meant to be a portrait of Nicandra herself. In either case, the artist's attempt to suggest a female figure can hardly be called successful. Entirely concealed under a heavy robe, the form might be that of a man. The sculptor's lack of confidence in his ability to deal with his material is betrayed by the way in which he spread out the hair to afford support to the neck and hardly separated the arms from the sides. The form of the whole statue, also, which is very thin from front to back, shows how the maker was dominated by his material, a thin slab of the marble of Naxos. The few similar figures that have been found all seem to represent goddesses or women, so that they may be regarded as early examples of the standing female type.

FIG. 25—STATUE DEDICATED BY NICANDRA. NATIONAL MUSEUM, ATHENS

Standing draped female type. Most female figures, even of the early part of the archaic period, exhibit an advance over the Nicandra statue. The Hera of Samos (Fig. 26) may serve as an example. The identification is here fairly certain; an inscription below the right hand states that the statue was dedicated by a man, Cheramyes, to Hera. The inscription also dates the figure about 550 B.C. The curious cylindrical form of the lower part is perhaps due to the copying of an older figure hewn out of a tree-trunk; but the careful modelling of the toes and the upper body, and, above all, the raising of the left hand to the breast, show a distinct

advance in the representation of nature. In the drapery, too, although the use of parallel grooves to indicate the folds is very formal, the artist succeeded fairly well in differentiating the light *chiton,* or undergarment, from the heavier *peplos,* or cloak. The work is still far from perfect, but it is not absolutely primitive.

The "Apollos." The largest class of early archaic figures consists of the so-called "Apollos." The name, which was given to some of the first figures of this sort to be found, has been retained as a convenient label for the whole group of early nude male standing figures, though it is recognized that the same form was used to represent other gods and also human beings. Such "Apollos" have been discovered at many places, both on the mainland and in the islands, and are usually distinguished by the names of the finding places. The well-preserved Apollo of Melos in the National Museum at Athens (Fig. 27) is an excellent ex-

FIG. 26—HERA OF SAMOS. LOUVRE, PARIS. (PHOTO. GIRAUDON)

ample. The members of the group have certain common features—stiffly "frontal" position, with the left foot advanced, arms held tightly at the sides and rarely detached from the body completely, hair falling in a mass to the shoulders and treated as a row of snail-shell curls or in other pattern-like arrangements over the forehead, eyes never sufficiently sunk under the brows and often very prominent and bulging, ears badly modelled and usually placed too high. Most marked of all, in the majority of the figures, the

corners of the mouth are drawn up into the meaningless "archaic smile," which probably is only an attempt on the part of the makers to get some expression into their puppet-like creations. This feature is common to most early

archaic statues, but it is interesting that one series of "Apollos" from Bœotia shows an absolutely different type of mouth with straight and bulging lips, producing what is known as the "Bœotian pout," and that there are, occasionally, other variations in the treatment of the lips, revealing, even in the primitive period, some study of the problem of facial expression.

The "Apollos," more clearly than any other group of early archaic figures, raise the question of oriental influence. There certainly are decided resemblances between them and the Egyptian type of standing male figure (cf. Figs. 1 and 3). The fact, especially, that the left foot, rather than the right, is regularly advanced in both cases, furnishes a

FIG. 27—APOLLO OF MELOS. NATIONAL MUSEUM, ATHENS

strong argument. It seems highly probable, therefore, that the makers of the earliest Apollos drew their inspiration from Egyptian models. At the same time, it is noteworthy that the Greek figures are entirely without the supporting slab which the Egyptian sculptor usually found necessary for stone statues, and that they are entirely without drapery and

show from the first the endeavor to render the anatomy with greater accuracy, thus foreshadowing the later development.

Draped seated type. The third group of archaic figures—the draped seated type—is most satisfactorily illustrated by a series of examples from the sanctuary of Apollo at Branchidæ near Miletus. These were discovered by the English

FIG. 28—STATUE OF CHARES, FROM BRANCHIDÆ. BRITISH MUSEUM, LONDON. (PHOTO. MANSELL)

explorer Newton, and the best of them are now in the British Museum. The figure that is identified as Chares by an inscription on the chair will give an idea of their character (Fig. 28). The heavy, fleshy form is almost completely hidden under the thick robes. It has well been said that the Chares "looks as if he could not get up without taking the chair with him." Clearly, the sculptor did not succeed at all in differentiating the man from his seat or from his clothing.

Examples of the type which were evidently meant to repre-
sent women show practically the same forms, and this is the
justification for the name "nondescript seated draped type."
It has sometimes been thought that Assyrian influence should
be seen in these heavily draped figures, but in this case the
oriental influence, though
probable in itself, certainly
cannot be proved.

FIG. 29—VICTORY OF DELOS. NATIONAL
MUSEUM, ATHENS. (PHOTO. ALINARI)

The winged flying type.
Most striking of all the
types that were evolved
during the early archaic
period is the winged flying
figure. Of this a remark-
able example was found by
the French explorers of De-
los in 1877 (Fig. 29). It
is badly mutilated, but with
the help of small figures in
bronze which reproduce the
same type, its original ap-
pearance can be restored
with practical certainty.
Near the fragments of the
statue, there was discovered
a damaged base, on which
the statue was probably set
up, and which contains
the names of the sculptors,
Mikkiades and Archermus

of Chios. We have literary records of the activity of these
sculptors in the first half of the sixth century, as well as a
statement that Archermus was the first sculptor to represent
Nike (Victory) with wings. It is tempting, therefore, to see
in this figure the first example of the winged Victory which
plays so great a part in the later art of Greece. Even if it is
not absolutely the first, it shows well the difficulties which
the early sculptors met with in their attempts to suggest

motion. The upper body of the figure from Delos preserves an absolutely "frontal" position, the lower part is in profile, so that there is a twist of ninety degrees at the waist. The head displays all the peculiarities that we noticed in the heads of the Apollos. Yet the attempt to render such a difficult subject shows the initiative of the Greek genius. If the idea, as seems probable, was drawn from oriental sources—the winged human type suggests the winged deities of Mesopotamia—it must be said that the Greek artist worked it out in an original and hitherto untried manner. None of the oriental models which might have inspired the figure from Delos suggest motion so successfully. It is, therefore, one of the best examples of the Greek ability to transform the creations of the older civilizations so as to express Greek ideas.

FIG. 30—THE CALFBEARER. ACROPOLIS MUSEUM, ATHENS. (PHOTO. BOISSONNAS)

The Calfbearer. Not all the statues of the early archaic time conform absolutely to one of the four types. There are many interesting variants. Only one can be mentioned here —the so-called Calfbearer from the Athenian Acropolis (Fig. 30). In this an Athenian artist has changed an Apollo into the figure of an offerrant, carrying on his shoulders the young bull which he has brought for sacrifice to Athena.

Early reliefs. Metopes from Selinus. Relief sculpture, as
well as sculpture in the round, was undertaken by the artists
of the earliest period, and these reliefs, as the first examples of
work in a field in which the Greeks were destined to achieve

FIG. 31—PERSEUS AND MEDUSA. MUSEUM, PALERMO. (PHOTO. ALINARI)

some of their greatest triumphs, are not without interest.
Among the best preserved are three metopes which were re-
covered in 1822 from the ruins of an early sixth century
temple at Selinus in Sicily (called Temple C). The one
that we have chosen as an example shows Perseus cutting
off the head of the Gorgon in the presence of Athena (Fig.

31). The figures are in very high relief, but there is no uniform background, a method of carving that is found in many primitive reliefs. The squat, heavy figures are posed with heads and shoulders in front view and legs in profile, in much the same way as the contorted figures of Egyptian reliefs. The mask-like face of the Gorgon simply reproduces the type that was current for this monster, but the heads of Perseus and Athena show the prominent eyes and large, badly placed ears that we have noted in archaic statues in the round. In details, as in the extremely short right arm of Perseus and the left leg of the Gorgon, the artist's difficulties in adapting his design to the space at his disposal are very evident. Some of these deficiencies, no doubt, were partially concealed by color, traces of which are still preserved.

"Poros" reliefs from Athens. Other interesting reliefs from the early part of the sixth century have been found on the

FIG. 32—"TYPHON." ACROPOLIS MUSEUM, ATHENS

Acropolis at Athens. They are often called the "poros" reliefs, from the material, a rather soft limestone, which the ancients called poros. Most of them originally formed parts of the decoration of buildings destroyed when the Persians sacked the Acropolis in 480 B.C. As they were exposed to the weather for a comparatively short time, they still retain much of the paint with which they were covered, and furnish the best evidence we have for the use of color on early Greek works of sculpture. The largest and most interesting is the so-called "Typhon" relief, representing a triple-bodied monster, with wings and a snaky tail, cut in very high relief (Fig. 32). It originally filled one half of the pediment of an early building, of which the other half is

probably preserved in a relief of similar dimensions representing Heracles wrestling with the Old Man of the Sea. The human heads and bodies exhibit all the characteristic traits of early archaic sculpture, especially the carving of the eye in full face when the head is in profile, a detail that persists through the whole archaic period. But the most significant feature is the color. This is almost completely unnaturalistic. The human bodies were painted red, with blue hair and beard; the coils of the serpents were striped with red, blue, and black. Color, in fact, was used simply for decoration, to bring out parts of the figures more clearly, and also, no doubt, to cover deficiencies in the soft stone.

Ionic and Doric art. These few examples may serve to give some idea of the earliest Greek works of sculpture. They reveal an art in its infancy, but already giving promise of better things, and it is clear that during the first half of the sixth century, sculpture was eagerly cultivated in many different regions of the Greek world. With the help of literary accounts, it is possible to distinguish several "schools" or groups of sculptors, and to draw some distinctions between them. Here we must be content with one or two broad distinctions. In general, the artists of the Ionic region, that is, the coast of Asia Minor and the islands of the Ægean, appear to have devoted themselves especially to the female figure; they were concerned with the rendering of drapery, rather than with the study of anatomy, and the figures in Ionian art tend to appear fleshy and heavy under their thick garments. In the Dorian schools of the Peloponnesus and the west, on the other hand, the opposite principle prevailed. There it was the nude male figure, rather than the draped female, that especially interested the sculptors. The figures of Dorian sculpture are often squat and heavy, but the heaviness is due to overemphasis on the muscles, rather than to neglect of bodily forms. The Attic school, with its liking for strange monsters and emphasis on heavy muscles, seems neither exactly Ionic nor Doric, but appears like an independent development.

Later Archaic Period (about 550-480 B.C.). With the late archaic period, or, as it is often called, the period of

advanced archaism, these distinctions between Ionic and Doric sculpture become clearer. This was a time of rapid advance, marked by more extensive and more difficult undertakings on the part of the sculptors, as well as by much greater skill in carrying them out.

FIG. 33—FAÇADE OF THE TREASURY OF THE SIPHNIANS, RESTORED. MUSEUM, DELPHI. (PHOTO. GIRAUDON)

Ionic sculpture. The Treasury of the Siphnians at Delphi. As an example of Ionic sculpture, we may take the Treasury of the Siphnians at Delphi (sometimes incorrectly called the Treasury of the Cnidians). Of this building, which was

erected about 520 B.C., so many remains were found by the French excavators of Apollo's great sanctuary that they were able to undertake a reconstruction of the façade in plaster (Fig. 33). Details in the reconstruction are open to criticism, but it undoubtedly gives a good general idea of the appearance of the building and its elaborate decoration. What first catches the eye is the use of female figures in place of columns in the portico—the first known instance in Greece of the use of such forms as architectural supports. Though unsuccessful architecturally, they are excellent examples of Ionic female figures of the later archaic type. Many features of early archaic work still persist, such as the prominent eyes and smiling mouths, but in most respects we note a great advance. The hair is carved in formal waves over the foreheads, and the locks which fall in front of the shoulders are carefully grooved to suggest the separate strands. Most noticeable of all is the improvement in the drapery. The folds of the garments are much more naturally rendered than in earlier work, with elaborate "swallow-tail" effects at the edges. Though still stiff and formal, they show increasing ability to suggest the long, sweeping lines of the Greek dress; and the painstaking care with which they are worked out is characteristic of later archaic sculpture, and especially of the Ionic schools.

The pediment. The triangular pediment was filled with a representation of the struggle between Heracles and Apollo for the Delphic tripod. This is interesting, technically, as a sort of transitional stage between early pediments in relief, like the Typhon pediment at Athens (Fig. 32), and later compositions with figures in the round (cf. Figs. 35, 44, and 53). Here the lower parts of the figures are in relief, the upper parts are completely cut out, but very flatly worked. As a pedimental composition, the design is primitive. The subordinate figures are smaller than those at the centre, and the movement, which is from left to right throughout the whole, fails to emphasize the central figures by means of converging lines. But it is clear that the comparatively small space at his disposal—the whole pediment is less than nineteen feet long—greatly hampered the designer.

The friezes. By far the most successful parts of the decoration are the four friezes that adorned the four sides. Two are almost completely preserved: one, which represents a contest between Greeks and Trojans led by Menelaus and Hector, with an assembly of gods as spectators, has been used to fill the frieze in the reconstruction; the other, with a battle of gods and giants, occupied one of the longer sides (Fig. 34). The advance over earlier reliefs is very marked. The groups of fighting gods and giants are freely posed and skilfully carved. The exuberant liveliness of the Ionic imagination comes out in many figures, especially in He-

FIG. 34—BATTLE OF GODS AND GIANTS. MUSEUM, DELPHI. (PHOTO. GIRAUDON)

phæstus (at the left hand end of the frieze), who works a great pair of bellows as he forges weapons for the gods, and in one of the lions of Cybele's chariot, which seizes a giant and bites him in the thigh. The Ionic interest in drapery and skill in rendering it in formal folds are everywhere apparent. At the same time, details are often incorrect, and show that the sculptor is not yet free from the trammels of archaism. The figures, though actively posed, are often stiff and angular; heads are rarely in any but the profile position, and sometimes are turned completely about on the shoulders; eyes are still in front view when the head is in profile; and the attempt to suggest the powerful muscles of the contestants

results in rather flabby forms, which show little knowledge of anatomy. Yet, in spite of these defects, the frieze succeeds remarkably well in conveying the impression of a mighty combat, and as it stood originally, with many details made clearer by color, it must have formed a brilliant addition to the delicate Ionic architecture.

Dorian sculpture. The Schools of Argos, Sicyon, and Ægina. In regard to Dorian sculpture in the later archaic period, considerable information is preserved in literature. Important schools are recorded in three places especially: Argos, Sicyon, and Ægina. For each of these the literary records, supplemented by inscriptions, make it possible to draw up lists of sculptors, but in every case, one man seems to have overshadowed the rest to such an extent that he may properly be called the head of the school. At Argos, the leading position was held by Agelaidas; at Sicyon, by Canachus; at Ægina, by Onatas. The recorded works of these men and of their associates show the tendencies of Dorian art at this time. They consist very largely of statues of gods and athletes, so that the Dorian schools have often been called "the schools of athletic sculpture."

The Ægina marbles. The Dorian masters worked almost exclusively in bronze, and most of their productions have perished, but we are fortunate enough to have one fairly large group of works by which we can test the inferences drawn from the literary records—the so-called Ægina marbles. These were found in 1811 in the ruins of a temple on the island of Ægina, sold to the Crown Prince of Bavaria, restored in Rome by the sculptor Thorvaldsen, and then set up in the Glyptothek, or Museum of Sculpture, at Munich. More careful exploration of the ruins of the temple in 1901 resulted in the discovery of many more fragments, and proved that the edifice was dedicated to a local goddess named Aphaia. Unfortunately, no direct evidence for the date of the temple has been recovered, but on grounds of style a date between 500 and 480, the very end of the archaic period, seems probable.

The majority of the figures come from the two pediments. Fifteen were put together by Thorvaldsen, of which five are

from the eastern pediment, ten from the western. Many suggestions have been made in regard to the exact composition of each pediment, none of which has met with universal acceptance, but the schemes proposed by Furstwängler in 1904 at least give a general idea of the arrangement (Fig. 35). Each pediment was occupied by a scene of battle, and it is generally believed that the eastern pediment represented a contest of the earlier expedition against Troy, which was led by Heracles, and the western, a contest in the famous Trojan War. In both cases, Athena occupied the central position; she was probably thought of as the arbiter of the combats, invisible to the fighting warriors. In composition, the groups show a marked advance over earlier pediments (cf. Figs. 32 and 33). The figures are all of the same size,

FIG. 35—WEST PEDIMENT OF THE TEMPLE OF APHAIA AT ÆGINA, RESTORED.
(FROM FURSTWÄNGLER, "ÆGINA," P. 206)

and so designed as to fit into their places in the narrowing fields in a fairly natural way. Yet the groups as a whole suffer from too exact balance. Every figure on one side is almost exactly similar to a figure on the other. The separate groups, too, are not bound together at all. The designer has greatly improved on his predecessors, but has failed to grasp the important principles that underlie all such decorative compositions, namely, that the skeleton of the design must not be too obvious, and that the separate groups should be linked in some way so that the eye may pass easily from one to another.

Similarly, in the individual figures, although there are lingering archaisms, the advance is notable. It is evident that, for the master of the Ægina pediments, the law of frontality no longer holds. His warriors are freely posed, bending

to right or to left as their actions or their positions in the pediment demand. This breaking of the law of frontality is found in other figures of late archaic times, and is one of the most important evidences of increasing confidence on the part of the sculptors. The Ægina marbles also show a knowledge of anatomy, or at least, of the appearance of the human body in different positions, which is far in advance of anything we have yet seen. Muscles and sinews are rendered with approximate correctness, though in a rather hard manner, giving little suggestion of the suppleness of the

FIG. 36—FALLEN WARRIOR FROM ÆGINA. GLYPTOTHEK, MUNICH.
(PHOTO. BRUCKMANN)

human model. In this, it is surely reasonable to see the influence of athletics and athletic figures, which has been emphasized as one of the qualities of the Peloponnesian schools. Archaic conventionality is most marked in the heads. In sharp contrast to the expressive bodies, the heads of the warriors reveal hardly a trace of the feelings inspired by the conflict. Details are treated with great care, especially the hair, which is usually represented in two braids, brought together and tied over the forehead, in a manner common in figures of athletes. But the eyes are still insufficiently sunk under the brows, so that they seem staring and expressionless. Most remarkable of all, the mouths, in almost all cases, wear

the quite inappropriate ar-
chaic smile. Only in one
case, the figure of a wound-
ed warrior from the eastern
pediment (Fig. 36), which
in other respects also is the
most advanced of these
sculptures, the curve of the
lips is so modified by the
shadow cast by the short
moustache that the expres-
sion seems a grimace of
pain, rather than the mean-
ingless smile.

The Ægina marbles, then,
serve excellently to show
both the skill and the limi-
tations of the Greek sculp-
tors towards the end of the
archaic period. They prove
that by this time the prob-
lem of expression in bodily
forms was practically
solved, although the forms
employed were still too
hard to be entirely natural,
but the problem of facial
expression was still far from
solution.

*The Attic School. Works
under Ionic influence.* The
most important school of
all in the later archaic
period was that of Athens.
We have already noticed
that in the early archaic
time the Attic school ap-
pears to have pursued an independent course. In the
later archaic period, the sculptors of Athens were strongly

FIG. 37—DRAPED FEMALE FIGURE. ACROP-
OLIS MUSEUM, ATHENS

influenced by the products of Ionian art. Proof of this is found especially in the interesting series of female figures which are commonly called the Acropolis maidens (Fig. 37). These were found on the Acropolis at Athens between 1886 and 1890, and are the remains of statues offered to Athena before 480, damaged in that year when the Persians sacked the Acropolis, and piously buried when the Athenians returned to the city after the Persians were forever driven out of Greece. Most of them were probably set up between 540 and 510, during the tyranny of Pisistratus and his sons. The fact that several bases with the names of Ionic sculptors were found in the "Persian *débris*" makes it likely that some of these figures are actually the work of Ionians, but most of them were made by Athenian sculptors, strongly affected by foreign models. Evidences of Ionic influence are seen in the elaborate working of the folds of the robes, and in the high, egg-shaped heads, long, narrow eyes, and exaggerated smiles of many of the figures. In others, the squarer head-type, more or less triangular eyes, and somewhat more sober mouths recall the qualities of Attic works of the earlier period, such as the Calfbearer (cf. Fig. 30). The use of Pentelic marble for some of the figures, also, although many are of Parian, points to an Attic origin. Fragments show that the extended hand, which has almost universally been broken off, contained a fruit or other object, so that the figures were probably intended to represent girls making a perpetual offering to Athena in her sacred precinct.

The most important contribution that the Acropolis maidens have made to our knowledge, however, is that they give an excellent idea of the use of color on marble statues of the later archaic period. The system is quite different from that in vogue for the earlier work in poros. In these later statues, few surfaces are covered with a solid color. The hair, the small part of the chiton that shows on one shoulder, and the shoes usually are painted in this way. For the rest, polychromy was used only sparingly, the larger part of the statue being left in the color of the marble, or possibly toned to an ivory yellow. The colors are simple—red, black, blue, and green predominate—and the system did not aim at nat-

uralism in all respects. In most of the figures, the hair was painted red, and red was also used for the iris of the eye. But the total effect is extremely pleasant, especially in the delicate patterns that are strewn over the garments and in the richly decorated borders. By such a system of polychromy, the beauty of the marble is not obscured, but enhanced, and the Acropolis figures furnish the best possible refutation of the charge that the coloring of marble, as the

FIG. 38—MAN MOUNTING A CHARIOT. ACROPOLIS MUSEUM, ATHENS

Greeks practised it, was barbarous. In later times, as we shall see, the range of colors was enlarged, but the method of employing color to pick out details in marble statues and reliefs was apparently retained throughout the Greek period.

Reliefs under Ionic influence. A number of monuments show that relief sculpture in Athens fell under the same strong Ionic influence as work in the round. The figure of a man mounting a chariot, from an extended composition of which other fragments are known, will illustrate the point

(Fig. 38). The extremely careful carving of the hair and the robe, together with the comparative neglect of the anatomy, are quite in the spirit of Ionic art.

Attic works under Doric influence. In several of the most advanced statues from the Persian *débris*, a new tendency makes its appearance, a tendency towards a more sober treatment, accompanied by greater interest in anatomical details and greater skill in rendering them. This we may fairly attribute to Dorian influence, especially as several bases with signatures of Dorian sculptors were found. The new influence is seen in some of the female figures and in several examples of the nude male standing type. The most interesting is a female figure which was dedicated by a certain Euthydikos (Fig. 39). The upper part of the statue and the lower part with the inscribed base have been put together from fragments, but the connecting middle portion is lost. The differences between t h i s statue and the majority of the female figures are very great. In contrast to the fussy treatment of the drapery in the Ionicizing figures, there is here a series of very simple, flat folds; the marble is not tortured into snail-shell curls, but the hair is more simply and naturally carved in waves on either side of a central parting; the eyes, though still not quite sufficiently sunk, are provided with thick lids, which cast more shadow than the shallow lids of the earlier figures, and so

FIG. 39—STATUE DEDICATED BY EUTHY-DIKOS. ACROPOLIS MUSEUM, ATHENS. (PHOTO. ALINARI)

produce a more natural effect; and the lips, far from curving upwards into a smile, actually curve downwards and give a pouting effect, so that one of the nicknames for the figure is *La petite boudeuse,* the "Little Pouter."

General character of archaic Greek sculpture. If from the most advanced products of the archaic period we look back to the statue dedicated by Nicandra (Fig. 25) and the earliest Apollos (Fig 27), we gain a vivid impression of the rapid progress made by the Greek sculptors during the first century and a half of their activity. The first works seem little removed from barbarism, the latest give evidence of much accurate observation and skilful execution. It is in this steady advance towards more exact representation that the merit of the sculptors of the archaic time appears most clearly. The constant study of the human model to which their works bear witness pointed the way for their successors, and made possible the great achievements of the centuries that followed.

BIBLIOGRAPHICAL NOTE

The best general history of Greek sculpture, charmingly written and beautifully illustrated, is M. Collignon's *Histoire de la sculpture grecque,* Paris, 2 vols., 1892-97. The equally elaborate work of J. Overbeck, *Geschichte der griechischen Plastik,* Leipzig, 2 vols., 4th ed., 1893-94, is excellent for facts, but written in a dry style and poorly illustrated. E. A. Gardner's *Handbook of Greek Sculpture,* London, 2d ed., 1915, gives an authoritative and fairly comprehensive treatment of the subject. E. von Mach's *Greek Sculpture, its Spirit and Principles,* Boston, 1913, emphasizes the æsthetic, rather than the historical, point of view. The same author's *Handbook of Greek and Roman Sculpture,* Boston, 1905, contains brief descriptions and bibliographical data on the series of 500 half-tone reproductions of Greek and Roman sculpture issued by the Bureau of University Travel. R. B. Richardson's *History of Greek Sculpture,* New York, 1911, in spite of its compactness, records many interesting points of view.

The passages from Greek and Roman writers that throw light on the history of Greek sculpture are collected in J. Overbeck's *Die antiken Schriftquellen zur Geschichte der bildenden*

Künste bei den Griechen, Leipzig, 1868. The most important of these notices are published, with English translation and brief commentary, in H. S. Jones's *Select Passages from Ancient Authors Illustrative of the History of Greek Sculpture,* New York, 1895. The parts of Pliny's *Naturalis Historia* of interest to the student of sculpture and painting are conveniently published in K. Jex-Blake and E. Sellers's *The Elder Pliny's Chapters on the History of Art,* New York, 1897. The most useful edition of Pausanias is Sir J. G. Frazer's *Pausanias's Description of Greece,* New York, 6 vols., 2nd ed., 1913.

The best introduction to the art of the bronze age in Greece is H. R. Hall's *Ægean Archæology,* London, 1915, with a good bibliography. Among books that deal especially with archaic Greek sculpture are the eighth volume of Perrot and Chipiez's *Histoire,* Paris, 1903; H. Lechat's *Au musée de l'acropole d'Athènes,* Paris, 1903, and *La sculpture attique avant Phidias,* Paris, 1904; W. Lermann's *Altgriechische Plastik,* Munich, 1907; H. Schrader's *Archaische Marmorskulpturen im Akropolismuseum zu Athen,* Vienna, 1909; and W. Deonna's *Les Apollons archaïques,* Geneva, 1909.

CHAPTER V

GREEK SCULPTURE: THE FIFTH CENTURY

Political history. The defeats inflicted on the Persian invaders in 480 and their final expulsion from Greece in 479 exerted a powerful influence on the development of Greek art, an influence which was felt both directly and indirectly. The rebuilding of cities that had been sacked, like Athens, and the execution of the many thank offerings voted by the separate states for their deliverance made immediate demands upon architects, sculptors, and painters. Even more important was the impulse to creative effort that came from the repulse of the barbarians. The parallelism in this case between the development of sculpture and the development of literature is exact. The *Persians* of Æschylus and the *History* of Herodotus were directly inspired by the Persian struggle; the inspiration of the other masterpieces of fifth century literature may fairly be traced indirectly to the uplift of spirit which resulted from the victories of the Greeks. During almost all of the fifth century, Athens was, both politically and artistically, the leading state in Greece. Of the statesmen under whose guidance she won and maintained her leadership, the most important was Pericles, and the period of Athenian supremacy is often called the Age of Pericles.

The School of Athens and the School of Argos. The great master of the Attic school of sculpture at this time was Phidias, to whom was entrusted the oversight of the grandiose scheme adopted by Pericles for beautifying the city. The plan included the erection of the four famous buildings of the Acropolis—the Parthenon, the Propylæa, the Erechtheum, and the Temple of Wingless Victory—buildings which were universally admired throughout all antiquity, and which,

81

even in ruins, make Athens a place of pilgrimage today. The Athenian sculptors did not work for Athens alone, but executed commissions for other states and for the great shrines, such as Olympia and Delphi. Another prominent school during the fifth century was that of Argos. Its leader was Polyclitus, and works of its members, like those of the Athenians, were widely distributed throughout Greece.

Distinction of periods. The change from archaism to absolute freedom was a gradual one; in fact, it was not until the middle of the fifth century that archaic mannerisms were wholly abandoned. The thirty years between 480 and 450, therefore, are often called the Transitional Period, the years between 450 and 400, the First Half of the Great Period.

The Transitional Period (480-450 B.C.). The earlier works of both Phidias and Polyclitus were executed during the age of transition, but the literary notices that prove this give little information about the appearance of these statues and groups. But works of other sculptors are preserved in the original or in copies in sufficient numbers to show the character of transitional sculpture.

"Roman copies." In considering the works of the great masters, we frequently have to deal, not with the originals, which have been destroyed, but with copies made in later times. Sometimes these were executed in the same material and on the same scale as the originals, but often they were not. Bronze statues were often copied in marble; the scale of the work, in many cases, was reduced; statues in the round were frequently copied in relief, especially for the decoration of coins; vase-painters sometimes drew their inspiration from the creations of the sculptors; so that the student of sculpture often has to deal with evidence of many sorts in attempting to recover an ancient work. The most important group of copies, however, is made up of marble statues on a fairly large scale, and these are what are commonly meant when critics speak, without qualification, of copies of ancient statues. Such copies, of course, might have been made at any time after the completion of the originals, but most of them, apparently, were made for Roman patrons after the Roman conquest of Greece in 146 B.C. For this reason, the name

"Roman copies" is usually applied to them. They differ, naturally, in many respects from the originals. Not only were the copyists less able sculptors than the great masters, but it is clear that they often based one copy on another and sometimes intentionally introduced modifications, so that the result is a reflection, rather than a copy. Especially in making marble copies of bronze originals, the copyists were often obliged to introduce supports of various kinds, which sadly mar the total effect.

"Restoration." Moreover, until about a century ago, the mutilated ancient statues that were discovered were almost universally turned over to "restorers," who supplied missing heads and arms and other parts. Sometimes such restorers were fortunate enough to recognize the original types, but more often they were obliged to interpret the fragments that were given to them as best they could, and "restoration" produced many strange and confusing figures. In dealing with our preserved monuments, therefore, we have constantly to keep in mind that their evidence may have been confused in two quite different ways, first by faulty or careless copying in antiquity, and secondly by false restoration in modern times.

Critius and Nesiotes. The Tyrannicides. All these difficulties can be well illustrated in the case of one of the most famous works of the transitional time, the group called the Tyrannicides. This represented, under somewhat idealized forms, the two Athenians, Harmodius and Aristogiton, whose attack upon the sons of Pisistratus in 514 B.C. was afterwards regarded as the primary cause of the overthrow of the tyranny and the establishment of democratic government in Athens. Immediately after the expulsion of Hippias in 510, a sculptor named Antenor was commissioned to make a group in bronze representing the Athenian heroes. This was duly set up in the market place, only to be carried off as part of the booty from Greece by the Persian invaders. When the Athenians returned in 479, one of their first acts was to place a commission for a new group of the Tyrannicides with two sculptors named Critius and Nesiotes, and this was set up in the market place in 479 or 478 B.C. Later,

after the conquest of Persia by Alexander the Great, the older group by Antenor was sent back to Athens either by the conqueror or one of his successors, and was placed beside the work of Critius and Nesiotes.

Greek and Roman writers mention the Tyrannicides not infrequently, but seldom in such a way as to tell us much about the appearance of the two groups, or, indeed, to make it clear to which of the two they refer. There are copies and reflections on a small scale on Athenian coins and painted vases and in a mutilated relief on a marble chair, now in a private collection in Scotland. But the most important evidence is found in several mutilated Roman copies of the usual sort, that is, figures or parts of figures in marble, which were evidently meant to reproduce closely the size and the stylistic peculiarities of the originals. The most important of these are two figures in Naples (Fig. 40), which have been arranged, following the evidence of the coins and the vases, with Harmodius on the spectator's right and Aristogiton on his left. Both the figures have been considerably restored. In the Harmodius, the modern additions include both arms, almost all of the right leg, and the left leg from the knee down. In the Aristogiton, numerous small bits have been added, and the head, although ancient, is from a copy of some work of the fourth century. The awkward tree-stumps are due, as they commonly are, to the fact that the figures are marble copies of bronze originals.

In spite of all these changes, the statues in Naples give us a fairly clear idea of one of the groups of the Tyrannicides. It is generally believed that this was the group by Critius and Nesiotes, rather than that by Antenor, since such free poses and accurate modelling can hardly be attributed to so early a date as 510. Besides, one of the female figures from the Acropolis is very surely a work of Antenor's, and this shows a stiffness and formality of treatment very different from the freedom of the Naples group. Here, then, we see the qualities of Attic art just after the Persian wars. It is evident that in the bodies there is little of archaic formalism. They are easily posed, and the muscles are accurately rendered, though with a certain hardness. In the head of the Harmo-

FIG. 40—HARMODIUS AND ARISTOGITON. MUSEUM, NAPLES

dius, however, many traits are reminiscent of archaic manner-
isms. The hair consists of a mass of snail-shell curls all over
the head; the eyes, though they have the thick lids which
are found in the latest
statues from the Persian
débris, are still not suffi-
ciently sunk and produce a
staring effect; and the
mouth has no real expres-
sion, though the archaic
smile is quite gone. The
persistence of archaic traits
in the heads is one of the
most marked features of
transitional sculpture.

The Charioteer of Delphi.
It is pleasant to turn from
a work of which only copies
are preserved to an original
like the bronze charioteer
found at Delphi in 1896
(Fig. 41). This formed a
part of a life-size group
representing a four-horse
chariot, such as were fre-
quently set up to commem-
orate victories in chariot
races. A mutilated inscrip-
tion shows that the group
was dedicated in the seven-
ties of the fifth century.
With this date the style of
the bronze agrees perfectly.
The folds of the charioteer's
robe, though rather formal,
are worked out with a free-
dom and accuracy that suggest a posed model; but in the
head, the flatly modelled hair, the abnormally sharp eye-
brows, the prominent eyes, and the expressionless mouth

FIG. 41—BRONZE CHARIOTEER. MUSEUM,
DELPHI

are all suggestive of archaic times. Among the interesting details are the pastes and enamels used to form the eyes—the regular practice in Greek bronze statues—and the traces of silver inlay in the pattern on the fillet about the head. Evidently the Greeks aimed at polychrome effects even in bronze statues. Several details, such as the working out of the first growth of beard on the cheeks and the notching of the eyelids to suggest the eyelashes, show the advance towards accuracy that characterizes the transitional age. Above all, the freshness and vigor of the Charioteer make us realize how much we lose when we are forced to study copies of Greek masterpieces rather than originals.

Calamis of Athens and Pythagoras of Rhegium. In spite of much debate, there is no general agreement as to the author of the Charioteer of Delphi. Among the sculptors whose names have been suggested are two who are shown by literary notices to have been among the most famous masters of the period—Calamis of Athens and Pythagoras of Rhegium. Of the two, Calamis, whose chariot groups and horses are especially mentioned, is, perhaps, the stronger claimant. But in this, as in many other cases where no work of the sculptor has been surely identified, certainty is quite impossible. Notwithstanding the researches of many skilful critics, Calamis and Pythagoras are still little more than names.

Myron. In the case of Myron, we are in a more fortunate position. Two of his works, at least, have been identified in copies, and the literary accounts contribute some helpful information. Born at Eleutheræ in Bœotia, he was active in Athens, and so is accounted an Athenian sculptor. Of his works, the most famous was a Discobolus, or Discus-thrower, the popularity of which is attested by a number of copies. These differ in details, but by combining the best parts of several, the original can be reconstructed with practical certainty (Fig. 42). The fame of the statue rests largely on the skill with which action is suggested. The position is one of momentary rest, as the athlete gathers all his force for the final effort. Yet so skilfully is the pose chosen that it seems like one that could be held almost indefinitely. In

the modelling of the muscles, the best copy (that from Castel Porziano, now in the National Museum in Rome) shows a roundness and softness that are distinctly in advance of anything we have yet seen, but the regular locks of the hair,

FIG. 42—DISCOBOLUS OF MYRON, RESTORED. NATIONAL MUSEUM, ROME. (FROM BRUNN-BRUCKMANN, "DENKMÄLER," PL. 632)

lying close to the skull, have something of the formality of archaic art.

The second work of Myron's that can be recovered is a group of Athena and Marsyas, which was on the Acropolis at Athens. The moment chosen for representation was that in which the goddess, having practised playing the double flute and thrown it away in disgust, turns angrily on Marsyas, who

gazes covetously towards the discarded instrument. Figure 43 is an attempt to reconstruct the group, based principally on a copy of the Athena in Frankfort on the Main and one of the Marsyas in the Lateran Museum in Rome. As a study of arrested motion, the Marsyas is a worthy rival of the Discobolus, and the tense muscles show the same under-

FIG. 43—ATHENA AND MARSYAS OF MYRON, RESTORED. ARCHÆOLOGICAL MUSEUM, MUNICH. (FROM "ARCHÄOLOGISCHE ANZEIGER," 1908)

standing of the appearance of the body in an unusual position. The simple, girlish figure of Athena forms a pleasing contrast to that of the Silenus, though the grouping, with one figure in front view and the other in profile, cannot be called success-ful. Both figures show an unusual attempt at facial ex-pression which helps to confirm the belief that Myron was the most original sculptor of his age and marked the last step in the transition from archaism to perfect freedom.

Sculptures from the Temple of Zeus at Olympia. The pediments. Among the original works of the transitional period which have been preserved, the largest group is the series of decorative sculptures from the temple of Zeus at Olympia, erected about 460 B.C. Both pediments of this temple were filled with large figures, about one and one-half times life-size, and parts of all of these were found by the Germans in their excavation of Olympia between 1875 and 1881. With the help of Pausanias's description, therefore, it is possible to restore the original appearance of the two compositions with practical certainty (Fig. 44). The subject of the eastern pediment was "the chariot race of Pelops with

FIG. 44—PEDIMENTAL GROUPS OF THE TEMPLE OF ZEUS AT OLYMPIA, RE-STORED. (FROM LUCKENBACH, "OLYMPIA UND DELPHI," FIGS. 13 AND 14)

Œnomaus about to begin." The central figure was Zeus, as arbiter of the contest. On his right stood Pelops and Hippodamia, on his left, Œnomaus and Sterope. Then followed, on each side, a chariot with attendants, and the figures in the angles represented the two rivers of Olympia, the Alpheus and the Cladeus. In the western pediment was the battle of the Centaurs and the Lapiths, with Apollo as the central figure.

Composition and style. The comparison that suggests itself at once is with the pedimental sculptures from Ægina, and such a comparison shows the progress that had been made in the thirty years or more which separate the two works. It is clear that the designer had not yet completely solved the

problem of pedimental composition. Each of the Olympia pediments is made up of a series of balancing groups, so that the skeleton of the design is still too prominent. Yet inside the groups, there is considerable variety, and the balance is by no means so exact as in the pediments from Ægina. Even

FIG. 45—APOLLO FROM THE WESTERN PEDIMENT. MUSEUM, OLYMPIA

more marked is the advance in the individual figures. The Olympia sculptures have little of archaic formalism (Fig. 45). The modelling is often superficial and sometimes decidedly careless—faults which are partially explicable, perhaps, by the fact that they would hardly be noticed at a height of forty feet, in figures brilliant with color—but the main facts are correctly rendered. The drapery has lost all

92 A HISTORY OF SCULPTURE

its "fussiness," and falls in very simple folds. There is a notable attempt at expression in the faces of many figures. Only in the heads, where the hair still is represented by wavy grooves, where ears are sometimes misplaced, and where eyelids do not overlap at the outer corners, do we find reminiscences of the earlier mannerisms. The finest of these figures, the Apollo from the western pediment, which has

FIG. 46—HERACLES, ATLAS, AND A HESPERID. MUSEUM, OLYMPIA

rapidly become a favorite with lovers of Greek art, seems not unworthy of a great master.

Authorship. The question of the makers of the Olympia pediments has been much debated. Pausanias says that the eastern pediment was the work of Pæonius of Mende, the western, of Alcamenes, a pupil of Phidias. But the one work of Pæonius that we have (see p. 101) and the traditions about Alcamenes certainly do not tend to confirm Pausanias's statement. The style of both pediments seems absolutely the same, and modern critics, in general, are inclined to think the tradition mistaken. The most likely suggestion is that the

pediments are the work of local, that is, of Peloponnesian sculptors, considerably influenced by Ionic art.

The metopes. Such a theory is confirmed, to a certain extent, by a study of the metopes from the temple of Zeus. Twelve of these were carved in high relief, with the twelve labors of Heracles. One of the best preserved (Fig. 46) shows Heracles supporting the heavens, while Atlas holds out before him the apples of the Hesperides and one of the daughters of Hesperus tries to assist him. The simple, direct modelling is quite in the spirit of the pedimental sculptures. So, too, are the attempt at expression in the faces and the blocking out of the hair of Heracles and Atlas, for which the details were no doubt supplied by the painter. As evidence of the progress made in the transitional period, the carving of the eye no longer in front view, but almost correctly fore-shortened, is noteworthy.

The Ludovisi Throne and the Boston Relief. Even finer than the metopes from Olympia as examples of transitional work in relief are the two marbles most commonly called the Ludovisi Throne and the Boston Relief (Fig. 47). Each of these consists of a heavy block of marble, hollowed out at the back and decorated on the three outer sides with low reliefs. The designation of one as a "throne" is due to this peculiar form, but it is much more probable that both served as parapets at the two ends of a long, rectangular altar. The larger compositions represent in one case, the birth of Aphrodite from the sea, in the other, the contest of Aphrodite and Persephone for the beautiful Adonis, with Eros holding the scales. The single figures on the sides are most plausibly interrupted as worshippers of Aphrodite, and the altar was, presumably, dedicated to the goddess of love. In these reliefs, the crisp and delicate handling of the marble, the wide variety in the corresponding figures, and the many touches which give evidence of close study of nature almost make us forget the lingering archaisms. They have the charm so often found in works that just precede the period of perfect freedom.

The Great Period: First Half (450-400 B.C.). By the middle of the fifth century, the Greek sculptors had definitely

FIG. 47—THE "LUDOVISI THRONE" (ABOVE) AND THE BOSTON RELIEF (BELOW). NATIONAL MUSEUM, ROME, AND MUSEUM OF FINE ARTS, BOSTON. (FROM "JAHRBUCH DES KAISERLICH DEUTSCHEN ARCHÄOLOGISCHEN INSTITUTS," 1911, PL. 1)

abandoned the archaic formulæ, and the years from 450 to 400 B.C. witnessed the creation of many of the works most admired by later generations. The most famous masters of this time were Polyclitus of Argos and Phidias of Athens, and since both these sculptors began their careers before the middle of the century, it is fair to argue that the advance from archaism to perfect freedom was largely due to them.

Polyclitus. Of the life of Polyclitus we have little information, except that he was born early in the fifth century, was a pupil of Agelaidas, was working as late as 420, and in his maturity was the recognized head of the Argive school. In regard to his ideals and tendencies, however, the ancient writers have preserved a number of interesting notices. From their statements it appears that he was a theorist and a scholar, much interested in the problem of ideal proportions for the human figure. This appears especially in a statement that he published a book on proportion, which he called "The Canon," that is, "The

FIG. 48—THE DORYPHORUS. NATIONAL MUSEUM, NAPLES

Rule," and then illustrated his principles by making a statue which he also called "the Canon." Among his works, many statues of athletes are mentioned, and his favorite material was clearly bronze. All this suggests that Polyclitus was a

sculptor who carried on in the great age the traditions of the old Argive school of athletic sculpture.

Although we have no original from the hand of Polyclitus, three of his works can be recognized in copies: the Doryphorus, or Spearbearer; the Diadumenus, or Man tying on a Fillet; and an Amazon. The very complete copy of the Doryphorus found at Pompeii in 1797 (Fig. 48) shows well the important features of the Polyclitan ideal—the pose with one foot set back and touching the ground only with the toes (often called the "walking *motif*" of Polyclitus) ; the powerful, stocky figure, with muscles modelled in large masses and with strongly defined boundaries; the squarish head, with hair in regular locks lying close to the skull; and rather prominent, slightly open lips. The whole suggests physical rather than mental power. The name Doryphorus is a descriptive title, such as were often given to statues in later days, and there is some evidence that the Doryphorus was really the Canon, the statue made to illustrate Polyclitus's rules of proportion. In any case, the very similar qualities in the Diadumenus and the Amazon prove that it represents the Polyclitan ideal. The ancient writers lay emphasis on the wonderful finish of Polyclitus's bronzes, a feature which the marble copies cannot reproduce, and consistently praise his gold and ivory statue of Hera at the Heræum near Argos, of which only the most distant reflections in coins have survived. If only an original had been preserved, we should probably form a much more favorable impression of the sculptor than we can from the marble copies. On the basis of what we have, the criticism preserved by the Roman Varro, that "Polyclitus's statues are squarish and almost of a pattern" seems fully justified. Nevertheless, the influence of the Argive sculptor was very great. This is shown not only by the long list of his pupils, but also by the large number of statues and heads with Polyclitan traits that have been preserved. Some of these, no doubt, go back to works of the master himself, while others are based on the productions of his pupils and imitators.

Phidias. The testimony of the ancients is practically unanimous in appraising Phidias as the greatest sculptor of the

fifth century. But their statements in regard to his life are so few and so contradictory that long controversies have been waged as to his exact date and the sequence of his works. He must have been born early in the fifth century, and probably was active as late as 430, perhaps even later. The one certain date in his career is the year 438, when his colossal gold and ivory Athena in the Parthenon was dedicated. Shortly after this, he was involved in litigation at Athens, and it was probably at this time that he was invited to Olympia and there created the great gold and ivory Zeus which became the most famous of his works. But it is possible that the Zeus was made before the Athena, between 456 and 448 B.C. Among his other works, a bronze Athena on the Acropolis, called the Lemnian Athena, was probably made between 451 and 447, when an Athenian colony was sent to Lemnos, and the colossal bronze Athena Promachos, also on the Acropolis, was presumably erected well before the middle of the century, since it is said to have been constructed from Persian spoil. The same statement is made about several other works of the master, and is the basis for the belief that his career began fairly early in the fifth century.

When we turn from literature to the monuments, we find ourselves in an even worse position than in the case of Polyclitus. Only two works of Phidias have been surely recognized in copies—the Athena Parthenos and the Olympian Zeus—and the copies are all on a small scale and, for the most part, of inferior workmanship. The most complete copy of the Athena, the Varvakeion statuette (so named from the place where it was found in Athens), doubtless reproduces accurately the pose and some of the attributes, such as the shield with the serpent coiled inside it, the triple-crested helmet, and the Victory on the right hand (Fig. 49). But it is a heavy, mechanical piece of work, and, since most of the color is lost, gives nothing of the brilliant polychrome effect of the original, in which, in accordance with the regular practice in such *chryselephantine* statues, the flesh parts were of ivory, the drapery and accessories of gold, and precious and semi-precious stones were used to some extent. Several parts of the decoration, also, which are known from literary accounts,

are omitted in the Varvakeion statuette, especially the reliefs which decorated the base, the shield, and even the edges of the sandals. On the original, which was some forty feet

FIG. 49—THE VARVAKEION ATHENA. NATIONAL MUSEUM, ATHENS

high, these reliefs could be modelled at a good scale and must have added much to the brilliant effect of the whole.

The Olympian Zeus was an even more elaborate figure than the Athena Parthenos. Its height was roughly the same, about forty feet, but as it was a seated figure, the scale was even larger. Most of our knowledge of the statue is derived from the very full description of Pausanias. The god held a Victory on his right hand; his left rested on a sceptre, on which was perched an eagle. The throne and a footstool under the feet were elaborately decorated with reliefs and figures in the round, and there were reliefs on the base as well. Between the legs of the throne were wooden panels, painted with mythological subjects by Panænus, the nephew and assistant of Phidias. Once more we suspect that much of the fame of the figure was due to these elaborate decorations. But the ancient writers comment especially on the impression of dignity and power, tempered by kindness, which Phidias

FIG. 50—HEAD OF ZEUS. MUSEUM OF FINE ARTS, BOSTON

imparted to the statue. Among the reflections of the Olympian Zeus, the most important are found on coins of Elis. On some of these the whole statue is reproduced, on others the head only. They confirm Pausanias's statements, but naturally omit many details. The copies of the head, however, make it possible to identify some reflections of the Zeus among ancient heads that have been preserved. The closest reflection yet discovered is a head in Boston (Fig. 50), itself a work of the fourth century. It seems as if the later

sculptor had overemphasized the kindly expression of the original, at the expense of the expression of dignity and power, but in all other ways the Boston head agrees closely with the coin types.

FIG. 51—VICTORY BY PÆONIUS. MUSEUM, OLYMPIA

These reflections of Phidias's greatest statues give us some impression of the dignity and grandeur of his figures of the gods, but exhibit few of those personal idiosyncrasies by which the style of one sculptor is distinguished from that of another. The influence of Phidias, therefore, is less easy to trace than that of the other great Greek sculptors. Yet there

can be no doubt that this influence was very great. Almost all his works that are mentioned were statues of divinities, and especially of the great divinities of the Greek Olympus, and it is clear that these profoundly affected the conceptions of later times. The fame of Phidias rests primarily on his success in expressing the lofty ideals of his contemporaries in regard to their highest gods, ideals which were modified by later men, but never completely abandoned.

Lesser sculptors of the fifth century. Pæonius of Mende. Of the less famous masters of the second half of the fifth century, there are very few whose works have yet been recognized. Pæonius of Mende is shown by his statue of Victory (Fig. 51) to have been a sculptor of great originality. The goddess was represented actually flying through the air.

Even in its mutilated condition, the statue conveys a vivid impression of rapid motion, with its windswept drapery and the flying eagle underneath the feet. This impression must have been even more vivid when the figure stood on its lofty pedestal, with upraised wings and a great robe bellying out behind. The whole exhibits so much greater freedom than the figures from the eastern pediment of the temple of Zeus that the tradition which assigns the pediment to Pæonius (see p. 92) seems incredible.

Cresilas of Cydon. Although he was a native of Cydon in Crete, Cresilas appears to have worked largely in Athens.

FIG. 52—PORTRAIT OF PERICLES. BRITISH MUSEUM, LONDON. (PHOTO. MANSELL)

Among his works was a portrait of Pericles, of which five copies are known (Fig. 52). This is interesting from many points of view. It gives us some idea of the manner of Cresilas and of the appear-

ance of the great Athenian statesman. Most interesting of
all is the obvious idealization. We can hardly believe that
the face of Pericles was so unwrinkled, the features so regular
as they appear in the work of the sculptor. Nothing, indeed,
shows the idealizing tendencies of Attic art in the Periclean
age more clearly than such elimination of personal traits
in a portrait.

Other sculptors of the fifth century. The majority of the
other sculptors of the fifth century who are mentioned by an-
cient writers still remain, in spite of much ingenious theoriz-
ing, little more than names. The list includes: Agoracritus of
Paros, Alcamenes of Athens, and Colotes of Heraclea in Elis,
pupils of Phidias; Praxias, pupil of Calamis; Lycius, son of
Myron; Styppax of Cyprus and Strongylion of Athens, whose
school connections are not recorded.

The sculptures of the Parthenon. Although the Parthenon,
like the other Periclean buildings at Athens, was erected
under the supervision of Phidias, it is nowhere stated that he
made the decorative sculptures, and indeed the amount of
these is so great that no one man could have carved them all
in the fifteen years (447-432 B.C.) during which the temple
was erected. It seems highly probable, nevertheless, that the
scheme of the decoration would be laid out by Phidias and
that he would himself design at least a considerable part of
it. However this may be, whether or not we may regard the
Parthenon sculptures as reflecting the personal style of
Phidias, they are original works of the Attic school of the
fifth century, and so of the very greatest importance. The
amount of sculpture on the Parthenon shows the builders'
intention to make this the most splendid of Greek temples.
Not only were both pediments filled with large figures in
the round, but all the ninety-two metopes were carved in
high relief, and around the main structure, at the top of the
wall, ran a continuous frieze in low relief, over 520 feet in
length. Considerable portions of all this decoration are pre-
served on the temple itself, but the greater part is in the
British Museum, among the so-called "Elgin marbles," a great
collection made in Athens by agents of Lord Elgin early in the
nineteenth century, and purchased by the British Museum in

1816. There are small pieces, also, in other European museums.

The pediments. The eastern pediment represented the birth of Athena; the western, the contest between Athena and

FIG. 53—THE WESTERN PEDIMENT OF THE PARTHENON, RESTORED. (FROM SCHWERZEK, "ERLÄUTERUNGEN ZU DER RECONSTRUCTION DES WESTGIEBELS DES PARTHENON")

Poseidon for the land of Attica. The composition cannot be determined in all details, but the main lines are clear. The western pediment, especially, can be restored with some certainty (Fig. 53), thanks to sketches made by an artist who

FIG. 54—"THREE FATES" FROM THE EASTERN PEDIMENT OF THE PARTHENON. BRITISH MUSEUM, LONDON. (PHOTO. MANSELL)

visited Athens in the train of M. de Nointel in 1674, thirteen years before an explosion of gunpowder destroyed a large part of the temple. Here, clearly, the designer has grasped the principle that the skeleton of a decorative composition should be concealed. The groups balance on either side of the centre,

but inside the groups the arrangement varies widely, so that the spectator is not conscious of the underlying plan. Such "occult balance," as it is sometimes called, is very characteristic of Greek design during the great age.

Of the preserved figures, the finest are the three from the eastern pediment which are generally, but probably incorrectly, called the Three Fates (Fig. 54). In these we see plainly the idealizing tendencies of fifth century art. "They look as if they were modelled on human bodies," said the

FIG. 55—METOPE FROM THE PARTHENON. BRITISH MUSEUM, LONDON.
(PHOTO. MANSELL)

sculptor Dannecker, when he first saw the Elgin marbles, "but where is one to find such bodies?" This is undoubtedly the impression that the sculptor wished to convey, of beings in human form, but without the imperfections of humanity, beings perfect in health and strength. Even the drapery is idealized, and shows only long, sweeping, graceful lines, following the poses of the figures.

The metopes. The metopes of the eastern and the western façades of the temple are still in place, but they are very badly mutilated. The subjects are the battle of the Gods and the Giants (eastern end) and the battle of the Greeks

and the Amazons (western end). A few of the northern metopes are also still on the building, but even the theme of these (perhaps scenes from the sack of Troy) is doubtful. Our knowledge of this portion of the sculpture, therefore, depends almost entirely on the eighteen metopes with contests of Centaurs and Lapiths that have survived from the southern series. Most of these are among the Elgin marbles in the British Museum. They are curiously uneven in style. In several the design is somewhat awkward and angular, the modelling hard, with details suggestive of the lingering archaism of transitional art. All this implies that the metopes were the first parts of the decoration to be carved. The style is precisely what one might expect in the work of pupils of Myron, Critius, and Nesiotes, before they were trained by Phidias (Fig. 55). Only a very few of the preserved metopes are entirely free from such reminiscences of earlier work.

The frieze. The continuous frieze, on the other hand, is carved with perfect freedom. There is some unevenness in the execution of different parts of the long composition, but these are clearly due to more or less careful workmanship, not to archaic constraint. The subject is the Panathenaic procession, the gorgeous pageant which every four years moved through the city to the Acropolis, escorting the victors in the Panathenaic games, bringing animals for a sacrifice to Athena, and carrying the *peplos,* or robe, woven for the goddess by a chosen company of Athenian girls. The way in which the subject is treated is very characteristic of the time. There is no attempt at photographic accuracy, but the frieze consists of a series of groups suggested by the participants in the actual procession, skilfully arranged to produce a varied and beautiful effect. The sculptor did not hesitate to depart from the actual whenever it suited his purpose. The *peplos* is not represented at all, and it is quite evident that the intention was to create an ideal picture of the ceremony as an epitome of all that was noblest and best in Athens (Fig. 56). Equally striking are the technical details. Since the frieze was under the colonnade, it had to be seen at a sharp angle and could receive light only from below. The relief,

therefore, was kept very low; it nowhere rises more than two
and one-quarter inches from the background, and the average
height is only an inch and a half, although this amount was
somewhat increased by the many attachments of metal, for
which the drill holes still exist. It is noticeable, too, that the
relief is generally higher at the top than at the bottom. Yet,
with this low relief, the designer did not hesitate to suggest

FIG. 56—HORSEMEN FROM THE NORTH FRIEZE OF THE PARTHENON. BRITISH
MUSEUM, LONDON. (PHOTO. MANSELL)

several figures one behind the other. The purpose was accom-
plished by a clever system of sloping planes, so arranged that
some part of almost every figure was brought out to the face
of the relief. The result is an impression of depth which is
remarkable in such low relief. Another interesting detail is
the observance of the principle called *isocephaly*, or *isocephal-
ism*, in accordance with which the heads of all figures are
brought close to the top of the relief, so as to cover the back-

ground and avoid unpleasant vacant spaces. In consequence, there is a marked disproportion between the horsemen and the standing and seated figures, but the isocephalism is so skilfully managed that the spectator is usually unaware of it it until it is pointed out.

The underlying principle is again the idealism, the willingness to depart from exact natural relations to produce a desired effect, which is so pronounced in the sculpture of the great age.

Other Attic temples. The Erechtheum. Of the other buildings erected in Athens during the age of Pericles, all except the Propylæa were decorated with sculpture. From the Erechtheum, numerous fragments of a long frieze with many figures in low relief are preserved, but so badly mutilated that not even the subject can be made out. The most curious peculiarity of this frieze is that the figures were carved separately in white marble and attached to slabs of dark "Eleusinian" stone. Much more impressive are the six female figures which carry the roof of the so-called Caryatid porch. Five of

FIG. 57—CARYATID FROM THE ERECHTHEUM. BRITISH MUSEUM, LONDON. (PHOTO. MANSELL)

these, considerably repaired, are still in place; the sixth is among the Elgin marbles (Fig. 57), and is represented on the temple by a cast. In the inscriptions that record the building of the Erechtheum, these figures are not called

Caryatides, but simply "maidens," and they were prob-
ably thought of as Athenian girls in the service of Athena,
to whom, along with Erechtheus, the temple was dedicated.
With their sturdy forms and simply arranged robes, they
seem entirely adequate for the task of holding the weight
that rests upon them, and the Caryatid porch is generally
regarded as the most successful attempt ever made to use
human figures as architectural supports. One significant
detail is the arrangement of the hair as a mass, with
separate locks falling over the shoulders in front, a device
which recalls the archaic formula, and which was adopted,
no doubt, to afford better support at the weakest point in
each figure. It is interesting, too, that the figures are not
mechanical reproductions of a single model, but each one
differs in small details from every other.

The Temple of Wingless Victory and the "Theseum." The
so-called Temple of Wingless Victory, dedicated to the wor-
ship of Athena as bringer of victory and officially called the
Temple of Athena Nike, had a continuous frieze of small
figures in high relief, representing a battle of Greeks and
Persians (perhaps the battle of Platæa) in the presence of
an assembly of the gods. On the so-called Theseum in the
lower city, built in the thirties of the fifth century, eighteen
metopes are decorated with exploits of Heracles and Theseus,
and at the ends of the main building are continuous friezes,
that at the eastern end representing a battle in the presence
of seated gods, that at the western, the contest of the Cen-
taurs and the Lapiths. In both these temples, the style of
the reliefs differs considerably from that of the Parthenon
frieze. There is a marked fondness for figures in violent and
contorted positions, the modelling is harder, the principle of
isocephalism is often disregarded. All this suggests the work
of men more strongly influenced by the older Attic
masters like Myron, Critius, and Nesiotes than by Phidias,
and these sculptures are sometimes referred to as productions
of "the non-Phidian group of Attic sculptors."

The balustrade of Athena Nike. Of the tendencies of
Athenian sculpture at the end of the fifth century, we have
interesting evidence in the fragments of the balustrade or

parapet of the temple of Athena Nike. The temple stands on the great tower which finishes off the southern wall of the Acropolis at its western end, and was built so close to the edge of the tower that some protection for visitors was felt to be necessary. To fur-nish this, a parapet of mar-ble, some three feet high, was erected, and decorated on the outside with reliefs representing winged Vic-tories engaged in various occupations, such as bring-ing cows for sacrifice and erecting trophies. Athena appears to have been repre-sented on each of the three sides of the parapet, and the Victories were no doubt conceived as honoring the great goddess. Of the num-erous fragments of the bal-ustrade that have been found, the favorite is one which shows a Victory ty-ing her sandal (Fig. 58). The skilful rendering of the gracefully poised figure and the treatment of the thin, clinging robes so as to show the form beneath make this one of the masterpieces of Greek sculpture. Histor-ically these qualities are in-

FIG. 58—VICTORY TYING HER SANDAL. ACROPOLIS MUSEUM, ATHENS. (PHOTO. BOISSONNAS)

teresting because they foreshadow the development of the sculptor's art in the next century.

Decorative sculpture under Attic influence. The influence of the Attic school of the fifth century is found in works from many widely separated places. The most important are: the well-preserved frieze from the temple of Apollo Epi-

curius at Bassæ near Phigalia in Arcadia, now in the British Museum; the sculpture from the "Nereid Monument" at Xanthus in Lycia, also in the British Museum; and the long series of reliefs from the so-called Heroön of Gjölbaschi-Trysa in Lycia, now in Vienna. In all these, single figures and groups, and sometimes whole compositions, were clearly inspired by the decoration of the great Athenian buildings of the Periclean age.

General character of fifth century sculpture. Throughout the fifth century, the Greek sculptors devoted themselves primarily to the human figure. Details of landscape and forms of animals were seldom introduced in their work unless they were necessary in connection with the human figures. The favorite subjects were the gods and the heroes and the myths concerning them, although athletes and other mortals were frequently represented. The transitional age witnessed a rapid progress towards more accurate modelling, and by the middle of the century, the sculptors were able to work out their ideas with perfect freedom. In the fifty years that followed, they endeavored to express the highest beauty that they could conceive, and the idealizing tendency is the most prominent characteristic of the sculpture of the period. In creating these ideal figures, the sculptors omitted many of the details that appear in an actual model, and the effect of superhuman beauty that the works of the fifth century produce is largely due to this "principle of elimination." With rare exceptions, the poses chosen were comparatively quiet, and even in the representation of active figures, the pose was such as to suggest the possibility of more energetic action, a characteristic that is sometimes referred to as the "rule of reserve force." It is noteworthy, too, that the faces of the figures rarely express any strong emotion. The expression is usually one of calm serenity, and this impassivity, combined with the quiet pose, produces the impression of dignity and perfect poise which was evidently the ideal of the sculptors.

BIBLIOGRAPHICAL NOTE

An interesting and suggestive account of the sculpture of the Transitional Period, with constant reference to developments in other fields, is A. Joubin's *La sculpture grecque entre les guerres médiques et l'époque de Périclès*, Paris, 1901. H. Lechat's *Phidias et la sculpture grecque au v^e siècle*, Paris, 1906, is a similar treatment of the following period. E. A. Gardner's *Six Greek Sculptors*, New York, 1910, contains chapters on Myron, Phidias, and Polyclitus, as well as on the great masters of the fourth century. A. Furtwängler's *Meisterwerke der griechischen Plastik*, Leipzig, 1893 (published in English under the title *Masterpieces of Greek Sculpture*, London, 1895) attempts, largely on stylistic grounds, to increase the body of work assigned to the famous Greek masters; many of Furtwängler's theories have not met with general acceptance, but the book is full of valuable suggestions. Semi-popular accounts of the two great masters of the Periclean age are M. Collignon's *Phidias,* Paris, 1886, and P. Paris's *Polyclète*, Paris, 1895. C. Waldstein's *Essays on the Art of Pheidias*, New York, 1885, is characterized by keen observation and illuminating criticism. A. Mahler's *Polyklet und seine Schule*, Leipzig, 1902, discusses the large number of preserved works in which the influence of the Argive master is evident.

The Parthenon and its decorative sculpture have a whole literature of their own. The most comprehensive work, although now out-of-date in many particulars, is A. Michaelis's *Der Parthenon,* Leipzig, 1871. M. Collignon's *Le Parthénon*, Paris, 1910, is a sumptuously printed volume, with many unusual illustrations. Similar in character is A. H. Smith's *The Sculptures of the Parthenon*, London, 1910. A. S. Murray's *The Sculptures of the Parthenon*, New York, 1903, is more modest in make-up, but excellent in matter, based on an intimate knowledge of the originals. For less detailed accounts of the great monuments of Athens, reference may be made to E. A. Gardner's *Ancient Athens*, New York, 1902; M. L. D'Ooge's *The Acropolis of Athens*, New York, 1908; and C. H. Weller's *Athens and its Monuments*, New York, 1913.

CHAPTER VI

GREEK SCULPTURE: THE FOURTH CENTURY

The art of the fourth century developed directly out of that of the fifth, and no sharp dividing line can be drawn between them. Nevertheless, there are considerable differences between the products of the two periods, so that the years from 400 to the death of Alexander the Great in 323 B.C. are commonly distinguished as the Second Half of the Great Period.

Political history. The political power of Athens was greatly impaired by the Peloponnesian War, and the early years of the fourth century witnessed the so-called Spartan and Theban "supremacies" (404-371 and 371-362 B.C.). From 359 on, most of the Greek states were involved in the intrigues of Philip of Macedon, whose control over Greek affairs was finally established by the battle of Chæronea in 338. The Macedonian domination continued under Alexander, who succeeded his father in 336 and soon after began the victorious campaigns in Asia by which Greek culture was extended over a large part of the ancient world.

The School of Athens and the School of Sicyon. The direct effects of these political changes are not especially marked. Throughout the second half of the great age, Athens remained the artistic leader of Greece, and the "Younger Attic School" of the fourth century, of which the most important member was the famous Praxiteles, produced many works that rivalled those by the older group of masters in fame. The school of Argos was supplanted by the school of Sicyon, under the lead of Lysippus. A third great master of the period was Scopas, who appears to have been a wandering artist, not closely connected with any school.

112

Influences of new conditions. The indirect effects of the unsettled conditions of the fourth century were much more important than the direct results. Most of the city-states were impoverished by the Peloponnesian War and the struggles that followed, so that they could not enter upon great public undertakings such as characterized the fifth century. At the same time, there was a decided increase of luxury in private life, and sculptors were more and more called upon to execute commissions for private citizens. The consequence was an increasing individualism, both in the sculptors and in their works, and a striving for grace and delicacy, rather than for the austerity and grandeur which were the ideals of the older sculptors. The new tendencies found expression in several ways, especially in slenderer proportions, in more detailed modelling, and in the use of thinner drapery, carved in rippling folds. The expression of emotion, also, greatly interested the men of the fourth century, and much of the more individual effect of fourth century figures is due to the sculptors' successful attempts to suggest the feelings or the character of their subjects. The general result is that the creations of the fourth century, though still much idealized, are more suggestive of human beings than the severer figures of the preceding age. The phrase, "the humanization of the gods," expresses well one marked feature of the development during this period.

Praxiteles. Of the three great masters of the period, Praxiteles is the most famous. He is, moreover, the one whose style is most surely determinable, and so may reasonably be considered first. He was born early in the fourth century, and his greatest activity seems to have fallen between the years 370 and 340. His fame is attested by the fact that no less than forty-seven of his works are mentioned by ancient writers. To modern students he is especially interesting as the one very famous sculptor from whose hand an original work has been preserved. This is the Hermes with the young Dionysus at Olympia (Fig. 59), which, since its discovery in 1877, has served as the basis of all study of Praxiteles. Hermes is here represented as he carries the baby Dionysus to the Nymphs, by whom, according to tra-

FIG. 59—THE HERMES OF PRAXITELES. MUSEUM, OLYMPIA

dition, he was brought up. He has thrown his cloak over
a tree-stump, upon which he leans. His right arm was raised
and held some object, probably a bunch of grapes, towards
which the child stretched out his left hand. Many of the
traits of fourth century sculpture can here be seen: the
slender figure (though there is no lack of strength); the
modelling in comparatively small surfaces, which pass into
one another by very gradual transitions and lack the strong
definition of fifth century work;
the expressiveness of the face,
with its slightly smiling mouth.
Among the specifically Praxite-
lean traits may be noted the pose
with one hip strongly thrown out,
producing what is sometimes
called the "S-curve of Praxite-
les"; the high skull, with its
strongly curved outline and dis-
tinct taper towards the chin; the
long, narrow eyes, with the lower
lid slightly drawn up and made
very thin, to produce an effect of
dreamy contemplation; the rend-
ering of the hair by a series of
deep, irregular grooves. But it
is above all in the marvellous
surface finish that the skill of
the master is most manifest—
in the smooth working of the
marble to suggest the flesh, the
rougher surface of the hair, the
clever suggestion of the folds of
the robe. With this figure before
us, we realize once more how
much we lose in being forced to

FIG. 60—APHRODITE OF CNIDUS.
VATICAN, ROME. (FROM "JOUR-
NAL OF HELLENIC STUDIES,"
1887, PL. 80; FROM A CAST)

study the styles of the great masters in the inferior Roman
copies.

 After the Hermes, such other works of Praxiteles as can
be recognized in copies are bound to be disappointing, al-

though some of them reproduce statues which in antiquity enjoyed much greater fame. This is especially true of the Aphrodite of Cnidus, the master's most renowned work. The mediocre copies, of which the best is in the Vatican (Fig. 60), give an idea of the pose and the general appearance of the figure, but lack the masterly technique of the Hermes. The nudity of the goddess is a striking innovation and one that was destined to exercise a powerful influence on later men. Up to this time, undraped female figures, like the flute-player on the "Ludovisi throne" (Fig. 47), were rarely represented by Greek sculptors. It was apparently Praxiteles who first made such types popular, and it is to be noted that he treats them with a restraint that is characteristic of the great age. The lack of self-consciousness in the Aphrodite of Cnidus is one of the traits that most distinguish it from the imitations and modifications of the type in later times.

Scarcely less famous than the Aphrodite among the works of Praxiteles were an Eros and a Satyr. The Eros has not yet been distinguished with certainty among several types of the god of Love which suggest a Praxitelean original, but the Satyr is very surely to be recognized in a type represented by a large number of copies, the best known of which is the so-called Marble Faun in Rome (Fig. 61). The spirit of Praxiteles speaks in every feature of the statue, the leaning pose, with its graceful, sinuous outline, the smiling mouth, the long, narrow eyes. One can imagine how the sculptor would delight in differentiating the texture of the panther skin from that of the flesh. The semi-bestial character of the satyrs, which is emphasized in most ancient renderings of these followers of Dionysus, is only hinted at here by the pointed ears and the slightly slanting eyes.

One other statue by Praxiteles can be surely recognized in copies, the Apollo Sauroctonus, or Apollo slaying the Lizard. This represents a very youthful Apollo, hardly more than a boy, leaning against a tree-stump and attempting to strike a lizard, which is moving towards him. The figure is interesting as one of the best examples of the humanization of the gods and also as one of the few works of Praxiteles

that are said to have been made of bronze. There are, further, in Athens, three slabs from Mantinea, which originally decorated the base of a group by Praxiteles representing Leto and her children. On these is carved the contest of Apollo with Marsyas in the presence of the Muses. We can hardly believe that decorative reliefs of this sort were carved by the master himself. But they might have been made from his designs by assistants, and the Muses may be taken as evidence for the type of draped female figure current in the school of Praxiteles. It is, as might be expected, of somewhat slenderer proportions than the draped figures of the fifth century, with the robes in very delicate and graceful folds.

FIG. 61—THE "MARBLE FAUN." CAPITOLINE MUSEUM, ROME

From these works alone we might draw the inference that Praxiteles was most interested in the representation of youthful deities, of figures in which the grace and the joy of life could best be expressed, and such an inference is fully justified by the literary notices of works that have not been preserved. Among these, few statues of the older gods are mentioned and few purely human figures. The literary accounts also show that he was a sculptor in marble, rather than in bronze;

they emphasize his great technical dexterity, a quality to which the Hermes bears eloquent witness; and one writer remarks that Praxiteles attained great skill in "expressing in marble the feelings of the soul," indicating that to ancient, as to modern, critics, the expressiveness of Praxitelean statues was one of their prominent features.

Scopas. Scopas was, apparently, a somewhat older contemporary of Praxiteles. Since he is called a Parian, he was probably born in the Ionian island of Paros, but he was a wandering artist, not closely affiliated with any school. In

FIG. 62—HEADS FROM THE TEMPLE OF ATHENA ALEA AT TEGEA. NATIONAL MUSEUM, ATHENS. (FROM "ANTIKE DENKMÄLER," 1, PL. 35; FROM CASTS)

the early years of the fourth century, he was at work in the Peloponnesus; around 350, he was engaged with other sculptors in decorating the Mausoleum at Halicarnassus in Asia Minor; but of the details of his life we have no information. Our knowledge of his style depends on several badly mutilated heads from the temple of Athena Alea at Tegea, of which he is said to have been the architect (Fig. 62). These heads, clearly, are the work of a sculptor of very different ideals from Praxiteles. Their most prominent trait is the expression of strong feeling, as if they came from figures under stress of violent emotion. This effect is produced

especially by the eyes, which are round and wide open, with upward directed gaze and strongly emphasized lids, deeply sunk under the brows and overshadowed at the outer corners by a heavy roll of flesh. It was further suggested by the open mouths, showing the teeth, and by the dilated nostrils, which, when the heads were uninjured, must have given an impression of heavy breathing. The total effect is often characterized as "intensity of expression." In shape the heads are squarish, and suggest the influence of the Polyclitan canon.

In spite of the decidedly individual style of t h e heads from Tegea, few of the other works of Scopas mentioned by ancient writers have been identified. A much mutilated statuette in Dresden is probably a copy of his Bacchante, which once stood in Constantinople and was famous as a successful embodiment of a frenzied worshipper of Dionysus. A Heracles in Lansdowne House, London, may be derived from Scopas's Heracles at Sicyon. An Apollo Citharœdus in the Vatican and the Ludovisi Ares in the National

FIG. 63—MELEAGER. FOGG MUSEUM
CAMBRIDGE

Museum in Rome are with some reason regarded as reflections of Scopasian works, considerably affected by the taste of later times. Among the statues attributed to Scopas on grounds of style alone, one of the most interesting is a figure of Meleager, the leader in the famous Calydonian boar-hunt. The most complete copies are in the Vatican and the Berlin Museum; the one that exhibits the closest similarities to the heads from Tegea is in Cambridge, Massachusetts (Fig. 63). The more

complete copies show that the pose resembled that of the Doryphorus, with the weight on the right leg and the left foot touching the ground with the toes only. But the tendencies of the fourth century are evident in the more accentuated curve of the body and in the modelling in smaller masses. In the head, the round, wide-open eyes, with the roll of flesh over the outer corners, the open mouth, and the broad nostrils, show clearly the Scopasian striving for the expression of strong feeling.

In Scopas, then, we have a master who may well be called the foil to Praxiteles. To Scopas the storm and stress of life appealed more strongly than its more joyous aspects, and we find in his creations a violence of feeling far removed from the graceful elegance of the Praxitelean types. In later times, the influence of Scopas was fully as great as that of his more famous contemporary.

Lysippus. Lysippus was the most prominent Peloponnesian sculptor of the fourth century, the leader of the school of Sicyon. His date is determined by his close connection with Alexander the Great (b. 356—d. 323), of whom he is said to have made many portraits, beginning with one of Alexander as a boy. There is evidence, moreover, that he was active before 356 and after 323, so that his career must have covered a large part of the fourth century. In the literary tradition, Lysippus is frequently mentioned, largely, perhaps, because one of his pupils wrote treatises on sculpture and painting that were much used by later writers. Among the innovations attributed to Lysippus is the introduction of a new canon of proportions, with a smaller head and a slimmer, less heavy body. He is praised for his rendering of the hair and for "extreme delicacy of execution, even in the smallest details." All his works, apparently, were in bronze, and ranged from small figures like the Heracles Epitrapezius which is said to have adorned the table of Alexander to colossi like the Zeus of Tarentum, sixty feet in height. His energy is suggested by the story that he was accustomed to put one coin from every honorarium he received into a money-box, and when this was opened by his heir, it was found to contain 1500 coins.

Under such conditions, we should expect to find among preserved works many copies, at least, of Lysippic statues. It is little less than astounding that there is not a single figure that can be regarded as an accurate copy of one of his works. There are plenty of statues that show Lysippic influence in their slender proportions and in heads about one-eighth of the total height, in contrast to the one-to-seven proportion of the Polyclitan canon, but there is none that can surely be called an accurate copy of a known work of the master. The two figures that have been most discussed in this connection are the Apoxyomenus in the Vatican (Fig. 64) and the portrait of the athlete Agias at Delphi (Fig. 65). The Apoxyomenus, as the name implies, represents an athlete scraping himself with the strigil, or curved scraper, which the Greeks used to remove oil and dust from the body after exercise. The slender proportions, the close-lying muscles, the small head, and the freely modelled hair are all qualities that are recorded as especially Lysippic; and since Pliny mentions an Apoxyomenus by the master which was greatly admired, the figure in the Vatican has often been regarded as a copy of that statue. A careful study of the Roman figure, however, shows in the anatomical details a scientific accuracy which certainly is not common in works of the fourth century, and in recent years the theory has gained ground that, although it probably is based on the Apoxyomenus of Lysippus, the copyist worked his figure out in accordance with the more realistic style of later times.

Such a theory is strengthened by a study of the Agias, which is one of a group of statues found at Delphi in 1897. The group was dedicated by Daochus, a Thessalian tyrant of Pharsalus, and inscriptions found long before in Pharsalus show that a similar group was set up there and that in this group the Agias, at least, was made by Lysippus. It seems reasonable, therefore, to argue that the statue at Delphi is a copy of the corresponding figure at Pharsalus, which presumably was of bronze. If this is so, we have in the Agias a fourth century copy of a Lysippic figure. Although some details in the two inscriptions are difficult to explain, this theory has been very generally accepted. A

comparison of the Agias with the Apoxyomenus, however, reveals so many differences that many critics find it hard to associate both statues with the same sculptor. In its slender proportions and small head, the figure at Delphi agrees well with the statue in the Vatican. But the modelling reveals

much less interest in anatomical detail, and the face with its deep-set eyes, recalling the intensity of Scopasian heads, is certainly more expressive than the face of the Apoxyomenus. In explanation of these differences, it may be said that the copyist who made the Agias probably did not attempt to reproduce the modelling of the original bronze exactly — the practice of making exact copies is certainly later than the fourth century—and since the Agias is a portrait, although Agias himself lived in the fifth century, there may have been an earlier statue, or perhaps only a tradition about his appearance, which would account for the expression. Under these conditions, it is safest to accept both statues as reflections of Lysippic works, made at widely different times and by sculptors of quite different tendencies.

FIG. 64—APOXYOMENUS. VATICAN, ROME

A somewhat similar problem is presented by the numerous portraits of Alexander the Great. There is no reason to doubt the tradition that Lysippus made many portraits of the great conqueror, but when we try to determine which among the

many preserved likenesses of Alexander go back to him, we are involved in many difficulties, not the least of which is due to our real ignorance of the personal style of the sculptor. So, also, in regard to many other works which show the slender proportions of the Lysippic canon combined with other traits that are found in the Apoxyomenus and the Agias, it is impossible to say with certainty that they reproduce statues by Lysippus himself; and critics have to be content with assigning them to the school of Lysippus, or to the still more indefinite category of "works under Lysippic influence." The number of such statues, at all events, is sufficient to confirm the ancient tradition of the influence of Lysippus on his contemporaries and successors.

FIG. 65—AGIAS. MUSEUM, DELPHI (PHOTO. ALINARI)

Relief sculpture. The Mausoleum. For the study of fourth century relief, the most important single monument is the Mausoleum at Halicarnassus, the elaborate tomb built for Mausolus, satrap of Caria, about the middle of the fourth century. Many parts of the decoration of this famous building have been recovered and are now, for the most part, in the British Museum. Besides numerous reliefs, they include portrait statues of Mausolus and his wife, Artemisia, fragments of a colossal four-horse chariot, which was placed at the top of the monument, several lions, and fragments of standing figures and horsemen. All of these are

interesting, especially the portrait statues, which are treated in a somewhat more realistic manner than the portraits of the fifth century, but show in many details, especially in the drapery, the influence of the earlier period. The most important relics are the slabs of a long relief, representing a battle of Greeks and Amazons—the most extensive single frieze that has come down to us from this period (Fig. 66). The figures exhibit many of the qualities of fourth century statues: slenderer proportions, more detail in modelling, and greater expressiveness, especially in the faces. Other qualities

FIG. 66—BATTLE OF GREEKS AND AMAZONS, FROM THE MAUSOLEUM AT HALICARNASSUS. BRITISH MUSEUM, LONDON. (PHOTO. MANSELL)

are a great fondness for lively and vigorous poses, neglect of isocephalism, wide spacing of the figures, and use of flying drapery to fill vacant spaces. In all these respects, the relief recalls the works of the non-Phidian group of Attic sculptors, and it seems a fair inference that it was from them, rather than from the Phidian reliefs of the fifth century, that the sculptors of the Mausoleum drew their inspiration.

These sculptors, if we may believe Pliny, were four, Scopas, Timotheus, Leochares, and Bryaxis; and many attempts, naturally, have been made to assign parts of the decoration to one or another of these masters. None of the attempts has

yet met with general acceptance, largely because, with the exception of Scopas, so little is surely known about the style of the artists. For Timotheus, we have the evidence of some decorative sculptures from the temple of Asclepius at Epidaurus (built about 375 B.C.), of which the most important are two Nereids riding on sea-horses and a mounted Amazon. These are shown by an inscription to be partly the work of Timotheus himself, partly from his designs. Their most striking feature is the thin, clinging drapery, recalling that of the Victories on the balustrade of Athena Nike. Leochares is represented by a copy, in the Vatican, of his Ganymede and the Eagle, a cleverly designed group, in which a sense of motion is well suggested by the upward gaze of the figures. Bryaxis's name is carved on a base in Athens decorated with figures of three horsemen, which he probably designed. New discoveries may some day throw further light on the distinctive traits of these sculptors and the share that each had in the decoration of the Mausoleum. Even if the problem of authorship proves insoluble, the sculptures from the Mausoleum furnish important evidence for the tendencies of fourth century art, especially in relief sculpture.

The Attic grave reliefs. Another significant group of fourth century reliefs is the great series of gravestones from Attica and the neighboring districts. In respect to subjects, these follow the older tradition in representing the occupant of the tomb engaged in some simple action of daily life. But the form of the stele is considerably developed, until in many cases it resembles a small shrine, and the number of figures is often increased to five or six. The favorite type is what may be called the "family group," with two figures clasping hands (one of them commonly seated) in the presence of one or more others (Fig. 67). In this we may reasonably see a reference to the parting of death, though the scene is conceived as an ordinary farewell. With rare exceptions, all subjects are treated with marked restraint, in a way that recalls fifth century reliefs. But the influence of the fourth century appears in the expressiveness of the faces and in the slender proportions of most of the figures. The workmanship varies greatly, but in general is surprisingly good, so

that the gravestones, like the decorative sculptures of the Periclean buildings, give us a lively impression of the large number of well-trained sculptors at Athens during the great age.

FIG. 67—GRAVESTONE OF KRINUIA. UNIVERSITY OF PENNSYLVANIA MUSEUM, PHILADELPHIA

General character of fourth century sculpture. In the fourth century, no less than in the preceding period, the Greek sculptors devoted themselves to the human figure and endeavored to express their ideals of the highest beauty. But they did not depart quite so far from the human model as their predecessors had done, and their striving for graceful-

ness and the expression of emotion resulted in many changes. In the fourth century, the gods descend a little from Olympus and become more like ordinary human beings, and figures of athletes and portrait statues are more individual in expression than those of the preceding age. But these are differences in degree, not in fundamental ideas. To later generations, the statues and reliefs of the fourth century have sometimes appealed more strongly than the severer types of the earlier time; but in general, the works of both periods have been equally admired, and the years between 450 and 323 are usually regarded as the "great age" of Greek sculpture. The fame of the sculptors of the great age rests primarily on the fact that, in the field that they chose to cultivate, figure sculpture, they produced works that no later masters have surpassed, and established standards of which the validity has never been seriously questioned.

BIBLIOGRAPHICAL NOTE

Both E. A. Gardner's *Six Greek Sculptors* and A. Furtwängler's *Meisterwerke der griechischen Plastik* (see page 111) contain interesting discussions of the great masters of the fourth century. Useful monographs on individual artists are W. Klein's *Praxiteles*, Leipzig, 1898; G. Perrot's *Praxitèle*, Paris, 1905; and M. Collignon's *Lysippe*, Paris, 1905. A good summary of the modern discussions about Lysippus is given in W. W. Hyde's *Olympic Victor Monuments and Greek Athletic Art*, Washington, 1921, pp. 286 ff. The great series of Attic gravestones may be conveniently studied in A. Conze's *Die attischen Grabreliefs*, Berlin, 4 vols., 1890-1922, which is a *corpus* of monuments of this class. P. Gardner's *Sculptured Tombs of Hellas*, New York, 1896, gives a more popular account of Greek funerary sculpture.

CHAPTER VII

GREEK SCULPTURE AFTER ALEXANDER

Political history. The death of Alexander was followed by many struggles, as his successors fought for portions of his great empire. The kingdoms that resulted from these struggles were essentially Greek, but the habits and customs of the native populations brought about many changes, so that the Greek world after Alexander was very different from what it had been before. The later age of Greek civilization, therefore, is called the Hellenistic period, to distinguish it from the earlier centuries of pure Greek, or Hellenic, culture. This period may be dated from the death of Alexander in 323 to the Roman conquest of Greece in 146 B. C. Ultimately, all the Hellenistic kingdoms were absorbed by the growing power of Rome, and the years from 146 to the establishment of the Roman Empire in 27 B. C. are conveniently called the Græco-Roman period. In a broader sense, the term Hellenistic is often used of the whole development of ancient sculpture from the death of Alexander to the end of the Roman Empire, since the influence of Greek ideas is evident in many ways in the products of the Græco-Roman period and the Roman age.

Influence of new conditions. Among the changes that were brought about by the conquests of Alexander, one of the most noteworthy was a shift in the centres of Greek life and thought. In the Hellenistic age, these were either new cities in the East founded by Alexander or his successors, such as Alexandria and Antioch, or ancient towns in Asia Minor, such as Pergamum, Ephesus, and Rhodes, which rose to new importance as a result of the eastward extension of the Greek world. With these, rather than with the cities of the

mainland, the great schools of Hellenistic sculpture are associated, and their importance continued even after the demand in Italy for Greek works brought about a revival of activity among the sculptors of the mainland. The sculpture of the post-Alexandrian age reflects the changed character of Greek civilization. It is much less uniform than that of earlier centuries, displaying in many cases a striving for novel and striking effects and an increasingly realistic method of treatment. Some works, however, still preserve much of the spirit of the earlier time, and with these we can best begin our study.

The Victory of Samothrace. The Victory of Samothrace (Fig. 68) was set up in the island of that name in the early years of the Hellenistic period, probably to commemorate the naval victory which Demetrius Poliorcetes won over Ptolemy of Egypt in the year 306. The goddess stands on the prow of a ship, and coins of Demetrius, on which the figure was copied, show that with her right hand she held a trumpet to her lips and in her left she carried a long stake, as if she were proclaiming the success of the victors and preparing to set up a trophy. In the sturdy, vigorous figure and the long sweeping lines of the robe, there is much of the spirit of the great age. The new tendencies appear in the rather theatrical pose and the agitated folds of the drapery, with emphasis on minor details, such as an earlier sculptor would have eliminated. Yet these tendencies are well restrained, and the statue fully deserves its fame as one of the finest embodiments of the idea of victory in the whole range of ancient sculpture.

The Tyche of Antioch. For Antioch, the city built by Seleucus on the Orontes River to be the capital of the kingdom of Syria, a bronze figure of the Tyche, or Fortune, of the city is said to have been made by Eutychides, a pupil of Lysippus. In later times, the statue was copied on coins of Antioch, and through the coins a marble copy of the statue has been recognized (Fig. 69). The attributes and the details seem clearly to be due to a desire to make every feature significant of some aspect of the city itself. The rocky seat suggests the hill on which the town was built; the mural

FIG. 68—VICTORY OF SAMOTHRACE.　LOUVRE, PARIS.　(PHOTO. GIRAUDON)

crown, its battlements and towers; the ears of wheat, the fertility of the surrounding plain; and the swimming figure, on whose shoulder the goddess rests her foot, is, no doubt, the god of the river Orontes. In all this elaborate allegory, we see the taste of an erudite and pedantic age, such as is suggested by many works of Hellenistic literature. But the simple folds of the robes show that the figure is not far removed from the period of the great masters. The original must have been modelled early in the third century.

FIG. 69—TYCHE OF ANTIOCH. VATICAN, ROME

The Aphrodite of Melos. To the third or the second century we must probably assign the famous Venus de Milo (Fig. 70), perhaps the most generally admired of all Greek statues. Even today, after a full century of discussion, most of the problems connected with this figure are still unsolved. Some critics, basing their opinion on the evident idealization, both in the head and in the drapery, would assign it to a master of the fifth century. But this seems impossible, in view of the marked expressiveness of the face, which is suggestive of fourth century art, and, more particularly, of Praxiteles. The proportions, moreover, with the remarkably small head, exaggerate the Lysippic canon, in a way that might be expected in the period after Lysippus. It is also true that the eclecticism that appears in the combination of

traits of different epochs is most easily explained by the assumption that the maker was a sculptor of the later period. An inscribed block which was found with the statue contained some letters of the name of a sculptor from Antioch on the Mæander. Since this town was not founded until 281 B.C.,

the inscription would go far to settle the date of the statue, if it could be proved to belong to it. But, unfortunately, the block has disappeared, and the evidence for its connection with the Aphrodite is far from conclusive. It is best, therefore, to regard the figure as the creation of an unknown Hellenistic sculptor, who drew his inspiration from the works of his great predecessors and succeeded in producing a statue that rivals their finest products and seems to sum up in itself the efforts of many generations to express the Greek ideal of the goddess of Love.

FIG. 70—APHRODITE OF MELOS. LOUVRE, PARIS. (PHOTO. GIRAUDON)

The Apollo Belvedere and the Artemis of Versailles. Similar controversies have raged about two other popular and familiar statues, the Apollo Belvedere (Fig. 71) and the Artemis of Versailles. That these are derived from works of a single sculptor, or at least, of a single school, is evident from their close similarity, extending even to small details, like the sandals. Both are Roman copies of bronze originals, which were very surely works of the Hellenistic period. They have, however, been attributed to the fourth century, and, more definitely, to Leochares (cf. pp. 124f.). The small heads and the slender proportions make it impossible, in any event, to place them earlier than the fourth century.

The principal arguments for a Hellenistic date are the decidedly theatrical poses and the great elimination of anatomical details, which are so far slurred over and lost as to produce an almost unnatural effect. Such qualities are most readily explained as due to a late sculptor, who exaggerated the mannerisms of earlier artists in his attempt to imitate them.

FIG. 71—APOLLO BELVEDERE. VATICAN, ROME

The Alexander sarcophagus. The chance discovery in 1887 of an underground tomb at Sidon in Phœnicia led to the recovery of seventeen large sarcophagi, several of them of Greek workmanship, which are now among the principal treasures of the Ottoman Museum in Constantinople. The largest and most splendid is called the Alexander sarcophagus, from the figure of the conqueror which is carved on each of the longer sides. In one relief, Alexander appears in a battle between Greeks and Persians (Fig. 72); in the other, he is engaged in a lion-hunt, with companions in Persian and in Greek costume. On the ends are other scenes of battle and hunting. The monument was undoubtedly made for some follower of Alexander who wished to commemorate on his tomb his association with the great monarch. It must have been carved, therefore, early in the Hellenistic age. With this date the style of the reliefs is in full accord. Single figures, in some cases, are reminiscent of types employed in the reliefs of the great age; the Greeks, especially, are often represented in more or less idealized forms. But the Persian dress is copied with painstaking care, and many of the faces suggest portraits

and are treated with marked realism. The most interesting
feature of the Alexander sarcophagus, however, is the remark-
able preservation of the color with which the relief was
enlivened. Even today, when the pigments have faded con-
siderably, the sarcophagus from a little distance seems more
like a painting than like a relief. The delicate colors, skil-
fully applied, enhance, without obscuring, the finely carved
surfaces, and give us an impression of the possibilities of

FIG. 72—ALEXANDER SARCOPHAGUS. OTTOMAN MUSEUM, CONSTANTINOPLE

painted sculpture such as we gain from no other ancient
monument.

*The First School of Pergamum. The Dedications of At-
talus I.* The tendency towards greater realism in Hellenistic
art is very marked in the so-called Dedications of Attalus I.
These were a series of elaborate groups set up on the acropolis
of Pergamum and the Athenian acropolis during the reign of
Attalus (241-197 B.C.), to commemorate his victories over
the bands of roving Gauls who had several times invaded
his territory. At Athens, Pausanias tells us, four subjects
were represented—the contest of the gods and the giants, that

of the Athenians and the Amazons, the battle of Marathon, and Attalus's own struggle with the Gauls. The intention clearly was to suggest a parallelism between the victories of Attalus and the repulse of the Persians in the fifth century and to correlate these historical battles with two of the most famous of mythical contests. At Pergamum, only the defeat of the Gauls is mentioned, but it may be that the other subjects also were represented there. The original groups were of bronze, the Pergamenian figures life-size, those

FIG. 73—DYING GAUL. CAPITOLINE MUSEUM, ROME

at Athens about three feet high. These bronze figures have perished, but in marble a number of single figures and one group have survived, relics, evidently, of copies of which there is no literary record. All are carved in the same marble, which is believed to come from Asia Minor, and they probably were made by Pergamenian sculptors during the reign of Attalus. A single example will serve to show the qualities of all—the famous statue in Rome called the Dying Gladiator (Fig. 73). In reality, it represents a Gaul, who, in spite of a severe wound, tries to struggle to his feet and fight on. The fame of the statue rests partly on the restraint

with which the idea of death in battle is handled, partly on the extremely accurate and skilful representation of the figure in a difficult position. In the restrained handling, we may, perhaps, see something of the spirit of the great age; it is the anguish of defeat rather than the physical agony of death that the sculptor has chosen to emphasize. The realistic treatment, on the other hand, is something quite different from the usual practice of earlier sculptors. Every detail of bone and muscle is carefully rendered; the drops of blood which flow from the wound are represented plastically; the thick, bushy hair, the short, bitten moustache, and the characteristic *torques*, or twisted necklace, of the Gaul are painstakingly reproduced; and on the ground are a shield, a trumpet, and a sword (the latter due to a justifiable restoration), the litter of the battlefield. But there is no exaggeration. The sculptor's aim was to reproduce nature closely, and this he has done with great skill. Such tempered and restrained realism is characteristic of the works of the First Pergamenian school, as the group of sculptors who were active during the reign of Attalus I is commonly called.

The Second School of Pergamum. The Altar of Zeus and Athena. The successor of Attalus I on the throne of Pergamum was Eumenes II (197-159 B.C.), and under this king another group of sculptors was active, who are called the Second Pergamenian school. Their most important work was the altar of Zeus and Athena. Many parts of this elaborate structure were found by the Germans during their exploration of the acropolis of Pergamum in the eighties of the last century. It consisted of a massive rectangular platform, on the top of which, in a court surrounded by a colonnade and approached by a monumental stairway, was the altar for sacrifice. Two friezes decorated this structure, the great frieze, which ran all around the outside of the platform and measured something over 400 feet long and seven feet high, and a smaller frieze, which was probably placed inside the colonnade. The subject chosen for the great frieze, the battle of the gods and the giants, shows great confidence on the part of the designer. It was one that had been treated many times before, and seems at first sight a very hackneyed theme. Yet

the Pergamene designer succeeded in producing a really original composition, and the method by which he accomplished this is typical of the Hellenistic age. Since the great gods of Olympus could not be made to fill the length of the frieze, he added to them many of the lesser deities of the Greek pantheon. Some of these would probably have been hard even for a Greek to recognize, and the names that were written above them were doubtless necessary for complete understanding. The gods are accompanied by their appropriate attendants and animals, and these too take part in the struggle. Among the giants, some are represented as earlier artists conceived them, in human form, although wilder and fiercer than ordinary men, but many are monsters, only partly human. Some have serpents in place of legs; several have great wings attached to their backs; and there are many other combinations of human and animal forms. Their names, which were inscribed below, are sometimes familiar, but often strange. The result is a design of great variety, very different from the simpler compositions of the great period, a design that reflects the spirit of a learned and artificial age.

In the carving of the figures, also, we find a marked departure from earlier tradition (Fig. 74). The relief everywhere is high, so that some figures are practically in the round. The folds of the robes are universally agitated and deeply cut, hair falls in masses of undercut curls, eyes are deep-set and often gaze upward in a way that recalls the style of Scopas, muscles are exaggerated and represented as knotted masses. The total effect is one of agitated motion, in which there is hardly a single quiet, restful figure. Yet the carving itself is masterly. Never has marble been made more completely subservient to the sculptor's chisel. Though we may be repelled by the restlessness and the exaggeration of the frieze as a whole, we cannot but admire the skill with which the design was carried out. Like many another Hellenistic work, the great frieze shows clearly that there was no loss of power among the sculptors of this age.

The smaller frieze. Although the small frieze of the altar

of Pergamum is much more damaged than the great frieze, enough of it is preserved to show that this, also, presented many novel and interesting features. The subject was the story of Telephus, a mythical king of Mysia, the district in which Pergamum is situated. Several episodes in the life of Telephus were represented in the same field, with no marked divisions between them—an interesting revival of

FIG. 74—ATHENA SLAYING A GIANT, FROM THE GREAT FRIEZE OF THE ALTAR
AT PERGAMUM. BERLIN

the continuous method of narration, which we noticed in Egyptian and in Mesopotamian monuments, but which was not used by the Greek sculptors of the great age. Another novelty is the introduction of details of landscape in the background of the relief, in marked contrast to the practice of the fifth and the fourth centuries.

"Genre" figures. Among the innovations of the Hellenistic age was the representation of *genre* figures, that is, of types drawn directly from daily life. The commonest subjects are

fishermen and peasants, and the *genre* figures represent in sculpture the same tendency that appears in literature in the *Idylls* of Theocritus. Such figures appealed strongly to the Roman patrons of a later day, and many of the examples that we have are Roman copies. But a few originals of Hellenistic date have been preserved.

One of the finest is the Old Market Woman in the Metropolitan Museum, New York (Fig. 75). In spite of the mutilation which the statue has suffered, the action can be inferred with practical certainty. The left arm was lowered, and t h e hand grasped the pair of chickens and the basket of fruit which are still attached to the side. The right hand was advanced and probably held some bit of farm produce. The realism which is a marked feature of the *genre* figures appears clearly in the whole pose and the wrinkled face and neck. Yet something of the older feeling survives in the carefully arranged folds of the garments, which might be those of a fourth century statue.

FIG. 75—OLD MARKET WOMAN. METRO-POLITAN MUSEUM, NEW YORK

Boethus. The Boy and the Goose. In its careful rendering of the characteristics of age, the Old Market Woman reflects one tendency of the makers of the *genre* figures, who often represented their subjects as advanced in years. At the same time, the opposite extreme was not neglected. Figures of children are frequent among the *genre*

types. An excellent example is the group representing a small
boy struggling with a goose, of which numerous copies are
preserved. The copies vary considerably, so that it is possible
that all do not go back to the same original. The type that
was apparently most pop-
ular (Fig. 76) is attrib-
uted with good reason to
Boethus of Chalcedon,
who, according to Pliny,
made "a child strangling a
goose by hugging it." In-
scriptions show that Boe-
thus lived in the second
century B.C., and a herm
of bronze with his signa-
ture was recovered from
the sea near Tunis in 1908.
The group of the Boy
and the Goose is interest-
ing for its conscious hu-
mor — a not uncommon
trait in the Hellenistic
genre figures — but even
more for its very careful
rendering of the forms of
babyhood. Here again, the
Hellenistic sculptor at-

FIG. 76—BOY AND GOOSE. CAPITOLINE
MUSEUM, ROME

tained novelty by cultivating a field that the masters of the
great age had neglected.

Portraits. The portraits of the Hellenistic period, as might
be expected, show the realistic tendencies of the times. One
of the finest is the life-size bronze figure found in Rome in
1884 (Fig. 77), and called the "Hellenistic Ruler," since it
probably represents one of the successors of Alexander. Not
only are the muscles worked out in great detail, but the face
shows an attempt at exact portraiture, even to the engraving
of fine lines on the cheeks to render a short, clipped beard.

Pictorial reliefs. The introduction of picturesque back-
grounds, such as is found in the small frieze from the

Pergamene altar, appears in a series of other reliefs, both large and small, which are conveniently grouped together under the name of *pictorial* reliefs (Fig. 78). The same monuments are sometimes called *pastoral* reliefs, since the subjects of many of them are drawn from the life of herdsmen and shepherds. Others, however, have mythological subjects, and the common characteristic is the introduction of backgrounds of r a t h e r formal landscape. Many of these reliefs were undoubtedly made in Roman times, and in recent years it has sometimes been argued that the pictorial relief was not invented until the period of the Roman Empire. But in a few cases, t h e workmanship suggests a Hellenistic date, and the Pergamene frieze proves the existence of the pictorial tendency as early as the second century B.C., so that here, as in so many other cases, it would appear that the sculptors of the Roman age merely carried on a tradition that originated in Hellenistic times,

FIG. 77—"HELLENISTIC RULER." NATIONAL MUSEUM, ROME

developing especially at Alexandria and other centres in the eastern Greek world.

Damophon of Messene. Before we leave the Hellenistic period, mention, at least, should be made of Damophon of Messene, almost the only Hellenistic sculptor of the mainland

who is more than a name. Pausanias speaks of several works by Damophon, all of which were in the Peloponnesus, and in 1889, considerable parts of a colossal group of his were found in the ruins of a temple at Lycosura in Arcadia. These include heads of Demeter, Artemis, and the Titan Anytus, a large fragment of drapery, and many smaller bits. The style

FIG. 78—PEASANT DRIVING A COW TO MARKET. GLYPTOTHEK, MUNICH

is curious, showing in the heads of the deities types which lack the dignity of earlier statues of divinities, and in the drapery, great use of decoration in low relief imitating embroidered patterns. All this suggests a sculptor of individual tendencies, who was little affected by the work of his contemporaries in other parts of the Greek world. The date of Damophon can be determined through inscriptions as the second century B.C.

The Græco-Roman Period (146-27 B.C.). Even before the Roman conquest of Greece, the capture of Greek cities in southern Italy and the earlier campaigns of Roman generals in Greece had been followed by the transportation to Rome of many Greek statues. The establishment of Roman rule

resulted in further enrichment of the capital at the expense of Greek cities and shrines, and created a demand for copies and adaptations of older works, to which the Greek sculptors were not slow to respond. This was true especially of the sculptors of the Greek mainland and of southern Italy. In the eastern

FIG. 79—LAOCOÖN AND HIS SONS. VATICAN, ROME

Greek world, the Hellenistic tradition persisted, and was little, if at all, affected by the demands of Roman patrons.

The School of Rhodes. The Laocoön group. Inscriptions show that during late Hellenistic times and in the Græco-Roman age, Rhodes was the centre of a flourishing school of sculptors, and one work, at least, of this school has been preserved. This is the famous group representing Laocoön and his sons entangled by the serpents, as a punishment for the

father's sin (Fig. 79). The group was found in Rome in 1506, and is very surely the original work of three Rhodian sculptors, Agesander, Polydorus, and Athenodorus, which Pliny mentions as standing in his day in the palace of the Emperor Titus. The date of the sculptors can be fixed by means of inscriptions about the year 40 B.C. Owing partly to its early discovery and excellent preservation, the Laocoön group has enjoyed a greater fame than its intrinsic merits warrant. It was long regarded as one of the greatest masterpieces of Greek sculpture, and the German critic Lessing used it as a basis for an essay on the limitations of sculpture and painting, naming the essay after the group, *Laocoön*. In recent years, there has been a tendency to modify the extravagant praise that earlier critics bestowed upon the work. It has been condemned as a mere *tour de force*, intended only to show off the sculptors' knowledge of anatomy and skill in carving marble. It has been argued that the lack of any suggestion of reserve force and the emphasis on acute physical agony become in the end painful to the spectator and are unworthy of perpetuation in marble. There is, undoubtedly, much truth in these criticisms. The ideals of the makers of the Laocoön were very different from those of the masters of the great age. Yet the group undoubtedly shows skilful composition and great ability in extremely realistic rendering of the human form. It furnishes further proof that the works of the later Greek masters betray no loss of technique, but only changed ideals. If we may judge by this work, the school of Rhodes was strongly influenced by the school of Pergamum.

The Farnese Bull. The colossal group called the Farnese Bull (Fig. 80) also reveals the influence of Pergamenian ideas. Made, as Pliny tells us, by Apollonius and Tauriscus, two sculptors of Tralles in Asia Minor, it was brought from Rhodes to Rome, where it stood in the collection of the famous Asinius Pollio. The sculptors probably worked in Rhodes during the first century B.C. The group represents Amphion and Zethus fastening Dirce to the wild bull by which she was dragged to death, a punishment that she had devised for Antiope, the mother of the two heroes. Here

again, clever composition and skilful workmanship are asso-
ciated with an essentially unpleasant subject and realistic
rendering of details; and now that the earlier and more
idealistic works of the Greek sculptors are better known, the
group has lost much of the reputation it once enjoyed. Among
the interesting details are the rocks and trees and the herds of

FIG. 80—FARNESE BULL. NATIONAL MUSEUM, NAPLES

sheep in low relief on the base, recalling the smaller frieze
of the Pergamenian altar and the pictorial reliefs.

The School of Ephesus. The Borghese Warrior. A work
that shows the realism of Hellenistic art pushed to an ex-
treme is the so-called Borghese Warrior (Fig. 81). This bears
the signature of Agasias, son of Dositheus, of Ephesus. By
means of the inscription, it may be dated about 100 B.C. and
brought into connection with other inscriptions which prove

the existence of a school of sculptors at Ephesus during the Græco-Roman period. The statue very surely is meant to represent a warrior defending himself against an enemy who towers above him, but the sculptor merely suggested his equipment by carving on the left arm the arm-band of a shield, and in the right hand the hilt of a sword. What really interested him was the detail of bone and muscle in a figure so posed that every muscle is strained to the utmost, and he carried this idea so far that there is no suggestion of the texture of the flesh. The statue creates much the same impression as the flayed models that are made for teaching anatomy, and, indeed, the Borghese Warrior is often used for this purpose in drawing schools. That it breaks the rule of reserved force is obvious, but Agasias would probably have denied the validity of any such rule.

FIG. 81—BORGHESE WARRIOR. LOUVRE, PARIS. (PHOTO. GIRAUDON)

The Laocoön, the Farnese Bull, and the Borghese Warrior show how Hellenistic ideas persisted in Asia Minor and the neighboring islands. In these regions, Roman ideas never exercised any strong influence. The Hellenistic forms were dominant throughout the period of Roman rule, until, modified by new ideas from the East, they formed the basis of the Early Christian development.

The Neo-Attic School. In the western Greek world, on the other hand, the effects of the Roman conquest were immediately felt. One interesting development was a revival of

activity among the sculptors of Attica. This is proved by a number of statues and reliefs with signatures, in which the artist records his name and appends the adjective 'Aθηναῖος, an Athenian. The purpose of such an addition must have been to increase the value of the work by showing that the maker was trained in a famous school. Whether these men worked in Athens for the Italian market, or whether they actually migrated to Italy, where most of their works have been found, cannot be surely determined. The statues and reliefs, at all events, together with unsigned works that show similar qualities, are conveniently grouped together as works of the Neo-Attic school. Their one common quality is dependence on earlier types. Some are exact copies of famous works, like a bronze head in Naples, signed by Apollonius, son of Archias, which is copied from the Doryphorus of Polyclitus. In other cases, the later sculptor changed his model in various ways. The colossal Farnese Heracles in Naples, which bears the signature of Glycon, is based on a Lysippic original, but betrays in its heavy and swollen muscles the taste of a later day. The so-called Germanicus in the Louvre, the work of Cleomenes, is a portrait of a Roman, but the nude body is modelled on a type of Hermes created in the fifth century. The famous "Venus dei Medici" in Florence, although the signature has been proved a modern forgery, is probably the work of a Neo-Attic sculptor. In it the type of Praxiteles's Aphrodite of Cnidus is so modified as to lose much of its divinity and to become little more than a beautiful woman.

The eclectic, imitative character of the work of the Neo-Attic sculptors is even more evident in their reliefs than in their statues in the round. In the reliefs, all sorts of types drawn from works of earlier times are combined in different ways to produce a decorative effect. The same types recur in varying combinations, often with no attempt at unity of style. Archaistic types, that is, figures in which the mannerisms of the archaic period are imitated and exaggerated, are not infrequently combined with others in the style of the great age. The result is often not unpleasing, in spite of the unoriginal character of the work, and the vogue of these

reliefs, as decorations in gardens and houses, is readily understood.

The School of Pasiteles. Another group of Græco-Roman sculptors, recognized through a combination of literary and monumental evidence, is the school of Pasiteles.

From several notices in Pliny and one in Cicero, it appears that Pasiteles was a Greek of southern Italy, who obtained Roman citizenship and won a considerable reputation in Rome during the first half of the first century B.C. No work of his has yet been identified, but further evidence of his fame is afforded by a statue now in the Villa Albani in Rome (Fig. 82), which is signed by Stephanus, "pupil of Pasiteles." The purpose of this unusual form of signature must be the same as that of the Neo-Attic sculptors in appending 'Aθηναῖos to their names; it was meant to enhance the value of the work by showing that Stephanus was trained in a good school. The statue presents m a n y curious features. Its stiff and formal pose, knobby shoulders, hard treatment of the muscles, prominent eyes, meaningless smile and formal hair recall the statues of the early fifth century, but the small head and the slender proportions are such as no fifth century

FIG. 82—STATUE SIGNED BY STEPHANUS. VILLA ALBANI, ROME

sculptor would have adopted. Clearly, therefore, the work is imitative, like so many products of the Neo-Attic artists. Through this statue several unsigned works with similar qualities are assigned with great probability to the Pasitelean school, and it has sometimes been argued that Pasiteles and his followers devoted themselves especially to the imitation of works of the transitional period. But this inference is not justified by the evidence. Another work of the school shows no trace of transitional mannerisms, but seems rather to have been modelled on statues of the fourth century. This is a group in the National Museum in Rome, signed by Menelaus, "pupil of Stephanus." It appears, therefore, that the ideals of this coterie of sculptors did not differ greatly from those of the Neo-Attic school. Both drew their inspiration from earlier creations of different periods, which they imitated and modified to please their Roman patrons.

General character of post-Alexandrian sculpture. The most prominent characteristic of the work of the later Greek masters is its great variety. Alongside of sculptors who looked back to earlier times and drew their inspiration from the men of a former day, others attacked new problems and cultivated new fields. The most important tendency is the increasing realism of treatment. Others are the theatrical quality and the restlessness of many of the products of this time. But some works prove clearly the persistence of the older ideals, and the Neo-Attic sculptors and the followers of Pasiteles appear to mark a definite reaction from the exaggerations of the Pergamenians. The varied character of Greek civilization after the conquests of Alexander is closely reflected in Hellenistic and Græco-Roman sculpture.

BIBLIOGRAPHICAL NOTE

G. Dickins's *Hellenistic Sculpture,* Oxford, 1920 (published after the death of the author), is an attempt to define more exactly the qualities of the various schools of post-Alexandrian sculpture and is full of interesting suggestions. The monuments discovered at Pergamum are elaborately published in the work

called *Altertümer von Pergamon,* issued by the Royal Museums in Berlin; especially important for the student of sculpture are Vol. III, 2, *Die Friese des groszen Altars,* 1909, 1910, by H. Winnefeld, and Vol. VII, *Die Skulpturen, mit Ausnahme der Altarreliefs,* by F. Winter. A well-illustrated semi-popular account of the Great Altar and other Pergamenian monuments is given in E. Pontremoli and M. Collignon's *Pergame,* Paris, 1900. The Alexander sarcophagus is described, with excellent colored plates, in O. Hamdy-Bey and T. Reinach's *Une nécropole royale à Sidon,* Paris, 1892-96, and F. Winter's *Der Alexander-Sarkophag aus Sidon,* Strassburg, 1912. The "Hellenistic reliefs" are collected in T. Schreiber's *Die hellenistischen Reliefbildern,* Leipzig, 1889-94. For the Neo-Attic reliefs, the fundamental work is F. Hauser's *Die neuattischen Reliefs,* Stuttgart, 1889.

CHAPTER VIII

ROMAN SCULPTURE

Long before the Romans became the rulers of a world empire, Rome was a prosperous city, and the squares and public buildings were decorated with statues and reliefs. Our knowledge of early Roman sculpture depends almost entirely on literary sources, since comparatively few monuments of regal or republican Rome have been preserved. The most important are a few portraits of late republican date, which are carved, in general, in a decidedly realistic manner. From the literary notices, however, it is clear that the earliest sculpture was strongly influenced by Etruscan models— Etruscan artists were invited to Rome to decorate public buildings, such as the temple of Jupiter Capitolinus, erected in the sixth century—and that later, especially from the third century on, Greek influences more and more prevailed, until in the Græco-Roman age, many Greek sculptors found profitable employment in catering to Roman demands.

Etruscan sculpture. Since many monuments of Etruscan sculpture have been preserved, we can gain some idea of the nature of the earliest statues and reliefs in Rome. Figure 83 represents a well-preserved Apollo of terracotta found on the site of Veii in 1916, which is a remarkable example of Etruscan sculpture from the last years of the sixth century. It is evident at a glance that the artist was familiar with contemporary Greek figures. In the almond-shaped eyes, the smiling mouth, the elaborate locks of hair, and the robe with its zigzag edge, the mannerisms of Ionic sculpture of the later archaic period are readily recognized. Other Etruscan works show similar dependence on Greek models of different periods. Although Etruscan sculpture has certain traits of its own, especially a fondness for rather heavy figures, decided realism

151

in portraiture and, usually, careless execution in details, it clearly owed much to Greek inspiration.

Greek influence. Meaning of Roman sculpture. Greece, therefore, appears to have exercised a double influence on Rome, at first indirectly through Etruria, and later directly, through the transportation to Rome of Greek originals and the production by Greek artists of copies a n d imitations for the Roman market. Throughout the period of the Empire, the Greek influence persisted. Most of the sculptors of this period appear to have been Greeks, and the making of copies and imitations of Greek statues and reliefs formed a considerable part of their activity. But alongside of these essentially Græco-Roman works, other monuments were created which expressed Roman ideas, and it is to these, rather than to the imitations of Greek models, that the term Roman sculpture is commonly applied. The most important classes of such monuments are historical reliefs, carved to decorate memorials of military triumphs or other important events, and portrait statues and busts. Many critics, to be sure, see little that is essentially Roman in these works, arguing that the innovations found in them are to be traced to Hellenistic Greek sources, to

FIG. 83—APOLLO FROM VEII. ROME, MUSEO DI VILLA PAPA GIULIO. (FROM "NOTIZIE DEGLII SCAVI," 1919, PL. 2)

schools of sculpture in Asia Minor, Alexandria, and Antioch. But even if many of the characteristic traits of Roman sculpture are dependent on new ideas from the Hellenized East, it seems clear that the need of expressing the power and the grandeur of Rome led the sculptors to develop the new ideas more elaborately than before and that the monuments thus created may properly be called Roman.

The Augustan age (27 B.C.-14 A.D.). The sculpture of the reign of Augustus shows the effect of that reaction against the exaggerations of the Hellenistic schools which appears in the sculpture of the Græco-Roman period. Augustan sculpture is characterized by academic correctness and dignity. Very Greek in many of its qualities, it nevertheless exhibits new tendencies that are essentially Roman.

The Augustus of Prima Porta. One of the noblest monuments of the Augustan period is the portrait of the Emperor discovered at Prima Porta in 1863 (Fig. 84). Augustus is represented as a military commander haranguing his troops. Many details are obviously copied from life and reveal the realistic spirit that is found in the portraits of republican times. The reliefs on the breastplate, the fringes of the tunic, the folds of the military cloak are carefully imitated. But the bare feet, the Cupid riding on a dolphin—intended, no doubt, to recall the fact that Venus was the ancestress of the Julian family—and the similarity in pose and proportions to the Doryphorus of Polyclitus all show how strongly the sculptor was influenced by Greek ideas. The calm, self-contained expression of the face is very characteristic of the Augustan age, and is found in many other portraits of the time.

The Ara Pacis Augustæ. Of Augustan relief, the finest examples are the numerous fragments that have been preserved from the decoration of the Ara Pacis Augustæ. This "Altar of Augustan Peace" was voted by the Senate on the return of Augustus from Gaul and Spain in the year 13 B.C., and was dedicated not quite four years later, in the year 9. The actual altar was surrounded by a paved square and enclosed by a marble wall some twenty feet high, measuring about thirty-seven feet long on two sides and about thirty-five on the

other two. The wall was elaborately decorated with reliefs
both inside and out. Among the subjects were scenes of sac-
rifice, an allegorical figure of *Tellus,* Mother Earth, between
personifications of the Air and the Water, elaborate garlands
of fruit and flowers suspended from ox-skulls, scrolls of

FIG. 84—AUGUSTUS FROM PRIMA PORTA. VATICAN, ROME

foliage with buds and flowers attached, and two long proces-
sions of dignitaries, presumably representing the ceremonies
at the foundation of the altar. Some portions merely con-
tinue the Hellenistic tradition. The scenes of sacrifice and
the Tellus relief closely resemble the "pictorial" reliefs.
The garlands and the scrolls have their prototypes in Hellen-
istic decoration, but are much more elaborate and more realis-

tically treated than anything that we know of earlier date. In the garlands (Fig. 85), the relief is very high at the centre and grows lower towards the sides, suggesting the form of an actual garland much more closely than the rather flat relief, with sharply defined edges, which is common in the simpler garlands of the Hel-lenistic age; and in the scrolls of foliage, a growing vine is suggested not merely by the addition of buds and flowers, but also by the in-troduction of small birds and insects, which hover about the leaves or crawl upon them. In these novel features, we may reason-ably see the influence of the Roman liking for what is real and tangible.

FIG. 85—GARLAND FROM THE ARA PACIS AUGUSTÆ. NATIONAL MUSEUM, ROME

This spirit is even more noticeable in the proces-sional reliefs (Fig. 86), in which the dress in all cases is that of daily life and the faces are clearly portraits, although modern attempts to identify individuals have not yet met with much success. The rather cold correctness and the dignity of Augustan sculpture are here very evident. It is noticeable, also, that the figures are not all carved in one plane, as is the normal method in Greek reliefs, but some are in considerably higher relief than others, so that there is an attempt to sug-gest actual depth in space by varying the depth of the relief. This attempt at "spatial," or "tridimensional" effects, which in recent years is often called "illusionism," is one of the striking innovations of the Roman age. It probably had its origin in experiments made by the artists of the Hellenistic period. In the reliefs of the Ara Pacis, we have a compara-

tively early stage of the development, with figures arranged in two distinct planes. Later, the principle was carried much further.

Julio-Claudian sculpture after Augustus (14-69 A.D.). From the reigns of the Julio-Claudian emperors from Tiberius to Nero, few remains of larger sculpture have been preserved. What we have consists mostly of small marble urns for the ashes of the dead and altars which were set up over graves. In these, the decoration usually consists of elaborate gar-

FIG. 86—PROCESSIONAL RELIEF FROM THE ARA PACIS AUGUSTÆ. UFFIZI
GALLERY, FLORENCE. (BRUNN-BRUCKMANN, "DENKMÄLER," PL. 401)

lands, reminiscent of the garlands of the Ara Pacis, carved with the same fidelity to nature, and associated with birds and other animals. The so-called "mural reliefs," slabs of terracotta used for the decoration of houses and other buildings, sometimes exhibit similar qualities, but often their designs were copied directly from Greek models, and show the strength of Greek influence. In portraits, on the other hand, the calm, academic type of the Augustan age was gradually modified by an increasing realism, in which we may fairly see the Roman spirit once more asserting itself.

The Flavian age (69-96. A.D.). The Arch of Titus. The

reigns of the Flavian emperors, Vespasian, Titus, and Domitian, produced the most impressive examples that we have of the illusionist manner. These are the famous reliefs on the arch of Titus in Rome (Fig. 87). Erected to commemorate

FIG. 87—RELIEFS ON THE ARCH OF TITUS. ROME

the Jewish War of 71 A.D., this arch was dedicated in the year 81. In its large reliefs, one on either side of the central passageway, are represented two scenes from the triumphal procession. In one, we see the Emperor in his chariot, ac-

companied by lictors and Roman citizens, much as he doubt-less appeared in the actual procession. Other figures, how-ever, are clearly allegorical: Victory crowns the Emperor, the goddess Roma leads the horses, and in front of the chariot is the *Genius Populi Romani*. All of these are ideal figures, such as are frequently introduced in reliefs commemorating historical events. In the second relief, another part of the triumphal procession is shown, with soldiers carrying the spoils from the temple at Jerusalem, the long trumpets which summoned the people to prayer, the table of the shewbread, and the seven-branched candlestick, as well as tablets on which were inscribed, originally, the names of the conquered cities of Judæa. The principle of varying the height of the relief to suggest distance is here carried very far. There is no longer any question of two or three different planes such as we noted in the processional reliefs of the Ara Pacis. Some figures are almost in the round, others are sketched in low relief on the background, and between these extremes, many different heights are employed. The result is that light and air play among the figures, creat-ing the illusion of beings ac-tually moving in space, in a way that had not been so suc-cessfully attempted before. The reliefs imply an original and very skilful sculptor. His failure to make his moving crowds absolutely convincing is due to his ignorance of the laws of perspective, which were not discovered until many centuries later. The modern spectator cannot fail to be disturbed by the false

FIG. 88—FLAVIAN PORTRAIT HEAD.
METROPOLITAN MUSEUM, NEW
YORK

lines of the horses and the chariot, and by the slewing of the archway through which the soldiers are supposed to pass. But in spite of such faults in these and similar reliefs, it

still remains true that the artists of the Flavian age introduced new ideas and realized new possibilities in sculpture.

Flavian portraits. Similar experiments with effects of light and shadow appear in the portraits of the Flavian age, in which a combination of illusionist principles with a return to the realism of earlier days produced some of the most successful portrait busts that were ever created (Fig. 88). The suggestion of character in these heads is no less remarkable than the skilful modelling, so that it is the portraits, quite as much as the reliefs of the time, that lead many critics to regard the Flavian period as the golden age of Roman sculpture.

Trajan (98-117 A.D.). The Column of Trajan. The monuments from the reign of Trajan are similar, in many ways, to those of the Flavian age. Most conspicuous among them is the famous column of Trajan, erected as part of the decoration of the forum that the Emperor completed and dedicated about 113 A.D. The reliefs are carried in a spiral band about the shaft of the column and exemplify most completely another innovation that plays a great part in the sculpture of the Roman age, namely, the elaborate working out of the continuous method of narration (Fig. 89). In these reliefs, the attempt is made to record the whole history of Trajan's two campaigns against the Dacians from the crossing of the Danube to the final victory. The single episodes are of many kinds—the sacrifice at the beginning of the campaign, the building of bridges and fortified camps, the Emperor reviewing or exhorting his troops, battles and sieges, the bringing in of prisoners, the reception of delegates to sue for peace—and these are so combined that one scene passes into the next without any sharp dividing line. Everywhere the Emperor is prominent; he appears some ninety times in the 660 feet of the sculptured band. The result of this insistence on the imperial figure is that instead of the unity of time and place which the Greek sculptors regularly observed, we have a kind of unity of idea—the idea of the power of the Roman Empire, symbolized by the figure of its ruler. One other feature of the column of Trajan suggests

oriental rather than Greek models. This is the elaborate
background of trees and buildings and even whole towns and
fortified camps, carved on a much smaller scale than the
human figures, to give the setting of the various events. In
these portions of the relief and also in the careful rendering
of the armor, the standards of the legionaries, the facial

FIG. 89—THE COLUMN OF TRAJAN. ROME

traits, and the dress of the barbarians, the Roman love of
realistic detail is everywhere evident. In relief of this sort,
with many small figures, there is, naturally, little chance for
"illusionist" treatment, and as a matter of fact, the figures
of the column of Trajan are carved practically on one level.

 Trajanic reliefs on the Arch of Constantine. That the
illusionist manner continued to be employed, however, is
shown by other works of the period. Among the most

interesting are four large reliefs taken from one of Trajan's buildings and used to decorate the arch of Constantine. One of them is reproduced in Figure 90. Here, clearly, there is the same desire to suggest the third dimension as in the reliefs on the arch of Titus. The principal difference lies in the closer setting of the figures, which results in an impression of crowding, less pleasing, on the whole, than the effect in the earlier work. Incidentally, it is interesting that in this relief, also, we have an example of the continuous method. At the

FIG. 90—RELIEF ON THE ARCH OF CONSTANTINE. ROME. (PHOTO. ALINARI)

left, the Emperor enters Rome in triumph, escorted by Victory and the goddess Roma; at the right, the Roman cavalry charge the Dacians, two actions widely separated in time and place.

Hadrian (117-138 A.D.). In the sculpture of the reign of Hadrian, the most noticeable change is a reaction from the elaboration of Flavian and Trajanic art towards a simpler and more idealistic treatment. Portraits lose something of their intense realism, and in reliefs there is less attempt at spatial effects and less crowding of the figures. It is natural to attribute these changes to a new wave of Greek influence.

Since Hadrian himself was a lover of Greek art and lived for some time in Athens, it is generally assumed that they were due largely to his personal taste and influence, and the new movement is conveniently called the "Hadrianic revival." An

excellent example of the new tendencies is a relief found in 1908 not far from Rome, in which Antinoüs is represented as Silvanus (Fig. 91). Antinoüs was a favorite of Hadrian's, who, after his mysterious death in Egypt, where he is said to have destroyed himself to avert some danger from the Emperor, was deified and worshipped throughout the empire. He was frequently identified with one of the youthful divinities, as he is here with Silvanus. The simple, standing figure, holding a pruning-hook and accompanied by a dog, is reminiscent of the Attic grave reliefs of the fourth century, while the altar and the grapevine suggest comparison with the Hellenistic "pictorial" reliefs. On the altar is the signature of the sculptor, Antonianus of Aphrodisias, a town in Caria. There are several

FIG. 91—ANTINOÜS AS SILVANUS. NATIONAL MUSEUM, ROME. (BRUNN-BRUCKMANN, "DENKMÄLER," PL. 635)

other works of the early second century signed by artists from Aphrodisias, so that it seems clear that at this time a "school of Aphrodisias" must have established a considerable reputation.

The Antonine Period (138-192 A.D.). Reliefs. The effects

of the Hadrianic revival lasted for many years. They are evident in most of the reliefs from the reigns of the Antonine emperors, Antoninus Pius (138-161), Marcus Aurelius (161-180), and Commodus (180-192). In these, in general, there is little crowding of the figures, and attempts at spatial effects are not pronounced. Figure 92, in which Marcus

FIG. 92—RELIEF OF MARCUS AURELIUS. CAPITOLINE MUSEUM, ROME

Aurelius is represented sacrificing before the temple of Jupiter Capitolinus, is a good example. The careful representation of actual buildings to show the setting of an action is very common in Roman reliefs throughout the period of the Empire and is another bit of evidence of the Roman love of what is real and tangible, in contrast to the idealistic tendency of most Greek reliefs.

The Column of Marcus Aurelius. The most impressive
relic of the Antonine period is the column of Marcus Aurelius,
in which the triumphs of that emperor over the Germans and
the Sarmatians are celebrated. This monument is clearly
an imitation of the column of Trajan, with a spiral band of
reliefs worked out in the continuous method. The transi-
tions, however, are not quite so cleverly managed as in the
earlier monument, and the workmanship, on the whole, is
rather less skilful.

Portraits. In the portraits of the period, a number of
interesting changes appear. Hadrian had introduced the
fashion of wearing a short beard. Under the Antonines,
longer beards and longer hair were worn, and the sculptors
of the time were quick to realize the possibilities of contrast
between the masses of hair and the flesh of the face. Hair
and beard were rendered in flowing locks, deeply undercut
with the drill so as to produce shadows, whereas for the face
the marble was carefully smoothed and sometimes polished.
At the same time, the practice of suggesting the eye more
definitely by outlining the iris and introducing one or two
drill holes for the pupil—a method occasionally used in
earlier times—became general.

The period of decline (192-330 A. D.). Sarcophagi. After
the death of Commodus, the decline in the sculptor's art ap-
pears to have been rapid. Even on the arch of Septimius Seve-
rus (dedicated in 203 A.D.), the small and carelessly carved
figures offer a striking contrast to the dignified and carefully
studied compositions of the public monuments of the preced-
ing centuries; and from the greater part of the third century,
no historical reliefs have survived. The brief and troubled
reigns of the many emperors of this time were nat-
urally unfavorable to the production of elaborately decorated
monuments. Our knowledge of the period, therefore, de-
pends largely on the marble sarcophagi which were carved
to receive the bodies of the dead. Such monuments are not
unknown from the earlier centuries, but their use became
more general during the third century, and great numbers
of them have been preserved. Since they were made to be
placed against a wall in underground tombs, only three sides,

ordinarily, were decorated with reliefs. The subjects were
taken almost exclusively from Greek mythology, an interest-
ing proof of the persistence of Greek influence. Sometimes
these subjects are such as have a possible reference to death—
the carrying off of Persephone, Diana and Endymion, Cupid
and Psyche, and many others. Often, however, they have
no connection with the use of the sarcophagi—Dionysus and
his train were constantly represented—and it is evident that
the makers were simply reproducing traditional compositions
for decorative effect. But though the subjects are largely
Greek, the style, with rare exceptions, is that of the later
Roman monuments. Figures are closely crowded, with deep
undercutting to produce heavy shadows, though the relief,
in general, is kept in one plane. Proportions are often incor-
rect, facial expression is exaggerated, and the work usually
betrays haste and carelessness. In the composition, the con-
tinuous method is frequently employed.

Later portraits. In the portraits of the later Roman age,
the decline is not so pronounced. Throughout the third cen-
tury and even well into the fourth, the makers of portraits
were still able to reproduce the features of their subjects and
to suggest character with no little skill, in marked contrast
to the cruder workmanship of the mass of the sarcophagi.

Reliefs on the Arch of Constantine. The condition of the
sculptor's art towards the close of the period can best be seen
on one of the most famous of Roman monuments, the arch
of Constantine. This arch, which probably was erected as
early as the first century after Christ and afterwards dis-
mantled, was rededicated by Constantine in the year 315, to
commemorate his triumph over Maxentius and the firm estab-
lishment of his power. Much of the sculpture with which it is
adorned was taken from earlier works, especially from monu-
ments of Trajan (cf. Fig. 90) and Marcus Aurelius. The
character of the parts that date from Constantine's reign is
well shown in Figure 93. The Emperor is here represented
as he distributes gifts to the people. But how different are
the figures from those of earlier reliefs! Monotonously
ranged side by side, they appear more like puppets than like
participants in a common action. Each seems carved for

itself, as a spot in a decorative design, and all details, such as the folds of the robes, are superficially and formally rendered. In the isolation of the individual figures, some critics see yet another of those experiments with effects of light and shade which so engaged the attention of the sculptors of the Roman epoch. But even if this is admitted, the squat and

FIG. 93—RELIEFS ON THE ARCH OF CONSTANTINE. ROME. (PHOTO. ALINARI)

dumpy figures bear witness to a marked decline from the work of the early empire. Interest in the human figure and interest in the grouping of figures to suggest action, which up to this time were the leading concerns of the sculptor, seem almost entirely lost, and it is clear that we stand on the threshold of a new period.

Roman sculpture in the provinces. Outside of Rome and Italy, where Roman sculpture naturally attained its fullest development, many monuments similar in character to those

of the capital are preserved. In some cases, the workmanship is excellent, but for the most part, the authors of these monuments were decidedly less skilful than the sculptors of the capital, and Roman provincial sculpture is interesting primarily for its subjects and for the evidence it affords of the extent to which Roman ideas affected the many peoples whom the Romans conquered. Such monuments, in general, are more numerous in the western than in the eastern provinces of the empire. In the eastern provinces, monuments of distinctively Roman type are rare. In this region the traditions of Hellenistic art persisted with undiminished vigor for many years, until, modified by new ideas from Persia and the near Orient, they gradually developed into Early Christian art.

General character of Roman sculpture. In a broad sense, it is true that Roman sculpture represents the last stage in the evolution of Greek sculpture. But it is a mistake, in the opinion of the writer, to regard it, as many critics of the nineteenth century were inclined to do, as merely a late and degenerate phase of the Greek development. In some fields, notably in portrait sculpture and in the development of plant and foliage ornament, the sculptors of the Roman age advanced beyond their predecessors and introduced new ideas which profoundly influenced later generations. If, as seems probable, they did not invent the "illusionistic" style and the "continuous method of narration," they certainly developed them more completely and logically than earlier sculptors had done. The value of these innovations has been variously estimated. By some modern critics, they are regarded as further evidence of the originality and genius of the artists of the Roman period, by others, as mistaken attempts to enlarge the possibilities of sculpture. The attempt to suggest depth, as well as height and width, is thought by many to be more appropriate to painting than to sculpture, and even when it is undertaken with full knowledge of the laws of perspective, is held to transgress the bounds of the sculptor's art (see p. 307). The continuous method has been characterized by one competent critic as a relic of primitive art "which the Greeks had almost civilized off the face of the

earth." Whatever one may think of these conflicting opinions, the fact remains that the artists of the Roman age endeavored to realize possibilities in sculpture that the men of earlier times had for the most part neglected, and the "Roman episode," as it has sometimes been called, well deserves the more careful study that has been devoted to it in recent years.

BIBLIOGRAPHICAL NOTE

The best summary of the achievements of the Etruscans, although out-of-date in many respects, is still J. Martha's *L'art étrusque,* Paris, 1889. W. Hausenstein's *Die Bildnerei der Etrusker,* Berlin, 1922, presents a series of well-selected reproductions, accompanied by a brief essay on the character of Etruscan art.

The fullest account of Roman sculpture is Mrs. Arthur Strong's *Roman Sculpture from Augustus to Constantine,* New York, 1907. All recent discussions of Roman art owe much to F. Wickhoff's *Roman Art,* New York, 1900 (a translation by Mrs. Strong of the essay first printed as an introduction to *Die Wiener Genesis,* Vienna, 1895). There is a good brief account of Roman sculpture in H. B. Walters's *The Art of the Romans,* London, 1911. For important single monuments or groups of monuments, the following works may be recommended: E. Courbaud's *Le bas-relief romain,* Paris, 1899; E. Petersen's *Ara Pacis Augustœ,* Vienna, 2 vols., 1902; W. Altmann's *Architectur und Ornamentik der antiken Sarkophage,* Berlin, 1902, and *Die römischen Grabaltäre der Kaiserzeit,* Berlin, 1905; and C. Robert's *Die antiken Sarkophagreliefs,* Berlin, 1890-1904.

CHAPTER IX

THE SCULPTURE OF THE FIRST MILLENNIUM A.D.

I. Historical Background

Christianity began to seek sculptural expression probably as early as the second century A.D. The whole production from the second or third through the sixth centuries may be denominated as Early Christian sculpture. Certain phases and certain examples of this production, especially from the fifth and sixth centuries, are often described as Byzantine art; but Byzantium, or, as it was now called, Constantinople, did not attain a position of æsthetic originality equal to that of such other oriental cities as Alexandria and Antioch until the sixth century. It was only later, when the energy was crushed out of these capitals by the Mohammedan conquest, that Byzantium acquired an ascendancy. The customary phraseology assigns the name of the First Golden Age to Byzantine art of the fifth and sixth centuries, culminating in the brilliant reign of Justinian; but since, at least in sculpture, even during this period, Egypt, Syria, and Anatolia were more productive than Constantinople, it is perhaps wiser to apply the term Byzantine sculpture only to the works of the later period, the so-called Second Golden Age, and to group the whole earlier output together under the designation of Early Christian. The national decline of the seventh century put a quietus upon art in Byzantium. The iconoclastic disturbances of the eighth and early ninth centuries might have been expected to complete the devastation; but although for a time the representation of sacred figures and scenes was tabooed and in strictly Byzantine territory large sculpture in the round was permanently suppressed, the net result, curiously enough, was a reaction to a kind of Renaissance, which,

beginning at the end of the ninth century and extending to the establishment of a Latin dynasty at Constantinople in 1204, is known as the Second Golden Age.

Rome and western Christendom, during the Early Christian period, were not hearths of original æsthetic enterprise, but rather markets for the patronage and imitation of the art that flourished in the great Christian cities of the near Orient. Ravenna, particularly, which usurped the place of Rome as the seat of government for Italy in the fifth and sixth centuries, gave an enthusiastic welcome to the new Christian art that had been evolved in the East. The seventh and eighth centuries in the West, when out of the anarchy resulting from the disintegration of the Roman empire there were slowly emerging the beginnings of the modern nations, may be broadly defined as an Age of Barbarism in sculpture. The impetus given to art and letters by Charlemagne, in an attempt to revive something of the lost glory of Rome, has bestowed upon the ninth century the title of the Carolingian Renaissance. The Carolingian dynasty soon decayed, but Germany remained united and rose to a commanding position. She preserved Carolingian culture through the tenth century, particularly under the members of the Saxon dynasty, Otho I, the Great, his two successors of the same name, and, at the beginning of the eleventh century, Henry II, the Saint.

II. EARLY CHRISTIAN SCULPTURE

The origins and nature of Early Christian art. The adherents of the new religion simply took the existing Hellenistic [1] art and adapted it to their own purposes. The greatest centres of production, during the period in question, were Alexandria in Egypt, Antioch in Syria, Palestine, and Asia Minor, and all Early Christian art was profoundly influenced by the styles there evolved. The local æsthetic tendencies now impressed themselves upon the Hellenistic style in these

[1] In this and subsequent chapters, the term "Hellenistic" is used in its broader sense (cf. p. 128) to cover all the periods of artistic production in Greek and Roman territory after the death of Alexander.

districts even more strongly than in the days of paganism. Moreover, certain traits and elements, especially decorative *motifs*, were introduced from the Hellenistic centres of the far Asiatic hinterland—from Mesopotamia and from the district which is now modern Persia and which some critics believe to have been the birthplace of the world's art. Constantinople was not yet so original a centre for sculpture. It served as a melting-pot in which the Alexandrian, Syrian, and Anatolian influences, pouring in through the channels of commerce and monasticism, were fused with what remained of the ancient Greek feeling for well-defined form; and a certain number of works were produced in the capital in this composite style. As far as it can be said to have had a separate artistic existence, Constantinople revealed a tendency towards realism, and naturally also, as the residence of the imperial and other noble families, developed a school of portraiture. Although, while the civilization was still pagan, especially during the early empire, an essentially Roman manner appears to have been evolved as a subdivision of Hellenistic art, the numerous monuments of Early Christian sculpture found at Rome reveal few, if any, qualities that can be labelled as distinctly Roman, and during this whole period the eternal city merely imported or imitated the examples that were produced in Africa and Asia. In the great centres of Hellenistic civilization, Alexandria, Antioch, and the cities of Anatolia, much of the heritage from ancient Greek art, especially the old Hellenic respect for the human body as a plastic vehicle, lived on at first in the art of the Christians. Alexandria had stood in pagan art for what is called the picturesque style, characterized by an emphasis upon episodic scenes and pretty or naturalistic detail. The love of *genre* persisted here in Christian times, but gave way somewhat, under an augmented influence of the Orient and a more pronounced manifestation of indigenous Egyptian proclivities, both to monumentality and to an interest in narrative or sacred history. It was Syria and Palestine that played the most important rôle in fixing the ultimate iconography of Early Christian art. The Syrian capital, Antioch, seems at first to have clung to the more purely Hellenic tradition, but

its art must soon have been affected by the æsthetic develop-
ments in the rest of the province. In this section of the
Mediterranean basin, which began to assume a great impor-
tance in Christian art by the middle of the fourth century,
the Semitic strain tended to diminish the Hellenic sense of
beauty of form and to elongate the sacred personages into
eastern ascetics; the compositions were more solemnly
ritualistic, and at the same time there was a greater emotional
content than elsewhere (cf. Fig. 97). Geographically open to
influences from Mesopotamia and the farther East, the
Syrian style felt sculpture in the mode of painting and was
inclined to reduce the high and round relief in which the
Greeks had worked to a single plane of flat design. With an
oriental opulence of taste, it indulged in an almost complete
investiture of the given area with luxuriant ornamentation,
and evolved a wealth of decorative *motifs*, among which the
animals, real or monstrous, often confronting each other in
pairs, are again certainly derived from the eastern hinterland
(cf. Fig. 98).

Not only did the Christians take over the Hellenistic style,
but they often included even pagan subjects within their icon-
ographical repertoire, giving them usually a new symbolical
meaning. The constantly recurring figure of the Good Shep-
herd is probably not a Christian adaptation of Hermes the
Ram-bearer; the bucolic themes of Alexandrian art and liter-
ature were simply imported into the Christian system and in-
terpreted as representations of the joys of the after-life,
and the shepherd with his flock became a symbol of Our
Lord, the kindly keeper of Paradise. The fisherman, stand-
ing for Christ, the fisher of men, is likewise a translation from
the piscatory *genre* of Alexandria. The Hellenistic vintage
scenes from the cycle of the seasons were employed probably
at first without any very definite symbolism, and the ideas
of the analogy of the changes in the seasons to the fluctuations
of human life and to the resurrection of the dead may have
been merely after-thoughts.

Sarcophagi in the Alexandrian style. The most numerous
relics of Early Christian sculpture are the sarcophagi, the
treatment of which was suggested by the Hellenistic pagan

examples. Except at Ravenna, normally only the front and sides of the sarcophagus were adorned with carvings,[1] and even the sides were executed with less care. Since the sculptors were still close to the tradition of ancient art, until the middle of the fourth century the forms and draperies retained much classical grace and dignity, and the nude was treated with correctness and even beauty. The earliest type, the first specimens of which appeared perhaps in the second and surely in the third century, is unmistakably of Alexandrian provenience, though the examples have been found in Italy and southern France. The subjects, disposed in a single row, were, like the early paintings of the catacombs, chiefly sym-

FIG. 94—SARCOPHAGUS, NO. 183. LATERAN MUSEUM, ROME. (PHOTO. ANDERSON)

bolical, consisting of such themes as the Good Shepherd, the fisherman, and, to embody the idea of prayer and of the beatified praying soul after death, the Orans, a woman or man with hands uplifted in supplication. The later Alexandrian sarcophagi admitted also the scenes from the Old and New Testaments that were becoming popular. The two best known specimens in the Alexandrian style were executed at a somewhat later period, the former probably in the fourth century: the Jonah sarcophagus of the Lateran Museum, Rome, in which the gamut of decoration has been extended to include a second row, and, in addition to pastoral and piscatory symbolism, scenes from the Old and New Testaments, and the episodes are bound together by pictorial

[1] Cf. p. 164.

effects of landscape; and sarcophagus no. 183 of the same collection (Fig. 94), on which three figures of the Good Shepherd are set against a design of *amorini* engaged in the vintage. In a subdivision of the Alexandrian class, isolated subjects at the centre and ends are separated by a repeated *motif* of undulating strigils. The Vatican possesses two examples of grander porphyry sarcophagi from the fourth century, the monument of Constantia, the daughter of Constantine, embellished with another vintage scene, and the probable monument of his mother, St. Helen, adorned in a better style with a piece of Alexandrian narrative, a victory of Romans over barbarians.

FIG. 95—JUNIUS BASSUS SARCOPHAGUS. GROTTE VATICANE, ROME

Sarcophagi in the style of the near Orient. In another extensive class of sarcophagi, which are found throughout the Mediterranean basin, but particularly at Rome and in southern France, and which reached the height of their development in the fourth century, the symbolical repertoire is largely or wholly replaced by scenes from the Old and New Testaments, by ceremonial representations of Christ, and by the martyrdoms of the Apostles. A first subdivision of this class (Fig. 95) presents the scenes in an arcade of architectural niches, a *motif* which is probably to be ascribed to the use of an arcade on the pagan prototypes to represent the

palace of Hades; in the second, they are not separated but merge confusedly into one another.[1] The episodes from the Old and New Testaments on the latter group are almost confined to miracles of healing, of divine assistance, and rescue from death, and their presence in this sepulchral art, as in the case of similar themes in the catacombs, is probably due to the fact that in liturgical prayers, especially for departing souls, reference was made to these earlier celebrated examples of God's mercy; it is just possible that some of the scenes were conceived as symbols of the Eucharist. In the arcaded group, other episodes from the Old and New Testaments, especially from the passion of Christ, without any evident symbolism or relation to the liturgy, very much encroached upon the scenes typifying God's loving-kindness. Martyrdoms and events from the life of St. Peter were also introduced. Furthermore, Our Lord often stands in the middle, receiving the deceased, handing the Gospel, the new Law, to St. Peter or St. Paul in the subject called *Traditio legis*, or constituting the principal figure in some similar representation such as the Second Coming. It was here also that for the first time the bearded Syrian Christ sometimes appeared in place of the more essentially Hellenistic beardless Christ. Occasionally the new themes intruded even into the unarcaded type. Some of the themes from the Old Testament, when once established, were given a fresh symbolism as antitypes of the events of the Christian dispensation, the translation of Elijah, for instance, prefiguring the Ascension. The large addition of themes, many of which were to pass into the later iconography of Christian art, was chiefly of Syrian-Palestinian provenience, and the whole class of arcaded sarcophagi may now definitely be denominated as a type that was evolved in or near this region. The other subdivision, probably but less certainly, entered the West from the same source. In both groups, the carvings may be disposed in one or two bands, but there is some reason for be-

[1] This treatment of the scenes was probably suggested by the "continuous method of narration" on the pagan sarcophagi (cf. pp. 23, 159, and 165); but on the Christian examples the episodes represented next to one another are often not drawn from the same story.

lieving that in the unarcaded group the examples with two zones, containing large portrait busts of the deceased at the centre, were produced by a local Roman workshop with

FIG. 96—SARCOPHAGUS. LATERAN MUSEUM, ROME. (PHOTO. ANDERSON)

reminiscences of the Syrian-Palestinian manner (Fig. 96). The sarcophagi of this Roman stamp belong generally to a slightly later period, stretching into the fifth century, and,

FIG. 97—SARCOPHAGUS. MUSEUM, RAVENNA

like the ultimate specimens of the other types, are likely to betray signs of decadence, such as a confusion of Alexandrian and Syrian-Palestinian iconography, defective proportions, awkward poses, and slovenly technique, especially a

tendency to render folds of drapery merely by drilled lines. Inasmuch as many, possibly the majority, of the other sarcophagi at Rome were executed by local craftsmen working in the various foreign styles, now and then one may perhaps discern even in examples of these Alexandrian and Syrian types intimations of those qualities that have come to be associated with the Roman name, a strong feeling for the human form in three dimensions and a predilection for stockiness and solemnity.

FIG. 98—SARCOPHAGUS OF ST. THEODORUS. S. APOLLINARE IN CLASSE, RAVENNA

Sarcophagi at Ravenna. Partly for stylistic reasons and partly because the material is marble from the island of Proconnesus in the Propontis, it is now thought that the important group of sarcophagi at Ravenna, dating chiefly from the fifth century, constitute a type that was developed at Constantinople under strong Anatolian and Syrian influences, some of them manufactured at the Byzantine capital itself, others executed at Ravenna in the imported stone by foreign or local sculptors. Two of the classes that have been considered are found also here. The arcaded class, in this instance,

may be based upon Anatolian precedent; the class with the unbroken plane of relief, which eventually very much tended to supplant the other, is thoroughly Syrian. In many respects, however, the sarcophagi at Ravenna differ considerably from the Roman and southern French examples. There is usually a rounded, though occasionally a gabled, lid, and the carvings are arranged in a single zone. The composition is not so crowded, and the front contains only a single scene consisting of a few figures. The most frequent scene, often framed between two oriental palm-trees, is Christ exalted and surrounded by saints in such iconographical themes as the reception of the martyrs' wreaths or the ritualistic Syrian composition of the *Traditio legis* (Fig. 97). The episodes from Holy Writ, whether symbolical or merely narrative, are rare, being confined chiefly to the decoration of the end-pieces. Sometimes, particularly in the later period, Christian emblems and foliage, in formal and often very beautiful designs, were substituted for the figures; the symbolical peacocks, signifying immortality, and the lambs were especially popular (Fig. 98). The weaker modelling of the forms, the lesser grace of the draperies, the more careful symmetry of the design, and the conception of the space as an opportunity for decoration combine with other characteristics that have been mentioned to give the sarcophagi of Ravenna an even more tangible oriental cast than is discernible in the examples found in France and the rest of Italy.

FIG. 99—THE GOOD SHEPHERD. LATERAN MUSEUM, ROME

Other Christian sarcophagi. Here and there along the shores of the Mediterranean sarcophagi have been preserved which exhibit slight local variations from the types already considered. The later specimens reveal the presence of the invading barbaric races in a greater rudeness of technique and in the new decorative *motifs* that they brought with them.

FIG. 100—SCENES FROM LIFE OF JOSEPH, THRONE OF MAXIMIAN. ARCHI-EPISCOPAL PALACE, RAVENNA. (PHOTO. ALINARI)

Other Early Christian sculpture. The type of the Good Shepherd was taken from the sarcophagi and repeated in the round. Of some ten extant examples, the figure in the Lateran Museum, with a pouch slung at the side of the body (Fig. 99), still retains, in the middle of the third century, much noble ancient feeling. The old classical tradition of portraiture persisted, though with a certain rudeness of tech-

nique; the most familiar instance is the colossal and powerful bronze of an emperor, perhaps Theodosius the Great, dating probably from the fifth century, at Barletta in Apulia. At the same time, the Syrian-Palestinian influence manifested itself in its loveliest form in the carvings of the wooden doors of S. Sabina at Rome. If the study of the minor arts fell within the scope of this book, we should perhaps find the qualities of the Early Christian epoch better illustrated by the small ivories than by sculpture in the large. One work in ivory, at least, must be mentioned, because it intrudes upon the sphere of more monumental sculpture, the so-called throne of the Archbishop Maximian in the Archiepiscopal Palace at Ravenna (Fig. 100). The partisans of an ascription to the region of Antioch adduce as proofs the types of the personages and the ornamentation in incised technique with confronted beasts amidst the richest leafage. The partisans of Alexandria stress the presence of the popular Egyptian saint, the Baptist, the predilection for the story of Joseph, and the love of the picturesque in the perspective of landscape and buildings. The truth may very well lie between the two extremes of opinion: since stylistic elements were always circulating from one country to another, the throne may have been carved by Alexandrian hands under Syrian influence.

III. Byzantine Sculpture

General characteristics. We have already seen that, in the history of sculpture, the term "Byzantine" may very properly be restricted to the production of the Second Golden Age. The attack upon icons at first naturally diverted energy into secular art, for models of which it was necessary to look to antiquity. The study of ancient Greek art was thus renewed, and at the same time there was a fresh importation of influences from the East. A revived interest in historical themes brought with it the desire for the realism and especially the portraiture of Hellenistic Alexandria. Religious art shared for a time the salutary antiquarianism and the vigorous realism of the secular movement; but finally deriving, like the modern French church, increased enthusiasm

from the past persecution, it became in the eleventh century more hieratic than ever before, and, considering it a sacred duty to repeat again and again the forms and compositions that had been proscribed, ended eventually in a paralysis of theological conventionalism. The most disastrous effect of orientalism was to provoke a distaste for monumental sculpture in the round and for bold relief, so that by the end of the First Golden Age they had become almost extinct. Other influences made for the same end, especially the increasing disfavor with which the Church, partly because of its Hebraic derivation, looked upon "graven images," the forms in which paganism had chiefly clothed its false gods. Only a few low reliefs are left to represent what little sculpture in the large was produced in the Second Golden Age, and it is absolutely necessary for us to turn to the ivories in order to get our ideas of Byzantine plastic characteristics. Originally colored and gilded, and thus regarded as a species of embossed

FIG. 101—CRUCIFIXION. METROPOLITAN MUSEUM, NEW YORK. (COURTESY OF THE METROPOLITAN MUSEUM)

painting, they did not shock Byzantine religious sensibilities, and often indeed in composition and form were based upon contemporary miniatures.

The ivories. It was the ecclesiastical school of the Second rather than of the First Golden Age that evolved those qualities ordinarily connoted by the phrase "Byzantine art." They may be studied in their loveliest and fullest development, with the shortcomings as yet only foreshadowed, in a group of ivories of the tenth and eleventh centuries related in style

and in uniform excellence. This group is conveniently represented for us in America by a Crucifixion in the Metropolitan Museum (Fig. 101). The holy personages have a reserved dignity, not yet frozen into the stiffness of the decline. The postures are studied from nature and have not become mere reiterations of others' achievements; they do not possess the rigid monotony of a century or two later. The draperies, although they are approximating the ordinary Byzantine type with minute, multiplied, and parallel folds, retain much classical nobility and grace. However deficient in originality, however narrow and stereotyped through subjection to theological prescription, the best Byzantine art was always redeemed by the exquisite fineness of technical detail that distinguishes this Crucifixion. The tradition of skilful execution was gradually to be forgotten, the extremities particularly were to lose correctness of proportion, and the bodies were to suffer an excessive elongation and emaciation which the Virgin of the Crucifixion already foreshadows.

Sculpture proper. Our knowledge of the scanty output of Byzantium in larger sculpture during the Second Golden Age is confined to a few religious, mythological, or purely decorative reliefs preserved chiefly in the walls of St. Mark's, Venice, and in the near-lying cathedral of Torcello. The relief has sunk to a flatness in which the line of demarcation from actual painting is hardly visible. The reliefs of sacred purport, indeed, are simply marble translations from Byzantine pictures. Those of mythological content are concrete symbols of the interest in secular themes at this time and of a partial Renaissance of antiquity. The decorative slabs that avoid the human figure, exported throughout the Mediterranean, rely upon the oriental *motifs* of foliage, animals, and geometric designs.

IV. The Age of Barbarism

From the seventh century until the rise of Romanesque art in the eleventh century, very little large sculpture was produced in Europe. One of the reasons for the plastic collapse

was the potent influence, during these centuries, of the æsthetic principles of the near Orient, where there was a growing distaste for monumental carving. There are some isolated

FIG. 102—BEWCASTLE CROSS. (FROM "THE DATE OF THE RUTHWELL AND
BEWCASTLE CROSSES" BY A. S. COOK)

examples of rather fine carving in pure design; but when the barbarians of the seventh and eighth centuries did have the temerity to attempt figure sculpture, the results usually resembled the mere groping of children. The disagreement of the learned pundits upon the question of dating does not

permit us as yet to decide whether in Italy and Great Britain, because of a more pronounced dependence upon the Early Christian models of the East, there were sporadic exceptions to this general debasement. The stucco figures upon the canopy over the altar of S. Ambrogio, Milan, for instance, and the feminine saints of the same material above the door of S. Maria in Valle, Cividale, have been assigned by some critics to the ninth and eighth centuries respectively; by others, owing to the advanced technical knowledge, they have been relegated to the end of the Romanesque period. The same chronological dispute exists in regard to a group of British fragments in Northumbria, chiefly two great stone crosses at Bewcastle (Fig. 102) and Ruthwell. One camp of scholars champions a dating in the twelfth century; the other camp connects the monuments with St. Wilfrid's evangelization of the province in the seventh century and explains the correctness in the rendering of the human form by a British knowledge of Early Christian models, towards which the eastern character of much of the ornament also points. Pieces of similar High Crosses, as they are called, and of analogous carving on grave-stones exist, indeed, in Armenia, but the relationship, if relationship there be, has not yet been thoroughly studied. In any case, the Northumbrian development may have been much indebted to the contemporary art of Ireland, which was compounded of elements drawn from the Christian East, and, especially in ornament, from the rude æsthetic inheritance of the Celts. The most conspicuous Irish product was the illumination of manuscripts, but there was also much excellent work in metal and stone. Since, however, it does not appear possible to ascribe the extant stone crosses in Ireland, such as that of Muredach at Monasterboice, to a date before the tenth century, the English and Scottish specimens, if placed in the seventh century, may have set the precedent for the sister island, or they may be considered to be derived from early Irish examples that have perished.

V. The Carolingian Renaissance

If, as the chroniclers and poets declare, the partial revival of æsthetic interest under Charlemagne and his successors in the ninth and tenth centuries expressed itself in any monumental pieces of sculpture, at least no examples of significance are preserved that can with certainty be assigned to this period, and we must rely for our conceptions upon the minor arts of ivory and bronze. The coalition of so large a part of Europe under the single sceptre of Charlemagne created in all kinds of art a general and international style. Recent authorities distinguish national schools and local tendencies within the unified style, but this criticism has not as yet attained anything like final results. The east-Christian influence was still potent, especially in ornamental detail; and the renewed emphasis upon Roman antiquity, which was the mainspring of all forms of cultural activity during this epoch, was bound to turn the eyes of sculptors with fresh enthusiasm to the ancient remains and to the Early Christian adaptations of the Hellenistic style. For direct models, the sculptors of the Carolingian Renaissance naturally had recourse to the examples nearest at hand, the illuminations in manuscripts, which then in the West had best preserved a tradition for the delineation of the human form and the style of which was evolved from east-Christian prototypes and from a separate western tradition that had been gradually unfolding in Europe. It was perhaps from models in Anglo-Saxon manuscripts that the masters of ivory and bronze derived the bent and slightly contorted bodies which they represented, and it was possibly under east-Christian influence that they tended to make them rather slim. The process of bronze-casting was understood throughout the Carolingian Renaissance, especially in Germany. The indebtedness of sculpture to painting has never been more pronounced. The most startling parallelism is found in the ivory covers for psalters, which illustrate very literally and naïvely the verses of the psalms. The stock example is the cover for the Psalter of Charles the Bald, now in the Bibliothèque Nationale at Paris

(Fig. 103), on which the figures of speech in the fifty-seventh psalm are reduced to matters of fact, copied exactly from the miniatures of well-known psalters at Utrecht and in the Oxford Library. A celebrated specimen of the goldsmith's work is the casing or *paliotto* for the altar of S. Ambrogio at Milan,

FIG. 103—COVER OF PSALTER OF CHARLES THE BALD. BIBLIOTHÈQUE NA-
TIONALE, PARIS. (PHOTO. GIRAUDON)

ordered in 835 by the Archbishop Angilbertus II from a certain Wolvinius.

Germany. It was, however, in Germany that the sculpture of the Carolingian Renaissance attained its most effective and individual expression. A more correct appellation, perhaps, would be the Renaissance of the Othos; but the plastic style was a continuation and development from the models evolved under Charlemagne. One of the great centres of activity was Hildesheim during the episcopate of St. Bern-

FIG. 104—BRONZE DOORS, CATHEDRAL, HILDESHEIM. (PHOTO. NEUE PHOTO-
GRAPHISCHE GESELLSCHAFT, STEGLITZ)

ward (993-1022). Certain critics have sought to explain this Teutonic superiority by the supposed intrusion of many Greek craftsmen in the train of the Byzantine princess, Theophano, the wife of Otho II. Some of the monuments indeed are very eastern in their feeling, notably the technically preeminent but rather uninspired bronze Easter column, with scenes from the Gospels, in the cathedral of Hildesheim, said to have been set up by St. Bernward and imitated from the non-extant, metal paschal candle-sticks of Roman churches or from the column of Trajan or similar, destroyed columns at Constantinople. But the nature and the number of these Byzantine artists are hypothetical, and the best and most typical productions of the period, such as the bronze doors of Hildesheim cathedral, executed under the patronage of St. Bernward (Fig. 104), are far removed from the conventionalities of the East. The Renaissance of the Othos is permeated by a crude but powerful realism, striking already that popular note which has given the distinctive tone to German art from first to last.

BIBLIOGRAPHICAL NOTE

One of the earliest general works on Early Christian and Byzantine art composed according to the principles of modern scholarship was the first volume of F. X. Kraus's *Geschichte der christlichen Kunst*, Freiburg im Breisgau, 1896. The treatment of these subjects in A. Michel's *Histoire de l'art,* vol. I, pt. I, 1905, by André Pérraté and Gabriel Millet has not been so far superseded as to have lost its value. Since a large proportion of the objects of art mentioned in the present chapter are in Italy, the first two volumes of A. Venturi's *Storia dell'arte italiana,* 1901 and 1902, covering the whole Pre-Romanesque period, are indispensable to the student who wishes to pursue the subject further. The celebrated Austrian scholar, J. Strzygowski, has the honor of having definitely established the essentially eastern character of Early Christian and Byzantine art; though discursive in their nature and not averse to merely tentative theories, the following works by him constitute an epoch-making series: *Orient oder Rom,* Leipzig, 1901; *Hellas in des Orients Umarmung,* Munich, 1902; *Hellenistische und koptische Kunst*

SCULPTURE OF FIRST MILLENNIUM A.D. 189

in Alexandria, Vienna, 1902; *Kleinasien, ein Neuland der Kunstgeschichte*, Leipzig, 1903; and *Ursprung der christlichen Kirchenkunst*, Leipzig, 1920. Walter Lowrie's *Monuments of the Early Church*, 1901, is a small, rather popular, but accurate manual. More recent general books on the Early Christian and Byzantine periods, written with all the knowledge and resources at the command of the critic of the present day, are C. Diehl's orderly *Manuel d'art byzantin*, Paris, 1910, and O. M. Dalton's somewhat desultory but important *Byzantine Art and Archæology*, Oxford, 1911. The latest discoveries and hypotheses are clearly and interestingly set forth in Oskar Wulff's *Altchristliche und byzantinische Kunst*, in two volumes, Berlin, 1914 and 1918. Special works on the sarcophagi outside of Italy are E. Le Blant's *Étude sur les sarcophages chrétiens antiques de la ville d'Arles*, Paris, 1878, and *Les sarcophages chrétiens de la Gaule*, Paris, 1886, and José Ramón Mélida's *La escultura hispanocristiana*, Madrid, 1908.

In addition to Venturi, the chapters in pts. I and II of vol. I of Michel's *Histoire* by E. Bertaux, E. Molinier, and J. J. Marquet de Vasselot provide a satisfactory treatment of the sculpture of the Barbaric and Carolingian epochs. E. Molinier has also written a great work on the *Histoire générale des arts appliqués à l'industrie*, Paris, two volumes of which are older but not antiquated discussions of these periods, one on the *Ivoires*, 1896, and the other on *L'orfèvrerie*, 1900. The English and Irish Crosses may be studied in Margaret Stokes's *Early Christian Art in Ireland*, Dublin, 1911, in the definitive work on British sculpture of the Middle Ages, *Medieval Figure-Sculpture in England*, by E. S. Prior and A. Gardner, Cambridge, England, 1912, but above all in G. Baldwin Brown's *The Arts in Early England, The Ruthwell and Bewcastle Crosses*, etc., London, 1921. The chief American protagonist of the later dating of the Crosses is Professor A. S. Cook in *The Date of the Ruthwell and Bewcastle Crosses, Transactions of the Connecticut Academy of Arts and Sciences*, XVII (1912-1913), pp. 217-361. Further knowledge of the Renaissance of the Othos may be obtained from the general works on mediæval German sculpture mentioned at the end of the next chapter. The student who wishes to learn what has at the present been discovered about Armenian sculpture should turn to J. Strzygowski's *Die Baukunst der Armenier und Europa*, Vienna, 1918.

CHAPTER X

THE MIDDLE AGES

I. INTRODUCTION

Classification. For the purposes of this book, the Middle Ages may be taken to extend from the eleventh through the fifteenth century, except in Italy, where the Renaissance is usually considered to have been inaugurated at least as early as 1400. In the eleventh and twelfth centuries the field of art was occupied by the style called the Romanesque; but the first signs of Gothic began to show themselves in the French province called the Ile-de-France by the middle of the latter century and elsewhere by the end of the century. The developed Gothic style, undergoing successive modifications in its evolution, flourished throughout the greater part of Europe from 1200 to 1500 and in places lasted on during the earlier sixteenth century. The heart of mediæval Europe was France, and French institutions, customs, manners, schools, literature, and art were the patterns for the rest of the Christian world.

Religion. The strongest motive force in mediæval art was religion. The robust, sincere, fervid, and concrete faith that remained in unimpaired soundness at least until the fourteenth century made it the greatest essentially Christian art that the world has produced. The vigor of Christianity overflowed into many channels. Monasticism swelled to colossal proportions, and the monasteries continued to be the chief patrons of art until the end of the Romanesque period. The ebb of Benedictinism was stemmed by many Reforms of the Order. The first, that of Cluny in Burgundy, founded in 910, became so powerful that it was one of the chief agents in the dissemination of the Romanesque style. The be-

ginning of the noblest century of the Middle Ages, the thirteenth, was marked by the appearance of the two great mendicant orders of the Franciscans and Dominicans. The former, through the life and precepts of its founder, eventually helped in the fifteenth century to achieve the humanization of art and a more appreciative study of nature. Another beacon light of the thirteenth century was the typically Christian philosophy of scholasticism, which then shone brightest with such famous names as St. Thomas Aquinas, Duns Scotus, and Albertus Magnus. An exact parallel to its categorical subtleties is found in the elaborate iconographical arrangements of sculpture and stained glass in the early Gothic churches. The cult of the Virgin was much emphasized and became a vital and altogether lovely aspect of mediæval art. The Crusades, extending from the end of the eleventh to the end of the thirteenth century, were not wholly political and economic in their aims, as some prejudiced historians would have us believe, but they were also a sincere expression of religious enthusiasm. Incidentally, they fostered commerce between the East and West, especially for Genoa, Pisa, and Venice, and the closer contact with the productions of Byzantium and the near Orient contributed to the flowering of Romanesque art.

The pilgrimages. A final factor in mediæval religion, the significance of which for literature and art can hardly be overestimated, was the popularity of the pilgrimages to Rome, the Holy Land, and especially to the shrine of St. James (Santiago) at Compostela in Spain. The churches and hospitable monasteries on the highways to Rome and Jerusalem and on the several European routes to Compostela, the so-called "Way of St. James," were bound to take on unusual splendor of architecture and decoration because of the wealth that accrued to them through the pious beneficence of pilgrims and because they wished proudly to exhibit to their visitors a real magnificence. The Order of Cluny, furthermore, realizing and seizing upon the advantage of possessing holdings all along the Way, propagated by these roads its enthusiasm for sculpture as a mode of ecclesiastical embellishment. The pilgrimages also provided routes by

which artistic influences could readily travel from one place and even from one country to another, and the monuments along these arteries often tended to assume a similarity in certain details or even occasionally in general style. In particular, an acquaintance with the art of the near Orient was acquired through the pilgrimages to the Holy Land.

Methods of mediæval sculptors. Throughout the Middle Ages the same man was very often both architect and sculptor, but a large number of the craftsmen must have specialized in sculpture. Authorities are not agreed as to whether in the Romanesque period it was the more general custom to carve the stones before or after they were set into the edifice. Perhaps there was no established rule; but if one practice did prevail and if this practice was to do the stonecutting upon the building itself, it would have provided an additional reason for the Romanesque conception of sculpture as only a part of the architectural scheme. In any case, the general Gothic custom, although there were many exceptions especially in the later Middle Ages, was to carve the sculpture before putting it in place. The natural results were, on the one hand, ever increasing correctness and fineness of detail, and, on the other, the constantly developing tendency, which culminated in the fourteenth and fifteenth centuries, to make the figure stand forth from the background and to treat it as a separate object. Romanesque art did not afford much opportunity for stone statues detached from the body of the building. When their use was developed in the Gothic period, either for architectural embellishment or as completely isolated objects of devotion, the normal procedure, again with many exceptions, was to hew all parts of a figure from a single block. This method of working, by restricting the amount of agitation and consequent projection of members, constituted a contributory cause for the repose that distinguishes the sculpture of the thirteenth and fourteenth centuries.

Polychromy. In regard to the universal and much discussed practice of painting sculpture in the Middle Ages, a certain number of facts seem now to be established. In the Romanesque period, in the thirteenth century, and, in the

majority of places, in the fourteenth, the tones were subdued, and the scheme of color was conventionalized. In order to avoid garish effects, gilding was admitted, except on bronzes, only very chastely and sparingly. It was used here and there for creating accents, as on a crown, a star, or a halo, and for making light and simple patterns over the garments. By conventionalization of polychromy it is meant that the colors and arrangements of colors were not chosen with the purpose of reproducing closely those observed in actuality but rather with the idea of obtaining agreeable decorative combinations. The fifteenth century brought with it some changes. The general realism of the period entailed a partial abandonment of conventionalization of color and a desire to approximate the appearances of nature. Flanders was already delighting in a gayer, not to say gaudier, system of color, and with the spread of Flemish fashions this less subdued tonality won a footing in the rest of Europe. In one respect the fondness of brilliancy gained a point even over realism, for it lavished gold over the figures in places where it was not to be found in actuality and with a profusion that could not have been paralleled in contemporary life. Premonitions of this deterioration of taste occurred in certain regions in the fourteenth century, especially in the Low Countries and Spain.

II. Romanesque Sculpture

A. INTRODUCTION

The evolution of Romanesque sculpture. The Romanesque period witnessed the revival of monumental sculpture. The height of Romanesque plastic development may be placed at the end of the eleventh and in the first half of the twelfth century. The models from which the stone-cutters learned were chiefly the illuminations of east-Christian, Carolingian, and contemporary manuscripts. From them they adopted iconography and even such curious stylistic details as the clinging of garments closely to the body and

the use of concentric folds of drapery over chest and knees. To a lesser extent, they depended upon the other minor arts, such as the ivories, upon the relics of ancient statuary, particularly the sarcophagi, and upon earlier or contemporary frescoes and mosaics. All these models, however, they put to such new uses and transfused with so new a spirit that Romanesque sculpture was virtually an original manifestation. The dependence upon the miniatures, the other minor arts, and painting tended at first to result in low and flat relief and in a reproduction in stone of the designs and technique of these prototypes, especially in a rendering of detail by incised lines; but sculpture gradually emancipated itself, began to comprehend its own aim of modelling in the round and in many planes, and sought to become self-sufficient. By a strange historical paradox, Romanesque sculpture began with the forms of an already highly developed and sophisticated art, the art of the miniaturists; and its task was that of working towards simplicity and naturalness. It was not until the Gothic age that these ideals were fully realized.

Subordination to architecture. The key to the interpretation and the charm of Romanesque sculpture is that, although it had recovered the ability to render forms correctly and naturalistically in the round, it always remained the hand-maid of architecture. The figures are conceived as parts of the general architectural system, and the separate groups are coerced into designs as formal as the curves of the vaulting or as the plan of a portal. The shapes are consequently treated with a license that approximates them to the work of the Post-Impressionists, except that the distortions of the human form by our most recent artists are usually dissociated from an architectural scheme. Human bodies are elongated by the Romanesque sculptor until at a short distance they appear as much mere lines in the composition as do the colonnettes or the arches. The figures on capitals are arranged in patterns and twisted into forms required by the symmetry of the Corinthian norm, which was usually in the artist's mind. The drapery is commonly pleated in long, narrow folds; and in places, in order to contrast with

the rigid architectural lines, its edges are thrown into arti-
ficial and wind-blown spirals suggested by models in minia-
tures. Often, indeed, for this same purpose of variation,
the sculptors created with the figures, as well as with the
drapery, elaborate curvilinear rather than rectilinear designs.

Iconography. The subjects of Romanesque sculpture were
drawn primarily from sacred history, legend, and symbolism.
The iconography of the Old and New Testaments was pro-
vided chiefly by the manuscripts, but the borrowings were
often enlivened by an originality of adaptation. For the
representation of the legends of post-Biblical saints the
carvers were obliged to rely largely on their own ready in-
vention. It is possible that the revival of ecclesiastical
symbolism, after its lapse since the seventh century, was due,
in considerable degree, to the great abbot of St. Denis in the
second quarter of the twelfth century, Suger. The monu-
ments, especially the portals, were often the objects of ex-
tensive iconographical schemes, though by no means so
elaborate as in a Gothic church. Favorite themes for Roman-
esque tympana were the Apocalyptic Christ, the Last Judg-
ment, and the Ascension. The carvings, however, also
present a bewildering plenitude of profane material. The
characteristic labors of the different months were frequently
represented upon portals. The richest variety of themes is
found in the capital (Fig. 105), and here particularly, in ad-
dition to sacred matter, every sort of secular subject ob-
truded itself. The panorama of mediæval life is displayed
before our eyes—its aristocrats and peasantry, its battles,
trades, amusements, and romances. On the capitals and in
other sections of the church the sculptor reveals also a pro-
nounced taste for the forms of beasts. Sometimes these are
the actors in Æsopic fables, or they bring morals from the
Bestiaries; but very commonly they are the fiercest animals
and the most prodigious monsters, employed, with no sym-
bolic significance, merely for a decorative purpose. Normal
and abnormal beasts alike engage often in the most sangui-
nary combats. Much of this fantastic *ensemble* was the re-
sult of an imitation of oriental fabrics and tapestries; but
additional weird monstrosities were created by the imagina-

tion of the Romanesque artists, reflecting their barbaric
origins still bursting through the veneer of civilization.

Preëminence of France. Southern France attained such a
brilliant development in sculpture that to a very considerable
extent she taught the rest of Europe. It should, however, be
stated at once that there is a tendency in the most recent
criticism to diminish the importance of France as a dis-
seminating centre of the Romanesque sculptural style in

FIG. 105—SPANISH ROMANESQUE CAPITALS. 1. S. CUGAT DEL VALLÉS.
STREET-ACROBATS. 2. CATHEDRAL OF TARRAGONA. ON ABACUS, FABLE OF THE
CAT AND MICE

favor, on the one hand, of Lombardy, and on the other, of
the Way of St. James. Professor A. Kingsley Porter is the
leading exponent of the idea that the Romanesque school
which exercised the strongest and most widely spread influ-
ence was neither French nor Spanish but attached to the
Way of St. James in both countries and therefore inter-
national. The writer of the present chapters, nevertheless,
is inclined to believe that, however great the significance of
the Way in fostering and spreading sculpture, the creative
impulse and the original models, as in the case of the relation-

ship between Provençal and Catalonian literature, came from southern France.

Languedoc. The French school that was most comprehensive in its scope developed in Languedoc. It was possibly because of this comprehensiveness that the achievements of Languedoc had a greater vogue than those of any other province and furnished a considerable share of the foundations upon which were built the mature Romanesque schools, not only in many sections, if not all, of France, but also in a large part of the rest of Europe. Even if the precedence be ultimately awarded by historians of art to the school of the Way of St. James, it can never be denied that the workshops of Languedoc were among the most important constituents of the international school. The broader scope of the school of Languedoc is exemplified by the fact that it includes two subdivisions partially differentiated from each other in style. Although the sculptors of both tendencies felt the carving architecturally, they cultivated liveliness to a greater or less degree and sought to avoid a too obvious stiffness by taking refuge in two peculiar mannerisms: the crossing of the legs, an old *motif* in European æsthetic tradition, probably derived in Romanesque sculpture from models in the minor arts; and the above-mentioned agitation of the edges of the garments in formal scrolls, suggested by similar flourishes in miniatures. The principal monuments of the first subdivision are great assemblies of sculpture on portals. The composition is given an architectural regularity and symmetry, and the figures are arbitrarily thrown into exaggerated curves or drawn out into extravagant elongations in order that they may fit into the space and become like lines and masses of an architectural arrangement. Even the features have a more pronounced geometrical cast than in the other subdivision. The effort for vivacity and expressiveness is much more evident, the pleats of the drapery are fewer, and all the lines are sharper and deeper-cut, creating an effect of greater crispness. The supreme example of this first phase

of the production of Languedoc is the portal of St. Pierre at Moissac (Fig. 106), variously dated from 1115 to 1150. Like the analogous portal in the interior of the church at Souillac, this doorway contains one of the piers that are characteristic of the region, built of conglomerations of beasts and human forms and perhaps derived from similar *motifs* in manuscripts that were executed under oriental influences. The figures on the piers and the capitals in the cloister of Moissac

FIG. 106—TYMPANUM, PORTAL OF ST. PIERRE, MOISSAC. (PHOTO. FROM A CAST)

were carved at the very beginning of the twelfth century in a similar, though not identical, style. In the second subdivision of the sculpture of Languedoc, which may be illustrated by a series of Apostles of about the year 1145 from a portal of the chapter-house of the church of St. Etienne, Toulouse, now in the Museum of the city (Fig. 107), the figures, in imitation of ancient sarcophagi or of the Christian ivories or perhaps again through suggestion from illuminations, are frequently disposed in niches, conversing with one another, and

their vivacity is curbed in order to accord with architectural solemnity. The masterpiece of this tendency, already affected by the embryonic Gothic movement of the north, is the Annunciation in the same Museum, executed in the last quarter of the twelfth century.

FIG. 107—APOSTLES. MUSEUM, TOULOUSE

Burgundy. In its predilection for extremely attenuated figures and in its bizarre conceptions, the school of Burgundy, which was at its height in the first half and middle of the twelfth century, outdid that subdivision of the school of Languedoc which is best represented by the portal of Moissac. Other distinguishing qualities are a great richness of ornamental detail, a high degree of animation in forms and draperies, finding expression particularly in more violent swirls at the bottom of the garments than in Languedoc, and a powerfully developed dramatic sensibility. The most celebrated examples are: eight superb capitals from the choir of the great abbey of Cluny, now in the Museum of the town, dated variously from the end of the eleventh to the middle of the twelfth century; the portal that opens from the narthex into the church in the Cluniac abbey of Vézelay, the tympanum of which embodies the bestowal of the Holy Spirit

at Pentecost; and the allied doorway of St. Lazare at Autun, which represents the Last Judgment and constitutes the most extravagant instance of Romanesque license in the manipulation of the human form (Fig. 108). The capitals from Moûtier-St. Jean in the Fogg Museum, Cambridge, make it possible for Americans to obtain an excellent idea of the Burgundian manner even in their own country. In the third

FIG. 108—TYMPANUM, PORTAL OF ST. LAZARE, AUTUN. (PHOTO. FROM A CAST)

decade of the twelfth century, the style of this province vied with that of Languedoc in influence upon other parts of Europe.

Provence. The presence of a greater number of antiques in what had been for a time the most flourishing province of the Roman empire made it natural that its school should retain the old characteristics. The school of Provence was also invigorated by contact with the youthful school of Chartres.[1] The façade of St. Trophime at Arles, executed in

[1] Cf. p. 226.

the third or even the fourth quarter of the twelfth century, is typical (Fig. 109). The heritage from antiquity may best be discerned in the larger figures of saints in niches—bodies of squatty proportions, heads of an inordinate magnitude and stolid expression, classical draperies, an absence of the technical delicacy that distinguishes the carvings of Languedoc and Burgundy. The heaviness carries with it, however, its compensation in a certain senatorial dignity, and

FIG. 109—SECTION OF FAÇADE OF ST. TROPHIME, ARLES. (COURTESY OF PROFESSOR A. KINGSLEY PORTER)

accords well with the solid spirit of Romanesque architecture. The other great collection of sculptures in this region, dating from the middle to the end of the twelfth century and perhaps earlier than those of Arles, is found on the façade of the church at St. Gilles.

Poitou and Saintonge. In the interdependent schools of Poitou and Saintonge, the carvings, lavished over the archivolts and often over large sections of the façade, possess more decorative value than technical fineness. The relief on the archivolts tends to an oriental flatness, creating the effect

of a rich embroidery. Since the portals ordinarily had no tympana, it was the arches that were very extensively carved with human forms, vying with *motifs* of monsters and vegetation. A common subject for the embellishment of façades was the mounted cavalier, usually representing the emperor Constantine but occasionally St. George, St. Martin, or even other personages. Among the best churches for the study of the Romanesque of this region are Notre Dame la Grande at Poitiers, St. Pierre at Angoulême (sadly "restored"), Sainte Marie aux Dames at Saintes, and St. Pierre at Aulnay. A section of the sculptural adornment of Notre Dame de la Couldre at Parthenay in Poitou may now be seen at Fenway Court, Boston.

Other schools. The Romanesque output of the other French provinces is not distinguished by such clearly defined features. The most interesting monument in Auvergne is the lateral door of Notre Dame du Port at Clermont-Ferrand, the large figures of which betray less stubby proportions than were usual in this region. The style of Auvergne seems to have coalesced with other strains to produce the great tympanum of Ste. Foy at Conques, although, geographically speaking, the church does not lie strictly in the province. Executed in the second quarter of the twelfth century, it may have been of great significance in forming the developed school of Auvergne, influencing even the portal of Notre Dame du Port. Famous specimens of the rich sculptural treasures of the Loire exist at St. Benoît-sur-Loire and at La Charité-sur-Loire. The district of the Ile-de-France was already evolving Gothic.

C. SPAIN

The great period of Spanish Romanesque began at the end of the eleventh century with the introduction of French influence through the Order of Cluny and through the incessant flow of pilgrims to the shrine of Santiago de Compostela. The hypothesis of an international school attached to the Way of St. James has already been outlined above as an explanation of the similar characteristics of French and Span-

ish Romanesque sculpture, in place of the orthodox theory
of a dependence upon France; Professor Porter even believes
that if perchance the workshops of one country predominated
over those of another, Sto. Domingo de Silos and Compostela
were probably more vital centres than Toulouse. But the
evidence does not as yet seem to justify the repudiation of
the traditional explanation; and the school of Languedoc
may still be looked upon as the most considerable creditor
of Spanish Romanesque. The most significant work at Sto.
Domingo de Silos, in the style of the carvings in the cloister
of Moissac, is found in the six superb reliefs on the corner
piers of the cloister, embodying the last episodes of the
Gospels; the two reliefs at the southwest angle, the Annuncia-
tion and the Tree of Jesse, belong to early Gothic. Even
if we follow Professor Porter in accepting as remote a
date as c. 1075 for the six reliefs, instead of the more usual
date of the middle of the twelfth century, the priority of one
great Spanish monument does not imply that France was not
the general source of energy, that earlier and now destroyed
French carvings may not have provided precedents for Sto.
Domingo, or that during the great period of Romanesque, the
twelfth century, France did not assume the hegemony which
Sto. Domingo may momentarily have held. In any case, it
is not absolutely proved that the six reliefs are of the eleventh
century. The subdivision of the school of Languedoc that
had its seat at Toulouse itself is most signally represented
in the first half of the twelfth century by the south portal
of Santiago de Compostela, the Puerta de Platerías (Fig.
110), which in disposition of carvings and in style resembles
the south door of St. Sernin at Toulouse. Although some of
the sculpture on the Puerta de Platerías has been imported
from the destroyed portal of the north transept and perhaps
from a west portal replaced by the present Pórtico de la
Gloria, yet even in its original condition it must have be-
trayed a tendency to cover every inch of the surface with
carvings. This complete investiture of a façade is a common
indigenous characteristic, carried to a farther point than in
the analogous proclivity of the school of Poitou and oc-
casioned by proximity to the prodigal art of Moorish Spain.

Occasionally other schools found favor. Of several possible examples of an Italian influence, the lower façade of the church at Ripoll in Catalonia exhibits its superabundant carving arranged in bands in the manner of the Lombard-Romanesque; the reliefs themselves, direct adaptations of the illuminations in the Catalan manuscript, the Bible of

FIG. 110—PUERTA DE PLATERÍAS, CATHEDRAL, SANTIAGO DE COMPOSTELA. (PHOTO. LACOSTE)

Farfa, or some similar Bible, constitute one of the most undeniable examples of the influence of miniatures upon sculpture.

D. GERMANY AND RELATED COUNTRIES

General character of monumental German sculpture in the Romanesque period. The best Romanesque work of Germany is found in her bronzes, continuing the tradition of the Carolingian Age, and in her sepulchral effigies. The

monumental decoration of churches in stone is technically somewhat inferior to that of France. In the more national style that prevailed until about 1180, as in the tympanum of the north portal of St. Cecilia, Cologne, the compositions were simpler, and the forms were not only more solid and

FIG. 111—FONT. CATHEDRAL, HILDESHEIM. (PHOTO. DR. FR. STOEDTNER, BERLIN)

tranquil but also less naturalistic; at the end of the twelfth century the indebtedness to France and Italy became much more apparent. No portals or façades have the magnificence of Moissac, Vézelay, or Angoulême; the cathedral of Basel and the church of St. James at Ratisbon provide the only examples of importance, both belonging to the very end of the Romanesque period and both under foreign influence.

Bronzes. The Saxon workers in bronze attained such popularity that they exported doors like those of Hildesheim even to Verona in Italy, to Novgorod in Russia, and to Gnesen in Poland. In this as in other phases of German Romanesque sculpture, either through Byzantine or French influence the forms gradually became more correct, but on the other hand there was a partial loss of the old Teutonic realism. The two valves of the door of S. Zeno at Verona are now a conglomeration from ruder sections belonging to the first half of the eleventh century and more advanced sections of a subsequent enlargement in the twelfth century. A more developed knowledge distinguishes also the bronze doors of the cathedral at Augsburg. In the bronze lion set up by Henry the Lion as his emblem in 1166 at Brunswick, heraldic conventionalization is tempered by naturalistic study, and Germanic pride exults in a superb consciousness of strength. The font in the cathedral of Hildesheim, as

FIG 112—TOMB OF ARCHBISHOP FREDERICK I. CATHEDRAL, MAGDEBURG. (PHOTO. DR. FR STOEDTNER, BERLIN)

ornate in decoration as it is elaborate in iconography, was executed at the beginning of the thirteenth century, but still belongs to the same Saxon tradition (Fig. 111).

Tombs. Saxony was likewise a centre for the production of grave-reliefs in bronze. As in the series of doors, crude realism, represented at the end of the eleventh century by the effigy of Rudolf of Swabia in the cathedral at Merseburg, gave way in the twelfth to a desire for correctness, repose, formal beauty of draperies, and idealism, represented by the monument of the Archbishop Frederick I in the cathedral at Magdeburg (Fig. 112). Much the same evolution may be traced in the succession of sepulchral effigies in stone carved for the abbesses of Quedlinburg.

E. THE LOW COUNTRIES

From the region that later became Belgium and Holland, little Romanesque sculpture remains. Its art was dominated chiefly by France, though Germany may have exercised some influence, especially in the adjacent districts of Holland and of the Meuse. Over the few tympana and other monuments, our scope does not permit us to tarry. Tournai was the most important sculptural centre, because its black marbles were made into fonts and sepulchral slabs and enjoyed such popularity in the twelfth century as to be exported into northern France and England. Even in the exported examples, as, for instance, the slab conjectured to be the memorial of Bishop Roger in the cathedral of Salisbury, the craft never rose much above the level of mere shopwork. Already in the twelfth century an important school of metal' workers and goldsmiths had developed in the Walloon district of Belgium, deriving its forms, perhaps, from earlier ivory-carvers in this region, and it was probably this school that had the honor of producing the loveliest monument of Romanesque sculpture in the Low Countries, the brass font now in St. Barthélemy, Liége, executed in the first half of the twelfth century by Renier de Huy and decorated chiefly with a series of famous baptisms, skilfully varied in compact compositions.

F. ENGLAND

Chronology. Romanesque sculpture in England may be divided into two periods, the first extending from the Norman Conquest in 1066 to about the middle of the twelfth century and consisting of a rude and arduous apprenticeship in the art, the second including the latter half of the twelfth century and resulting under French influence in actual attainment.

The first period. The early Romanesque style of England was an amelioration of the forms and conceptions inherited

FIG. 113—TYMPANUM, CHURCH AT DINTON. (FROM "MEDIEVAL FIGURE-SCULPTURE IN ENGLAND" BY PRIOR AND GARDNER)

from the barbaric productions of the ninth and tenth centuries. These were constructed of elements drawn from the Celtic tradition, but particularly from the ideas of the Scandinavian raiders. The Normans, being Scandinavians themselves and finding the Irish-Viking style to their taste, adopted it, developed it, and, as in the tympanum at Dinton, Bucks (Fig. 113), employed it for the decoration of their parish churches. The monsters of Norse mythology were endowed with Christian symbolism, the fighting warrior became a St. George or a St. Michael, and the old ornaments

of knob and interlacement remained the stock in trade of the stone-cutter. The qualities of the early Romanesque manner appear also in a large number of fonts.

The second period. Under the spell of the more mature and refined style of France, flat relief and the rendering of detail through incised lines were abandoned for modelling in the round, better proportions became the general rule, and the old symbolistic beasts and combats gave way to the more humane subjects from the Bible. Nevertheless, perhaps because of the sculptural sterility, in contrast to the architectural achievements, of Normandy, upon which English art depended more closely than upon other French provinces, the Romanesque sculpture of England was less distinguished than the architecture, and its amount was comparatively limited. For their models the English stone-cutters usually had to turn to other districts of France, which in certain instances taught them particularly how to use the portal as the vehicle of an iconographic system. For example, the west doorway of Rochester resembles in some respects the portals of Poitou and Saintonge. The sculptors of northern England derived their methods from Languedoc and surpassed the south in their realization of form; their attainments may be illustrated by four reliefs in the cathedral library at Durham, containing episodes from the Passion and Resurrection. The fonts, such as that of Hereford cathedral, reveal the same improvement in style as the monumental carving. England produced very few sepulchral monuments prior to the Gothic period. The Romanesque examples were imitations of the slabs imported from Tournai; in the second half of the century they began to develop modelling in the round. The tomb of Bishop Jocelyn in the cathedral of Salisbury may be taken as typical.

G. ITALY

General characteristics, schools, and chronology. In contrast to the attitude that found its highest expression in France, the Italians tended to dissociate exterior carving from the general organic scheme, to look upon it as mere decora-

tion, and therefore to employ for it slabs of marble inlay rather than the local stones of which the fabric itself was built. The iconographic schemes of France were paralleled only sporadically, and then under Transalpine influence. The production of the period may conveniently be treated in three geographical divisions, the northern or Lombard, the central or Tuscan, and the southern. In order that the sculpture of Nicola and Giovanni Pisano and their followers in the second half of the thirteenth and in the fourteenth century may subsequently be grouped together and considered as the Gothic output of Italy, a discussion of Italian plastic work of the first half of the thirteenth century is included at the present point. Such an arrangement is not illogical, since, although Italian carving of the early thirteenth century had already begun to be Gothic, Italy had as yet evolved no great Gothic schools, and the prevalent styles were, for the most part, only freer developments of the various Romanesque manners. It is, in any case, a mere convention to apply either "Romanesque" or "Gothic" to the antiquarian school of Campania and Sicily in the twelfth and thirteenth centuries.

Northern Italy. First period. At the end of the eleventh and beginning of the twelfth century the greater part of the important sculpture of northern Italy falls into two schools. In one of these schools, a more than usual addiction to the savagery of Romanesque subjects resulted in ruthless battle and hunting scenes and in a nightmare of grim beasts and revolting monsters, often tearing one another to pieces. Good specimens are afforded by the capitals of S. Ambrogio, Milan, and by the façade of S. Michele at Pavia, where, according to the Lombard custom, the lower section is covered with a series of carved bands, disposed without any apparent order. The second school, which was founded by a Master Guglielmo, was not so much inclined to these brutal medleys and preferred the human figure, in sacred and secular subjects, treating it with a rude Lombard vigor. The style of Master Guglielmo, accompanied by his signature, may be seen upon the façade of the cathedral of Modena and in the reliefs from the New Testament at the left of the portal of S. Zeno,

Verona;[1] the less ponderous and more flexible style of his pupil, Master Niccolò, also with the signature, may be studied in the reliefs from Genesis at the right on S. Zeno (Fig. 114) and upon the main portals of the cathedrals of Verona and Ferrara. To this movement belongs a large amount of the carving of northern Italy in the first half of the twelfth

FIG. 114—MASTER NICCOLÒ. RELIEFS FROM GENESIS. S. ZENO, VERONA.
(PHOTO. ALINARI)

century. Since the work of Guglielmo and Niccolò resembles the early style of Languedoc, the question of French influence has been much mooted; but it has not yet been proved that the analogies are not due merely to the use of similar models in the minor arts and in the antique, or, if a re-

[1] It is not absolutely proved that the Master Guglielmo of Verona is identical with the sculptor of Modena.

lationship is to be postulated, whether the influence operated from France to Italy or from Italy to France or in both directions. Authorities, for instance, have not yet reached an agreement as to whether small effigies of Prophets on the vertical supports of the archivolts in the splayed doorways of the cathedrals at Cremona, Ferrara, and Verona may have assisted to set the precedent for the similar treatment of portals on a larger scale in French Gothic, or whether the primacy in the matter, on the contrary, belongs to the early school of Chartres. It is even possible that the idea originated in such columns, carved with figures in relief, as may be seen in the Puerta de Platerías at Santiago.

Northern Italy. Second period. The Gallic influence, now emanating from Provence, becomes indubitable in the latter part of the twelfth century. The disseminating centre about 1175-1180 may have been a later workshop at Modena, represented by a series of reliefs in the cathedral containing episodes of the Passion from the old parapet of the tribune; and here perhaps was trained the chief exponent of the tendency, Benedetto of Parma,[1] one of the most appealing of Romanesque sculptors, whose activity began in 1178. His works exhibit so many analogies to the carvings of Arles and St. Gilles that it is almost necessary to assume that at some time he himself studied also in Provence, and his draperies suggest that, like the sculptors of these Provençal towns, he may have seen even the early Gothic carvings of Chartres. His mature style is exemplified in his extensive decoration of the exterior and interior of the Baptistery at Parma, where two of the three doorways that possess sculpture (Fig. 115) are elaborated into the iconographic systems of France. The embellishment of the façade of the cathedral at Borgo San Donnino is absolutely in his manner and probably partly executed by his own chisel. Although, as a true Italian, he was never quite able to harmonize his creations with their architectural setting, it was in all likelihood a familiarity

[1] Until recently usually known as Benedetto Antelami; but there is good reason for believing that *Antelami* was not a surname but the title of a guild of builders and sculptors derived from the valley of Antelami in the Apennines.

with Provençal prototypes that helped him to attain in his larger figures true monumentality. The angels accentuating some of the archheads in the interior of the Baptistery embody a solemn grace that is one of his most delightful qualities. In the Solomon and the Queen of Sheba on the outer wall, the intimate mysticism that pervades all his figures reaches its climax. The achievement of Benedetto ap-

FIG. 115—BENEDETTO OF PARMA. PORTAL, BAPTISTERY, PARMA. (PHOTO. ALINARI)

proaches close to early Gothic in its freedom, and much of north Italian sculpture at the end of the twelfth and beginning of the thirteenth century can be traced to his school.

Central Italy. In central Italy, Tuscany was the only province of real sculptural significance. Even here the addiction to adornment by effects in marbles of different colors partially usurped the important place occupied by reliefs in the architecture of the northern and southern divisions of the peninsula. The Romanesque development came later

than in other regions, and much of the carving seems to have been done by Lombard craftsmen. There was possibly also an infiltration of influence from Provence. The figure-work tends to be rather elementary, but the foliage and other decorative *motifs* are often of great skill and beauty. Even Lombard sculptors, when their hand is to be discerned, succumbed to the old Etruscan tradition of this part of the peninsula, modelling stocky forms and humorously large heads. Tuscan carving appears chiefly upon the architraves of portals at Pistoia and Lucca and upon such pulpits or ambos as that which Guido da Como executed in 1250 for S. Bartolommeo in Pantano at Pistoia. In the whole series of pulpits an interest in religious narrative, treated in rows of panels, is substituted for the symbolic representations on the examples in southern Italy. The Romanesque sculpture on the tympana, lintels, and façade of the cathedral at Lucca, representing the lives of St. Martin and St. Regulus, the labors of the months, and the glorified Christ, is much more successful than the average Tuscan style in its rendering of form and drapery.

Southern Italy. The Byzantine influence. The most significant sculpture in the south of the peninsula may be divided into two groups, the one deeply indebted to the art of Byzantium, the other based upon the antique. The unusually potent Byzantine inspiration was occasioned by the proximity to the Eastern Empire and by the fact that in 1066 the Benedictine abbot of Monte Cassino, Desiderius, summoned to his service a group of craftsmen from Constantinople, who diffused Greek forms throughout the district. An important manifestation of this Byzantine interest was a series of bronze doors. In the first sets, imported from Constantinople in the eleventh century, the figures were rendered by the process of damascening, the filling of grooves incised in the bronze with silver or enamel. After executing imitations of these specimens, the Italians next began to express the western feeling for saliency in contrast to Byzantine flatness by substituting reliefs for the damascening. A certain Barisanus of Trani, in the second half of the twelfth century, executed three doors of this kind—for his own town, for the

cathedral of Ravello, and for the lateral entrance of Monreale near Palermo. The panels usually contain single effigies of saints or such profane figures as centaurs, sirens, dragons, cavaliers, or archers. Occasionally Biblical scenes are admitted. The subjects in all cases are faithfully copied from Byzantine ivories or goldsmith's work, and the same mould,

FIG. 116—DETAIL OF BRONZE DOORS, CATHEDRAL, BENEVENTO. (PHOTO. ALINARI)

as at Augsburg, is frequently repeated twice or oftener, even on the same door. In the more essentially Italian examples by Bonannus of Pisa for a side entrance of his own cathedral and for the main entrance of Monreale, sacred episodes intruded into the panels, ultimately of Byzantine suggestion but executed with a less exquisite technique, with stronger relief, and with a more pronounced, popular *bon-*

homie than in the doors by Barisanus. The exact relationship between the works of Barisanus and Bonannus and the similar Romanesque doors of Germany is as yet an unsolved question. It remained to combine the Italian naturalism of Bonannus with a high degree of Byzantine skill. This task was achieved at the end of the twelfth century in the anonymous bronze doors of the cathedral of Benevento (Fig. 116).

Southern Italy. The antiquarian tendency. Campania and Sicily were the seats of a movement which outdistanced

FIG. 117—BUSTS OF PIER DELLE VIGNE AND OF PERSONIFIED CAPUA.
MUSEUM, CAPUA

the rest of Romanesque sculpture in its knowledge and reproduction of the antique and which has a peculiar significance as the probable training-school of Nicola d'Apulia. The carving of this movement is found principally on pieces of ecclesiastical furniture, such as pulpits and paschal candlesticks. The robust bodies, the poses and costumes, the vigorous relief, were suggested by fragments of Roman sculpture, but, like the Byzantine forms of the door at Benevento, the classical borrowings were revivified by an appreciation of every-day life. The style appears in a long series of monuments, famous among which are the ambos at Salerno and the

reliefs with the lives of Joseph, Samson, and others in the chapel of S. Restituta in the cathedral of Naples. Antiquarianism became even more pronounced under the emperor Frederick II. His chief sculptural undertaking was the decoration in 1234 of a castle or work of defence at Capua in the form of a Roman triumphal arch. Fragments of this have now been gathered in the local Museum (Fig. 117): a decapitated effigy of the Emperor with the dignity and the toga of a Roman senator; busts of his ministers, Pier delle Vigne and Taddeo da Sessa, reproductions of Roman busts; a noble head of the personified city of Capua, copied perhaps from an old Juno; and other, ornamental heads.

III. Gothic Sculpture

A. INTRODUCTION

General characteristics of the sculpture of the thirteenth century. The Gothic sculptor took advantage of the knowledge gained by his Romanesque predecessor, but he largely abandoned the models of the miniatures and the other minor arts and the resulting conventions. He studied nature itself, and attained much greater skill in its reproduction. He thought no more in the derivative terms of a small illumination or ivory, but in the absolute terms of the finished and monumental stone figure. So far as any movement in art has ever been original, the Gothic period evolved this plastic sense and its own forms from its own æsthetic consciousness. The statues tended to emerge from the mass of the building, to stand forth in the round, to lose their frontality, and to be the objects of more special attention; but at the same time, by their position in projecting shrines and by a stateliness that would make it possible to inscribe their principal outlines within imaginary upright piers, they preserved a connection with the architecture and an architectural feeling. Despite the advance in correctness of representation, the artist used for his forms the simple, noble lines and the idealization proper to the severity and formality of archi-

tectural decoration. In small reliefs, narrative also was treated with an architectural simplicity. The episode was reduced to its lowest terms, the fewest possible figures were used, the setting and accessories were not realistic but restricted to a merely suggestive scale and number, the controlled postures and gestures aimed only at an unvarnished exposition of the tale. Simplicity and idealization, these were the dominant notes of the thirteenth century, and these were the qualities that could fitly express its lofty and robust religion. The whole Gothic period, indeed, as the most essentially Christian of all artistic epochs, laid the emphasis not upon the beauties of the body but upon the expression of the thoughts and emotions of the soul. The nature of the expression varied between degrees of idealism and realism in the several centuries; and diverse treatments of the drapery partially took the place that the body and the nude had occupied in ancient art as aids to artistic utterance or as objects of purely æsthetic delight.

The fourteenth century. The monumental decoration of the churches was now largely finished, and the chisel was confined more and more to such separate articles of ecclesiastical furniture as devotional statues or to the tombs by which the individuals who had succeeded to the municipalities in patronage sought to perpetuate their fame. By the middle of the fourteenth century a kind of international style had developed, the radiating centre of which was probably France. Wherever the figure was still employed in architectural adornment, it lost its architectural lines, often bent to the side and backward, and was a detached entity. The ampler draperies, though more naturalistic in texture and folds than those of the thirteenth century, were conceived as opportunities for the display of ingenuity in design. Winding hither and thither, they separated into smaller pleats, and sought effects of chiaroscuro through deeper indentations. In body and drapery alike, the sculptors endeavored to obtain the long, undulating lines that have become synonymous with the word Gothic. The broad and generalizing manner that was suited to architectural function inevitably gave way to "fussiness" of detail and here and there to further individual-

ization of the figures. The tendency to subtlety rather than
to monumentality augmented the number of small anecdotal
panels in architectural adornment. Even at the end of the
thirteenth century, idealism, having exhausted itself, had
already, by a natural evolution, begun to incline towards ex-
cessive refinement or to react towards a more careful repro-
duction of actuality. In other words, the sculpture of the
fourteenth century was characterized by mannered idealism
and by prognostications of the coming realism.

The fifteenth century. A profounder realism was the dis-
tinctive feature of the fifteenth century, and the realistic
tendency was ubiquitous; but Flanders, eventually, played an
important part in the dissemination of the style, and Ger-
many gave it the most pronounced expression. The drapery
was now often treated with varying complications and under-
cuttings to create pictorial effects of light and shade. The
Mystery plays, which were at the height of their popularity,
exerted an influence upon art that has been variously esti-
mated; but it can scarcely be doubted that the realistic tone
of the religious theatre, especially in matters of costume and
episodical *genre,* was reflected in both sculpture and painting.
The intellectual faith that had been embodied in the scholastic
philosophy of the thirteenth century and had animated the
spiritualized figures upon the cathedrals was submerged in
the fifteenth century, partly owing to the influence of Fran-
ciscanism, beneath an emotional tendency that infused senti-
ment into the objects of its devotion. The internationalism
of the fourteenth century gave way to national styles and
in these national styles, with the emergence of the per-
sonal artist, even to local schools based upon the achieve-
ments of individual masters. While retaining certain com-
mon European elements, such as realism and a very general
allegiance to Flemish standards, the Gothic art of the sev-
eral countries became more differentiated. Italy, though she
too shared in the universal realism, separated herself even
more than hitherto from the rest of Europe and became the
torch-bearer of the Renaissance.

The "détente." In France, at the end of the century, the
tumultuous storm of realism abated, a sudden lull once more

spread the calm of idealism and simplicity over the graven images, and thus occurred what has been called the relaxation or *détente*. The tendency may be discerned sporadically in the Low Countries, Spain, and even Germany.

Iconography of the thirteenth century. With some important exceptions, the subjects of early Gothic sculpture continued the same as those of the Romanesque period. The great innovation was that the superb intellectualism of the thirteenth century coördinated all the carvings and stained glass of each cathedral into one mighty iconographic scheme. The effort had already extended itself during the preceding century over single portals or even façades, but now the different subjects that had been scattered separately through many churches were collected into the ornamentation of one cathedral, the decoration of the whole edifice was brought within the system, and the scope of each section was enlarged. The constituent parts of the scheme were arranged with stricter logic, and yet much ingenuity was exercised in varying the disposition from town to town. Our Lord, as the source of all things, is ensconced on the central pillar of the main portal or in the Last Judgment on the tympanum above. All ancient history prepares the way for His coming or is symbolic of His life upon earth; He is therefore surrounded by the Prophets and by His ancestors according to the flesh; and their stories are enshrined in reliefs or in the windows. All subsequent history tells of Him or is derived from Him; He is therefore accompanied by the Apostles and saints, and, without and within, are figured the episodes of the New Testament, of sacred legend, and occasionally even of profane history, so far as it is connected with the development of Christianity. Since Christ's mother was an object of even dearer devotion in the thirteenth century than heretofore, at least one of the doors is allotted to her, and her images and the events of her life are multiplied throughout the church. A third door is given to the patron saint or saints. Nature is Christ's handiwork, and so the artist may carve his capitals and mouldings with the loveliest and most varied foliage of his native land. The storied capital is much less frequent, vanquished by this love of the natural world,

and even when figure-subjects still remain, they are usually combined with foliage. The sculptor repudiates the conventionalized Romanesque plant, and returns to nature, not only for a study of the human form, but also for decorative *motifs* of flower and leaf. Sometimes he fills the interstices with birds. Less often he introduces the other animals into his iconographic plan. The wonders of the Bestiaries are related amidst the verdure of the capitals. Not uncommonly the birds and beasts have a symbolic significance, like the four emblems of the Evangelists, or the pelican indicative of the Atonement. The monsters and savage scenes of Romanesque imagination have disappeared, except in rare instances, and in their stead the barbaric blood that still ran in Gothic veins created the gargoyles. The hieraticism of the Romanesque period also yielded. As adornment for the tympana, the Apocalyptic Christ and the Ascension disappeared in favor of the more animated Last Judgment, and the more touching Coronation of the Virgin took the place of the haughtily enthroned Queen. For the single space of the Romanesque tympanum were substituted zones of sacred figures and narrative.

Iconography of the fifteenth century. In the comparatively small amount of monumental decoration during the fourteenth century and in the other phases of sculpture, no essential changes manifested themselves; but by the fifteenth century, Gothic iconography had suffered some losses and made compensating gains. In those few churches that received an extensive sculptural adornment, the scheme of arrangement was somewhat less carefully thought out than by the synthetic minds of the thirteenth century. The Sibyls, whose popularity had originated in Italy, were joined with the Prophets as inspired harbingers of the Christian dispensation. The growing velleity for the pathetic and for subjects connected with death multiplied abnormally the scenes from the Passion. Just before 1400, it added to the sacred repertoire also the Pietà, the dead Christ upon His mother's lap, and between 1420 and 1450, the Entombment or Holy Sepulchre as a large separate work of art. The infinitude of themes, sacred, secular, and grotesque, on the Romanesque

capitals obtained, in the fourteenth and fifteenth centuries, a new lease of life on the misericords and other parts of the choir-stalls.

The tombs. It was in the Romanesque period that there appeared the first tombs sculptured with a representation of the deceased. Comparatively few in number, they consist merely of a slab of stone or bronze containing the effigy executed in high or low relief and naïvely conceived simply as a standing figure laid on his back. The earliest extant examples, of the second half of the eleventh century, are German; and indeed throughout the Romanesque period, it is only the German specimens that have any æsthetic significance.

In the Gothic period the tombs sculptured with a recumbent effigy of the deceased may be divided into three general classes, within each of which occur many modifications and variations in detail: the slab of stone or bronze embodying the effigy and usually set in the pavement of the church; a high base surmounted by the effigy, isolated or against the wall; and a miniature Gothic edifice, made of a niche in the wall or projecting from the wall, the whole more or less elaborately adorned and containing the effigy, likewise upon a base or sarcophagus. There were, however, many sporadic anomalies in sepulchres; and almost every country developed national peculiarities, which will be noted in their proper places. The different parts of the two more pretentious classes of tombs were often carved with the scenes of the death, funeral, and reception of the deceased into heaven, with figures of relatives and dependents, and, especially after 1300, with themes from sacred history. In the fourteenth century the relatives and dependents began to be represented in the formal mourner's costume of a heavy cape and enveloping hood, except in England, where this dress was not assumed until a hundred years later. In general, in the spirit of contemporary Gothic architecture, the sepulchres of the fourteenth and fifteenth centuries took on a more elaborate embellishment of decorative detail, of multiplied reliefs, and numerous statuettes. Over the type of tomb with a high base, a canopy was sometimes erected, especially

towards the end of the Gothic period. Before 1400 there had already appeared, in place of or together with the effigy, a new *motif* that constantly gained in popularity, the mortified cadaver. By the end of the fifteenth century, the kneeling posture for the deceased had begun to enter upon that usurpation of the recumbent posture which was frequent in the sixteenth century.

At first the efforts of the sculptors were largely directed towards lifting the effigy from the sunken flatness of the Romanesque slab to existence in the round. It was not until the latter part of the thirteenth century that they began to break with the Romanesque convention of carving the body like a prostrate standing figure, and it was only in the fourteenth century that they gradually attained the ability to give the impression of recumbency to form and drapery. The idealism of the thirteenth century manifested itself in the choice of early manhood or womanhood for representation, no matter at what age the decease had taken place, and it postponed the beginning of portraiture in sepulchral effigies until just before 1300. By the end of the fourteenth century mortuary portraiture had been definitely evolved.

A fourth type of memorial, which may conveniently be described by the technical German term *epitaph*, was the mortuary tablet or larger relief in which the deceased usually kneels in adoration before some religious subject. By the time of the Renaissance the *epitaphs* had often developed into great structures against the walls, sometimes with figures in the round, and the themes were not always drawn from the sacred repertoire. In its simpler or its more ambitious form, this sepulchral type has enjoyed constant favor almost to the present day.

The retable. The sculptured Gothic reredos, or to use the more cosmopolitan term, the Gothic retable, began to enter upon its career of prodigious popularity in the fourteenth century. A few earlier examples exist, even from the Romanesque period; but it was not until the fifteenth century that the retables attained their greatest size and the height of their development and vogue.

1. The Transition from Romanesque to Gothic

The School of Chartres. The qualities of Gothic sculpture were already embryonically present in the Ile-de-France and the immediately adjoining territory by the middle of the twelfth century. From another standpoint, therefore, since the carvings of this region were still marked by a considerable degree of stiffness and conventionality, and since representation was still readily subordinated to æsthetic exigency, it would be possible to denominate them as Romanesque; they certainly constituted the archaic preparation for developed Gothic more truly than the Romanesque work of the other schools. Much confusion exists as to where the impulse to the new movement first appeared; some authorities hold that it was the west portal of St. Denis (in its present condition almost entirely a modern restoration) which set the precedent. In any case, the movement is most satisfactorily illustrated by the west portal of the cathedral of Chartres, embodying, within the same general style, different stages of attainment that date from about 1140-1165, and perhaps containing even slightly later work in the Apocalyptic Elders at the springing of the main archivolts. The designer has gathered about the three doors a vast iconographic *ensemble* consecrated to the glorification of Our Lord. The idea of decorating the deeply splayed openings with rows of statues, henceforth to be so common a Gothic *motif*, is here fully matured in the effigies of Christ's ancestors. They have so far emerged into separate entities as to be set upon pedestals, and they are largely realized in the round (Fig. 118). Despite the retention of a partial rigidity, declaring itself even in frontality, naturalism has made conquests everywhere, especially in the highly individualized heads and narrow, clinging draperies.

Relation to the Romanesque of other French provinces. The question of dates is so difficult that it is hard to say how far these works exhibit a derivation from the Romanesque achievements of the rest of France or how far they exhibit a

parallel evolution. Certainly some important, though not
definitive, characteristics of the northern school appear also
in the other provinces. The elaborately wrought colonnettes,
the storied capitals, and the iconography of the tympana,
especially the central one at Chartres with the noble Christ
between the Evangelistic symbols, are more Romanesque
than Gothic. The progress from relief to modelling in the

FIG. 118—SCULPTURE ON WEST PORTAL OF CATHEDRAL, CHARTRES

round had already begun in the Romanesque art of other
regions. The excessive elongation of Vézelay, Autun, and
Moissac is here bestowed upon the larger statues in order that
they may have the same architectural effect as the supporting
pillars. The treatment of the garments in minute pleats and
the general refinement of manner recall Burgundy; such
peculiarities in drapery as the crescent folds upon the chest
and the designation of folds by double lines are native also

to Languedoc. Professor Porter has recently suggested that
the chief master at Chartres was trained in Poitou and
Saintonge. Stylistic and particularly chronological grounds
prevent us from accepting Vöge's theory of a primary de-
pendence upon Provence; the influence apparently moved
rather from the north to the south. Whatever precedents
the exponents of the new manner had, the innovations were
so many and so significant as to promise more originality for
the movement than for any previous epoch of Christian
sculpture.

Other examples of the School of Chartres. There are many
other monuments in northern France, dating from about the
middle to the end of the twelfth century, which were produced
by the same school that worked at Chartres. The Metropoli-
tan Museum is so fortunate as to possess a beautiful ex-
ample from some one of these monuments, probably repre-
senting a King of Judah.

2. The Thirteenth Century

The first half of the century. The æsthetic ideals which
were innate in the Gothic genius and which had already been
foretold in the school of the west portal of Chartres were now
realized. The transitory breath of keener naturalism that had
distinguished the best carving at Chartres succumbed every-
where to a high religious idealism which reached its ultimate
expression in the rightly named Beau Dieu of Amiens, the
Christ on the pier of the central door. Two kinds of stuff
may be seen in the French draperies of the thirteenth cen-
tury—a thinner material falling in smaller, more numerous,
and almost parallel folds, as on the lateral portals of
Chartres, and a heavier fabric falling in larger, fewer, and
more curving folds, as on the front portals of Amiens (Fig.
119); but in either case the Byzantine subtlety of the earlier
draperies loosened from the body and expanded into freedom
and nobility of line confined within a solemn grace. Another
celebrated instance of the sober elegance of Gothic in north-
ern France in the first half of the thirteenth century is pro-

vided by the central and left doors of the main portal of
the cathedral of Paris, excepting the large statues, which are
modern. Lovely examples of narrative simplicity in small
reliefs exist in the long double series, combined with rep-
resentations of the Virtues, Vices, and Months, beneath the
statues on the façade of Amiens (Fig. 120).

FIG. 119—PORTE MÈRE-DIEU, CATHEDRAL, AMIENS. (COURTESY OF GIRAUDON,
PHOTOGRAPHER)

The second half of the century. Many of the statues on
the cathedral of Reims conform [1] to the style of the first
half of the century. Among the best of this class are those
of the two portals of the north transept and the Samuel,
Abraham, Moses, Isaiah, St. John Baptist, and Simeon on
the right portal of the west façade. But the majority of

[1] In writing of Reims, the present tense is used for the sake of
convenience, although much of the sculpture has been destroyed.

the sculptured figures at Reims, notably the other statues of the portals of the west façade and the numerous statues scattered over the upper parts of the building, date from the second half of the century and reveal several different styles. The Virgin and St. Elizabeth of the Visitation, on the central door of the façade (Fig. 121), belong to a manner strongly influenced by the antique, which is exemplified, as a sporadic phenomenon in France, by other statues on the cathedral

FIG. 120—RELIEFS BENEATH STATUES OF HEROD AND THE THREE KINGS, FAÇADE OF CATHEDRAL, AMIENS

and which, emanating from Reims, became popular in Germany. The angel of the Annunciation on the central door (Fig. 121) embodies still another plastic fashion, which is also frequently encountered at Reims and leads directly into the art of the fourteenth century. The exponents of this fashion cultivated a more realistic expressiveness in the face, here exemplified partly by the subtle smile; they began to bestow upon the body a mannered curve; and they sought in the drapery greater involution and a more sinuous grace. Another typical instance of this more fastidious style of the

FIG. 121—CENTRAL DOOR OF WEST FAÇADE, CATHEDRAL, REIMS. (COURTESY OF GIRAUDON, PHOTOGRAPHER)

later thirteenth century is afforded by the Madonna, tympanum, and archivolts of the Porte Dorée at Amiens.

Dissemination of the Gothic style. Having cast its spell over northern France in the first half of the thirteenth century, Gothic sculpture in the second won the centre and south of the country to its allegiance, especially along the pilgrimage routes to Compostela. The renowned and captivating Last Judgment of the main tympanum at Bourges adds to the expressiveness of Reims the taste for animated and realistic episode that was to characterize the succeeding century. A well-known monument of the south is the porch of St. Seurin at Bordeaux.

The tombs of the thirteenth century. The two more pretentious classes of Gothic sepulchres, of which the type with the high base is more numerous, are well represented in the royal mausoleum, the abbey of St. Denis, by the sixteen tombs that in 1264 St. Louis caused to be constructed for his predecessors from Dagobert to Louis VI and by the tombs of his eldest son, Louis, and his brother, Philip (Fig. 122). The bases of the two latter monuments are embellished with the procession of the obsequies. The fine statue of Prince Louis is already partially felt as reposing in the sleep of death. Portraiture is begun at St. Denis in the white marble figure of St. Louis's successor, Philip III, who died in 1285 but whose tomb was not commenced until 1298.

3. The Fourteenth Century

The decoration of the cathedrals went on until the second quarter of the century; but, with the adoption of a mannered grace and elegance, the statues largely renounced their architectural feeling. For the sake, however, of making some show at connection with the edifice, they were sunk in architectural niches in place of the protruding shrines of the thirteenth century. A good example of the style of the period is afforded by the decoration of the more easterly part of the cathedral at Bordeaux.

The portal of the north transept contains at the centre a restored effigy of Pope Clement V and at the sides six prelates. Although the heads of the six prelates are already somewhat individualized, the figures are still in a rather sober style. It is in the tympanum and especially in the statues upon the buttresses of the apse that the new forms, the new drapery, and the new feeling appear. An absolutely characteristic specimen of the style in an

FIG. 123—VIRGIN. CATHEDRAL, PARIS

American collection is the St. John Baptist of the Metropolitan Museum (accession no. 16. 32. 39). The small anecdotal panels are more typical of the sculptural embellishment of architecture in the fourteenth century. Notable instances are: the Porte des Libraires of the cathedral at Rouen, especially the grotesques; the scenes from the life of the Virgin set into the exterior chapel walls of the east end of the cathedral of Paris; and the façade of the cathedral at Lyons, including illustrations of contemporary short stories and *genre* from every-day life. A lovely instance of the an-

ecdotal interest applied to interior decoration is the series of reliefs from the life of Christ on the choir-screen of the cathedral of Paris by Jean Ravy and his nephew Jean le Bouteillier. The mode of the fourteenth century is most unmistakably illustrated by the many separate devotional statues of the Virgin and Child (Fig. 123). Their expression is likely to tend towards "smiling coquetry" or, in accordance with the growing inclination for pathos, to sorrowful musing. In general, the kindly queen of the early thirteenth century

FIG. 124—CHARLES V AND JEANNE DE BOURBON. LOUVRE, PARIS. (PHOTO. GIRAUDON)

gradually assumed the mien of a more ordinary woman. In no other class of sculpture is the characteristic curve of the body more apparent.

The School of Paris. As the year 1400 approached, the style of the fourteenth century tended to assume at Paris a more individual form. A colony of Flemings had been establishing themselves at the French capital since the beginning of the century; the chief of these in the second half of the century was the painter and sculptor, André Beauneveu (active 1360-1403). To them it has been the custom to ascribe the more decided realism that marked the ebbing

of the fourteenth and the incoming of the fifteenth century. But it cannot be demonstrated that the sculpture of Flanders up to this moment had revealed any greater predilection for realism than that of the other countries of Europe, and native French sculptors were also prominent in Paris. A sounder criticism would conceive of the proclivity towards realism as a generally prevalent characteristic of the period, developing into a more emphatic form at Paris because the vigorous artistic atmosphere of the great city fostered all new movements. Realism found an expression not only in sepulchral effigies, but also in portrait statues, which now began to be popular. The figures of Charles V and his queen Jeanne de Bourbon were erected not only at one entrance to the old Louvre but also at the portal of the chapel of the Célestins. The two latter statues, by an unknown sculptor, are still extant in the Museum of the Louvre (Fig. 124). Both are superb examples of the best mediæval portraiture. The queen, instead of being rejuvenated as in earlier idealistic sculpture, is represented as much older than she actually was in order that the artist may have opportunity for a realism that is more unsparing.

The tombs. The draperies even of sepulchral effigies were somewhat more flowing and involved than before, but the rigidity of death imbued them with greater conservatism than was retained in the decorative sculpture of churches. Portraiture was definitely achieved in the monument of Charles V at St. Denis by André Beauneveu. The fixed type of the French knight, clad in armor, with shield at side and hands pressed together in prayer, is well exemplified in St. Denis by the effigies of the two constables, Bertrand du Guesclin and Louis de Sancerre, who died respectively in 1380 and 1402. In both these instances, the portraiture is more realistic than in the figure of their master, Charles V. With a slight variation, the knights of Burgundy hold in their hands a lance. The more pretentious adornment of tombs in the fourteenth century may be illustrated by the monuments of the popes at Avignon; one or two of these carry the elaboration to the point of constructing an opulent canopy over the effigy on a free-standing base.

4. The Fifteenth Century

The School of Burgundy. Origins. An important constituent of the Burgundian style of the fifteenth century was a pronounced strain of Flemish, or, according to other critics, German realism. The chief master of the school during its early period, Claus Sluter (d. 1406?), was probably of Dutch extraction, but he may have had German blood in his veins. In any case, direct Flemish influence was constantly exercised at the Burgundian court through the political connection with the Low Countries and through the presence at the capital, Dijon, of a series of Flemish artists. On the other hand, no sudden change took place in the tradition of French sculpture. Throughout the preceding century, especially in the Parisian school, it had been slowly moving toward the consummation now achieved in Burgundy. Indeed, the principal immediate predecessor of Sluter in the employ of Philip the Bold, the Fleming Jean de Marville, had been drawn from the Parisian school; and the only piece of sculpture that can be ascribed to him with any degree of surety, the Virgin on the portal of the Carthusian monastery at Champmol in the environs of Dijon, does not differ essentially from the work of Sluter on the same monument, although, in this instance, Jean de Marville may have learned from the Dutch master. However the problem of origins be solved, the borrowings were transformed, elaborated, and treated in a new spirit, so that it is possible to speak of a distinct Burgundian school. Inasmuch as somewhat more massive bodies and copious draperies had already differentiated Burgundian sculpture even in the earlier Gothic period, it is perhaps legitimate to distinguish a native Burgundian strain in the work at Dijon during the fifteenth century.

Monuments at Champmol. At the death of Jean de Marville in 1389, Claus Sluter brought the portal of Champmol to completion. In addition to the statue of the Virgin, it includes at either side the portraits of Philip the Bold and his wife, accompanied by Sts. John the Baptist and Catherine. He next erected a magnificent well in the cloister of the Carthusian monastery, of which the pedestal for the Calvary

FIG. 125—CLAUS SLUTER AND CLAUS DE WERVE. PEDESTAL FOR CALVARY OVER A WELL. CARTHUSIAN MONASTERY, CHAMPMOL, NEAR DIJON

has been preserved *in situ* and the bust of the Crucified in the Museum of Dijon. He himself did all except the angelic caryatides, for which he drew the designs but the execution of which he left to his nephew and assistant, Claus de Werve (d. 1439). The statuary of the pedestal (Fig. 125) is a crystallization of the kind of Mystery Play known as the *Judgment of Jesus*, in which the Prophets upheld in debate the necessity of the atoning sacrifice on the cross. The individualization and realism of the heads and postures are

FIG. 126—CLAUS SLUTER AND CLAUS DE WERVE. TOMB OF PHILIP THE BOLD.
MUSEUM, DIJON

more penetrating than in previous French sculpture. The heaviness of the stuffs with deep-cut folds reproduces the Flemish fabrics that were then the vogue, and their all-enveloping, majestic amplitude is also derived from contemporary costumes. The involution, however, is less than in some work of the fourteenth century, and the folds are not so broken as in Flemish art. By realizing the dignity of man and by imbuing the Prophets with a lofty intellectuality, Sluter ennobled his realism and differentiated it from the homely naturalism of the Flemish.

The tombs. Two other famous Burgundian monuments,

now in the Museum at Dijon, are the almost identical tombs of Philip the Bold (Fig. 126) and of John the Fearless and his wife, Margaret of Bavaria. The former, designed possibly by Jean de Marville, was begun by Sluter; but after Sluter's death, the greater part remained to be executed by his nephew and to be brought to completion in 1411. The latter tomb, ordered from Claus de Werve as early as 1410 and probably designed by him, was begun sometime after his death by a wandering artist of fortune, the Aragonese, Jean de la Huerta, and not finished until 1469, long after the Duke John's decease, by Antoine le Moiturier (d. 1497). The tombs in form are more pretentious examples of the type employed in St. Denis for the son and brother of St. Louis. The mourners are emphasized, and much augmented in number. The mourning costume is more conspicuous, and its capabilities of variation and gyration in the Burgundian mode are ingeniously used to stress the endlessly and wondrously differentiated expressions of sorrow, which embody the dramatic emotionalism of the school. Like the angel upon the well of Champmol who wipes his eye, some of the cortège, especially one who blows his nose and another who cleans his ears, approach dangerously near to the *bourgeois* quality of Flemish realism.

Later history of the Burgundian style. After about 1440 the sculptural production of this school, in Burgundy itself, had already begun to languish. The first extant detached Entombment or Holy Sepulchre of 1454 at Tonnerre (Fig. 127) is in a Burgundian style that already inclines somewhat towards the mildness of the *détente*. Except in the Ile-de-France, Champagne, and the region of the Loire, however, the influence of the Burgundian movement was felt throughout the country, particularly in the second half of the fifteenth century.

The School of Paris. Despite the national disasters in northern France, the Parisian masters, continuing and developing the style of the court of Charles V, still found some employment at the first of the century, especially on sepulchres. The more essentially religious work of the school is represented by one of the loveliest creations of French genius, the

Coronation of the Virgin, on the castle of La Ferté-Milon. The draperies have the greater amplitude, simplicity, and rhythmic flow which developed in the sacred sculpture of northern France about 1400 as well as in Burgundy; but here and elsewhere in Parisian work, they are less swollen and more keen-edged than in Burgundian examples.

Franco-Flemish work other than Parisian. A long series of monuments, extending even into the first half of the six-

FIG. 127—HOLY SEPULCHRE. HOSPITAL, TONNERRE. (PHOTO. GIRAUDON)

teenth century, were produced by French artisans working in the Flemish manner by themselves or together with Flemish masters. Typical is the relief above the door of the chapel of the château of Amboise, dating from the end of the fifteenth century and representing St. Christopher and the Vision of St. Hubert, in which the stress upon landscape setting, upon scenic properties, and upon elaborate composition is peculiarly Flemish. The choir-stalls provide the most characteristic examples of the anecdotal reliefs of the Low

Countries, because the manipulation of wood was a national gift of the Flemings, and their French imitators readily adopted their peculiarities. Some few sets had been carved in the earlier Gothic period, but they were now multiplied from one end of the country to the other. Among the best from the second half of the fifteenth century are those of the cathedral of Rouen; the superb series of the cathedral of Amiens illustrates how, at the first of the sixteenth century, a few Renaissance details made their appearance.

Sculpture leading to the "détente." For the region of the Loire, the term *détente,* or "relaxation," of realism is a misnomer, since the asperities of the Burgundian and Flemish styles had there found but little favor, and the older tradition of French sculpture was uninterrupted. The few specimens extant from the first three quarters of the fifteenth century show that the artists of the Loire continued to work in the style of the fourteenth century, but they gradually learned to abandon the mannerisms of intricate drapery, studied pose, and winsome countenance with which jaded idealism during that period had cloaked its *ennui,* and they adopted a mild realism. Among the most notable monuments are the statues of feminine saints in the chapel of Châteaudun (about 1464) and, in the same manner as these, a St. Catherine in the Metropolitan Museum (accession no. 07.197). Along the Loire, therefore, the mature style of the *détente* at the end of the fifteenth and beginning of the sixteenth centuries was not produced, as in other sections of France, by relaxing the harshness of realism and the tumult of draperies; it consisted simply in the persistence of the gentler æsthetic tradition that had prevailed unbroken in this district throughout the Gothic period, now slightly modernized and taking on more definite local characteristics which enable the critic to speak of a unified school. In parts of the rest of France, where realism had held sway, the tendency to a *détente* began to assert itself, sporadically, as early as the middle of the fifteenth century, in a gradual abandonment of the Burgundian and Flemish peculiarities. The Burgundian style, for instance, is obviously softened in the carvings upon the house of Jacques Cœur at Bourges.

5. The *Détente*

General characteristics. The *détente* was a partial return to the lofty and simple idealism of the thirteenth century, which, indeed, had never been quite eclipsed; but it was only a partial return, for its exponents could not be oblivious of the intervening conquests of realism. They drew their types from actual life, even from popular life, but they ennobled them, avoiding the extremes and the eccentricities both of the Burgundian and the Flemish schools. The *détente* manifested itself particularly in bewitching feminine figures, and here it is easy to recognize the starting point in the French woman of the middle or peasant classes. The draperies of the *détente* reacted against the ponderous elaboration of Burgundy and the angular pettiness of Flanders towards naturalism and a comparative simplicity. The realistic interest was concentrated upon a free adaptation of contemporary costume and upon an attention to precise detail rather than upon the individualization of figures. Although the Italian Renaissance occasionally supplied ornamental details to French monuments, and although the sculpture of Italy in the Quattrocento afforded certain analogies to the creations of the *détente,* especially in tempered realism, during the fifteenth century the foreign style had not sufficiently penetrated France or produced enough distinguished examples in the country to have had any part in the formation of the movement.

Monuments of the Loire. Michel Colombe and his school. By the end of the fifteenth century the *détente* was general throughout France, extending even to Burgundy, but its centre was the region of the Loire, especially Touraine. One of the best specimens of the prolific output of the movement in this district is the Holy Sepulchre of the abbey of Solesmes (1496), the architectural setting of which is already decked with pilasters of the Renaissance. This justly famous monument has sometimes been ascribed to Michel Colombe, the greatest exponent of the *détente* in Tours, where, though he was born at Saint Pol-de-Léon in Brittany about 1430, he had set up his shop at least as early as 1473. His only

undoubtedly authentic works that are extant were done in his old age. His greatest achievement was begun in 1502, the tomb of Francis II of Brittany and his wife, now in the cathedral of Nantes (Fig. 128). Both the material, white marble, and the architectural decoration are Italian; and the

FIG. 128—COLOMBE. TOMB OF FRANCIS II OF BRITTANY. CATHEDRAL,
NANTES

painter, Jean Perréal, who seems to have designed the monument, superimposed certain Italian items upon the French sepulchral iconography—the twelve apostles in niches on the longer sides and detached statues of the four cardinal Virtues at the corners, which had hitherto not been admitted to French tombs. The mourners had to be relegated to rows

of smaller medallions beneath the tier of the Apostles and other saints. The actual execution of the design, by Michel Colombe and his pupils, is thoroughly French, and constitutes the most beautiful expression of the *détente*. His only other certain work, with the exception of a medal for Louis XII, is the marble panel of St. George and the Dragon done in 1508 or 1509 and now in the Louvre. After his death between 1512 and 1519, his style lived on through the first quarter of the century with almost undimmed loveliness in the hands of his immediate followers. Among these, the only one who can be absolutely connected with a definite monument is

FIG. 129—ST. ANNE AND VIRGIN. CATHEDRAL, BORDEAUX

his nephew, Guillaume Regnault, the author of the recumbent forms of Louis Poncher and his wife, Roberte Legendre, for the tomb of which the fragments have been gathered in the Louvre. The appeal of the movement is perhaps felt most irresistibly in a series of Virgins, the best of which, worthy of Michel Colombe himself, is the Vierge d'Olivet in the Louvre.

The "détente" in the rest of France. School of Champagne. In other regions the *détente* was probably evolved through a spontaneous evolution and not necessarily through the influence of Touraine. The multiplicity of examples are all so lovely that it is hard to select any one for special mention. Certainly no other is more alluring than the group of St. Anne and the Virgin in the cathedral of Bordeaux (Fig. 129), a theme that was very popular during the *détente* because its sweet domesticity accorded with the spirit of the movement.

Another instance of this subject, also produced by some master of the *détente*, may be seen in the Metropolitan Museum (accession no. 16.32.31). The same Museum possesses further characteristic examples of the movement in a Holy Sepulchre and a Pietà from the Château de Biron. It was Champagne, however, that in the first quarter of the sixteenth century harbored the most significant school of the *détente*, outside of Touraine. Its highest achievements, almost Hellenic in their purity of taste and intimate idealism, were produced by the *atelier de la Ste. Marthe*, so called from one of the definitive statues of the workshop, a St. Martha in the church of the Magdalene at Troyes. The masterpieces of the *atelier* are two Holy Sepulchres at Chaource and Villeneuve - l'Archevêque. The utterly captivating statue of a feminine saint in the Museum at Princeton (Fig. 130) belongs to the same period and perhaps to the same workshop. The drapery in the school

FIG. 130—FEMININE SAINT. MUSEUM, PRINCETON. (COURTESY OF PROFESSOR ALLAN MARQUAND)

of Champagne soon began to assume studied complication through the influence of Flanders or of advancing Italianism;

and although sculptural activity continued here unabated, the French style of the *détente* succumbed before the conquests of the Renaissance.

The thirteenth century. Throughout the thirteenth and for the first two-thirds of the fourteenth century, the sculpture of Belgium continued to be chiefly an offshoot of the production of France. Even when the later vandalism of the Protestants is taken into account, the small amount of monumental plastic decoration that remains indicates that it was here never so enthusiastically cultivated. Of the thirteenth century, the two principal examples are the sacred figures in the lowest row upon the façade of the cathedral of Tournai (if these are not rather to be assigned to the early fourteenth century) and the rather provincial double tympanum of the Hospital of St. John at Bruges. The proximity of Holland and of the banks of the Meuse to Germany introduced a Teutonic strain into the sculpture of this region during the Gothic as during the Romanesque period. The great south portal of St. Servatius at Maastricht belongs to the group that in the early thirteenth century comprises such doors as those of Freiberg and Münster.

The fourteenth century. Belgium and Holland did not exhibit signs of the oncoming realism earlier than other countries. If the phenomenon was to manifest itself anywhere, it might be looked for first in an attempt at portraiture in sepulchral effigies, but an unprejudiced eye fails to discern it in the Flemish tombs either of the thirteenth century or of the first seventy years of the fourteenth. Nor does the monumental decoration of the fourteenth century, the chief extant specimen of which is the somewhat Teutonic Bethlehem portal of Notre Dame at Huy, proceed any farther along the road towards realism than the contemporary work of France. The usual mannered Virgin of the fourteenth century may be illustrated, in an extreme aspect, by the statue in the Baptismal Chapel of the cathedral of Antwerp. Even the

late and peculiarly French types of realism at the end of the fourteenth and beginning of the fifteenth centuries were sporadically imitated in the Low Countries: the Franco-Flemish manner of Beauneveu and the Parisian *milieu*, for instance, by the superb St. Catherine of Notre Dame at Courtrai; the Burgundian manner by the Virgin on the south portal of Notre Dame at Hal.

Flemish realism of the fifteenth century. Realism was not, then, a creation of the Low Countries; but the tendency that manifested itself everywhere in Europe in the fifteenth century also assumed in Flanders a peculiarly Flemish form. Instead of large and impressive statues, the Flemish mind found satisfaction in little figures, multiplied, on the screens and retables, into the familiar crowds of the streets, repeated on the portals with that addiction to rhythms of small objects at short intervals which is characteristic of the art of the Low Countries. The postures and gestures of the figures were adopted from the ordinary sights of every-day experience. The draperies were broken into numerous small and complicated divisions in contrast to the great sweeping expanses of Burgundy. The sculptors carried their realism so far as to call into service also the resources usually considered peculiar to painting. The pictorial accessories of landscape and architecture were freely introduced; pictorial perspective was occasionally attempted, with the more remote forms diminished in size; the groups were arranged in pictorial compositions; and the artists permitted themselves a violence of gesture and movement that is commonly deemed inconsistent with the mediums of sculpture. The commercial environment made the plastic art an industry. The producers were shops with their trade-marks rather than individual artists conscious of their high calling. The articles manufactured were sold broadcast throughout Europe—the sepulchral slabs of Tournai, the metal-work of Dinant, the wooden retables of Brabant and Antwerp. Wood, indeed, was the favorite Flemish medium because of the greater ease with which it could be exported.

Sepulchral sculpture. At the end of the fourteenth and commencement of the fifteenth century, when the Low Coun-

tries begin to shake off their æsthetic dependence upon France and Germany, the first signs of realism may be discerned in a peculiar kind of *epitaph* manufactured at Tournai but soon imitated by the craftsmen of other towns. In these reliefs, for the well established effigies of the saints, the sculptor naturally clung to the old traditions of his shop, but the figures of the dead, whether actual or imaginary portraits, offered opportunity for the cultivation of the new realism.

FIG. 131—*EPITAPH* OF ROBERT DE QUINGHIEN. MUSEUM, TOURNAI. (PHOTO. PHONO-PHOTO, TOURNAI)

An interesting example is afforded by the *epitaph* of the canon de Quinghien (1429) in the Museum of Tournai, perhaps by the great painter, Roger van der Weyden (Fig. 131). For the sepulchral monuments in bronze it has usually been considered that Jacques de Gérines of Brussels (active 1392-1463) was one of those most in requisition, but there are some who would now make him only a caster of others' models. His monument of Louis de Mâle at Lille perished in the French Revolution, but extant drawings of the accompanying statuettes, representing the members of the Burgun-

dian ducal family, make it possible to identify the ten bronze figures now in the Ryks Museum of Amsterdam as designed for this tomb, although replaced by others, or as executed by Jacques de Gérines for some other destination in an identical style. They are among the most appealing examples of Flemish realism, especially the feminine effigies, and suggest vividly the painted portraits of Jan van Eyck.

FIG. 132—ROOD-SCREEN, ST. GOMMARIUS, LIERRE. (PHOTO. BECKER)

Ecclesiastical furniture. The principal ecclesiastical decoration of the fifteenth and early sixteenth centuries consisted in the application of small figures and especially small scenes from sacred story in large numbers to elaborately wrought articles of religious furniture. Characteristic specimens are: the screen of the sixteenth century at Lierre (Fig. 132), the tabernacle in St. Jacques, Louvain, and the choir-stalls of Ste. Gertrude at Louvain and of the church at Breda.

The retables. The Flemish retable was divided into a

number of compartments, side by side or sometimes also one above the other. The compartments were occupied by crowds of figures in animated episodes and were covered by canopies of luxuriant Gothic lacework. To give the impression of actual human beings, the figures were usually detached in the round. The commonest themes were the Passion of Our Lord and the life of the Virgin. In the last quarter of the fifteenth century Brussels and Antwerp became busy emporiums for the manufacture and exportation of retables. The greatest carver of these objects in the former city was Jan Borreman (active c. 1479-1522), whose chief extant retable in Belgium, now in the Musée du Cinquantenaire at Brussels, embodies the legend of the tortures of St. George (Fig. 133). A weaker sensibility to beauty of form, to existence in three dimensions, and to correctness of modelling differentiated the products of Antwerp from the masterpieces of Brussels. The panels were more crowded with actors, violence of posture often degenerated into frenzy and homeliness of gesture into vulgarity, the drapery was thrown into a seething mass, the figures and their frames are heavy beneath gaudy color and lavished gold. It must be remembered, however, that the great majority of the examples come from a later period than the best work of Brussels, from the very end of the fifteenth and the first half of the sixteenth century, when the qualities of Flemish sculpture in general were exaggerated. The earlier retables of Antwerp, such as that in the church of Ste. Materne, Tongres, betray only premonitions of extravagance.

Holland. Mention has already been made of two or three monuments in Holland connected with the general Flemish development. The Dutch critic, Pit, would discern in other monuments from the fifteenth and sixteenth centuries certain slightly differentiated national traits—heavier but simpler draperies, the familiar Dutch cast of countenance, a still further accentuation of the homely realism characteristic of the whole region of the Low Countries. Such works as the Epiphany of the Episcopal Museum at Haarlem or the Visitation and organ panels of the Ryks Museum at Amster-

FIG. 133—JAN BORREMAN. CENTRAL SECTION OF RETABLE OF ST. GEORGE. MUSÉE DU CINQUANTENAIRE, BRUSSELS.
(COURTESY OF MR. C. BEMELMANS)

dam foreshadow the great Dutch *genre* painting of the seventeenth century.

D. GERMANY AND RELATED COUNTRIES

1. Introduction

General characteristics. The Romanesque plastic style of Germany might, of itself, have developed into Gothic; but, as a matter of fact, there was a new importation of Gallic influences, and in the thirteenth and fourteenth centuries, German sculpture was dependent upon French, though with very pronounced national traits. Throughout its history Gothic sculpture in Germany was more realistic than in any other country of Europe. In the thirteenth century it was less idealistic; in the century of realism, the fifteenth, it out-Heroded Herod. From the first there existed a tendency to greater expressiveness, which finally degenerated into emotional extravagance. A certain restlessness permeated even the drapery. Already agitated in the early Gothic period, it subsided in the developed art of the thirteenth century, but it ended in the fifteenth century by committing the wildest and most capricious excesses. Compensation for this relative lack of taste may be sought in the energetic strength of the figures and in a technical skill that occasionally surpasses the attainments of other Europeans.

The style of the thirteenth century. The greater realism and expressiveness, the livelier postures and draperies, partially destroyed the architectural lines that were still preserved in the carvings of France. The realistic proclivity introduced into the sculpture of religious edifices more secular matter than was admitted in France, especially effigies of the noble founders of the churches. The subject of the Wise and Foolish Virgins enjoyed a peculiar popularity as a compromise between the sacred and the profane. The great centres of monumental Gothic sculpture were Saxony and the adjacent districts in the contiguous provinces, particularly Westphalia and Franconia.

2. The Transition

The more national monuments. At the end of the twelfth and beginning of the thirteenth century, in a series of examples, chiefly stucco or stone choir-screens, it is possible to observe that gradual infusion of German Romanesque forms with naturalism which might have ended in Gothic without foreign interference, if the importation of the new style from France had not stunted the movement. The crossing of the legs, the twisted or spiral folds, the coupling of the sacred personages in conversation, suggest that these sculptures owe something to Romanesque France, but they certainly owe as much to the ivories of Byzantium, which, because of relations between Germany and the court at Constantinople, continued in the twelfth century to exercise a potent influence. With the transitional French school of Chartres there is not necessarily any connection. The principal monument, slightly later than the others, is the stone screen of the cathedral of Bamberg, the masters of which have already achieved or adumbrated the typical qualities of German sculpture in the thirteenth century. The varied postures and gestures of the sinewy figures are dramatic and intense; the realistic cast of the features is frankly Teutonic; and the folds of the garments are restlessly contorted. In the same cathedral, the door of the northeast tower, the tympanum of which represents the donation of the church by the sainted king, Henry II, and his queen, Kunigunde, is still very Romanesque and similar in style, although the mood and the draperies are less vehement and the date is probably later. On the columns at the left of the Portal of the Princes, at least the majority of the Apostles and the Prophets would also seem to belong to the earlier workshop of Bamberg.

The French influence. Intermediate between this movement and the fully developed style of the thirteenth century lies another large group of monuments in which, generally speaking, the Byzantine and Romanesque elements are fewer and less pronounced, the familiar earmarks of Gothic more apparent, and the influence of early French Gothic is clearly

perceptible. The examples date usually from the first third of the century. The most celebrated representative of this group is the Goldene Pforte of the cathedral at Freiberg (Fig. 134), really the first great portal of German Gothic, the elaborate iconographical scheme of which was suggested by the monuments of the Ile-de-France. The slim types of

FIG. 134—FREIBERG. GOLDENE PFORTE. (PHOTO. DR. FR. STOEDTNER, BERLIN)

Romanesque sculpture are replaced in the tympanum and in the larger statues below by more substantial German figures, impressive in their solid and practical piety; the primitive formalism of drapery has given way to much freedom and flowing grace. The more provincial artisans who executed (with the exception of five later statues) the south portal of Münster in Westphalia were ruder workmen than their Saxon brothers.

THE MIDDLE AGES

53

3. The Developed Style of the Thirteenth Century

Classification in schools. The mature sculpture that dates from the last two-thirds of the thirteenth century may be divided into two broad classes: the Saxon, more directly related

G. 135—ST. GEORGE (?). CATHEDRAL, BAMBERG. (PHOTO. DR. FR. STOEDTNER, BERLIN)

to the previous carvings of the province, more German in temper, and, in the midst of the general French influence, often revealing a particular dependence upon Reims; and the Rhenish, produced by a more immediate but far from servile study of French models, especially those of Paris and of the lateral portals of Chartres.

The Saxon group. Bamberg, though not absolutely in

Saxon territory, affords the best illustration of a connection
with Reims. The sculpture of the cathedral that belongs to
this period includes: on the Portal of the Princes, the alle-
gorical figures of the Church and the Synagogue, the Apostles
and Prophets on the columns at the right, and the tympanum;

FIG. 136—EKKEHARD AND UTA. WEST CHOIR, CATHEDRAL, NAUMBURG.
(PHOTO. DR. FR. STOEDTNER, BERLIN)

the Portal of Adam in the southeast tower; and a series of
statues within the church. Of numerous instances of a rela-
tionship so direct that it is necessary to assume that the
artists of Bamberg spent a long period of apprenticeship at
Reims, the following must suffice to prove the point: the
Church and the Synagogue, derived from the similar per-
sonifications beside the rose-window of the south transept at

Reims; the superb equestrian statue of St. George (St. Stephen of Hungary or Conrad III?) (Fig. 135) in the interior, suggested by a young standing King on the exterior of the north transept of Reims; and the group of the Visitation, also inside the church, imitating the antiquarian style of the identical subject on the central door of the French cathedral. The very parallelism between these two supreme examples of two nations' art throws into stronger relief their differences. In the German figures a higher degree of individualization and an almost tragic intensity are distinctly evident. The general reliance upon German types of humanity may be gauged by comparing the Marys of the two Visitations. The greater size and weight of the Teutonic bodies appear to best advantage in the Church and the Synagogue, who possess the heroic beauty of Valkyrs. Germanic technical skill here reaches its acme in the delineation of the diaphanous fabrics and the lovely feminine forms emerging everywhere beneath them. The best known production of Saxony itself is found in the twelve statues of benefactors of the cathedral in the west choir of Naumburg (Fig. 136). Though not strictly portraits, they are the most imposing instances of powerful individualization in the thirteenth century. The masculine figures are more forceful than attractive, the straining after expressiveness has rarely proved successful, but one or two of the women, especially the Markgräfin Uta, have true physical and spiritual beauty.

The Rhenish group. For the sculpture of this period the most important monument on the Rhine is the cathedral of Strassburg. To the first half and middle of the century belong the Church, the Synagogue, and two tympana with the Death (Fig. 137) and Coronation of the Virgin on the portal of the south transept, and within the south transept a pier adorned with the participants in the Last Judgment arranged in three tiers. Since the sculptors of these works must have been actually educated among the masters who in the thirteenth century executed the carvings of Chartres and Paris, their productions possess slimmer proportions and greater refinement, elegance, and simplicity than those of their Saxon rivals. Occasionally, however, as in the Death of the Virgin,

a poignant intensity suggests the German strain. The wealth
of sculpture on the triple portal of the west façade, dating
from the end of the thirteenth and the beginning of the next
century, not only exhibits the characteristic traits of the later
period but also reverts to physical types that are more essen-
tially Teutonic.

FIG. 137—DEATH OF THE VIRGIN, PORTAL OF SOUTH TRANSEPT, CATHEDRAL,
STRASSBURG. (FROM DEHIO AND VON BEZOLD, "DIE DENKMÄLER DER
DEUTSCHEN BILDHAUERKUNST")

The tombs. In distinction from the practice in France, the
effigy was still executed in relief much more commonly than
in the round. As already in the Romanesque period it was
sometimes represented as if in a kind of open stone box,
sometimes was left unframed. Occasionally the bases of the
monuments were very low. The tomb of Duke Henry
IV of Silesia in the Kreuz-Kirche at Breslau exemplifies the
class of Gothic sepulchre in which the figure is placed upon a
high base carved with the ceremony of the obsequies. It is
surprising, when one remembers the architectural statues of
the period, that there was little more attempt at portraiture

than in France. Some individualization may perhaps be here and there discerned, for instance, in the tomb of Henry the Lion and his duchess at Brunswick, but this belongs to a small group that differ in a more essential respect from French examples: the extraordinarily free and ample draperies have the agitation that has been noted in the architectural sculpture of the transition from Romanesque to Gothic, with which the mortuary series is probably contemporary. These sepulchres are exceptional in Germany also because they begin to recognize the recumbent posture.

4. The Fourteenth Century

Monumental sculpture. In Germany, as elsewhere, the local divergences that we have observed in the thirteenth century were effaced, and everywhere the single international style was employed, which Germany joined with the other countries of Europe in borrowing from France. The greater individualization of the personages that had been the distinction of Germany in the thirteenth century was abandoned for fixed types, which differed from the French only in the choice of Teutonic features. The wonderful use of the garments to define the character and thought of the figure was sacrificed to the familiar amplification and undulation. The small scenes from sacred narrative often exhibit the proclivity for homely realism that in the next century was to become so characteristic of Germany. Saxony and the north in general, with the exception of the region of the Rhine, resigned the important rôle that they had hitherto played in the history of sculpture. Here and there indigenous tendencies put in a timid appearance amidst the universal style. The Christ, Virgin, and Apostles on the pillars of the choir of the cathedral at Cologne are distinguished by the expression of mystical intensity so characteristic of the art of this city. The portals of the cathedral of Ulm are among the chief monuments of Swabia, where already there began to manifest itself that tendency towards softness and sentiment which was to develop into a kind of *détente*. Nuremberg is very rich in

sculpture of the fourteenth century, and it was amidst the
vigorous civic life of this town that indigenous qualities es-
pecially declared themselves. The heads of the heroes from
the Schöner Brunnen, now in the Museum of Nuremberg,
have more reality than was common at the period; the seated
Apostles of terracotta, six in the Museum and four in the
church of St. James, are strongly individualized; the sacred

FIG. 138—(READING FROM LEFT TO RIGHT) TOMBS OF ALBERT VON HOHEN-
LOHE, CATHEDRAL, WÜRZBURG; KONRAD VON WEINSBERG, CATHEDRAL,
MAYENCE; GERHARD VON SCHWARZBURG, CATHEDRAL, WÜRZBURG. (FROM
DEHIO AND VON BEZOLD, "DIE DENKMÄLER DER DEUTSCHEN BILDHAUER-
KUNST")

narrative in the tympana of the churches of St. Sebaldus and
of St. Lawrence is related with Teutonic *bonhomie*. Germany
has also her mannered and often charming Madonnas of the
fourteenth century. Typical specimens may be seen in St.
Gereon, Cologne, and (with the three Magi) on a pier of the
cathedral of Würzburg.

The tombs. The sepulchral monuments now greatly in-
creased in number. Already in the fourteenth century, the

simple slab was occasionally exalted from its former place
on the pavement to an upright position on the wall. For the
ordinary high base there were now sometimes substituted four
pillars, or more rarely two vertical planes or the bodies of
lions, so that the tomb looks like a table upholding the
effigy. Now and then, on the floor beneath the table, was
placed another slab with another effigy. So in the Wilhelmer-
Kirche at Strassburg, the canon Philipp von Werd is repre-
sented beneath his brother, Count Ulrich. Although the
figure was sometimes enclosed in a kind of case and some-
times was left unframed, in many other instances it was
surrounded by Gothic architectural detail, giving the effect
of a body ensconced in a shrine, occasionally with statuettes
in the lateral sections or with a projecting *baldacchino* above
the head. In other examples the Gothic ornament was com-
bined with the old casing. The development of portraiture
earlier than in the rest of Europe betokens the reassertion of
the German spirit (Fig. 138).

5. The Fifteenth and Early Sixteenth Centuries

General characteristics. In Germany, the realism typical
of the period was more accentuated and brutal. The rise of
the people in the great industrial towns to the position of
patrons often gave it a tone that was perhaps even more
bourgeois than in the Low Countries. The general German
tendency to excess transformed grace into affectation, over-
loaded the monuments with ornament, and exaggerated the
expressiveness of face and body. Although the Germans were
seldom able to attain genuine dramatic power, they fre-
quently infused the figures, especially in the school of Swabia,
with intense and even tragic feeling. The European epidemic
of complicated drapery reached an alarming stage, partly
through a desire for pronounced pictorial effects of chiar-
oscuro. The nature of the favorite material of the age, wood,
played its part also in breaking up the drapery into small,
brittle, knotty folds, often intersecting in confused patterns;
and the peculiarities of wood were either transferred to other
mediums or appeared there spontaneously. At the beginning
of the sixteenth century, such men as Riemenschneider were

inclined to return to a more orderly and dignified arrangement of longer folds, but between these folds the old disease still retained a certain hold. The late Gothic of Germany, especially in its love of display and pictorial effect, may be conceived as the baroque stage of early Gothic; and though it has the defects of the baroque, it also has the merits of the style, a compelling emotional abandon and an impressive grandiloquence. The plastic output may be divided into two great geographical groups, the northern and the southern. The former was largely dependent upon the Low Countries. The latter, though here and there subject to foreign influence, was thoroughly German and far more significant.

The retables. The essentially German retable was evolved in the south. The centre is occupied by a large box, usually rectangular (*Schrein*), containing the representation of a sacred scene, a row of sacred personages, or a combination of both *motifs*. The space of the *Schrein* is sometimes divided into a horizontal series of large compartments, but in the south the vertical superimposition of one compartment upon another is very rare. The *Schrein* is flanked by single (sporadically double) wings, which ordinarily open and shut. The painted subjects connected with the main theme of the *Schrein*, with which it seems to have been the earlier custom to decorate the wings, are often replaced by carved reliefs, which may be single large representations or, much more rarely, a set of smaller representations or figures side by side or above one another. Over the *Schrein* rises an elaboraté Gothic structure of florid turrets and open-work, enclosing statues or even scenes. The retables of northern Germany imitate the Flemish.

Northern Germany. In the north it is only the retables that have any universal significance. The greatest centres for their manufacture were Calcar on the lower Rhine and Lübeck in the Hanseatic region. The two chief names are Heinrich Douwermann (active 1510-1544), whose altarpieces may be seen at Calcar, Cleve, and Xanten, and Hans Brüggemann (*c.* 1480-*c.* 1540), who, in his celebrated retable now in the cathedral of Schleswig, realized more than his rivals the stockier and ruder German type of humanity.

Southern Germany

Franconia. The School of Nuremberg. The sculpture of Franconia was distinguished by passionate intensity and a pronounced love of the dramatic. Of the two principal artistic cities, Nuremberg and Würzburg, the former was the more important. The two greatest sculptors of Nuremberg who still belonged essentially to the Middle Ages

FIG. 139—VEIT STOSS. DEATH AND ASSUMPTION OF THE VIRGIN. ST. MARY'S, CRACOW. (PHOTO. LANGEWIESCHE)

were Veit Stoss and Adam Krafft. Not only do critics disagree about the date of the former's birth, which is set even as early as 1431, but the place itself is in dispute, since both Poles and Germans claim him as a fellow-countryman. Certain it is that he was active at Cracow from 1477 to 1496 and at Nuremberg from 1496 until his death in 1533. The main elements of his art, in any case, seem to have been evolved from precedents in the latter city. His powerful individuality vented itself in the dramatic force and harsh

realism of his personages. The perturbation of the forms is transmitted to the draperies, which are pulled, wound, and broken into the most tumultuous shapes and are often tossed up over or beside the body in arbitrary swirls. Among his most characteristic achievements are the Death and Assump-

FIG. 140—KRAFFT. STATIONS OF THE CROSS. GERMANIC MUSEUM, NUREM-BERG. (FROM DEHIO AND VON BEZOLD, "DIE DENKMÄLER DER DEUTSCHEN BILDHAUERKUNST")

tion of the Virgin, the *Schrein* of his first great retable, in St. Mary's, Cracow (Fig. 139), and the Annunciation, the centre of the great Rosary hung over the choir of St. Lawrence at Nuremberg. Essentially a wood-carver, he used the deep cuttings of that material in the few instances where he

tried his hand at stone, as in the reliefs from the Passion in the choir of St. Sebaldus. The somewhat calmer mood of his late period is well illustrated by the altarpiece of 1523 in the Pfarrkirche at Bamberg, in which the slightly more classical drapery may indicate the only trace of an influence that the Renaissance exerted upon him. Adam Krafft (between 1455 and 1460-1509) differed both in medium and temperament from Veit Stoss. Active only at Nuremberg, he had the almost unique distinction, at this period, of confining himself to the old Gothic material of stone. Trained possibly in the more placid school of Ulm, he refrained from Stoss's emotional extravagances. Although he does not characterize so powerfully, his realism is more sincere. He is less imaginative, but at the same time he does not seek effect through mannerisms. He could not disentangle himself completely from the contemporary meshes of drapery, but partially because he felt in stone rather than in wood, his folds are much simpler than those of Stoss and better accommodated to the bodies. His modelling is more summary and the proportions are not always correct, but the postures are likely to possess more naturalistic ease, and the compositions hold together more tightly. The culmination of his career is embodied in the restored seven Stations of the Cross (1505), six of which are now in the Germanic Museum, Nuremberg (Fig. 140), and replaced, on the road to St. John's Cemetery, where they originally stood, by modern copies. The other relief of the seven, the Fourth Station, representing the encounter with St. Veronica, is built into the wall of a house on the Burgschmiet-Strasse. His ciborium in the church of St. Lawrence, with its multiplied and highly wrought details, established a precedent for these articles of ecclesiastical furniture in southern Germany.

Franconia. The School of Würzburg. The other great Franconian school of Würzburg centres about Tilman Riemenschneider (1468?-1531), equally successful both in stone and wood. His magnificent series of sepulchral monuments, most impressive among which is that of Bishop Rudolf von Scherenburg in the cathedral, shows that he had Franconian realism at his disposal; but when not dominated by the neces-

sity of portraiture, in his religious pieces he fell into lyric strains that he may have learned in Swabia. Neither in single figures nor in compositions was he a dramatist. His talent lay in another direction. He infuses his countenances with a dreamy, melancholy poetry, and, so far as was possible for a German of the late Gothic period, he had, like the artists of Swabia, a feeling for ideal beauty. In contrast to the more robust forms of Nuremberg, his canon was a slim and graceful body, with disproportionately long legs. The style of Riemenschneider at its best may be studied in the Adam and Eve now in the collection of the Historical Society, Würzburg (Fig. 141), in the retable of the Holy Blood in St. James at Rothenburg, in the Madonna of the Städel Art Institute, Frankfort, and in the bust of a youthful saint belonging to the Altman Collection of the Metropolitan Museum.

FIG. 141—RIEMENSCHNEIDER. HEAD OF ADAM. HISTORICAL SOCIETY, WÜRZBURG. (PHOTO. DR. FR. STOEDTNER, BERLIN)

Swabia. The school of Swabia, though less celebrated than that of Franconia, possessed distinct merits of its own. In contrast to the agitation and drama of its rival, it cultivated restfulness and the expression of deep but not passionate feeling, sometimes through restrained gestures but chiefly only through the countenance. The forceful and profoundly realistic individualization of Franconia must not be usually expected. In compensation the drapery is not so hard and broken, but flows in fuller folds. In its tranquillity the art of Swabia corresponds to the art of the Loire in France, and if its style had spread, a general *détente* might have occurred.

The greatest and most essentially Swabian centre was Ulm.
The outstanding master of the fifteenth century was Jörg
Syrlin the Elder (c. 1430-1491), who was able to achieve
a most happy compromise between the peacefulness of the
Swabian school and realistic expression. Of his few docu-
mented works, the most important are the choir-stalls of the
cathedral of Ulm, like most other south German examples,
less overladen with ornament and figures than those of the
Low Countries or northern Germany. Though some would
degrade him into a mere carver of ornament, he probably
planned the whole
series, and executed
with his own hand
at least the Sages
and Sibyls (Fig.
142).

Bavaria. The
presence of quarries
of limestone and red
marble in Bavaria
gave greater popu-
larity to these ma-
terials than to wood.
The most striking
examples are a num-
ber of sepulchral
slabs in Munich and
other Bavarian

FIG. 142—JÖRG SYRLIN THE ELDER. SIBYL.
CHOIR-STALLS, CATHEDRAL, ULM. (PHOTO. DR.
FR. STOEDTNER, BERLIN)

towns, with the usual unsparing German characterization. A
superb specimen, in St. Peter's church, Munich, was finished in
1482 for Ulrich Aresinger by Erasmus Grasser (c. 1450-after
1526), who appears to have had some slight contact with the
Venetian Renaissance. To him have been ascribed, with the
collaboration of at least one other sculptor, the stalls of the
Frauen-Kirche at Munich (1502), the figures of which are
livelier in attitude and more penetrating in characterization
than the similar productions of Swabia. Both these quali-
ties are purposely carried into the realm of caricature in
his ten statuettes of lithe morris-dancers on the corbels of

the great hall of the Old Rathaus (1480). The best known
wood-carvings of Bavaria, the Christ, Virgin, and Apostles of
the church at Blutenburg near Munich (1496), are more
praiseworthy for their appreciatioñ of ideal beauty and for
the comparative freedom of their majestically conceived dra-
peries from the ordinary German conventions than for con-
vincing lifelikeness or skilful modelling.

The Middle and Upper Rhine. The foreigner, Nicolaus
Gerhaert of Leyden (d. 1487), imported into this region a
brilliant and impressive style, the great influence of which
upon south-German sculpture is just beginning to be appre-
ciated. This style, which resembles that of the workshop of
Dijon almost at its best, seems to have been produced by the
same æsthetic traditions in the Low Countries that had
helped to form Claus Sluter, and it is even possible that Ger-
haert had visited Burgundy. His earliest known signed work
(1462), the sepulchral slab of the Archbishop Jacob von
Sierck in the Diocesan Museum, Trèves, is already distin-
guished by Sluter's vitalized drapery and spiritualized real-
ism. The busts of a Sibyl and a Prophet from a door of the
Chancery at Strassburg, though destroyed in the siege of
1870, may still be seen in casts in the Maison de Notre Dame
of the same city; the original head of the Prophet has lately
come to light and is now in the Municipal Museum. Gerhaert
ended a life of unusually widespread activity in the employ
of the emperor, Frederick III, executing, with the aid of pu-
pils, the monument of the sovereign himself, now in the cathe-
dral of Vienna, the last word in the profuse elaboration of the
sepulchral type that appears in the ducal tombs at Dijon.

E. ENGLAND

General characteristics. Partly because the stone-cutters
were unable to define their figures strongly and crisply or rid
them of apathy and partly because their statuary seldom rose
above the level of respectable shop-work, English Gothic
sculpture generally lacked the vibrant life and distinction
of continental carving. How much the plastic art of Gothic
England owed in its origins to France is a problem. It is

difficult, at least, to follow insular patriotism so far as to
deny to the earlier appearing monumental sculpture of France
anything but the influence of example. The stylistic parallel-
isms are too close. Indigenous characteristics are, of course,
to be discerned, some of them inherited from the Romanesque
period. A notable difference, during the thirteenth century,
is found in the place assigned to the carvings. English Gothic
developed no great portals upon which to lavish sculpture;
only the tympana were occasionally decorated with one or
more little reliefs in frames, and rarely a few statues were
set at the sides. Some of the great screens that form the
peculiar English façades were elaborately adorned with tiers
of statues and reliefs; but the spandrels of arches and other
sections of the interiors, to a larger extent than in the rest
of Europe, provided fields for plastic embellishment.

The transition. The style that was transitional from Ro-
manesque to Gothic is best represented in England by the
statues of Apostles and Prophets in the Museum at York,
originally belonging to a portal in the ruined abbey of St.
Mary. The figures have stepped forth into full plastic
roundness and have already achieved nobility and differen-
tiation of type, ease of posture, and sober grace of drapery.
Certain factors suggest that the new manner at York was
developed, not spontaneously or on the precedent of the
school of Chartres, but through a knowledge of the Pórtico de
la Gloria at Compostela acquired in a pilgrimage to the shrine
or in working along the Way of St. James.

The developed style of the thirteenth century. The most
important examples of English monumental statuary in the
thirteenth century are found on the façade of Wells (1220-
c. 1250) (Fig. 143); the Apostles and angels at the top, how-
ever, must be dated at least as late as the fourteenth century.
The frequent elongation of the forms may indicate a relation
to the antecedent school of the west portal of Chartres; but
certain critics perceive in the carvings of Wells a greater
tenderness and intimacy than in French Gothic, qualities that
perhaps may be better understood as a softness of outline con-
sistent with the vaporous atmosphere of the island. The
drapery is rippled in a fashion which was usual in the monu-

mental statues of England during the century and which was
more beautifully realized on the lateral portals of Chartres
and at Strassburg. The façade of Wells also contains the
most remarkable English series of smaller reliefs for ex-
terior decoration. Among the few other extant large statues

FIG. 143—STATUES ON NORTH TOWER
BUTTRESSES, CATHEDRAL, WELLS

of the thirteenth century
should be mentioned the
figures about the Judgment
Porch at Lincoln. The re-
lief that gives the Judgment
Porch its name, still retain-
ing much of the Roman-
esque pictorial manner, is
the only significant in-
stance, in Gothic England,
of a tympanum the whole
face of which is sculptured
with a single subject. The
arch-mouldings, however,
are occasionally carved
with rows of little figures,
either in the continental
setting of small niches or,
after the old English Ro-
manesque fashion, in the
interstices of foliage. Both

systems appear on the lovely archivolts of the Judgment
Porch. Apart from Wells, the most notable work in relief
is found on the spandrels of interior arches in southern
and western England. Best known are the sadly "restored"
specimens from the Old Testament in the chapter-house of
Salisbury. In distinction from narrative reliefs, a popular
English theme for the spandrel, as, indeed, for all English
sculpture, was the angel, whose outspread wings were pe-
culiarly fitted to fill the given space. The examples include
the supreme achievements of English Gothic carving, the four
angels above the windows of the triforium level at the two
transept ends of Westminster (Fig. 144). The thirty angels
of the triforium arches in the "Angel Choir" at Lincoln are

still lovely, though less noble and already somewhat tainted with the coquetry that was to become general in the fourteenth century.

Tombs of the thirteenth century. In England the tombs frequently took the place of sections of the screen between the

FIG. 144—ANGEL, SOUTH TRANSEPT, WESTMINSTER ABBEY

sanctuary and the ambulatory; and instead of the niche in a wall, the superstructure thus became an elaborately wrought canopy of open-work. The most interesting sepulchral peculiarity was the greater agitation of the knights. About the middle of the century, they began to be represented with their legs crossed. The posture may have originally sym-

bolized the crusader, but later it became merely a stereotyped attitude without any such significance. Possibly, instead, the intent had been to give the impression of movement according to the old precedent of the Romanesque school of Languedoc or to embody a position that the Middle Ages connected with the aristocrat. Familiar instances may be seen in the Temple Church, London. Often, as in a fine example in the Mayor's Chapel, Bristol, the activity was extended to the gesture of drawing the sword. The Henry III and Queen Eleanor (wife of Edward I) in the Confessor's Chapel, Westminster, begin auspiciously a momentous series of royal mortuary bronzes.

The fourteenth century. English sculpture of the fourteenth century was apparently based, with some sporadic exceptions, upon the typical style of the period in France; but within this general plastic manner there was a good deal of local experimentation and variation until about 1350, when production began to be reduced to that single norm which, with constant deterioration, was maintained throughout England until the end of the Gothic period. It is possible to trace the change on the façade of Exeter, which alone, from the fourteenth century, has preserved its monumental decoration. The Warriors and Kings that were carved in the lowest row about 1345 exhibit a praiseworthy spirit of initiative in the study of movement and dramatic expression; the Apostles and Prophets in the upper tiers of about 1380 possess, to be sure, more intrinsic beauty, but they are only good, honest pieces of craftsmanship, stolid in proportions and attitudes, and perhaps dependent upon Franco-Flemish art. Among the best examples of the characteristically animated small reliefs of this century are the many episodes from the life and miracles of the Virgin on the spandrels of the stone seats for the clergy in the Lady Chapel at Ely. In wood-carving, also, the upper row of choir-stalls at Ely may be classed with the finest specimens that England produced. In the sculpturing of such objects the English have nothing to fear from a comparison with the greatest continental masters. Of many other examples of the fourteenth century, those at

Chester and Gloucester may be singled out for special mention.

Tombs of the fourteenth century. At the first of the century, certain knights, such as two examples from a series at Aldworth (Fig. 145), show how the histrionic attitude was

FIG. 145—KNIGHT ON A TOMB, CHURCH AT ALDWORTH NEAR OXFORD. (FROM "MEDIEVAL FIGURE-SCULPTURE IN ENGLAND" BY PRIOR AND GARDNER)

now sometimes increased to an almost painful agitation. On the other hand, as in the lovely effigy of Aymer de Valence at Westminster, the return to tranquillity was more usual. The hands were soon united in prayer above the chest, and by 1350 even the crossing of the legs was abandoned. If the

FIG. 146—SEPULCHRAL EFFIGY OF EDWARD III. WESTMINSTER ABBEY. (FROM "MEDIEVAL FIGURE-SCULPTURE IN ENGLAND" BY PRIOR AND GARDNER)

figures around the bases of tombs were conceived as weepers, at least they did not assume the conventional costume of mourners until the fifteenth century. In the matter of portraiture the English were conservative; they came nearest to realizing the individual on the royal sepulchres, as in the bronze effigy of Edward III at Westminster (Fig 146).

The late Gothic. The fifteenth century gave birth to no such important movements in England as in the other countries of Europe, but continued with less freedom and correctness the monotonous style that had been evolved throughout the island after 1350. A certain amount of Flemish realism was imported, but it was devitalized into a fixed and commonplace dryness. The best monumental statuary of the period,

now and then enlivened by a breath of sincerer realism, is found upon such interior structures as the reredos and the chantry, which now became frequent and pretentious objects in English churches. The assembly of saints in the chapel or chantry of Henry VII at Westminster (1510-1512), despite the recurrent stubby proportions and other defects, are rather remarkable for variation of type and posture. The kinship to Flemish sculpture is manifest, and a slight acquaintance with the Renaissance has helped the craftsmen to some realization of ideal beauty and, sporadically, as in the Sts. George, Martin, and Sebastian, to an embryonic attainment of Italian elegance (Fig. 147).

FIG. 147—ST. SEBASTIAN AND TWO EXECUTIONERS, CHAPEL OF HENRY VII, WESTMINSTER ABBEY. (FROM "MEDIEVAL FIGURE-SCULPTURE IN ENGLAND" BY PRIOR AND GARDNER)

Smaller architectural carving of figures largely disappeared, except in the case of heraldic symbols, the gargoyles, and the angels on the cornices, all of which now obtained a great vogue. A famous instance of the last form of decoration occurs in St. George's Chapel, Windsor. The stalls continued to be carved without much change in style, except

for some Flemish influence. Spirited examples may be seen at Norwich, Ripon, and in Henry VII's Chapel.

The retables. The most truly English articles of ecclesiastical furniture were the alabaster retables. Although the style of the reliefs was doubtless influenced by Flemish retables and by English painting, the attempt at the pictorial was not carried so far as in Flanders, the story was not told with such a charming spirit of *genre*, and the mannered exe-

FIG. 148—PANELS FROM AN ENGLISH RETABLE. METROPOLITAN MUSEUM, NEW YORK. (COURTESY OF THE METROPOLITAN MUSEUM)

cution was lamentably inferior. The forms are extravagantly thin and stiff, the anatomy puerile, the poses affected and perfunctory; the craftsmen succeed in reproducing actuality only in the studied contemporary costumes. The cheapness of these *objets de piété,* however, ensured them so enthusiastic a market abroad, particularly in near-lying Normandy, that complete examples may now be seen only on the continent. The Metropolitan Museum possesses three panels, parts of a retable of the Passion and probably to be dated early in the fifteenth century (Fig. 148).

General characteristics of the earlier Gothic period. The
French influence continued to dominate Spanish sculpture
during the thirteenth and fourteenth centuries. The indig-
enous impress, however, is to be found, now here and now
there, in Moorish elements, in the taste for luxuriant decora-
tion, in a kind of provincialism, in the personal types, in a

FIG. 149—PÓRTICO DE LA GLORIA, CATHEDRAL, SANTIAGO DE COMPOSTELA.
(PHOTO. LACOSTE)

frequent heaviness of physique, in a tendency to petrify the
sacred figures into the solemn rigidity of idols, or, on the
other hand, in a more familiar naturalism.

The transition. A transition from Romanesque to Gothic
is embodied in the principal portal and the narthex of San-
tiago de Compostela, the Pórtico de la Gloria, which, as one
of the noblest assemblages of mediæval sculpture (Fig. 149),
richly deserves its title. It needs only a glance to realize
the derivation from the school of Chartres, but there is

evidence also of an acquaintance with southern French and especially Burgundian Romanesque. The vigorously differentiated and expressive heads form one of the most striking proofs of the relationship to the transitional school of northern France. The statues, however, are less elongated than at Chartres itself, the art is more naturalistic and less schematized, the poses and draperies are freer and more cognizant of grace, and the twenty-four Elders on the main archivolt reveal a tenser dramatic sense. The author of the portal, a Frenchman or Gallicized Spaniard, has proudly signed his name on the under side of the main lintel, together with the

date of the installation of the sculpture — Master Matthew, 1183. The same transitional Spanish style is superbly represented also by the pairs of Apostles in the Cámara Santa of the cathedral of Oviedo and, with stronger Burgundian influences, by the west portal and Annunciation of the lateral portal of S. Vicente, Avila.

FIG. 150—STATUES OF PRINCES, CLOISTER OF CATHEDRAL, BURGOS

The thirteenth century. Whole sections of Spain during the thirteenth century still remained impervious to the new style across the Pyrenees; the most important centres of the Gallic fashion were the cathedrals of Burgos and Leon on the pilgrimage routes from France. At Burgos the chief sculptural monuments belonging to this period are the transept portals of about the middle of the century, the portal of the second half of the century leading from the transept into the cloister, and a number of fine statues in the cloister itself, most interesting among which are

a king and queen with five princes, probably representing Alfonso the Wise, Violante of Aragon, and their five sons (Fig. 150), and incorporating a tendency to introduce contemporaries into sacred art as in Germany, though without the German desire for realistic portraiture. The carvings at Leon include the main and transept portals and seem to have been executed chiefly at the end of the century, perhaps partly under the influence of the atelier of Bourges. The congregation of the redeemed in the lowest zone of the central tympanum of the façade and the Virgin on the pillar below, Nuestra Señora la Blanca, are treated with a charming naturalism that bespeaks the Spanish environment.

Tombs of the thirteenth century. The ordinary Spanish type of the thirteenth century was a niche, usually pointed, in the wall of the church or cloister; tympanum, base, and arch were decorated with reliefs. The monument of Bishop Martin in the cathedral of Leon introduces on the sarcophagus one of the prelate's works of mercy, the distribution of food to the poor and sick, treated already with something of Ribera's delight in squalid naturalism. The sepulchre of the cantor Aparicio in the old cathedral of Salamanca may serve, with its frieze of stalactite vaults, to illustrate a subdivision of Spanish tombs in which Moorish decoration was already fused with the Gothic to form a primitive stage of the architectural style called the *mudéjar.*

The fourteenth century. During this period, the French manner, in the form that it then assumed, won its way into all the other important parts of Spain, leaving uninvaded only the sections that were still Moorish or had lately been so and such remote provinces as Estremadura. For monumental sculpture the two great fields were now Navarre and the eastern kingdom of Catalonia and Aragon, which had been sterile for the last hundred years. The cloister of the cathedral at Pampeluna, the capital of Navarre, contains much thoroughly Gallic work, the finest example of which is the door called La Preciosa, leading to the old chapterhouse. Catalonia reveals a more original adaptation of the French models, but the originality by no means implies

superiority. A palpable difference exists between the Gallicized Virgin and eight Apostles on the main door of the cathedral of Tarragona from the end of the thirteenth century and the rather Spanish Apostles and Prophets around the adjacent buttresses, which, executed towards the end of the fourteenth century, are heavier, less flexible, and more colossal. To keep company with the Italian influence upon Catalonian architecture and painting, there was naturally some Italianate sculpture. The most marked example is the reliquary of St. Eulalia in the crypt of the cathedral of Barcelona, a rude counterpart of such shrines as that of St. Peter Martyr at Milan. Of the three great western cathedrals, Burgos, Leon, and Toledo, the last had waited until now to receive its plastic adornment. But the age of monumentality was passing, and the tympanum of the first portal to be decorated, the Puerta del Reloj, received four zones of many small episodical reliefs. According to the peculiar arrangement of Spanish churches, the screen that marked off the large enclosure or *coro* for the clergy in the nave became a prominent article of furniture, and is already embellished at Toledo with a long series of Biblical reliefs in the homely manner of the period.

Tombs of the fourteenth century. It is in general only the more lavish Gothic ornamentation that differentiates the

FIG. 151—TOMBS, S. ESTEBAN, CUÉLLAR

tombs from those of the preceding century. In the mausoleum of the Archbishop Lope Fernández de Luna in the Seo of Saragossa, the niche is even amplified into a kind of mor-

tuary chapel. Mohammedan fancy continued to give a national tone to Spanish art in such sepulchres as those of two knights in the church of S. Esteban at Cuéllar near Segovia: the bases, arches, and their frames are embellished with a profusion of Gothic and Moorish *motifs* in flat oriental relief (Fig. 151).

The fifteenth and early sixteenth centuries. The French influences were now supplanted by Flemish and eventually also German models. Oc-

FIG. 152.—PERE JOHAN DE VALLFOGONA. MARTYRDOM OF ST. THECLA. SECTION OF RETABLE OF CATHEDRAL, TARRAGONA

casionally it was the Burgundian modification of the Flemish style that was cultivated. The national genius declared itself more emphatically, not so much in single figures as in the ways in which they were grouped together and in the prodigality with which they were employed as decoration. In the west the great commissions were often assigned to foreign artists. Of architectural sculpture in this section of Spain may be mentioned the German Apostles on the Puerta de los Leones of the cathedral of Toledo, dating from the middle of the fifteenth century, and the decoration of the two lateral doors in the façade of the cathedral of Seville, ascribed by some connoisseurs to Lorenzo Mercadante, who, though of Breton origin, had come under Burgundian influence, and by others to Pedro Millán, a charming master, perhaps also a foreigner, likewise trained in Burgundian traditions, and active in Seville at the beginning of the sixteenth century. The style of Catalonia and Aragon continued to be more original, and the work was usually executed by

native artists, who, though schooled in the Flemish manner, yet impressed local qualities upon their work. Among the best examples, dating from the first half or middle of the fifteenth century, are the archangel over the door in the old façade of the Casa Consistorial at Barcelona, and a frieze of realistic heads, with a medallion of St. George, over the entrance to the Casa de la Diputación.

The retables and choir-stalls. The Spanish retables were huge structures, larger than the examples produced in the rest of Europe. Not transportable but fixed immovably in their places, they were higher than they were broad and lacked folding wings. The material in the east was alabaster. The finest specimens were done by Pere Johan de Vallfogona and his workshop: one for the cathedral of Tarragona, begun in 1426 (Fig. 152); another for the Seo at Saragossa, only the *predella* of which was executed by Pere Johan, in 1445, leaving the body of the huge structure to be carried out in a German style by the Swabian Master Hans of Gmünd between 1470 and 1480; and another *predella* of the same period as that of the Seo for the archbishop's chapel at Saragossa, now in the Metropolitan Museum, New York. In the west, during the reign of Ferdinand and Isabella, the retables became colossal screens of sculptured wood, sumptuously colored and overladen with a truly pagan magnificence. The high altars of Seville and Toledo are surmounted by the two most remarkable examples. The choir-stalls, such as those of the cathedral of Leon or the lower range at Toledo with scenes from the siege of Granada, now received a care and an elaboration that make them equal, if not superior, to any others in Europe.

The late Gothic tombs. In Catalonia, as on the tomb of the Bishop Bernard de Pau in the cathedral of Gerona, in Navarre, and even in other parts of Spain, as notably at Sigüenza and Cuenca, the mortuary repertoire sometimes took the eccentric form of a vertical arrangement in bands. In addition to the sepulchral niche, there appeared for the first time in Spain the completely detached base upholding the effigy. An early example is the fine monument of Charles the Noble of Navarre, now in a hall adjoining the cathedral of

Pampeluna, executed in 1416 by a Fleming, Janin Lomme of Tournai, with an approximation to the Burgundian tomb of Philip the Bold.

The "détente." At the end of the fifteenth century Gil de Siloé, who was perhaps himself a native of northern Europe

FIG. 153—TOMB OF DON MARTÍN VÁSQUEZ DE ARCE. CATHEDRAL, SIGÜENZA. (COURTESY OF HISPANIC SOCIETY, NEW YORK)

and in any case had been formed by the Teutonic masters working at Burgos, retained their influence in his complicated draperies, but he sought, especially in his countenances, an ideal beauty that constituted a partial *détente* of realism. His most ambitious achievements, in which Spanish fondness

for the luxuriant runs riot, are found in the sanctuary of the Carthusian church of Miraflores near Burgos: the unusually opulent retable (in collaboration with Diego de la Cruz); in front of the altar the joint tomb of Isabella's royal parents; and against one wall the monument of her kneeling brother, the Infante Alfonso. Gil de Siloé always rose to the occasion of carving the sumptuous stuffs and jewelled embossings of the draperies in which he delighted. The most superb example is perhaps to be seen in the tomb of Isabella's favorite page, Juan de Padilla, now in the Museum of Burgos. A similar tendency to a *détente* may be discerned in a sculptural school which centred at Sigüenza at the end of the century and cultivated in its figures a quiet, vague, and almost mystic melancholy. The masterpiece of the school is the tomb of the young Knight of Santiago, Don Martín Vásquez de Arce, erected about 1490 in the cathedral of Sigüenza (Fig. 153).

G. ITALY

Introduction. By a rather arbitrary but convenient nomenclature, the chronological limits of the Gothic period in Italian sculpture are usually defined as including the plastic production that began with Nicola d'Apulia about the middle of the thirteenth, and continued, largely in dependence upon him and his son, Giovanni Pisano, until the end of the fourteenth century. French Gothic sculpture and, in northern Italy, German sculpture certainly played their parts in the formation of the Italian style; but, because of the development of more distinct personality in Italian masters, greater originality was impressed upon the foreign borrowings than in other countries.

Nicola d'Apulia. The principal significance of Nicola d'Apulia (c. 1205?-1278?) is that, even to a greater extent than is to be seen in the archaizing statues at Reims, he superimposed an imitation of the antique upon the Gothic forms. Whether or not he was actually born in Apulia, he certainly obtained his training amidst the revival of classicism in the south. The name, Nicola Pisano, by which until

recently he has been known, was derived from his residence
and probable citizenship in Pisa. The polygonal form of his
pulpits he acquired from the artistic tradition of Apulia,
but he took from earlier Tuscan pulpits the complete in-
vestiture of the panels with sacred narrative. His first great
monument, the hexagonal pulpit of the Pisan Baptistery, he

FIG. 154—NICOLA D'APULIA. PULPIT. BAPTISTERY, PISA. (PHOTO. ALINARI)

completed in 1260 (Fig. 154). The derivation from Hellen-
istic sarcophagi is evident in the heroic Roman types and in
the crowding of the reliefs; he even copied some of his figures
from antiques that have now been relegated to the Campo
Santo. Nicola, however, was more than a mere imitator.
He possessed a fine sense of composition, and he imported
into his rendering of the sacred drama a keen observation
of actual life. He was able to give freer rein to his origi-

nality in the second of his two principal works, the pulpit
of the Sienese cathedral, begun with the aid of several pupils
in 1265 or 1266. An elaboration of the earlier monument,
it is an octagon, substituting statuettes for the small grouped
columns that had separated the reliefs. The Olympic
majesty of the Pisan pulpit is partly sacrificed to the crowd-
ing of the panels with smaller figures and to a greater

FIG. 155—NICOLA D'APULIA. SECTION OF PULPIT. CATHEDRAL, SIENA.
(PHOTO. ALINARI)

realism (Fig. 155). In the statuettes of the corners, as
especially in the Virgin and Child, Nicola gave his highest
expression to the ideal beauty cultivated by the thirteenth
century, but it was now an idealism based as much upon
a study of nature as upon classical art.

Giovanni Pisano. Like his father, Giovanni Pisano (*c.*
1250-after 1317) expressed himself most characteristically in
two pulpits. The first, executed 1298-1301 for the church
of S. Andrea at Pistoia, is like Nicola's Pisan pulpit in con-

struction, except that it employs statuettes for the dividing angles above and substitutes a range of Sibyls (Fig. 156) between the arches below. By accentuating the realism and agitation of the Christian subjects, he has moved further away from an imitation of the antique, so that his forms, even more than the late works of Nicola, resemble the Gothic sculpture of the rest of Europe. Being slighter and more human, they crowd the spaces less. But Giovanni had an individual trait, emotionalism, which, in his productions, impressed a highly personal character upon the general Gothic foundation. This emotionalism declared itself at times in the tender and pathetic attitude towards the religious themes bred by Franciscanism; or it took the shape of a nervous and in places an almost tragic intensity, revealed in the expression of the countenance, in distortion of the body, and in violence of single and grouped action.

FIG. 156—GIOVANNI PISANO. SIBYL ON PULPIT. S. ANDREA, PISTOIA. (PHOTO. ALINARI)

The most elaborate pulpit in the series was built by Giovanni Pisano between 1302 and 1310 for the cathedral of Pisa. It was injured by fire at the end of the sixteenth century, but its principal parts are preserved in the cathedral and the Museum and in the Kaiser Friedrich Museum at Berlin. The pitch of emotionalism has now been raised to the feverish, and the movement has become wild. The sculptor defiantly indulges in incorrect proportions, in order to divert the observer's attention from accurate representation to the impression of passion. The torsos, especially, are often too long for the legs, and the forms are marked by a neurotic, pathological

emaciation. His separate devotional statues of the Madonna
and Child exemplify a serener phase of his activity; but his
tragic outlook on life led him to choose as a model the sor-
rowing rather than the smiling Virgin of the French four-
teenth century. The loveliest example in the series was
sent about 1305 to the Arena Chapel at Padua.

Arnolfo of Florence. Whether the sculptor Arnolfo of
Florence, a pupil of Nicola d'Apulia, was identical with the

FIG. 157—ARNOLFO OF FLORENCE. *BALDACCHINO*, S. PAOLO FUORI LE MURA,
ROME

celebrated architect Arnolfo di Cambio, is an open question;
in any case the sculptor established the vogue of two
artistic types in Italy, the Gothic *ciborium* or *baldacchino*
and the Gothic tomb. Of the *baldacchino*, he executed two
examples at Rome, in S. Paolo fuori le Mura (1285) (Fig.
157) and in S. Cecilia in Trastevere (1293). Although he
was a less correct and skilful modeller than Nicola d'Apulia,
he followed him in superimposing upon the Gothic archi-
tecture figures suggested by the antique; but his forms are

stubbier and more naturalistic than those of his master. With the sepulchre of the Cardinal de Braye (d. 1282) in S. Domenico, Orvieto, Arnolfo began the tradition of the more elaborate Italian mediæval tomb or at least gave the stamp of his authority to it. The recumbent figure is set in a kind of mortuary recess, the curtains of which are drawn aside by two deacons; and above at the left the prelate appears again, kneeling before the enthroned Virgin, to whom he is presented on his own side by St. Paul and on the other

FIG. 158—ANDREA PISANO. PANELS FROM BRONZE DOORS OF BAPTISTERY, FLORENCE, REPRESENTING THE NAMING OF ST. JOHN BAPTIST AND THE YOUNG ST. JOHN GOING FORTH INTO THE DESERT. (PHOTO. ALINARI)

by St. Dominic. The whole structure was originally covered by a Gothic canopy, now destroyed. The two effigies of the Cardinal embody the attempt at sepulchral portraiture that became general in Italy during the period.

The Pisan style at Florence. One of the most celebrated exponents of the Pisan style at Florence was Andrea di Ugolino, who was born, however, at Pontedera in the territory of Pisa and was called Andrea Pisano (*c.* 1270?-1348). He was certainly well advanced in years when in 1330 he began the most important commission of his life, the first

bronze doors of the Baptistery at Florence, consisting of twenty-eight rectangular panels, in which are inscribed Gothic frames of the common shape paralleled on the portals of Rouen and Lyons (Fig. 158). In the upper twenty of these frames is related the story of St. John Baptist, the patron of Florence, in the lower eight are allegorical Virtues. The reliefs are the work of a man whose nature was diametrically opposed to that of Giovanni Pisano. The distinctive notes are simplicity, repose, grace, and gentleness. In his simplicity of composition, Andrea Pisano was influenced by Giotto. For instance, he actually accommodated to the smaller scope of his panels sections of the painter's monumental frescoes in the Peruzzi chapel of S. Croce. It was perhaps the study of painting that led him to employ a certain amount of landscape setting, although he wisely did not attempt the pictorial perspective which later was to violate the boundaries of sculpture. His admiration for Giotto rendered it fitting that he should undertake the sculptural adornment of the campanile, the building of which that versatile artist at least supervised in its beginnings. Of the two zones of reliefs, the lower, including twenty-six panels, represents the Creation, the institution of labor by Adam and his descendants, and its different manifestations in the manual, representative, and intellectual arts. The upper zone, with twenty-eight panels, comprises the allegorical figures of the seven Liberal Arts (in contrast to their actual exercise below), followed by the seven Virtues, the seven Planets, and the seven Sacraments. Giotto seems to have conceived the whole iconographical scheme, but it is impossible to determine whether he himself did some little carving or at least made designs for the reliefs. With the exception of the five panels sculptured by Luca della Robbia in the Renaissance, the lower zone wholly or in very large part is apparently the actual handiwork of Andrea Pisano, who, in certain reliefs that exhibit an energy unusual for him, such as the representation of Agriculture, may have used models left by Giotto. The upper but less successful zone was carved by later Florentine sculptors of the Middle Ages. Andrea Orcagna (d. c. 1376), one of Giotto's most original followers in painting, nat-

urally revealed in his sculpture a more vital Giottesque influence than Andrea Pisano. His great monument in this phase of art is the opulent canopy over the miraculous Madonna of the church of Or San Michele, Florence, completed in 1359 after the precedent set by Arnolfo at Rome. He retained both the sturdy strength of Giotto's forms and his wonderful spirit of religious gravity; but more than his master he occasionally cultivated Gothic grace, especially in the draperies.

FIG. 159—TINO DI CAMAINO. TOMB OF MARY OF HUNGARY. S. MARIA DONNA REGINA, NAPLES. (PHOTO. ALINARI)

The Pisan style at Siena and Naples. The hedonistic and rather languid attitude towards life at Siena and the admiration for the mannered French Gothic models of the fourteenth century bred in her artists a predilection for sinuous elegance and sweet sentiment. The best known names are Tino di Camaino and Lorenzo Maitani. The former (d. 1337) owes his fame to the development that he gave to the Italian type of Gothic sepulchre. The most complete examples were done for the cultured Angevin court at Naples. Tino added to the precedent set by Arnolfo: the Virtues as caryatides; the decoration of the sarcophagus with the effigy of the deceased as living, surrounded by members of the royal family or of the court; and clerics performing the funeral rites within the mortuary chamber. Typical is the first monument that he constructed (in 1325), the tomb of Mary of Hungary, in the church of S. Maria Donna Regina (Fig. 159). Lorenzo Maitani (*c.* 1275-1330) in all probability planned the façade of the cathedral of Orvieto and, through French

suggestion, devised the iconographic scheme for the plastic decoration of the four broad pilasters at the bottom. The general unity of style would imply that he superintended the carving and that after his death the Sienese and Florentines who succeeded him used his models. Some would see his own chisel especially in the first scenes from Genesis, which represent the highest achievement on the façade (Fig. 160). In any case, the pilasters as a whole must be reckoned among

FIG. 160—MAITANI? RELIEFS OF THE CREATION. FAÇADE OF CATHEDRAL, ORVIETO. (PHOTO. ALINARI)

the masterpieces of Gothic sculpture. The graceful charm of Siena is ennobled, the nude is treated with enthusiasm and unexpected knowledge, and an Italian feeling for the body itself rather than the drapery as a plastic vehicle is evident in the effort to outline the forms beneath garments that are narrower and more clinging than was usual in the Pisan tradition. The embryonic but well defined pictorial perspective serves as a preparation for the accomplishment of Ghiberti.

The Pisan style in Lombardy. The purveyor of the Pisan

mode in Lombardy and the adjacent districts was Giovanni di
Balduccio of Pisa. His great monument for St. Peter Martyr
in S. Eustorgio, Milan (1339), was suggested by the shrine
designed by Nicola d'Apulia for St. Dominic at Bologna. The
best section is the row of Virtues as caryatides, which are

FIG. 161—TOMBS OF THE SCALIGER FAMILY. S. MARIA ANTICA, VERONA

already distinguished by the sensibility to feminine beauty
that was always peculiarly characteristic of Milanese art.
Other parts are inferior, especially the reliefs from the life
of the saint, and probably were largely the production of
pupils. The Pisan style was combined with the old Lombard-
Romanesque tradition, or with French or German borrowings,

by the Campionesi, a group of sculptors coming from Campione on Lake Lugano and enjoying wide patronage in northern Italy even as late as the first part of the fifteenth century. The most important works connected with their names are the group of sepulchral monuments for the Scaliger family in the little cemetery adjoining the church of S. Maria Antica at Verona (Fig. 161); but the collaboration of the Venetian exponents of the Pisan traits, the *bottega* of the Santi family, is now very generally admitted.

The Pisan style at Venice. The Pisan influence manifested itself particularly in the richly sculptured tombs, which resemble those of Verona, except that they were usually placed on the interior instead of the exterior wall of the church, and the crowning Gothic arch was likely to be in the most luxuriant Venetian taste. Sometimes a reredos was substituted for the arch. The first great representatives of the Pisan style at Venice, in the middle and third quarter of the fourteenth century, were a family named Santi and their workshop, the leading master in which was Andriolo Santi (d. 1377). His attainments may be studied at Padua in the tombs of Jacopo and Ubertino da Carrara in the church of the Eremitani. Late in the Trecento a very definite German influence joined itself to the Pisan in the persons of the brothers Jacobello and Pier Paolo dalle Masegne. The forceful realism of their Teutonic types is best illustrated by the Apostles on the iconostasis of St. Mark's.

BIBLIOGRAPHICAL NOTE

Of fundamental importance, not only for France but for all mediæval Europe and not only for iconography but for the art and culture of the Middle Ages in general, are the three great works of E. Mâle, all published at Paris, *L'art religieux du xii^e siècle en France*, 1922, *L'art religieux du xiii^e siècle en France*, third edition, 1910, and *L'art religieux de la fin du Moyen Age en France*, 1908.

In addition to the general books mentioned in the bibliography at the end of Chapter I, A. K. Porter's erudite and brilliant works, *Lombard Architecture*, New Haven, 1917, and *Romanesque Sculpture of the Pilgrimage Roads*, Boston, 1923, though com-

posed partly in defense of theories that do not seem to the present writer always tenable, yet constitute landmarks in the study of Romanesque sculpture. Professor Porter has also contributed to the subject many articles of the utmost significance; but his critics should likewise be read, such as P. Deschamps, in an article on Burgundian sculpture in the *Gazette des Beaux Arts*, 1922, II, pp. 61-80. A foundation-stone in the bibliography of French Romanesque and early Gothic is W. Vöge's *Die Anfänge des monumentalen Stiles im Mittelalter*, Strassburg, 1894. Other useful books are A. Marignan's *Histoire de la sculpture en Languedoc du xii^e-xiii^e siècle*, Paris, 1902, and G. Fleury's *Portails imagés du xii^e siècle*, Mamers, 1904. A handbook on the French Gothic sculpture of the thirteenth century, as delightful as it is scholarly, is L. Pillion's *Les sculpteurs français du xiii^e siècle*, Paris, 1911-1912. The authoritative monograph on the Burgundian school is A. Kleinclausz's *Claus Sluter et la sculpture bourguignonne au xv^e siècle*, Paris; on the *détente*, P. Vitry's *Michel Colombe*, Paris, 1901; on the school of Champagne, R. Koechlin's and J. J. Marquet de Vasselot's *La sculpture à Troyes et dans la Champagne méridionale*, Paris, 1900. An old, discursive work on early Flemish art is M. le Chanoine De Haisnes's *Histoire de l'art dans les Flandres, l'Artois, et le Hainaut avant le xv^e siècle*, Lille, 1886. For the problem of the origin of Flemish realism, important articles are those of R. Koechlin, *La sculpture belge et les influences françaises au xiii^e et ·xiv^e siècles, Gazette des Beaux Arts*, 1903, II, pp. 5-19, 333-348, 391-407. The mediæval school of Antwerp is the subject of a special monograph, J. de Bosschère, *La sculpture anversoise aux xv^e et xvi^e siècles*, Brussels, 1909.

A thorough-going treatment of German Romanesque and early Gothic, including the most recent information, may be found in G. Dehio's *Geschichte der deutschen Kunst*, vol. I, Berlin, 1919; E. Lüthgen's *Romanische Plastik in Deutschland*, Bonn, 1923, though somewhat too subtly concerned with æsthetic theory, is indispensable to the student of primitive German sculpture. The classical work on the Gothic sculpture of Germany in the thirteenth century is M. Hasak's *Geschichte der deutschen Bildhauerkunst im xiii. Jahrhundert*, Berlin, 1899. M. Sauerlandt, in *Deutsche Plastik des Mittelalters*, Leipzig, 1911, provides a well chosen collection of excellent reproductions of mediæval German sculpture in general. The achievements of north-German sculptors in the late Gothic period are set forth in S. Beissel's *Die Kalkarer*

Bildhauer, Zeitschrift für christliche Kunst, 1903, pp. 354-370, and in E. Lüthgen's *Die niederrheinische Plastik,* Strassburg, 1917, a work that contains illuminating discussions of many other aspects of mediæval art. A fundamental book for the study of the south-German retable is M. Schütte's *Der schwäbische Schnitzaltar,* Strassburg, 1907. For Stoss, the standard monographs are M. Lossnitzer, *Veit Stoss,* Leipzig, 1912, and B. Daun's *Veit Stoss und seine Schule,* Leipzig 1916; for Krafft, B. Daun, *Adam Krafft und die Künstler seiner Zeit,* Berlin, 1897, and D. Stern, *Der Nürnberger Bildhauer, Adam Kraft,* Strassburg, 1916; for Riemenschneider, Edward Tönnies, *Leben und Werke des Würzburger Bildschnitzers Tilmann Riemenschneider,* Strassburg, 1900. The late Gothic sculpture of Swabia may be further investigated in J. Baum, *Die Ulmer Plastik um 1500,* Stuttgart, 1911, and in E. Grill, *Der Ulmer Bildschnitzer Jörg Syrlin d. a. und seine Schule,* Strassburg, 1910. A. R. Maier's *Niclaus Gerhaert von Leiden,* Strassburg, 1910, has now been partially superseded by W. Vöge, *Über Nicolaus Gerhaert, Zeitschrift für bildende Kunst,* N. F. XXIV (1912-1913), pp. 97-108, by F. Back, *Ein wiedergefundenes Werk des Nicolaus Gerhaert, Münchner Jahrbuch der bildenden Kunst,* IX (1914-1915), pp. 297-302, and by T. Demmler, *Beiträge zur Kenntnis des Bildhauers Nicolaus Gerhaert, Jahrbuch der preussischen Kunstsammlungen,* XLII (1921), pp. 20-33. H. Bergner's *Handbuch der kirchlichen Kunstaltertümer in Deutschland,* Leipzig, 1905, is a convenient book of reference for German mediæval art, especially in the case of iconography.

The great work on English sculpture of the Middle Ages is E. S. Prior and A. Gardner's *Medieval Figure-Sculpture in England,* Cambridge, England, 1912. Francis Bond's London publications, *Screens and Galleries in English Churches,* 1908, and *Wood Carvings in English Churches,* 1910, and F. H. Crossley's *English Church Monuments,* London, 1921, are helpful compilations both for information and illustrations. In addition to E. Bertaux's articles in Michel's *Histoire,* which provide the best general discussion of Spanish mediæval sculpture, the student may consult for the Romanesque E. Serrano Fatigati, *Escultura románica en España,* Madrid, 1900, and the exasperatingly discursive book of G. G. King, *The Way of Saint James,* in three volumes, New York, 1920, in the labyrinth of which, however, important material is hidden. E. Serrano Fatigati's *Portadas artísticas de monumentos españoles,* Madrid, 1907, is useful both

for the Romanesque and Gothic periods, especially for its illustrations. The distinguished Spanish scholar, R. de Orueta, in *La escultura funeraria en España (Provincias de Ciudad Real, Cuenca, Guadalajara)*, Madrid, 1919, has begun an exhaustive investigation of the mediæval sepulchral art of Spain, which it is to be hoped he will complete. A. L. Mayer promises to follow up his convenient little compendium, *Mittelalterliche Plastik in Spanien*, Munich, 1922, with a larger book on the subject. In addition to the general works already mentioned, one may turn to the following volumes for mediæval Italy: the vast and epoch-making book by E. Bertaux, *L'art dans l'Italie méridionale*, Paris, 1904; M. Wackernagel, *Die Plastik des xi. und xii. Jahrhunderts in Apulien*, Leipzig, 1911; A. Brach, *Nicola und Giovanni Pisano und die Plastik des xiv. Jahrhunderts in Siena*, Strassburg, 1904; and H. Graber, *Beiträge zu Nicola Pisano*, Strassburg, 1911.

CHAPTER XI

THE RENAISSANCE

I. Introduction

The Renaissance began in Italy in the fifteenth century, or Quattrocento, reached its fruition in the sixteenth, or Cinquecento, and at that time, a hundred years after its inception, spread to the rest of Europe. The diversity between the Middle Ages and the Renaissance manifested itself in two principal channels—in humanism, the more eager and intelligent comprehension of antiquity, and in individualism, the greater emphasis upon personality. The mediæval study of classical antiquity had been somewhat desultory, and the imitations of ancient art and literature had been limited and casual; now, a ferment of archæological enthusiasm was created, and the practice of resorting to the models of Greece and Rome became more general and was pursued in a spirit of more scientific accuracy. Of special interest was the addition of mythological and classical themes to the repertoire of art, which had hitherto been so largely religious. By the sixteenth century humanism had acquired such a tyrannical power as to enslave artists rather than stimulate them. The man of the Renaissance extricated himself from the society in which he lived and sought to realize his own individuality and to cultivate to the fullest its many possibilities. The artist, conscious of his high calling, began to take the place of the mediæval craftsman, the member of a corporation, and iconography depended more on individual invention. The study of self led to an interest in other human beings and finally to an investigation of their environment, the natural world. The spirit of the age was revealed in art by the effort after a more truthful representation of actuality; and this tendency grew and grew until in the sixteenth century

almost all primitive eccentricities were repudiated, and an exact, but, as we shall see, a superficial, faithfulness to nature was the great desideratum. In Italy of the fifteenth century, the struggle for a more accurate reproduction of nature fell into line with the ubiquitous contemporary European emphasis upon realism. With this realistic consummation in view, many Italians devoted themselves, in the scientific temper of the day, to the solution of the technical problems of art, such as anatomy, perspective, and the rendering of movement. A growing appreciation for the æsthetic significance of the nude was due, not only to the pattern of the ancients, but also to the prevalent enthusiasm for investigation, which would not rest until it had reached what in the sphere of art is closest to the essence of things, the undraped human body. The attitude of inquiry and of rebellion from established formulæ had attained such proportions by the Cinquecento that it not only impaired Christian faith and the force of religion as an inspiration to art, but in northern Europe also helped to provoke the Reformation. Conditions within the Church itself were much ameliorated in the second half of the Cinquecento by the Counter-Reformation or Catholic Reaction, led by the recently founded order of Jesuits; but Jesuitism and the new Catholicism did not become effective as an æsthetic stimulus until the period of the baroque in the next century. Whereas in Italy the Renaissance was a natural development from the long established humanistic tendencies of the peninsula, in other lands it was, to some extent, a foreign excrescence and therefore not so suitable a medium for the expression of racial ideals. Except in England, however, the old artistic traditions of the several countries partially impressed themselves upon the Italian importations and gave to them, in each case, a certain national tone.

II. Italian Sculpture of the Fifteenth Century

A. General Characteristics

Despite the fact that Italian sculpture of the Quattrocento is regularly described as belonging to the Renaissance, yet

in many essential respects it is analogous to the Gothic output of other European countries during this period. Its realism was common, international property in the fifteenth century; but the phenomenon of individualism in Italy transformed even the figures of Holy Writ and of classical mythology into more incisively characterized portraits. To a further degree also than in other regions, the intellectuality of the early Renaissance and its individualistic concern with the inner life and meaning of things influenced Italian artists to represent the underlying thoughts and spiritual experiences of their personages through the outward manifestations in the body and particularly the countenance. In the first half of the century, the forms of Italian sculpture, as in Ghiberti and Jacopo della Quercia, often still remained largely Gothic; but even when, as particularly in the second half of the century, the forms became different from those of the rest of Europe, the spirit was the same. The tranquillizing effect of the antique may be called into service to explain the frequent moderation of realism and passion, although this phenomenon may also be viewed as the same kind of spontaneous reaction that is represented by the French *détente*. What difference existed between Italian and other European sculpture was chiefly created by this Italian devotion to the antique. It is true that classical models had been so vital to the mediæval style of Nicola d'Apulia that the Renaissance might have begun a century and a half earlier, if his son had continued to set the example of a fervid archæology; but now the imitation of the art of the pagan past was no longer sporadic but a universal phenomenon. The artists of the Quattrocento, however, adapted suggestions from the antique to their own purposes, instead of merely copying the antique like their successors of the Cinquecento. Details of modelling, poses, costume, and setting were often derived from classical prototypes, but the basic conception and execution remained original. The development of individualism instilled into art a fresh and unique spirit of enterprise and experimentation, sharply contrasted with the rather lifeless imitation of Pisan models in the later fourteenth century. The most vigorous, beautiful, and characteristic sculpture of the Quattrocento

was ‘produced at Florence, which was then the centre of
Italian civilization.

B. SCULPTURE AT FLORENCE

1. The First Half of the Quattrocento

Donatello. His career. The father of all Renaissance art
was Donatello (*c.* 1385-1466). His life may be divided into
four periods: the first, which extended to 1432, the year of
his journey to Rome with his partner, the architect and
sculptor, Michelozzo Michelozzi; the second, covering the
decade from 1433 to 1443 and confined chiefly to the sculp-
tural adornment of architectural monuments; the third and
the culmination of his career, including the next decade,
when he was occupied at Padua in the creation of the great
equestrian statue of the Venetian *condottiere,* Gattamelata,
and the bronzes composing the high altar of the church of
S. Antonio; and the fourth, his old age, from 1454 to 1466,
when, following the usual course of evolution, he exaggerated
the salutary qualities of his prime.

His realism. Donatello's outstanding characteristic was
his realism. Its early phase is exemplified by a group of
Prophets and Patriarchs for the cathedral and campanile
of Florence, belonging to a large series of monumental
statues that were executed at this time by Donatello and
others for these edifices and for the exterior niches of Or
San Michele. Breaking violently with the mediæval tradi-
tion, they are highly individualized portraits of withered
old men, to the delineation of whom Donatello gladly turned
because the wrinkles, the protruding bones, muscles, and
veins gave him an opportunity to show that he was not afraid
of a realism as unsparing as in the strikingly similar Bur-
gundian Prophets by Sluter. The illustration (Fig. 162) in-
cludes the Jeremiah and the figure nicknamed the Zuccone or
pumpkin-head by reason of his bald pate, probably repre-
senting Job or Habakkuk, not, as the inscription states,
David. Donatello abandoned the Pisan conventions of
drapery, and purposely complicated the folds peculiarly in

order to exhibit his new found skill in the extraordinary phases of actuality. Realism took with him partly the form of emaciation, by which also the structure of the body was laid bare. He found in it a kind of esoteric beauty, symbolic of the wiry energy, the unceasing activity, the purity, and the

FIG. 162.—DONATELLO. "LO ZUCCONE" AND JEREMIAH. CAMPANILE, FLORENCE. (PHOTO. ALINARI)

asceticism that for him constituted the highest ideals of life. The increased influence of the antique through his journey to Rome in 1432 helped to temper the extravagance that had marked his more youthful realistic experimentation. The ultimate examples of a moderated realism are the Paduan masterpieces, the Crucifix and saints of the altar and the

head of the Gattamelata (Fig. 163). In his old age, he abandoned this moderation, and, as in the Magdalene of wood in the Florentine Baptistery, he appears to have felt, like certain modern men of letters, that he could prove himself realistic only by turning to the sordid ugliness of life.

Intellectuality and passion. The quality that sublimated

FIG. 163—DONATELLO. GATTAMELATA. PADUA. (PHOTO. ALINARI)

his realism was the infusion of his figures with thought. Beyond mere accidents of subject and costume, what most essentially distinguishes his early work for Or San Michele, the St. George (now in the Bargello), from the statue of a classical hero is the impregnation of the head with a chivalrous nobility that makes him a typical representative of Christian knighthood. The Gattamelata is differentiated

from the Roman equestrian statue that gave Donatello some suggestions, the Marcus Aurelius of the Capitoline, by the intellectual traits which speak through the lineaments of the face. He also sought expression for his own emotional nature. His personages are highstrung and nervous. In the few reliefs of the Madonna and Child surely by his own hand and

FIG. 164—DONATELLO. DAVID. BARGELLO, FLORENCE. (PHOTO. ALINARI)

in the great number done by his immediate school, the yearning maternal love becomes so intense as to be almost painful. The climax was reached in the principal works of his old age, the two bronze pulpits for S. Lorenzo, Florence, both of them carried out very largely by pupils. The spaces are filled with surging throngs, whose figures, bowed beneath grief, terror, amazement, or adoration, are even crowded out behind or in front of the architectural divisions. With a

kind of impressionism, his nervous energy now sought to seize and crystallize momentary impressions, and he had come to prefer bronze because it preserved the freshness of the clay model and permitted more rapid execution.

His humanism. Amidst these eminently modern characteristics little place was left for any very vital influence of the antique, except in so far as it softened his realism and curbed his nervous energy. Its chief effect was to turn him towards the nude. He began in his early works by relieving many parts of the body of the Pisan wrappings. In the bronze David (Fig. 164), done at the end of his first period or the beginning of the second, of his own volition he stripped the Hebrew hero of all drapery, thus overriding mediæval prejudice and making an epoch with the first detached nude since the decay of classical art.

His invention. It has already become evident that Donatello possessed the temperament of a bold innovator. The Gattamelata was the first large bronze equestrian statue of modern times. The *putto* or nude child, suggested by the pagan Cupids or funereal genii, had already been employed in the Renaissance as a decorative *motif;* but in his part on the font in the Baptistery at Siena he was the first to introduce it as a free-standing figure, and by utilizing it as the principal *motif* on his exterior pulpit at Prato and on the singing-gallery of the Florentine cathedral (now in the Museum of the Opera del Duomo), he definitely established one of the loveliest elements in the art of the Quattrocento. He instituted *rilievo schiacciato;* and in mystic subjects (Fig. 165) he adopted its depressed and indistinct outlines to gain the unearthly effect required by the themes. His mind was so fertile in invention that he chafed under the bonds of traditional iconography: witness the utterly different but equally dramatic compositions for the Banquet of Herod in the bronze relief upon the Sienese font and in the marble relief of the Museum at Lille.

His achievement. Even a casual review of Donatello's career demonstrates the breadth of his genius. When he desired, the Annunciation in S. Croce (Fig. 166) shows that he could be as graceful as Ghiberti, and that without affecta-

FIG. 165—DONATELLO. ASSUMPTION ON TOMB OF CARDINAL BRANCACCI.　S. ANGELO A NILO, NAPLES.
(PHOTO. ALINARI)

tion; but he did not so far restrict himself to one kind of style that his personality can be defined by such phrases as the grace of Ghiberti or the robust vigor of Jacopo della Quercia. If it were necessary, however, to select and define

FIG. 166—DONATELLO. ANNUNCIATION. S. CROCE. FLORENCE. (PHOTO. ALINARI)

his outstanding contribution to the progress of art, the answer would be that he was the first since ancient days, either in painting or sculpture, to free the human body from its mediæval bonds, to realize its beauty as a thing in itself, and to demonstrate its significance as a plastic vehicle.

Ghiberti. His works. Lorenzo Ghiberti (1378-1455) is known chiefly as the author of the second and third bronze portals of the Florentine Baptistery. The second doors (1403-1424) are obviously based upon the prototype of Andrea Pisano. They are divided into the same number of twenty-eight compartments, the upper twenty containing the life of Christ and the lower eight the Evangelists and Latin

FIG. 167—GHIBERTI. PANEL REPRESENTING STORY OF ABRAHAM, EAST DOORS OF BAPTISTERY, FLORENCE. (PHOTO. ALINARI)

Fathers. Although the complication is greater, the scenes still consist of comparatively few figures, and the accessories of setting are simple. For Andrea's decorative border with accents of lions' heads is substituted a delicate *motif* of ivy with accents of human heads which are imitated from antiques or studied from actuality. The outer jambs and lintel are adorned with a chain composed of garlands of richly varied foliage, flowers, and fruits, filled, like the inner border, with all manner of things creeping and flying. All these

details are of Gothic derivation, but they sacrifice the partial conventionalization that the best Gothic artists deemed suitable to the rigidity of architecture for botanical and zoölogical accuracy bred by the revival of scientific interest. In the third portal (1425-1452) (Fig. 167), he used for the episodes from the Old Testament ten much larger panels, following the old custom [1] of compressing several scenes into the same frame. In accordance with the general tendency to elaboration manifested in the third doors, the inner border now includes, besides the heads, statuettes of Hebrew worthies and of Sibyls, and the continuous wreath of the outer frame is more luxuriant.

His style. Although in some respects Ghiberti was in sympathy with his times and owed much to humanism, he remained essentially a Gothic sculptor. In lines of body and drapery, he achieved the most exquisite Gothic elegance; but his forms differ from the earlier Gothic in that upon them is superimposed a desire for the beauty of the antique, which taught him classic restraint and prevented him from indulging in violence of attitudes or expression through the countenance. To a less degree than in Donatello and yet unmistakably, the body acquires more importance than in ordinary Gothic sculpture; but even his many nudes are marked by the almost feminine grace that permeates his whole production. Other tendencies of the Renaissance were bound to color his style. It is true that as early as his relief (now in the Bargello) which won him the commission for the second doors he had already abjured the realism and emotionalism that distinguish Brunelleschi's rival version of the same theme; but nevertheless with Ghiberti movement is always greater and more varied than with Andrea Pisano, and the members of groups and the decorative heads are differentiated in character. The sphere of his most daring experimentation was the pictorial treatment of relief, which attains its extreme manifestation in the third doors. The setting becomes an elaborate landscape of rocks and foliage or a grandiose expanse of architecture. For the effect of a deep perspective,

[1] Similar to the "continuous method of narration," cf. pp. 23, 167, and 175, note 1.

he uses a series of many planes, gradually diminishing in height of relief until they vanish into the background and so merging into one another that they create rather the illusion of one continuously receding plane. Purists in æsthetics have objected to the pictorial treatment because it confuses the aims of painting and sculpture and because perspective of landscape cannot be so convincingly rendered in the mediums of sculpture as in the gradated colors of painting. In any case, Ghiberti's achievement in this method was so transcendent that ever since his example has been often followed.

The inauguration of the type of Renaissance tomb. Bernardo Rossellino (1409-1464) has usually been considered the author of the tomb of Leonardo Bruni in S. Croce, Florence (1444) (Fig. 168), but a recent hypothesis, without any definite proof, ascribes to the architect Leon Battista Alberti the design of the monument and leaves to Rossellino only the execution. The tombs by Donatello and Michelozzo had been merely mediæval

FIG. 168—BERNARDO ROSSELLINO. TOMB OF LEONARDO BRUNI. S. CROCE, FLORENCE. (PHOTO. ALINARI)

forms adorned with *motifs* of the Renaissance repertoire. The sepulchre of Leonardo Bruni, though it borrowed certain elements from Donatello and Michelozzo, was, taken as a whole, a new invention, of such stately beauty that it henceforth imposed itself upon the Quattrocento, and with certain modifications, upon the Cinquecento.

Luca della Robbia. Like the other great sculptors of the first half of the Quattrocento, Luca della Robbia (1399 or 1400-1482) made a new contribution to the progress of art, a method of glazing terracotta with shining enamel of different colors, which he developed with such distinction that it enjoyed a phenomenal popularity, especially in the hands of the later members of his family's workshop. His color-scheme was always simple and restrained. The figures are

FIG. 169—LUCA DELLA ROBBIA. MADONNA AND ANGELS. BARGELLO, FLOR-
ENCE. (PHOTO. ALINARI)

white, delicately and sparsely accented with gold and set against a blue background. The hues are more varied only in decorative detail, such as the encircling wreaths of flowers and fruit, or in the heraldry of escutcheons. For the red glaze that it was impossible to obtain, violets, purples, and brown were substituted, and later real red was merely painted in. His style was no more complex than his color. He has little intellectuality or reminiscence of the antique. His simplicity, however, was illumined by the light of an acute

artistic sense, and he also possessed that rarest of gifts, the ability to express intense and tender religious devotion without sacrificing the majesty suited to divine personages and without passing into the region of the sentimental. He began in the more usual mediums and continued to employ them at times throughout his life. His rightly most popular achievement in marble is the singing-gallery of the Florentine cathedral, now reconstructed in the Opera del Duomo. The passionate rush of Donatello's companion piece is softened down into groups of children, arranged in separate panels and illustrating the verses of the CL psalm, in which humanity is called upon to praise God in different kinds of music. Concrete instances of his simple manner are the symmetrical composition in several of the panels and the avoidance of pictorial perspective. In bronze his most inspired religious style is represented by the doors of one of the sacristies in the cathedral of Florence, consisting of panels, each containing the Virgin, the Baptist, or one of the Evangelists or Fathers, between two angels. In glazed terracotta, his most beloved works are his numerous representations of the Madonna and Child (Fig. 169), sometimes more austere and hieratic, sometimes more human and familiar. He also employed the medium very effectively for architectural decoration, as especially in the medallions of Apostles on the walls and of St. Andrew over the entrance to the Pazzi Chapel, Florence, and in coats of arms and their surrounding wreaths.

2. The Second Half of the Quattrocento

a. *The Cultivators of Sentiment*

Andrea della Robbia. Confining himself almost wholly to glazed terracotta, Andrea della Robbia (1435-1525) in most respects clung so faithfully to Luca's principles that the diversities between them are the more apparent. Most significantly, he introduced sentiment into his uncle's themes. In what is usually reckoned an early commission, the medallions for the loggia of the Hospital of the Innocenti at Flor-

ence, the infants [1] already incline to be winsome. Affected, perhaps, by the contemporary cult of Neoplatonism and by a devotion to the teachings of Savonarola, Andrea bestowed upon his personages, especially the Virgin, a wistful and melancholy mysticism. With a Neoplatonic yearning towards the skies, he gave his subjects a more distinctly spiritual and heavenly tone by employing haloes, by flecking the back-

FIG. 170—ANDREA DELLA ROBBIA. ALTARPIECE. S. MARIA DEGLI ANGELI, ASSISI

ground with clouds, and by surrounding his sacred personages with flights of angels. A tendency to elaboration is evident everywhere in his production. With the precedent of probably not more than one instance in the work of his uncle, he extended the use of glazed terracotta to whole altar-

[1] Four of the fourteen infants, the pairs in the spandrels of the arches at the two ends of the loggia, are modern imitations.

pieces (Fig. 170). He sought pictorial effects of landscape in this medium, he extended the gamut of color, and indulged in more gilding. Ornamentation became excessive, and under the influence of the school of extreme Realists, the draperies were more involved. The tendencies to degeneration in the manipulation of the ware already apparent in Andrea della Robbia were carried still further by his son Giovanni (1469-1529 or 1530).

FIG. 171—DESIDERIO DA SETTIGNANO. MADONNA AND CHILD. PALAZZO PANCIATICHI, FLORENCE. (PHOTO. ALINARI)

Desiderio da Settignano. The most exquisite sculptor of the Quattrocento was Desiderio da Settignano (1428-1464). Though perhaps a pupil of Donatello, and certainly influenced by him, he did not inherit all the sides of that master's universal personality. What he did acquire was Donatello's supreme technical skill, and within his chosen sphere, which was restricted to the sweet and pleasant aspects of existence,

he was without a peer. He clothed his skill in aristocratic elegance, and applied it to the expression of a light and happy temperament. In his most monumental work, the tomb of Carlo Marsuppini, in S. Croce (1455), opposite Bruni's mausoleum, upon which it is modelled, he revealed his character by rendering Rossellino's sepulchral type less solemn and more graceful. His sensitive nature, as in his representations of the Virgin and Child (Fig. 171), spontaneously fell into Donatello's *rilievo schiacciato*. In his tabernacle for the Sacrament in S. Lorenzo, Florence, the treatment of the central panel in perspective as if it were a chapel leading to an inner shrine, even if anticipated by Bernardo Rossellino, was so beautiful that it established an important precedent in the Renaissance for these articles of ecclesiastical furniture. In his many effigies of children, his elegant temperament found delight, not, like Donatello, in their unrestrained expression of emotion or, like Luca della Robbia, in their robust innocence, but in the gentleness of their natures and the delicate lines of their young forms. Among the most characteristic of these productions should be mentioned the bust of the young St. John Baptist in the chapel of the Vanchetoni, Florence, the laughing *putto* in the Benda Collection, Vienna, and the *tondo* relief of the young Christ and St. John in the Arconati-Visconti Collection of the Louvre. The soft outlines of highly cultured ladies, as in the bust of the so-called Princess of Urbino in the Kaiser Friedrich Museum, Berlin, also offered an opportunity to Desiderio's refined chisel.

Mino da Fiesole. Mino da Fiesole (1430 or 1431-1484) has gained a reputation of which he was unworthy. His name has become a talisman for that delicate charm of Florentine sculpture at its height which was actually represented by Desiderio. The popular misconception of him is due to two causes, the false ascription to him of works by other masters and the ingenuous sweetness which, breathing through his whole production, wheedles us into forgetting his defects. He possessed also certain minor alleviating traits, such as the exquisiteness with which he carved architectural detail. But in the nobler qualities of sculpture he was lamentably

inadequate. He exaggerated the chief quality of the man who most influenced him: where Desiderio was delicate, Mino was dainty. He was ignorant of anatomy, and his modelling was sometimes even puerile. Many artists of the period gave their drapery decorative mannerisms, but Mino's folds are too stiff and too far removed from actuality. Bad enough in single figures, he was worse in the relative proportions of

FIG. 172—MINO DA FIESOLE. ALTAR. BADIA, FLORENCE. (PHOTO. ALINARI)

several objects and in the representation of pictorial background when it came to the complicated problems of perspective in scenes from sacred history. Characteristic specimens of his work are the two altars in the cathedral of Fiesole and in the Badia of Florence (Fig. 172). The Dance of Salome, one of three panels that he did for the indoor pulpit of the principal church at Prato, is a shocking instance of his faults in episodical relief and of his lack of religious seriousness. His masterpiece is perhaps the monument of Count

314 A HISTORY OF SCULPTURE

FIG. 173—AGOSTINO DI DUCCIO. PA-
TIENCE OF OBEDIENCE. S. BERNARDINO,
PERUGIA. (PHOTO. ALINARI)

Hugo von Andersburg in the Badia, Florence, a modification of Desiderio's sepulchral type. At Rome, where he was very popular, he usually collaborated on altars and tombs (cf. Fig. 184) with greater sculptors than he, Andrea Bregno and the Dalmatian, Giovanni da Traù.

Agostino di Duccio. In this group of cultivators of sentiment may be placed one of Donatello's pupils, Agostino di Duccio (1418-1481), who was essentially a decorator. From his master he derived his *rilievo schiacciato,* and from a study of Neo-Attic remains his disposition of transparent drapery in minute pleats and great swirls. This style he utilized for the adornment of architecture, always willing to subordinate realistic correctness, for which he had no talent, to his love of decorative undulating line and to the effective filling of the spaces. In his sacrifice of representation to calligraphic design and in his devotion to ethereal and languishing feminine types, he was a lesser Botticelli.

His two great undertakings were the embellishment of the

interior of S. Francesco at Rimini (according to the ornamental scheme planned by the medallist, Matteo dei Pasti) and of the façade of S. Bernardino at Perugia (Fig. 173).

b. *The Extreme Realists*

Antonio Pollaiuolo and Verrocchio distinguished themselves in painting as well as in sculpture. In the latter art, both

FIG. 174—ANTONIO POLLAIUOLO. HERCULES AND ANTÆUS. BARGELLO, FLORENCE. (PHOTO. ALINARI)

preferred the medium of bronze for the same reasons as Donatello in his last period and because it allowed more accuracy in detail. They were affected only very superficially by the antique, for instance in details of costume and architecture.

Pollaiuolo. Antonio Pollaiuolo (1432-1498) usually com-

bined in his productions (Fig. 174) his two chief interests, the scientific investigation of artistic anatomy and the representation of violent movement. By some magic of genius he was able to change his most unequivocal studies into works of art. A part of their appeal consists in the tremendous energy with which he endowed the physiques until the spectator himself feels that he is participating in the muscular strain. His training in the goldsmith's profession, even more than was usually the case with Florentine artists, inculcated a wonderful precision and delicacy. His greatest commission in sculpture, the bronze tomb of Sixtus IV, now removed from St. Peter's to the new papal museum of sculpture, differs widely from the customary Italian sepulchres of the period. A superb portrait statue of the pope, surrounded by reliefs of the Virtues, lies upon an elevated base with sloping sides, which is embellished with reliefs of the Liberal Arts. In the lightly clad allegorical figures, he now extended his investigation to the feminine nude. The difficulty of the concave surface in which the Liberal Arts are set was great enough, but he contorted the bodies, as well as those of the Virtues, in order to satisfy his craving to solve the most abstruse problems. Not content with the ordinary phases of reality, he chose those eccentric feminine types with long legs and short waists which he transmitted to Botticelli, and he arranged the drapery in complicated patterns.

Verrocchio. Andrea del Verrocchio (1435-1488) brought to its apogee the realism that Donatello had championed. Except for his superior Italian æsthetic sensibility, his art recalls vividly the realistic German sculpture of his time. Donatello in his David had forgotten a little his passion for realism in a desire to reduplicate the success of the ancients in the treatment of the nude; Verrocchio in his bronze David, now also in the Bargello, has reproduced with unsparing truth the wiry young athlete of the fields. A still more impressive opportunity for comparison with Donatello is afforded by the equestrian statue of the *condottiere*, Bartolommeo Colleoni (Fig. 175). Verrocchio has not, like Donatello, clothed his captain in the personality of a Roman general; he has boldly presented him, as he might actually

have appeared, compelling his troops by his iron will and eagle's glance. He has also given to horse and rider alike one of those vigorous poses in which Pollaiuolo excelled and in which there seems to be stored up all the powerful energy of the young Renaissance. Few critics would dispute the justice of calling Verrocchio's achievement the greatest equestrian

FIG. 175—VERROCCHIO. COLLEONI. VENICE. (PHOTO. ALINARI)

group in the world. His realism is as apparent in the boy with a dolphin now over a fountain in the court of the Palazzo Vecchio, Florence. A comparison with Desiderio's ethereal children is all that is necessary to prove the point. The marble group of Christ and the doubting Thomas in a niche on the Or San Michele is interesting, because it has fallen victim to the general European disease of the fifteenth century, the involution and indentation of the drapery for the

sake of chiaroscuro; but we forget details in the solemn majesty of the postures, which becomes more tangible by a comparison with the figures of the Sentimentalists or even of Benedetto da Maiano. The terracotta Madonna of the Bargello (Fig. 176) reveals that, when he would, he could be as aristocratically elegant as Desiderio. In his one unquestionably genuine portrait bust, the marble lady of the Bargello, he surpassed the delicacy of Desiderio in the modelling of the hands and the dexterity of Mino in the counterfeiting of fabrics. Both in the Madonna and the portrait, all these qualities have a greater effect upon the spectator because they are only auxiliaries to the general impression and are bestowed upon figures that possess more reality.

FIG. 176—VERROCCHIO. MADONNA AND CHILD. BARGELLO, FLORENCE. (PHOTO. ALINARI)

c. *The Group Intermediate between the Sentimentalists and Realists*

Antonio Rossellino. Similar in nature to Desiderio, Antonio Rossellino (1427-1478) compensated for lesser technical delicacy by a wider range of subject and was successful in episodical and dramatic reliefs. His figures are more solid and real than Desiderio's, and he preserved his brother Bernardo's religious sobriety in facial expression; but his forms were often more animated than those of either of the two sculptors to whom he was most closely related. The little

St. John in the Bargello is a striking contrast to Desiderio's hothouse products. The bust of the philosopher, Matteo Palmieri (Fig. 177), exhibits the unsparing realistic power of this group of sculptors when they undertook portraits. Like Bernardo and Desiderio, Antonio achieved renown by a great

mausoleum, that of the young Cardinal of Portugal in the Florentine church of S. Miniato, deepening the recess into a kind of mortuary chamber. The lovely relief of the Nativity in the church of Monte Oliveto at Naples applies to marble Ghiberti's pictorial perspective. Antonio Rossellino treated the same theme in the round in a beautiful group in the Metropolitan M u s e u m. At the end of his life, he joined the vanguard of those who abandoned the emaciated bodies of the Realists and the over-deli-

FIG. 177—ANTONIO ROSSELLINO. BUST OF MATTEO PALMIERI. BARGELLO, FLORENCE. (PHOTO. ALINARI)

cate forms of the Sentimentalists, and he began to show a predilection for the more robust figures of ancient art.

Benedetto da Maiano. Antonio Rossellino's follower, Benedetto da Maiano (1442-1497), cultivated realism more assiduously, and amplified the forms still farther, especially in his late works, accentuating the tendency by swathing the lower parts of the body in yards of drapery. His most celebrated piece is the pulpit of S. Croce, Florence, with reliefs from the story of St. Francis. It is marked by the greater richness of architectural decoration that is one of Benedetto's traits, signalizing the less chaste spirit of the later Quattrocento. In the works of his last years, such as the altar of the Annunciation in the church of Monte Oliveto, Naples, under increased classical influence he partly sacri-

ficed, like Andrea della Robbia, the freshness of the Quattro-cento and became rather dry and empty. His busts, for instance that of Pietro Mellini in the Bargello, are among the best of the period.

C. SCULPTURE OUTSIDE OF FLORENCE

The new style of the Renaissance was disseminated throughout the rest of Italy very largely by Florentine masters, especially Donatello.

1. Siena

Jacopo della Quercia. Siena's one boast in sculpture, Jacopo della Quercia (*c.* 1375?-1438), although he retained much Gothic feeling, was not Sienese in temperament. His personality is best expressed in the Virgin, Virtues, and scenes from the Old Testament, originally forming the Fonte Gaia at Siena but now removed to the Palazzo Pubblico for the safer keeping of the battered fragments that remain, and in the culminating works of his life, the statues of the Virgin and saints and the reliefs from Genesis and the infancy of Christ (Fig. 178) that he began in 1425 for the main portal of S. Petronio at Bologna. He here appeared as the truest precursor of Michael Angelo. An ardent lover of the nude, he chose powerful figures as of a race of supermen, and breathed into them passionate strength. One of his devices for imbuing his forms with a mighty energy was the transformation of the Gothic slouch into a violent backward and sideward thrust; the Virtues at Siena and the one bronze relief executed by him on the font that he himself designed in the Sienese Baptistery show how he could coerce magnificent sweeps of drapery into performing an emotional office. Unlike Ghiberti and Donatello, he admitted only a few large figures to his reliefs, and reducing the details of setting to their lowest terms, scorned almost entirely the pictorial treatment. Living at the dawn of the Renaissance and influenced by his Gothic predecessor, Nicola d'Apulia, Jacopo was

THE RENAISSANCE 321

somewhat indebted to Hellenistic art, especially for his re-
habilitation of the nude. In the case of both artists the
predilection for the massive may have been induced by the
old tradition of central Italy, which is recognizable in ancient
Etruscan art and in the Romanesque pulpits. In marked
contrast with Jacopo's usual agitated style is the tomb of

FIG. 178—JACOPO DELLA QUERCIA. SIN OF ADAM AND EVE. PORTAL OF S.
PETRONIO, BOLOGNA

Ilaria del Carretto in the cathedral of Lucca, one of the su-
preme works of the Renaissance and his earliest known ef-
fort. The loveliness of the sleep of death has never been ren-
dered with more classic tranquillity. On the base, bearing
funereal wreaths, are the first important nude *putti* of the
period. The French type of monument, the foreign costume,
above all the wide departure from Jacopo's ordinary man-
ner, have led Professor Marquand to doubt the justness of
the ascription.

Later in the century, Siena produced a good deal of respectable sculpture directly or indirectly inspired by Donatello.

2. Lombardy

It was only in the second half of the Quattrocento that Lombard sculpture rose to real importance in the Renaissance.

FIG. 179—STYLE OF THE MANTEGAZZA. ST. JAMES. FAÇADE OF THE CERTOSA, PAVIA

The style that was evolved was based upon the Florentine, amalgamated with Teutonic elements and distinguished by the luxuriance of its architectural detail. Except at Florence, indeed, sculpture during the fifteenth century was still looked upon as an embellishment of architecture, and little interest was manifested in free-standing statues. If the Lombard masters lacked the good taste and accuracy of the Florentines, they partially atoned by their brilliant invention.

The Mantegazza. The production of Amadeo may be taken as representative of the kind of sculpture that was being executed by many other Lombard sculptors of less renown, but a necessary preliminary to a discussion of his achievement is a consideration of the problem connected with the two brothers, Cristoforo and Antonio Mantegazza, who may have influenced him. Although it is impossible to attribute with certainty any one piece of sculpture to the brothers, it has become customary to ascribe to them a peculiar style that appeared in northern Italy in the latter part of the century. How far we are justified in this conjecture is a question. The style is exemplified in some parts of the façade of the Certosa near Pavia (Fig. 179), and we know that both of the Mantegazza labored here with Amadeo. But since the peculiarities are only exaggerations of elements in Amadeo's ordinary style, it may be that Amadeo himself produced these parts of the façade and other pieces of sculpture of the same sort, in the extravagant moments to which he was only too susceptible, or that his pupils are responsible, accentuating eccentricities that they found in their master's works. The bodies are often emaciated and elongated to the last degree, and yet even these impossible forms, especially the countenances, are rendered with a harsh realism. The neurotic figures and heads are infused with a painful intensity of emotional expression. The draperies, which are broken into a large number of minute, protuberant, and sharp-edged folds, have a distinctly metallic quality.

Amadeo. The production of Giovanni Antonio Amadeo (or Omodeo) of Pavia (1447-1522) demonstrates that no more than in Tuscany was there any sudden break with the tradition of the Middle Ages. Within the mortuary chapel of Bartolommeo Colleoni that he built as an annex to S. Maria Maggiore at Bergamo, the tomb that he made for the *condottiere* himself (Fig. 180) is an elaboration of the sepulchral form employed in the mediæval shrine of St. Peter Martyr at Milan. His figures are plainly reminiscent of the Gothic sculptors from Campione. The women, especially, have the same long, cylindrical necks and the same round heads with the hair bound close about the top and bursting

in a circle of heavy curls over the shoulders. A certain
Teutonism may perhaps be traced in the characteristics that
he shares with the works ascribed to the Mantegazza, an
obtuseness to physical beauty, a frequent elongation of the
members of the body, and a leaning towards passionate inten-
sity. His *putti* lack Donatello's anatomical correctness and
nervous energy, but no one has ever realized the charm of
childhood with more variety. His incorrectness is not con-

FIG. 180—AMADEO. DETAIL OF TOMB OF COLLEONI. COLLEONI CHAPEL, S.
MARIA MAGGIORE, BERGAMO. (PHOTO. ALINARI)

fined to the *putti*. He enthusiastically attempted difficult
perspective and foreshortenings, but seldom with success. The
anatomical defects into which he sometimes falls in adult
figures are perhaps intentional, as in the case of certain
other Lombard artists, for the sake of exotic effects in
which the Lombard temperament seems occasionally to have
revelled. He often resorted to a peculiar method of relief
that was very popular in northern Italy during the Quattro-

cento and was occasionally essayed in other parts of the peninsula. The figures in the foreground, though themselves kept in low relief, are undercut and almost detached so as to cast shadows and create an effect of chiaroscuro. Since Amadeo had a predilection for sharp outlines and therefore very commonly chose the profile position, the forms often look as if they had been stuck upon the background. The list of his most characteristic works, carried out with the extensive coöperation of assistants, includes: at Bergamo, the tombs of Colleoni and his daughter and the exquisite adornment of the façade of the chapel with the exuberant decorative repertoire of Lombard architecture; at the Certosa of Pavia (where he did much carving both on the exterior and the interior, but where his exact participation is hard to define), especially the door leading from the Minor Cloister to the church, some of the lovely little angels above the capitals of this cloister, and on the façade of the church, the reliefs of the Raising of Lazarus, Christ among the Doctors, the Nativity, and the Epiphany; the tomb of Giovanni and Vitaliano Borromeo in the chapel on the Isola Bella; and the shrine of St. Lanfranc in the church of the same name near Pavia.

3. Venice

Venetian sculpture was less significant than Venetian painting, which better embodied the taste of the city for color and display. In all phases of art and culture, Venice freed herself from mediævalism less quickly than Florence. The greatest native sculptors of the first half of the Quattrocento, Giovanni Buon and his son, Bartolommeo, evolved a manner that belonged half to the Gothic and half to the Renaissance. In the second part of the century, when the Renaissance was more definitely established at Venice, a potent Lombard influence united itself with the Florentine. The Lombard sculptors were much more numerous than the indigenous masters, but they tended to adapt themselves to the city's atmosphere.

Rizzo. The typical Venetian sculptor of the Quattrocento was Antonio Rizzo (d. 1499 or 1500). His figures are, to

a certain extent, inherited from the Campionesi, but they are less meticulous and nobler than those of Amadeo. The drapery takes grander sweeps, has deeper indentations, and

is not tainted by the Man-tegazza peculiarities. In the sepulchral field, his attainments are well exemplified by the tomb of the Doge Niccolò Tron in the church of the Frari, upon which he collaborated with Lombards, apparently executing at least the two Virtues beside the erect statue of the Doge at the bottom and, of the two jaunty pages, the one at the left. On Venetian tombs warriors or pages were commonly substituted for the Florentine *putti* as bearers of escutcheons. In the nude Eve (Fig. 181), one of the statues that he did for the Arco Foscari in the Ducal Palace, he embodied adequately the Venetian conception of feminine beauty, which in its voluptuousness varied essentially from the chaster and more emaciated Florentine type. Different from the nobler and more idealized Hellenic

FIG. 181—ANTONIO RIZZO. EVE. DUCAL PALACE, VENICE. (PHOTO. ALINARI)

type, it was to become as lovely in the magic hands of the painters Giorgione and Titian. The narrow, sloping shoulders, the emphasis upon the abdomen, the cast of countenance, and the greater naturalism in comparison with the feminine nudes of Florence, denote, as in Lombardy, a Teu-

tonic influence, whether German or Flemish, living on, at Venice, from the late Middle Ages.

The Lombardi. Of the Lombard invasion, the chief representative was Pietro Lombardo, active at Venice at least as early as 1462. His style is less vigorous, less individual, and more monotonous than Amadeo's, betraying both Florentine influence and traces of the Mantegazza drapery. His mausoleum for Pietro Mocenigo in SS. Giovanni e Paolo (Fig. 182) is an impressive example of Venetian pride in its transmutation of the central section beneath the great arch into a triumphal procession. The greatest architectural and sculptural undertaking of Pietro Lombardo, his sons Antonio and Tullio (who were also masters of distinction), and his *bottega* was the gem-like church of S. Maria dei Miracoli, a fitting witness to the Venetian love of splendor. Its walls, without and within, are completely covered by

FIG. 182—PIETRO LOMBARDO. TOMB OF PIETRO MOCENIGO. SS. GIOVANNI E PAOLO, VENICE. (PHOTO. ALINARI)

a rich incrustation of marbles, and the plastic decoration runs the whole Lombard gamut.

4. Emilia

The peculiarity of Emilian sculpture was a predilection for groups of large detached figures in painted clay or terracotta, constituting Holy Sepulchres or other sacred subjects

and treated with the utmost naturalism so as to give the illusion of breathing personages. The first example in Emilia, the Pietà in S. Maria della Vita, Bologna, was executed in 1463 by a master from the south, Niccolò da Bari (or dell'-Arca, d. 1494), who perhaps had visited Burgundy and seen there the Gothic Sepulchres. The most distinguished Emilian sculptor, Guido Mazzoni (1450-1518), may be studied in the Holy Sepulchre in S. Giovanni della Buona Morte, Modena,

FIG. 183—MAZZONI. NATIVITY. CATHEDRAL, MODENA. (PHOTO. ANDERSON)

and in the Nativity (Fig. 183) in the crypt of the cathedral of the same town. He is extremely realistic, introducing contemporary costume more often than Niccolò, and excelling in the rendering of the epidermis; but he is less frantic in his expression of grief and frequently sacrifices both realism and emotion to a feeling for beauty of form, countenance, and pose. He helped to spread the Renaissance by finally emigrating to France under Charles VIII. The technique of clay was adapted to the style of the Cinquecento by An-

tonio Begarelli (d. 1565). In his work the realism of Maz-
zoni has largely, though not wholly, given way to an idealism
that cultivates Raphael's translation of ancient forms and
costumes; and the compositions are more pictorial. His most
celebrated and pretentious composition is the group of the
Deposition from the Cross in S. Francesco, Modena. The
Madonna in glory with four saints below, in S. Pietro,
Modena, is an absolute transcription of the kind of painting
done by Raphael and his pupils.

5. Rome

Artistic conditions in Rome, especially the constant change
of pontiffs, prevented during the Quattrocento the formation
of any essentially Roman school. Several Italian sculptors
who came from other places to work in the capital·of Chris-
tendom have already been mentioned, and there now remains
for discussion the Lombard Andrea Bregno (1421-1506),
who was the chief personality in mortuary commissions at
Rome, often collaborating with his followers and with other
masters, such as Mino da Fiesole and Giovanni da Traù.
He was a really great sculptor, whose high merits have not
yet been properly appreciated. Through the classic influence
of Rome he evolved a much soberer and less mannered style
than his compatriots Amadeo and the Mantegazza. Here
and there one discerns a slight reminiscence of the peculiar
Lombard drapery, but the figures have none of the Mante-
gazza's elongation and are free from nervous agitation. With
exquisiteness and high finish he introduced the plenitude of
the Lombard decorative repertoire into his tombs, but he
used it with a restraint that cannot be paralleled in its home
in the north. Occasionally, also, he ennobled suggestions in
form and drapery derived from his partner, Mino. From the
precedents of Florence and Rome he created three types of
tombs that were often imitated by others. In the first type,
the most magnificent specimen of which is the monument of
the Cardinal Pietro Riario in the church of the SS. Apostoli,
the architrave cast so heavy a shadow that the relief or
painting in the background could not be clearly seen. Bregno

FIG. 184—ANDREA BREGNO. TOMB OF CRISTOFORO DELLA ROVERE. S. MARIA
DEL POPOLO, ROME. MADONNA BY MINO DA FIESOLE. (PHOTO. ANDERSON)

therefore devised two new types, modifying the old in such
a way as to obviate the difficulty. First, as in the sepulchre
of Raffaello della Rovere in the SS. Apostoli, he simply left
out the relief altogether and thus made the compartment into
a low cell. Another and the best way to avoid the difficulty
was to substitute the Florentine arch for the entablature,
and this he did on the tomb of the Cardinal Cristoforo della
Rovere in S. Maria del Popolo (Fig. 184), filling the arch,
as at Florence, with the Madonna (executed by Mino) and
adoring angels. He also produced a series of splendid altars,
suggested by the triumphal arch. In the cathedral of Siena,
the altar of Francesco Piccolomini, itself largely by his own
hand, is enclosed in a kind of little apse, the architectural
forms of which are Bregno's but the sculpture of which was
executed in great part by Michael Angelo and others.

6. Southern Italy

Like Rome, the kingdom of Naples and Sicily failed to
develop any great indigenous schools of sculpture, and im-
portant commissions had to be turned over to masters
from other regions. Of these, the chief was the Dalmatian
Francesco Laurana (c. 1425-c. 1502). There is no sure
knowledge of him until 1458, when we find him employed at
Naples upon the Triumphal Arch erected by King Alfonso I
before the Castel Nuovo. He certainly was already conver-
sant with Lombard and perhaps Florentine sculpture. The
rest of his life he divided between Sicily (1467-1472), where
his style found many imitators, the mainland of Italy, and
southern France (1461-1466 and again from 1476 until his
death). In regard to the distribution of labor on the
Neapolitan Arch between him and the numerous other
sculptors, there is no consensus of opinion. The most sig-
nificant works that he left in Sicily are several lovely statues
of the standing Madonna and Child, which, embodying the
same haunting feminine type that appears in his busts, set
the standard for this theme in the island. A charming ex-
ample may be seen in the Church of the Crucifixion at Noto,
signed and dated 1471. The chief relics of his activity in

France, both from his latter days and both probably in-
cluding the extensive collaboration of his atelier, are the
tabernacle of St. Lazarus in the Old Cathedral of Marseilles
and the relief of the Via Dolorosa in St. Didier, Avignon.
The most characteristic expression of his chisel is his series
of feminine busts. That of Battista Sforza in the Bargello,

FIG. 185—FRANCESCO LAURANA. "BEATRICE" BUST. MUSEO NAZIONALE,
PALERMO. (PHOTO. ALINARI)

Florence, stands apart in its somewhat greater individualiza-
tion. Attempts have been made to distinguish different
ladies even among the others; but since with a certain
idealization Laurana conforms the features to his own stand-
ard of womanly beauty and to his geometric treatment of the
countenance, all these others (Fig. 185) look very much alike,
and are perhaps rightly considered idealized portraits of

Beatrice, the second daughter of Ferdinand of Aragon, multiplied by the master as decorative objects for private palaces. Among the sculptors of the Quattrocento, Laurana was the linealist. He models his surfaces very slightly, and obtains his effects through lovely lines and their contrasts. Botticelli has demonstrated that, by a curious but not inexplicable psychological phenomenon, the desire for expressiveness seems to go with the temperament of the linealist. So it is that Laurana excels in rendering the mysterious subtleties of the feminine soul. His delicacy and sentiment suggest an analogy to Desiderio, but the Florentine by birth and environment was naturally more concerned with realistic modelling, more vigorous, and, in his feminine busts, not content with such simple means. From a sculptor with an endowment like Laurana's we must not expect dramatic scenes or ability to group figures; when he attempts these things, as at Avignon, he is likely to make a fiasco. He was great enough, however, to realize his limitations, and, like Desiderio, he confined himself ordinarily to themes suited to his genius.

D. THE SIXTEENTH CENTURY IN ITALY

1. Introduction

One of the factors that operated most powerfully to differentiate the art of the Cinquecento from that of the Quattrocento was the much augmented tendency to reproduce the antique. For the realism and individualization of the fifteenth century were partially substituted the idealization and generalization of the classic past. Although because of dependence upon ancient models artists in the sixteenth century were less faithful to the essentials of nature than in the fifteenth, they required that their figures should have a closer superficial resemblance to actuality; and they repudiated those eccentricities which were due to the readiness of the Quattrocento to subordinate the literal fact to other higher purposes, such as expressiveness, the emaciation of asceticism, decoration, the feeling of solidity, and beautiful lines. The

underlying thought, which since the beginnings of Christianity had been the chief concern of the artist, was now largely sacrificed to the cult of the body. One corollary of this change was the increased predilection for the nude, often imbued with a sensuality bred by resuscitated paganism. Another was the choice of those more robust forms of classical art which had been evolved as suitable to the themes represented by the ancients but had little relation to the content of Christianity. Relief lost the great favor that it had enjoyed, and separate statues in the round gained accordingly. The exuberant decorative repertoire of the Quattrocento

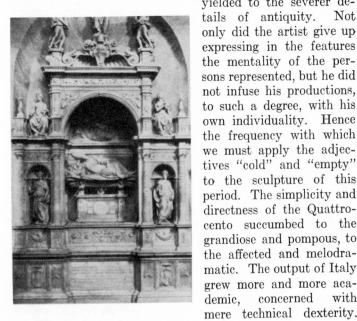

FIG. 186—ANDREA SANSOVINO. TOMB OF ASCANIO MARIA SFORZA. S. MARIA DEL POPOLO, ROME

yielded to the severer details of antiquity. Not only did the artist give up expressing in the features the mentality of the persons represented, but he did not infuse his productions, to such a degree, with his own individuality. Hence the frequency with which we must apply the adjectives "cold" and "empty" to the sculpture of this period. The simplicity and directness of the Quattrocento succumbed to the grandiose and pompous, to the affected and melodramatic. The output of Italy grew more and more academic, concerned with mere technical dexterity. The Cinquecento, however, with all its failings, still preserved much of the vitality of the Renaissance, and the name of Michael Angelo alone is enough to bestow lustre upon the century in which he lived.

2. The Transition

The sculptor who embodied best the transition from one century to the other was Andrea Sansovino (1460-1529). The two monuments in which most unequivocally he led the way into the new manner are the almost identical tombs of Girolamo Basso della Rovere and Ascanio Maria Sforza (Fig. 186) in S. Maria del Popolo, Rome, which, as direct imitations of the triumphal arch, established a precedent for sepulchres of the Cinquecento. The restlessness of the period, not content, in the effigy of the deceased, with the dignified repose of earlier days, wakes him to a half-reclining posture, derived from some ancient funereal relief, and crosses his legs.

3. Michael Angelo

His life and works. The man who affected most profoundly the sculpture of the Cinquecento was the Florentine Michael Angelo Buonarroti (1475-1564), and his influence has continued to be a vital factor in art down to our own day. Although he manifested supreme genius also in poetry, painting, and architecture, he was, by nature, essentially a sculptor, and he conceived and executed his painting from the sculptor's standpoint. His career may be divided into five periods. Of the first period, which may be extended to the date of his employment by Julius II, 1505, the most important works are the Madonna of the Steps or Bridge in the Casa Buonarroti, Florence, the Bacchus and the *tondo* of the Madonna in the Bargello, the Pietà in St. Peter's, Rome (Fig. 187), and the David in the Academy, Florence. The second period (1505-1512) was chiefly occupied by the painting of the Sistine ceiling, but the so-called Tragedy of the Tomb of Julius II then began, and continued until the latter part of his life. During his third period, the pontificate of Leo X (1513-1521), the master devoted himself principally to the mausoleum of Julius. He had first conceived the superhuman scheme of a separate temple in the midst of St. Peter's, but Julius soon desisted from the enterprise and thus con-

tributed to the embitterment of the artist's life. Of several later and less pretentious plans that Michael Angelo was allowed to draw up, the most significant, of 1513 or 1519, comprises a three-sided structure against the wall, derived from the triumphal arch. Around the base were to be a series of bound and writhing captives, symbolizing perhaps the Neo-

FIG. 187—MICHAEL ANGELO. PIETÀ. S. PETER'S, ROME

platonic concept of the imprisonment of man's soul in an earthly body or the fettering of the arts by the death of Julius, but also referring, for the master himself, to the fate that ought to descend upon the foreigners, the *barbari*, who were then seeking to subjugate the peninsula. Others have explained the symbolism of the Julius tomb as a crystallization of the words of a requiem mass. At the sides, in the second

FIG. 188—MICHAEL ANGELO. SLEEPING CAPTIVE. LOUVRE, PARIS. (PHOTO.
ALINARI)

stage, were to be seated Moses and St. Paul, typifying respectively the pope's military and intellectual abilities, and Rachel and Leah, typifying respectively the contemplative and active aspects of his life. Many things conspired, however, to thwart the realization of this plan, the scope of the monument was constantly reduced, and the work dragged on for thirty years more, until the tragedy, in its last sordid act, has produced in S. Pietro in Vincoli, Rome, a mere shadow of what Michael Angelo had intended. On the tomb as it now stands, the Moses and less certainly the inferior Rachel and Leah are by the master himself. Several other statues originally meant for the monument are scattered in different places; most notable are the Sleeping (Fig. 188) and the Heroic Captive of the Louvre.

His fourth period was the pontificate of another Medicean pope, Clement VII (1523-1534), when the misfortunes of Italy, culminating in the sack of Rome and the extinction of Florentine freedom, found expression in the tombs of the Medici in the second sacristy of S. Lorenzo, Florence. At the sides are the two similar monuments of Giuliano, Duke of Nemours, and Lorenzo, Duke of Urbino; at the back of the sacristy, the Madonna, one of Michael Angelo's greatest achievements, and the Sts. Cosmas and Damian by his pupils were at first intended as parts of a mausoleum of Lorenzo the Magnificent, who, with his brother, the elder Giuliano, is now buried modestly under these figures. The new type of sepulchre represented by the two ducal tombs was to have

FIG. 189—MICHAEL ANGELO. TOMB OF LORENZO, DUKE OF URBINO. SECOND SACRISTY, S. LORENZO, FLORENCE. (PHOTO. ALINARI)

a long history in the sixteenth and seventeenth centuries. The idealized portrait statue sits in an architectural façade; beneath is the sarcophagus surmounted by two reclining allegorical figures, for Giuliano, Day and Night, for Lorenzo, Dawn and Sunset (Fig. 189). The problem of their significance has given rise to many theories. Are they merely the four parts of the day, which, together, with the rivers of the earth, are invoked in a hymn by St. Ambrose for the feast of the titular saint, Lawrence? In any case, their gloom-sunken and agonized forms incarnate, more emphatically than ever before, the master's three-fold depression at the political degeneration of Italy, at the corruption of religion, and at the disillusionment of his own life. The characteristic sculptural production of his fifth and last period (1534-1564), when Christendom was ruled by the popes of the Catholic Reaction, is the Pietà, finished by Tiberio Calcagni, behind the high altar in the cathedral of Florence. The group has the fervid religious sentiment of the Counter-Reformation; and in contrast to the simplicity and freshness of his earlier rendering of the theme, the exhausted forms are bowed under the weight of grief, incorporating the old man's settled melancholy.

His relation to the antique. Michael Angelo embodied the characteristics that are observed in the other sculpture of the period, but he transcended them. A passionate enthusiast for the antique, he caught ideas from classical statues more often than has been surmised, but he absorbed these borrowings and made them a part of his own highly original style. The David, for instance, is derived from the two Horse-tamers on the Quirinal, Rome. Compared to Verrocchio's or even Donatello's David, it is classic and generalized; but compared to the sculpture of his own day, it is individualized and already infused with the master's tragic intensity. The early Pietà is perhaps the most marked example of the antique operating in Michael Angelo to smother emotional expression. Later, on the other hand, he was glad to find precedent for his contorted figures in the Laocoön (cf. Fig. 79), which he often used for suggestions. Though his love of the nude was partly inspired by antiquity, he did not ac-

quire his anatomy from Hellenistic figures but from life. The supreme skill with which he used the nude as a vehicle of expression and the masterly manner in which he obtained his effects better with the undraped than with the draped form may be illustrated by the wonderful impression of laxity imparted by the body of Christ in the early Pietà and by the Sleeping Captive, which belongs to the same glorious race as the youths of the Sistine ceiling.

The content of his works. He so imbued his productions with his high and peculiar sense of beauty and infused them with such profound thought or strong passion that he saved them from the prevalent danger of vacuity. This intellectual and emotional content usually emanated from his own powerful individuality, for he coerced his figures into embodiments of his religious, patriotic, and personal depression. Sometimes the tragedy is consigned to the countenance, as in the David, the Lorenzo of the tomb, or the Dawn; but he is more likely, according to the tendency of his century, to seek expression through the body. The straining forms bespeak also the constant struggle within himself between his fervent Christianity and his pagan love of physical beauty. So it was that he gave meaning to the contortions of his figures. The Bacchus, as yet with little emotional significance, reveals a preliminary stage of this phase of his style. In his maturity, by turning the head or one part of the form in a different direction from the rest of the form, he lent his authority to the posture which was to become a mania with the sixteenth century after him and which is described in Italian by the term *contrapposto*. By this convulsion of his figures, indeed, and by his high passion, he would have inaugurated the baroque style, had not the appearance of elegant mannerism in the second half of the Cinquecento postponed its definite development to the beginning of the seventeenth century. He did not, however, always confine himself to the expression of anguish; it was righteous wrath that he incarnated in the Moses, a statue which he has so infused with his own strong will and fierceness that it is one of the most terrifying pieces of sculpture in the world. This *terribilità*, this Titanic force of his own nature, he transferred to a

statue for the first time in the David. One sees here, also, how even at the beginning he thought in terms of the heroic, and one forgets, in the general, overpowering impression, to criticize such small details as the inordinate size of the right hand and, as not infrequently with Michael Angelo, of the head. Other early evidences of the epic character of his mind are the Madonnas of the Bridge and of the Bargello; in the latter instance, the effect is already accentuated by broad and majestic sweeps of drapery. Posterity has wondered why Michael Angelo left so many of his works unfinished. Some have believed that such was his definite purpose and that he sought thereby to gain a mystical effect. His troubled career, however, accounts sufficiently for the abandonment of many of his commissions, once begun, and certain of his most celebrated creations are highly finished. Yet perhaps he was not always sorry to be forced to leave some of his works in an inchoate condition, since with his Neoplatonic proclivities he must have valued the impression of mysticism.

4. The Colossal Tendency

In the rest of the sculptural output of Italy during the sixteenth century, two tendencies may be discerned: that which, preserving the outer shell but not the spiritual content of Michael Angelo, cultivated the massive and muscular, and usually chose the medium of marble; and that which retained more of the old Florentine feeling for grace and delicacy, and naturally preferred bronze. The majority of masters produced in both styles, but it is ordinarily possible to distinguish a more pronounced leaning in one direction or the other. The exponents of the former were likely to exaggerate it into a colossal vacuity, while the others debased grace into mannered elegance. The worst representative of the colossal tendency was the Florentine, Baccio Bandinelli (1493-1560), whose style may be summed up in the adjective, "academic." He was interested in the means rather than in the end; but his final condemnation is that he did not possess the technical skill on which he prided himself. The most notorious example of all his vices is the group of Hercules and Cacus at a corner

of the Palazzo Vecchio, Florence. In a famous passage of
the *Autobiography*, Benvenuto Cellini flays its defects so un-
mercifully that he leaves nothing further to be said. In the
similar tombs of the Medici popes, Leo X and Clement VII,
in S. Maria sopra Minerva at Rome, executed with the
collaboration of others, he carried still further the antiquarian
tendency that Andrea Sansovino introduced into the sepul-
chral type. Having abandoned altogether any reminiscence
of early Florentine mausoleums, he reproduced exactly the
triumphal arch, and abjured the luxuriance of the decorative
repertoire of the Quattrocento, which Sansovino had retained.
The most frankly academic works of his career are the
reliefs of Prophets and Apostles for the choir-screen of the
cathedral of Florence, twenty-four of which have been re-
moved to the Opera del Duomo. Considered as studies of
various postures and various dispositions of the drapery, they
are rather good, indeed so good that they are very generally
thought to have been principally executed by his pupil, Gio-
vanni Bandini, called Giovanni dell'Opera (1540-1599).

5. The Tendency to Elegance

Jacopo Sansovino. The first great representative of the
other tendency was the Florentine, Jacopo Tatti (1486-1570),
called Jacopo Sansovino from his master, Andrea. He has
much grace, but he is likely to exaggerate it into affectation.
He has much technical dexterity, but he is likely to bestow
upon it the tone of a cold, academic perfection, relieved only
by the sensuality of the epoch. The least mannered expres-
sion that he was capable of giving to these qualities he at-
tained in the masterpiece of his first period, the Bacchus of
the Bargello (Fig. 190). After 1527 he definitely settled at
Venice for the rest of his life. The sensuality of his art well
fitted him to be the principal sculptural exponent of the
paganish culture that was more gloriously embodied in paint
by his friend, Titian. His most notable plastic achievement
in this new environment was the embellishment of one façade
of the Loggetta, which he had constructed around the base of
the campanile, with four mythological bronze statues, em-

blematic of the civic virtues of the Republic. Despite his technical skill and the beauty of his decorative *motifs*, his cult of the graceful instead of the real and his theatricality caused him to fail in dramatic scenes such as the episodes

from the life of Christ on the bronze door of the sacristy of St. Mark's. The tomb of the Doge Francesco Venier in S. Salvatore, evolved upon the precedent of the triumphal arch, demonstrates that severe impressiveness was one of the compensations for the inordinate devotion to the antique.

Cellini. The persistence of the old Florentine tradition of delicacy in Benvenuto Cellini (1500-1571) is apparent in the fact that he began as a goldsmith and in essence always so remained. In

FIG. 190—JACOPO SANSOVINO. BACCHUS. BARGELLO, FLORENCE. (PHOTO. ALINARI)

small figures he could preserve the proportions and model delightfully, though affected by the bad taste of his day. He executed few large plastic works, and were it not for his persuasive boastfulness and for the charm with which he invests them by his descriptions in the *Autobiography*, as a monumental sculptor he would be comparatively unimportant. The salt-cellar of Francis I, now in the Imperial Treasury, Vienna, and the only absolutely authentic relic of his activity as a goldsmith, is an epitome of his style. First, it is highly ornate. Second, it prefers the nude human figure as a decorative *motif*. Third, the triumphal arch and the frigidity of the figures embody the increased enthusiasm for the antique. Of several pieces of sculpture which he states that he made in France, only one is extant, the bronze

recumbent Nymph now in the Louvre. As usual in Benvenuto's larger figures, there are anatomical defects, such as the attenuation of the nude, the masculine chest, to which breasts have been attached, and the awkward bend of the body. The breasts themselves, the abdomen, the arms, and the hands, however, exhibit the goldsmith's dexterity in details. The skilful and charming animals continue the tradi-

FIG. 191—CELLINI. DELIVERANCE OF ANDROMEDA. BARGELLO, FLORENCE.
(PHOTO. ALINARI)

tion of Ghiberti and the great bronze-workers of the previous century. His most celebrated statue is the Perseus, begun in 1545 on his return to Florence from France, the interest in which is piqued by his account of its no less than miraculous casting. In the first rough little sketch of wax in the Bargello, by a supreme effort of genius he succeeded in returning to the forceful simplicity of the Quattrocento. In the finished statue in the Loggia dei Lanzi, Florence, he abandoned his first ideas and created one of the popular

Herculean forms, frittering away his energy upon a study
of muscles. The statuettes on the base, especially the Danaë,
are again far superior. The relief of Andromeda's deliver-
ance, now transported from the base to the Bargello (Fig.
191), is full of every kind of *tour de force*, indicative of the
technical ostentation that marks the age and especially Ben-
venuto. He was not a great portraitist. Of his two authentic
bronze busts, that of Cosimo I in the Bargello illustrates pain-
fully the loss of the individuality that almost seems to speak
in a bust of the Quattrocento. The portrait of Bindo Altoviti,
at Fenway Court, Boston, is less theatrical.

Giovanni Bologna. The last great sculptor of the Italian
Renaissance proper was Giovanni Bologna (*c.* 1524-1608),
one of several distinguished Flemish masters who became
naturalized Italians at the end of the sixteenth and in the
seventeenth centuries. He combined both the colossal and
graceful phenomena, but inclined to the latter. Like all
others he was influenced by Michael Angelo. As a com-
panion piece to Buonarroti's so-called Victory in the Bargello,
for instance, he did the Florence overcoming Siena (also
named Virtue overcoming Vice) in the same Museum, exag-
gerating the writhings and failing to imbue them with
meaning. When he attempted colossal figures, he bestowed
upon them a factitious elegance which is incongruous
with the huge stature and creates the same unfortunate im-
pression as when we see in real life effeminacy united to a
large body. He possessed a high degree of technical dexterity,
most brilliantly illustrated by his best known work, the
bronze of the flying Mercury in the Bargello. The sixteenth
century was an age of fountains, several of which were de-
signed by the Florentine sculptor and landscape architect,
Niccolò Tribolo (1485-1550); and Giovanni Bologna labored
upon a number of notable specimens. Two belong to his
colossal manner, one of Neptune in the central square of
Bologna, and the other of Oceanus [1] on the Isolotto of the
Boboli Garden, Florence (Fig. 192). The Venus of a fountain

[1] On the actual fountain a copy of the central figure of Oceanus
has been substituted for the original, which has been removed to the
Bargello.

in the Grotto Buontalenti of this garden and a similar Venus over a fountain in the gardens of the Villa della Petraia belong to his other style in which, with exquisite grace but with some affectation, he maintained, like Cellini, the old Florentine tradition. His most avowedly academic production is the Rape of the Sabine Woman (Fig. 193), which exerted a tremendous influence upon the sculpture of the late Renaissance and the baroque. Viewed as merely academic, it is one of the greatest feats of all sculpture. It is planned to give three kinds of nudes, the feminine, the youthful masculine, and the more mature masculine, in as widely varied contortions as possible, and it may be inspected from any point with equal effectiveness.

FIG. 192—GIOVANNI BOLOGNA. FOUNTAIN OF OCEANUS. BOBOLI GARDEN, FLORENCE. (PHOTO. ALINARI)

Many of his sacred productions reveal an unexpectedly sincere religious sense, only slightly affected by mawkish sentiment and mannered elegance. The best examples are the bronze reliefs from the Passion now in the University of Genoa, the actual execution of which he perhaps consigned to his pupil Pierre Franqueville. Like Raphael he here caught and crystallized a happy, evanescent moment when the antique and modern civilizations almost blended, and he followed Raphael also in sometimes employing impressive architectural backgrounds to increase the solemnity of the scenes. As a portraitist he was unable to lend character to his subjects. Typical is the equestrian Cosimo I in the Piazza della Signoria, Florence, the steed of which set the precedent for the stocky horses of the baroque.

Tacca. Pietro Tacca (1577?-1640?), a pupil of Giovanni Bologna, in his equestrian Philip IV of the Plaza de Oriente at Madrid, with an incipient outburst of baroque ardor, created what is perhaps the first work of this sort in which the horse rears upon his hind legs. The idea may have come from some engraving or lingering tradition of Leonardo da

FIG. 193—GIOVANNI BOLOGNA. RAPE OF THE SABINE WOMAN. LOGGIA DEI LANZI, FLORENCE. (PHOTO. ALINARI)

Vinci's destroyed equestrian figure of Francesco Sforza at Milan, or from a painting by Rubens; but it is said that the attitude is derived also from the fashion of the Spanish riding-school. Among several other productions, his four chained Slaves around the base of Giovanni dell' Opera's statue of Ferdinand I at Leghorn are the most significant. He might once more have found the conception already in

some of Leonardo's drawings for equestrian monuments, but he probably took it from Giovanni Bologna's scheme for a monument to Henry IV at Paris. The figures are treated with a powerful naturalism, which again shows that Tacca had lived on into the days of the baroque.

E. THE RENAISSANCE OUTSIDE OF ITALY

The Renaissance did not penetrate from Italy into the rest of Europe until about the beginning of the sixteenth century, and then, at first, only in architectural detail. For the figures and often even for the ornament, the Gothic style persisted during the early years of the century, and, in places, beside the new Italian manner, well on into the century. It was the Italian style of the Cinquecento rather than that of the Quattrocento which was adopted.

1. France

Introduction. Although many Italians had already been honored with patronage in France, it was not until the reign of Francis I (1515-1547) that the Renaissance was actually ingrafted and produced French sculpture of the new fashion. The colony of Italian artists was much augmented. Francesco Primaticcio of Bologna (*c.* 1504-1570), who belonged to the Raphaelesque tradition, became the general director of Francis I's artistic enterprises, especially in the decoration of the palace at Fontainebleau. An important event for the history of French sculpture was Primaticcio's journey to Italy in 1542 to get bronze replicas of the famous ancient statues that had recently been excavated. These antiques and the Italian sculpture that was being produced at Fontainebleau made the palace a school in which many French masters were trained. The tomb of Louis XII and Anne of Brittany in St. Denis established at this time a precedent for royal sepulchres in the French Renaissance. The sarcophagus with the cadavers rests upon a base carved with reliefs of the sovereign's deeds in Italy and surmounted by a rectangular canopy of the Renaissance. Above the canopy

kneel the two effigies; at the four corners of the base sit the Virtues and under each of the arches one of the twelve Apostles. The two portraits and perhaps the cadavers were done by the school of Michel Colombe; the rest is largely the production of a family of Florentine sculptors established at Tours, whose name Giusto was there Gallicized into Juste. Outside of this series of royal sepulchres, by the end of the century the old mediæval tomb with the effigy upon a detached, elevated base had been abandoned for an edifice against the wall, partially suggested by Italian examples but with the important difference of the kneeling attitude for the deceased. The French sculpture of the Renaissance was distinguished from the production of Italy by an occasional reassertion of the mediæval sensitiveness to architectural function and by the delight in femininity that from first to last has impressed itself upon every aspect of French civilization. It was also saved from falling into such utter coldness as we often find in Italy of the Cinquecento by a certain persistence of the old Gallic naturalism of the Gothic period.

Goujon. There is less of Gothic naturalism and more of Italianism in the most celebrated French sculptor of the sixteenth century, Jean Goujon (probably a Norman, d. before 1568), and yet his achievement is by no means so frigid as the contemporary Italian output. All his important work was done for the decoration of architectural monuments. He elongated his forms for monumental effect, and he was always as ready to sacrifice correct anatomy to the exigencies of an architectural design as to his love of undulating outlines. A true Frenchman, he expressed himself most characteristically in sinuous feminine forms emerging from sinuous drapery. His masculine forms, likewise, tend towards a studied grace, but they also adopt, to a certain degree, the prevalent cult of the colossal, which French naturalism saved from vacuity. His drapery is Neo-Attic in its great swirls and in the minuteness of its pleats. It is particularly in this drapery that his peculiarly French nicety of execution manifests itself. His ideal of the feminine figure is approximated in the allegorical forms above the outside and inside of the

FIG. 194—GOUJON. NYMPHS ON FOUNTAIN, SQUARE OF THE INNOCENTS, PARIS. (PHOTO. GIRAUDON)

main portal to the edifice at Paris now known as the Hôtel Carnavalet. He achieved this ideal in his masterpiece, the Fountain of the Nymphs, now in the Square of the Innocents, Paris. At the remodelling towards the end of the eighteenth century, it was made into a four-sided structure, and three Nymphs were added to Goujon's original five; the plastic accretion was done by Pajou, who succeeded wonderfully in reproducing his predecessor's manner. Three reliefs of marine deities and monsters that Goujon had introduced on the base were removed in 1812 and are now in the Louvre. It is high enough praise to state that the Nymphs (Fig. 194) may be compared with the Victories of the balustrade for the temple of Athena Nike (cf. Fig. 58). Not since Greek days had any sculptor realized so well that happy mean between voluptuousness and noble restraint in the treatment of the feminine form. The culmination of Goujon's career, from the standpoint of renown, was his employment on the Louvre. About 1550 he executed three pairs of allegorical women to frame the round windows above the doors on Pierre Lescot's façade. The style is that of the Nymphs, impaired by the greater classical dryness that marks his last period. His most surprising achievement is within the palace, the four caryatides supporting a balcony in the antechamber of Catherine dei Medici, in the execution of which he perhaps followed freely models provided by some other artist. He could not have known the examples of the Erechtheum (cf. Fig. 57), but by brilliant intuition he reflected their glory in the monumental nobility of his impassive forms and in an architectural restraint of drapery, which is contrasted with the license that he ordinarily permitted himself in this phase of his art.

Pilon. The other great court-sculptor of the French sixteenth century, the Parisian Germain Pilon (1535-1590), although influenced by Goujon, was more closely related to the old Gothic tradition. In the monument for the heart of Henry II, possibly designed by Primaticcio and now to be seen in the Louvre, the three lithe Virtues made by Pilon to support the urn are more naturalistic translations of Goujon's feminine ideal. On the mausoleum of Henry II in St. Denis,

planned by Primaticcio, the bronze Virtues at the corners
were probably the work of the Italian master, but the kneel-
ing bronze portraits and the marble cadavers of the king and
queen were executed by Pilon, the two former figures in his
best naturalistic vein. As he grew older, he emancipated
himself further from the mannerisms of the late Renaissance
and cultivated a more uncompromising realism, often retain-

FIG. 195—PILON. SEPULCHRAL EFFIGY OF RENÉ DE BIRAGUE. LOUVRE,
PARIS. (PHOTO. GIRAUDON)

ing mediæval polychromy. The St. Francis, now in the
church of St. Jean-St. François, Paris, is Spanish in its
naturalistic presentation of religious ecstasy. His classical
training, however, helped him to maintain a proper repose
and monumentality in his busts and sepulchral effigies. His
greatest triumph of vigorous and penetrating portraiture is
the kneeling bronze of the Chancellor de Birague in the
Louvre (Fig. 195).

Provincial sculpture. Throughout the sixteenth century

the provinces were centres of considerable activity in religious sculpture. The old subjects and compositions, such as the retables and the Holy Sepulchres, were still repeated again and again, but the figures themselves were gradually Italianized. Agitated postures became more general; the gestures affected a mannered elegance; the drapery fluttered hither and thither; the countenances lost their individualiza-

FIG. 196—LIGIER RICHIER. HOLY SEPULCHRE. ST. ÉTIENNE, ST. MIHIEL. (PHOTO. BULLOZ)

tion and adopted the cold and generalized idealism of the Renaissance. The greatest of these provincial masters was Ligier Richier of Lorraine (c. 1500-1567). For the sacred personages he frequently employed contemporary costumes, and he still revealed not only the lovely feeling of the *détente*, but also, in a pronounced form, the notes of pathos and passion that mark so much late Gothic art. In the upright cadaver of René de Châlons in St. Pierre at Bar-le-Duc, he

gave to the common mediæval *motif* one of its most repellent
expressions, but even this skeleton covered with putrefying
flesh he ennobled in a certain way by the exaltation of the
gesture with which the deceased offers his heart to God. His
style in less eccentric sepulchral memorials may be illus-
trated by the figure of the aged nun, Philippe de Gueldres,
in the Franciscan church, Nancy, which is treated with a
vigorous but kindly realism. His religious masterpiece is
the Holy Sepulchre in St. Étienne at St. Mihiel (Fig. 196).

2. The Low Countries

Introductory. As in the flamboyant period the Flemish
had treated Gothic forms with the greatest opulence, license,
and fantasy, so now they overloaded their architecture and
pieces of ecclesiastical furniture with the Italian forms, some-
times giving the human body capricious proportions, delight-
ing in agitation, and in moulding the ornamental detail into
whimsical and grotesque shapes. Sculpture was conceived to
have a decorative rather than an intrinsic value, so that no
such great masters of form as in Italy and France were called
into existence. The production of Holland was not essentially
distinguished from that of Belgium, except that it was less
copious and brilliant; the principal centres were Breda, Dord-
recht, and Utrecht. In the latter part of the century a
highly Italianized form of Flemish sculpture dominated a
large part of Europe in the persons of Giovanni Bologna and
his pupils, who had emigrated from Belgium and Holland;
but curiously enough, neither these masters nor their man-
nered style found any favor in the Low Countries themselves.

Disseminators of Italianism. The most Italianate pur-
veyor of the Renaissance in sculpture, through study at Rome,
was Jacques du Broeucq (between 1500 and 1510-1584). He
never acquired the accuracy of modelling possessed by the
Italians, he usually made elongated bodies that have no back
bones, and he is full of the restlessness that marks the art
of his country. His capital production was the choir-screen
of Ste. Waudru, Mons, the majority of the fragments from
which may still be seen in the church. His tomb of Eustache

de Croy in Notre Dame at St. Omer, in its original disposition, constituted a sepulchral type which, with an allegorical statue at one end of the cadaver upon a bier, and a statue or statues at the other end, became popular in the Flemish baroque. Jean Mone (active during the first half of sixteenth century), if he is really to be credited with the works that

FIG. 197—CORNELIS FLORIS DE VRIENDT. SECTION OF CHOIR-SCREEN, CATHEDRAL, TOURNAI. (PHOTO. PHONO-PHOTO, TOURNAI)

have now been attributed to him, performed an equally or even more significant rôle in the propagation of the new fashions. Until recently he has been known only as the author of the Italianate retable in the church of Notre Dame at Hal. The painter and general artistic impresario, Lancelot Blondeel (1496-1561), also helped to Italianize sculpture by his designs for plastic monuments. One of the exponents of the more indigenous adaptation of the Renaissance and one

of the first Belgians to spread this style in other parts of Europe was the architect and sculptor, Cornelis Floris de Vriendt (1514-1575). In ornament he developed especially the Flemish grotesques and arabesques. His tabernacle in the church of St. Léonard, Léau, is an absolute translation into Italian of similar mediæval structures, with human figures used as supports in a fashion that was much affected in several kinds of monuments during this epoch in Flanders. In other works, as in the choir-screen of the cathedral of Tournai (Fig. 197), he is more Italianate. It was chiefly by his tombs in Denmark and Germany that he disseminated the fashions of his native land.

Characteristic monuments. The sepulchres of the sixteenth century, such as that of the Count Antoine de Lalaing in the church of St. Catherine, Hoogstraeten, possibly the work of Jean Mone, often continued the mediæval type with high base and with honestly realistic effigies. Other examples, such as the tomb of Jan III de Mérode in the church of St. Dympna, Gheel, ascribed to Floris, consist of a table supported by the popular human figures. *Epitaphs*, in the typical florid manner of the Flem-

FIG. 198—FIREPLACE. HÔTEL DE VILLE, ANTWERP. (PHOTO. THILL)

ish Renaissance, persisted as a frequent mode of commemoration. A series of pretentious fireplaces constitute one of the peculiarly Flemish contributions to the history of art. The example in the Burgomaster's Room of the Hôtel de Ville, Antwerp, perhaps by the painter Peeter Coecke (1502-1550),

combines Italianism with Flemish decorative elaboration (Fig. 198). The fireplace in the Stadhuis of Kampen, Holland, by Jacob Colyns de Nole of Cambrai (c. 1520-1601) is more classical. The most magnificent example, in the Council Chamber of the Palais de Justice, Bruges, was executed by Guyot de Beaugrant and others on the designs of Blondeel. Of carved wooden choir-stalls, for which the Low Countries had always been famous, the Renaissance produced several fine series. The most notable, in a severer taste than was common in Belgium or Holland, are those in the Groote Kerk at Dordrecht.

3. Germany and Related Countries

Introductory. The plastic style of northern Italy, and especially Venice, exerted the preponderant influence in the formation of the first stage of the German Renaissance, and the sculptors were also very much indebted to Dürer and other contemporary German painters and engravers. Very little important monumental sculpture was produced at this time in the style of the Renaissance, but the German masters excelled in small objects, such as statuettes and mythological plaques. An early focus of the new movement was Nuremberg, where for a considerable time it existed beside the mediæval manner of such men as Krafft and Stoss. When the Renaissance had definitely triumphed in the middle of the century, German sculpture, chiefly because of the religious wars, had fallen into decadence, and almost all significant production was in the hands of masters from the Low Countries.

The First Half of the Sixteenth Century

Vischer. Peter Vischer of Nuremberg (1460-1529), who presided over a workshop that excelled in the medium of bronze, died before Stoss and was himself half Gothic. The tomb of the Archbishop Ernst in the cathedral of Magdeburg (1496) could be reckoned still completely Gothic, were it not for the statuettes of Apostles around the base, which reveal in the heads an effort for a more ideal beauty and in

the drapery a predilection for more broadly flowing lines.
In the Stadt-Kirche at Römhild, the lovely tomb of Count
Hermann of Henneburg (about 1508) exhibits in the effigies
a greater classicism. It is always possible, however, that,
in this earlier stage of Vischer's career, these qualities were

FIG. 199—PETER VISCHER. RELIQUARY OF ST. SEBALDUS. ST. SEBALDUS,
NUREMBERG. (FROM DEHIO AND VON BEZOLD, "DIE DENKMÄLER DER DEUT-
SCHEN BILDHAUERKUNST")

due, not wholly to Italy, but partially to the tendency
towards a *détente* that was most pronounced in the Gothic
school of Swabia. The indebtedness to the Renaissance
is unmistakable in Vischer's masterpiece, the bronze canopy
(1507-1519) covering the old reliquary of St. Sebaldus
in his titular church at Nuremberg (Fig. 199); and yet its

fanciful opulence and certain other indigenous traits trans-
mit an impression that is distinctly Teutonic. Every avail-
able part is covered with a fusion of mediæval and Renais-
sance decoration, especially *putti*, which make up for what
they lack of Italian correctness by a certain Teutonic lusti-
ness and sportiveness. To the Apostles on the piers of the
canopy Vischer, though starting always with German types,
has given beautifully idealized heads and elegant bodies, the
lines of which are revealed by the classical folds of the
drapery. In the château of Montrottier, France, there have
recently been discovered fragments of the screen ordered from
him for the Fugger Chapel, Augsburg, eventually set up in
the Rathaus, Nuremberg, and finally dismantled; the two
bronze reliefs by the master himself demonstrate that at last
he succumbed completely to the Renaissance. It is customary
to attribute to Vischer the bronze statues of Arthur and
Theodoric among the twenty-eight ancestors that surround
the tomb of the Emperor Maximilian in the Franciscan
church at Innsbruck. The several German masters who were
responsible for the other ancestors made them look like the
manikins that exhibit heavy suits of armor in museums, but
the sculptor of the Arthur allows us to divine the body be-
neath the accoutrement. Here and in some of Vischer's cer-
tain works, the enduring qualities of the best German art
reassert themselves even in the surroundings of the Renais-
sance—firmness of pose, forceful realism, and restrained
vigor. The reliefs, Virtues, and kneeling effigy of the tomb
were finally executed by the Flemish sculptor, Alexander
Colin of Malines (1527 or 1529-1612), who enjoyed extensive
patronage in Germany and Austria.

Peter Vischer the Younger. Of several of Vischer's sons
who followed the paternal profession, the most distinguished
was Peter the Younger (1487-1528), whom some critics be-
lieve to have been responsible even for the more progressive
elements in the productions ascribed to his father. The
principal work that he himself executed without his father's
collaboration is the fine upright sepulchral bronze of the
Elector Frederick the Wise in the manorial chapel at Witten-
berg. The architectural ordinance seems to be imitated from

the section of the Venetian tomb of Niccolò Tron containing the erect effigy of the deceased. The impressive portrait has something of the sternness and testiness of the Reformation. The Vischer workshop, however, gradually lost its popularity and confined itself more and more to objects of virtu. A typical specimen is the younger Peter's bronze tablet of Orpheus and Eurydice, illustrating an original adaptation of the antique and existing in four repetitions.

Flötner. Another significant master of Nuremberg, who may even have influenced the elder Vischer, was Peter Flötner (*c.* 1485-1546), perhaps a Swiss by birth. Modern research has been endeavoring to make of him one of the pioneers in the German Renaissance by attributing to him designs for certain important German and Swiss monuments. Though chiefly an architect, he was a jack of all artistic trades. His plastic style was that of an Italian mannerist. His small plaques of sacred, mythological, or allegorical subjects were executed in stone, but copies were made in lead and bronze. The five bronze specimens, with episodes from the Old and New Testaments, in the Metropolitan Museum, contain the pictorial backgrounds that he often affected.

Adolf and Hans Dauher. It is a question whether we should follow certain critics in ascribing to Flötner or some other artist the elements of the Renaissance, such as the design, ornament, and *putti,* on the choir-stalls of the Fugger chapel in St. Anna, Augsburg, and the similar embellishment of the high altar of the church at Annaberg. As a consequence of such an ascription we should have to deny to Adolf Dauher of Ulm (*c.* 1460-1523 or 1524) the significant rôle in the importation of Italianism that has often been allotted to him. The stalls are preserved only in drawings and an etching, except for some fragments and sixteen busts of sacred personages and Sibyls, fifteen in the Kaiser Friedrich Museum, Berlin, and one in the Figdor Collection, Vienna. The majority, if not all, of these busts, in distinction from the decorative detail of the stalls, were certainly executed by Adolf Dauher. It is perhaps possible to trace in the busts and in his figures on the altar at Annaberg some Italian elegance, but they are essentially specimens of the

late German Gothic style, plainly influenced by the figures on Syrlin's stalls at Ulm. Adolf's son, Hans Dauher (*c.* 1485-1538), whom, as in the case of the Vischers, some have thought the innovating spirit in the workshop, is chiefly remembered for his *epitaphs* and slate plaques. In his backgrounds, which are often suggested by the architecture of the Lombard Renaissance or of Venetian tombs, he is fond of the triumphal arch; the figures, except the *putti,* and the drap-

FIG. 200—HANS DAUHER. TRIUMPH OF CHARLES V. METROPOLITAN MUSEUM, NEW YORK. (COURTESY OF THE METROPOLITAN MUSEUM)

eries are still largely Gothic. He is distinguished by a pow r of vivid characterization and by much stylistic gusto; one of his most agreeable qualities is an extreme delicacy of execution that reverts to low relief and recalls the Florentine Quattrocento. According to the German habit of the time, he probably often translated into his medium the compositions of others. The largest and most populous of his reliefs is the panel in the Metropolitan Museum representing the triumph of Charles V (Fig. 200).

Meit. Konrad Meit of Worms (active at the end of the

fifteenth and beginning of the sixteenth century) was en-
dowed with more personality than the majority of his con-
temporaries, so that he was able to impress upon all his
creations the appealing charm of his own highly developed
sense of beauty. Although he was affected by the new move-
ment, especially in his predilection for the nude and for *putti*,
he retained so much Gothic naturalism that his style seems
like that of an Italian master of the Quattrocento rather than
of the Cinquecento. The signed work upon which all the
other attributions are based, an alabaster statuette of
Judith in the National Museum, Munich, is a typical ex-
ample of his naturalistic nudes. Of a number of busts in
wood or alabaster ascribed to him, the two finest, quite the
equals of the best that the Italian Quattrocento achieved, are
similar portraits of young men, one in the Kaiser Friedrich
Museum at Berlin and the other in the British Museum.
Documentary evidence proves that he was extensively em-
ployed upon the magnificent tombs of Margaret of Austria,
Philibert of Savoy, and the latter's mother, Margaret of
Bourbon, in the church of Brou at Bourg in southern France;
but it is difficult to separate his production from that of the
crowd of his Flemish, French, and Italian collaborators.
Among the parts assigned to him, the three beautiful effigies
are half portraits, half idealizations, after the manner of the
détente; and the pair of captivating *putti* at the feet of
Margaret of Austria may again be compared with the most
famous specimens of fifteenth century Italy.

The Second Half of the Sixteenth Century

During the second half of the century Belgian and Dutch
sculptors monopolized important patronage, introducing the
mannered style of Giovanni Bologna, frequently in the form
that it had assumed at Venice. Their significant productions,
often consisting of fountains that imitate the Italian speci-
mens of the later Cinquecento, are found in southern Ger-
many, especially at Augsburg and Munich. The dominant
plastic personality in the latter city was Hubert Gerhard
(c. 1545-1620), who impregnated his Italianate manner with

a certain Dutch heaviness. His most celebrated achievement is the fountain of Augustus before the Rathaus at Augsburg (Fig. 201). Besides his certain works several familiar landmarks of Munich, such as the Wittelsbach Fountain of the Alte Residenz and the Madonna on the Column in the Marien-Platz, are beginning to be ascribed with some reason and unanimity to his design and partial execution. The name of the German sculptor, Hans Krumper, has also been mentioned in connection with these monuments, but he may have been only an assistant of Gerhard or no more than a caster of bronze. In any case, the trend of modern criticism is abandoning the tradition which exalted the Belgian painter, Pietro

FIG. 201—GERHARD. FOUNTAIN OF AU-GUSTUS. AUGSBURG. (PHOTO. DR. FR. STOEDTNER, BERLIN)

Candido (an Italianization of Peeter de Witte), into the designer of the plastic groups at present attributed to Gerhard and indeed of those that he surely executed. The most faithful disseminator of Giovanni Bologna's manner in Germany was Adriaen de Vries of The Hague (*c.* 1560-1627), who had a somewhat greater proclivity than his master for the muscular and contorted. Of his many extant works, which are all of bronze, the best known are the simpler fountain of the flying Mercury and the more elaborate fountain of Hercules and the Hydra, both at Augsburg.

4. England

The sculptural output of the Renaissance in Britain, partly by reason of the iconoclasm of the Reformation, was a very poor thing indeed. The Gothic style, in an enervated form,

dragged out a lingering death through the whole sixteenth century. A few Italians, none of them possessing the highest talent, found employment in London and the surrounding district; but England was blessed with no such native geniuses as Germain Pilon or Peter Vischer. The principal extant Italian works were done by Pietro Torrigiano of Florence (1472-1528). Having found his way to England in 1512, he left as his two greatest achievements in this country the tombs of Henry VII and of that sovereign's mother, Margaret, Countess of Richmond, both in Henry VII's chapel in Westminster Abbey. In the midst of decorative figures and architectural detail of the Renaissance, something of the English Gothic tradition still remains, especially in the sepulchral type with high base and in the style of the effigies themselves. By the second quarter of the century, exponents of Italianism from the Low Countries began to be the recipients of that favor which they were to enjoy for the next two hundred years in the island, and a number of mediocre Englishmen abandoned the Gothic to imitate either their achievements or more purely Italian work. The indigenous carvers confined themselves to the architectural repertoire of Italianism, and used the figure only in such details as ornamental heads or, particularly, profiled faces, which are almost caricatured portraits and constitute a peculiarity of the English Renaissance. The choir-stalls, for instance those of King's College, Cambridge, are perhaps the most noteworthy examples of this movement. From the death of Edward VI in 1553 to the accession of James I in 1603, the degeneration of sculpture was betrayed by its almost absolute restriction to uninteresting tombs, the effigies of which were debased descendants of their Gothic ancestors.

5. Spain

Italian disseminators of the Renaissance. Domenico Fancelli of Settignano (1469-1519) established a precedent for certain tombs of the early Renaissance in Spain. A good sepulchral portraitist, he has, in architectural detail, a breath of Desiderio da Settignano's elegance, but for his

forms he has already partially developed the amplitude of the Cinquecento. His impressive monument of Prince John, the son of Ferdinand and Isabella, in Sto. Tomás, Avila, is a marble transcription of Pollaiuolo's tomb for Sixtus IV; his later monument of the sovereigns themselves in the Royal Chapel adjoining the cathedral of Granada is merely an elaboration in a more mannered style. His earliest mausoleum in Spain, for the Archbishop Mendoza in the cathedral of Seville (1509), is of a different type, derived from the

FIG. 202—JUAN DE ARFE AND LESMES FERNÁNDEZ DEL MORAL. SEPULCHRAL EFFIGY OF CRISTÓBAL DE ROJAS. S. PEDRO, LERMA. (PHOTO. LACOSTE)

Roman wall-tombs of the later Quattrocento. Pietro Torrigiano brought his checkered life to an end by coming to Seville in 1526 and by finally starving to death in the Inquisition's prison. In his terracotta statues in the Museum of that city, a seated Virgin and a kneeling St. Jerome, like many another foreigner he was so overcome by the artistic atmosphere of the peninsula that he indulged in a pronounced Spanish naturalism. Under Charles V and Philip II, two great Italian bronze-workers, Leone Leoni (1509-1590) and

his son Pompeo (d. 1610), executed a number of monumental achievements. The masterpieces of the latter are the kneeling bronzes of Charles V and Philip II with their families on either side of the sanctuary in the Escorial. In a style similar to that of these figures, he also designed two sepulchral portraits of the Duke and Duchess of Lerma, now in the Museum of Valladolid; but they were actually executed by his assistant, Juan de Arfe (1535-1603), belonging to a family of Flemish or German goldsmiths who had emigrated to Spain at the beginning of the century, and they were finished by Arfe's son-in-law, Lesmes Fernández del Moral. Of the two statues of the Duke's uncles, intended to accompany those of the Duke and Duchess, only one was executed, that of Cristóbal de Rojas, now in S. Pedro, at Lerma (Fig. 202). Begun by Juan de Arfe and completed by his son-in-law, in aristocratic richness of accoutrement, in fineness of technique, and in tranquil beauty it is one of the most remarkable mortuary bronzes of the world. Pompeo Leoni also did marble tombs of this fashionable type, with kneeling effigies looking towards the altar from under an arch.

The transitional masters. Of the transitional masters who still retained much of the Gothic style and, like even the later sculptors of the Spanish Renaissance, clung to the tradition of polychromy, two may be taken as characteristic. The Burgundian Felipe Vigarni (d. 1543) had acquired the Franco-Flemish manner of the laté Middle Ages on his native heath. The large reliefs from the Passion on the screen behind the high altar of the cathedral of Burgos stand for his early Spanish style, in which he amalgamated with his Gothic training such Italianisms as elegance of attitude, interest in the nude, and greater tranquillity. His retable and kneeling statues of Ferdinand and Isabella in the Royal Chapel at Granada betray how his later, more definite enrolment in the new movement emptied his figures of Gothic life and left them cold. In the eastern part of the peninsula, Damián Forment (c. 1480-c. 1541), chiefly a sculptor of retables, passed through much the same evolution. His more Gothic phase may be illustrated by the retable of the church of the Pilar at Saragossa, patterned directly upon the

mediæval example in the Seo of the same city. The frame-
work and the greater part of the architectural detail are
florid Gothic; but the *predella* and base exhibit ornamental
elements of the Lombard Renaissance, and the figures them-
selves already have the fullness of the Italian sixteenth cen-
tury, accentuated by sweeping draperies. In the later retable
of the cathedral of Sto. Domingo de la Calzada, the deco-
rative sections of which are by another hand, the figures by
Forment exhibit the complete triumph of the Renais-
sance.

The sculptors of the first generation. Of the Spaniards
who actually studied in Italy, Bartolomé Ordóñez, a pupil
of Fancelli, was the most
Italianate. The statues
and reliefs from the life of
St. Eulalia on the choir-
screen of the cathedral at
Barcelona reveal him as a
provincial but not utterly
unworthy imitator of Mi-
chael Angelo. For the tomb
of the Cardinal Cisneros in
the Church of La Magistral
at Alcalá de Henares, he
merely modified a design of
Fancelli, who had origi-
nally received the commis-
sion, and he developed the
type to its greatest ornate-
ness in the sepulchre of
Charles V's parents in the
Royal Chapel at Granada.
The most vigorous and
most Spanish personality in

FIG. 203—BERRUGUETE. ST. SEBAS-
TIAN AND SACRIFICE OF ABRAHAM.
MUSEUM, VALLADOLID. (PHOTO. LA-
COSTE)

this generation was Alonso Berruguete (*c.* 1486-1561), a fa-
vored pupil of Buonarroti. He was a true Spaniard in his
religious emotionalism, which the contortions that the Span-
ish artists acquired in Italy were eminently fitted to express;
but he was also a precursor of the nervousness and force of

the baroque. His style is well illustrated by the figures of his first important work after his return to Spain before 1520, the wooden retable of S. Benito, Valladolid, the remains of which are now gathered in the Museum of that town (Fig. 203). The forms are not the powerful nudes of Michael An-

gelo, but are rather emaciated and long drawn out. Both in religious fervor and in type they seem to prophesy El Greco. The *contrapposto* reappears, somewhat moderated and applied to sturdier figures, in his masterpieces, the carvings on the upper range of stalls in the cathedral of Toledo, where, for a time, Vigarni coöperated with him.

The second generation. Juan de Juni (c. 1507-1577) carried Berruguete's contortions and religious passion into the region of disagreeable exaggeration, wound the draperies into hopeless entanglements, and colored his material of

FIG. 204—BECERRA. ST. JEROME.
CATHEDRAL, BURGOS

wood with an unusually garish brilliancy and opulence of gold. Typical works are the Entombment on the screen around the altar of the cathedral at Segovia and the less perturbed dead Christ of the Museum at Valladolid. If Juan de Juni was the Berruguete of the second generation, Gaspar Becerra (c. 1520-1570) was the Ordóñez. The retable of the cathedral at Astorga demonstrates his thorough Italianism and dependence upon Michael Angelo. His little statue of St. Jerome in the Chapel of the Constable in the cathedral of Burgos (Fig. 204), despite the classical head and the mannered elegance of the pose, reveals a Spanish

naturalism and explains Becerra's fame as an anatomical expert.

BIBLIOGRAPHICAL NOTE

The two standard works on the culture of the Italian Renaissance, vying with each other in wealth of material and intelligence of interpretation, are J. Burckhardt's *The Civilization of the Renaissance in Italy*, English translation by S. G. C. Middlemore, New York, 1909, and J. A. Symonds's *Renaissance in Italy*, Scribner's edition, 1907-1910, one of the seven volumes of which is definitely devoted to the Fine Arts and is so felicitous in its characterizations as not yet to be antiquated. The standard monographs on the Italian sculpture of the epoch are: M. Reymond, *La sculpture florentine*, in four volumes, Florence, 1897-1900; O. Sirén, *Florentinsk Renässansskulptur*, Stockholm, 1909; W. Bode, *Florentiner Bildhauer der Renaissance*, Berlin, 1910; and P. Schubring, *Die italienische Plastik des Quattrocento*, Berlin, 1919. Copious and excellent photographs of Italian sculpture will be found in the two collections by W. Bode, both accompanied by a short text, *Denkmäler der Renaissance-Sculptur Toscanas*, Munich, 1892-1905, and *Die italienischen Bronzestatuetten der Renaissance*, Berlin, 1907-1912. The following are the most important monographs on the masters of the Quattrocento: on Donatello, A. G. Meyer, Leipzig, 1903, W. Pastor, Berlin, 1906, and E. Bertaux, Paris, 1910; on the several members of the Della Robbia workshop, the various aspects of their production, and the related *atelier* of the Buglioni, a series of seven books written by A. Marquand with the fullest resources of modern scholarship from 1912 and 1922, consisting of *catalogues raisonnés* and brief, general essays of introduction and published at Princeton; on Agostino di Duccio, A. Pointner, Strassburg, 1909; on Pollaiuolo, M. Cruttwell, New York, 1907; on Verrocchio, H. Mackowsky, Leipzig, 1901, M. Cruttwell, New York, 1904, and M. Reymond, Paris, 1906; on Jacopo della Quercia, C. Cornelius, Halle, 1896; on Amadeo, F. Malaguzzi Valeri, Bergamo, 1904; on Laurana, F. Burger (Strassburg) and, more comprehensive, W. Rolfs (Berlin), both of 1907. For Sienese sculpture one may turn to P. Schubring, *Die Plastik Sienas im Quattrocento*, Berlin, 1907. The whole Venetian Renaissance in sculpture is superbly treated by L. Planiscig in *Venezianische Bildhauer der Renaissance*, Vienna, 1921. From the multiplicity of works on Michael Angelo, the following are

370 A HISTORY OF SCULPTURE

particularly recommended: J. A. Symonds, *The Life of Michelangelo Buonarroti,* London, 1893; H. Thode, *Michelangelo und das Ende der Renaissance,* Berlin, 1902-1903, and *Michelangelo, kritische Untersuchungen,* Berlin, 1908-1913; C. Justi, *Michelangelo,* Berlin, 1909; H. Mackowsky, *Michelagniolo,* second edition, Berlin, 1921; K. Frey, *Michelagniolos Jugendjahre,* Berlin; and G. Brandes, *Michelangelo Buonarroti,* Copenhagen, 1921. A further course of reading on Benvenuto Cellini may be pursued in the books of E. Plon, Paris, 1883, H. Focillon, Paris, 1910, and R. H. H. Cust, London, 1912. The monographs of P. Schönfeld on Andrea Sansovino, Stuttgart, 1881, and of A. Desjardins on Giovanni Bologna, Paris, 1883, have not yet lost their significance.

Specialized works on sculpture of the French and Belgian Renaissance are provided by: P. Vitry, *Jean Goujon,* Paris, 1909; P. Denis, *Ligier Richier,* Paris, 1911; R. Hedicke, *Jacques Dubroeucq von Mons,* Strassburg, 1904, and *Cornelis Floris,* Berlin, 1913. B. Daun's book on Vischer and Krafft, Leipzig, 1905, has been supplemented by the article of L. Réau, *Les bas-reliefs de Montrottier, Gazette des Beaux Arts,* 1921, II, pp. 225-236. Peter Vischer the Younger is studied by G. Seeger, Leipzig, 1897, and W. Bode in the *Jahrbuch der preussischen Kunstsammlungen,* XXIX (1908), pp. 30-43. On Flötner, not only should A. Haupt's monograph, Leipzig, 1904, be read, but also his article in the *Jahrbuch der preussischen Kunstsammlungen,* XXVI (1905), pp. 116-135 and 148-168. The Dauher should be studied in F. O. Wiegand's monograph, Strassburg, 1903, and in P. M. Halm's article in the *Jahrbuch der preussischen Kunstsammlungen,* XLI (1920), pp. 214-343. The evidence upon Konrad Meit is gathered in articles of W. Bode and W. Vöge in the *Jahrbuch,* XXII (1901), pp. iv-xvi, and XXIX (1908), pp. 77-118, and in the *Monatshefte für Kunstwissenschaft,* VIII (1915), pp. 37-45. C. Buchwald has written a satisfactory monograph on Adriaen de Vries, Leipzig, 1908. For Spanish sculpture of the Renaissance, the student is referred to E. Plon, *Leone Leoni et Pompeo Leoni,* Paris, 1887; Ad. Fäh, *Damián Forment* in *Die christliche Kunst,* VI (1910), pp. 97-130; and to the monumental work of R. de Orueta, *Berruguete y su obra,* Madrid, 1917.

CHAPTER XII

THE BAROQUE AND THE ROCOCO

I. Introduction

Chronology. Religion. The seventeenth and, to a lesser extent, the eighteenth century were dominated by the style called "baroque," and it was as the originator and disseminator of the baroque that Italy still exhibited her genius for æsthetic invention. In the eighteenth century, however, French civilization was so superior that the lighter but more exaggerated form of the baroque which was an expression of the graceful elegance of Louis XV's reign and is known as the "rococo" diffused itself from France over large sections of Europe. As the century progressed, there began to appear on every side signs of the reaction from the baroque and rococo and of the stricter imitation of the antique which were to develop into neoclassicism. It was in the seventeenth century that art experienced the full effects of the revival of Catholicism in the Counter-Reformation and of the ascendancy of the Jesuits. It is the fashion to decry the piety of this art as hysterical and insincere. The restlessness of the baroque is, undoubtedly, most painful when it agitates sacred subjects, and the naturalism of the style carries with it a disagreeable note when, in the spirit of contemporary Christianity, it makes celestial visions very concrete. Yet with all its shortcomings, the perfervid Catholicism of the epoch quickened its figures with more real feeling than the largely formal Christianity of the Cinquecento.

Characteristics of the baroque. The most palpable feature of the baroque is a tumultuous passion which seems to belie the monumentality of stone or bronze. Wherever the subject in any way suggested, and often where, to the ordinary mind,

the subject would not seem to suggest it, the figures were represented in movement; and the contortions of Michael Angelo were continued and even increased. As the nudities and mythologies of the sixteenth century lost something of their vogue, the draperies acquired greater significance in the general effect; and the impression of agitation was accentuated by exaggerated flutters of wide-flung expanses of carved stuffs. The sculptor sought more definite pictorial effects than ever before. He conceived his figures in pictorial postures and groups, often, as we have seen, in movement, and he set them in the midst of rocks, fabrics, clouds, and other scenic accessories, so that sculpture in the round was amalgamated with backgrounds into species of great reliefs. He even confused sculpture and painting in the same work, using painted backgrounds for sculptured figures, adorning the frames of pictures with figures in the round, or placing painted and sculptural decoration side by side. The figure was not designed to have value as a separate entity, but rather as a constituent of great decorative compositions. Draperies were broken up and forms were modelled in such a way as to achieve strong, pictorial contrasts of light and shade, and arrangements of colored marbles were cultivated. If some of these qualities be judged lapses from the purest taste, it must at least be acknowledged that the baroque clothed them in the perfection of technical skill developed by the long experience and practice of the Renaissance. The devotion to the antique was still widespread but less servile. In place of the expressionless heads and coldly statuesque bodies of the sixteenth century, there now appeared a revived naturalism which was more pronounced in Caravaggio and the school of painting in the seventeenth century that he founded. The pleasantest manifestations of naturalism are seen first in the portrait busts, which are once more vigorously individualized as compared with the vacuous specimens of the Cinquecento, and, second, in the *putti*, which rival those of the Quattrocento in charm. But the crowning virtue of the baroque was that it attained a grandiose impressiveness. If its compositions are theatrical, they have at least the same value as well managed stage pictures. Yet the

closest parallel to the baroque is not the theatre, at least the theatre of the present day. The artist of the seventeenth century conceived his arrangements, postures, and gestures rather in the more pompous mode exhibited by the best traditions of our modern grand opera.

Characteristics of the rococo. "Rococo" really refers to the greater exuberance of architectural decoration which was a further development from the baroque and was loath to leave any part of an edifice unembellished; but the term has been loosely extended to describe the general style of sculpture and even of painting in the eighteenth century. Compared to the baroque, the rococo ornament is lighter and airier in spirit, more fantastic and saccharine in its *motifs*, and more adverse to straight lines and angles. When the figure was employed in monumental decoration, it naturally conformed to the prevalent standards; and even detached statues and reliefs, not designed for any building, were affected by the tendency of the time. The *tempo* of the baroque was increased to a *presto*, the draperies floated and wound hither and thither with even more unrestrained abandon, a statue or group was cluttered with distracting accessories according to what has been called the "centrifugal" proclivity of the baroque, and the composition was more involved. Inasmuch as the character that the rococo took in France was imitated in many parts of Europe, the ultra-refinement of society in that country was reflected everywhere in a greater nicety and subtlety than appears in baroque sculpture, in slighter forms, in daintiness and prettiness; and the carefree spirit of the epoch manifested itself in a tone of gaiety and sweetness.

II. ITALY

Bernini. Many elements of the baroque existed embryonically in the sculpture of the late Cinquecento, but it was the genius of Giovanni Lorenzo Bernini (1598-1680) that gathered them together, developed them, and impressed upon the baroque its definitive form. His youthful work, the Apollo and Daphne, in the Villa Borghese, Rome, already pos-

sesses the greater movement of the baroque. The choice of a more fleeting moment than is common to the monumental nature of sculpture in the round illustrates at once the pictorial attitude. The remote dependence of the Apollo upon the statue of the Belvedere (cf. Fig. 71) is a case in point of the way in which he merely caught suggestions from the antique; it also taught him technical secrets and the custom of high finish. All of his early achievements, indeed, exhibit a technical dexterity rarely, if ever, equalled in the world's history. We may condemn the application of this dexterity to the counterfeiting of skin and flesh in the Daphne, as in other works of Bernini we take exception to the simulation of various fabrics; but we cannot withhold our amazement. In a number of superb examples, he began the tradition of the fountains of the baroque, which are treated naturalistically, like scenes from aquatic life, with assemblages of marine deities, monsters, and picturesque accessories of vegetation, shell, and cliff, in contrast to the more formal architecture of the Tuscan fountains of the sixteenth century. The two most famous specimens at Rome for which we are indebted to Bernini are the smaller Fountain of the Triton in the Piazza Barberini (Fig. 205) and the towering Fountain of the Four River Gods in the Piazza Navona (executed by his pupils). So, in mortuary art (Fig. 206), utilizing suggestions from the tombs of the late Renaissance, he established the definitive type for the restless baroque sepulchres in which the figures perform dramatic rôles. The

FIG. 205—BERNINI. FOUNTAIN OF TRITON. PIAZZA BARBERINI, ROME

Virtues no longer stare forth at the spectator as entities dissociated from the effigy except in their symbolism; by mourning for the deceased they are brought into an emotional relation to the main subject and make the tomb a unified dramatic whole. The personification of Death enters upon his baroque popularity as a sepulchral actor. In his

FIG. 206—BERNINI AND PUPILS. TOMB OF ALEXANDER VII. ST. PETER'S, ROME. (PHOTO. ANDERSON)

portrait busts (Fig. 207), Bernini not only resuscitated the power of incisive characterization, but by a selection of the best qualities in his sitters, by stress upon the elements in their personalities common to the several recurring types to which they belong, by a partial idealization, and by ingenuity in composition, he raised them from the sphere of the particular into objects of universal interest and beauty. In his

most celebrated religious work, the Ecstasy of St. Theresa in S. Maria della Vittoria, Rome (1646), all the signs of the baroque are present in their most typical expression, the unpleasantly realistic conception of the heavenly experience,

the fervor of Jesuitical Catholicism, dramatic postures, the endlessly broken and disordered draperies, the pictorial setting of clouds and gilded rays, the theatrical lighting from an unseen source. Henceforth there was a constant *crescendo* in the passion and tragic intensity of his sacred figures; and the lines of the form and of the garments were more and more adapted rather to general decorative schemes than to the natural activity of the body. In such works as the two angels of the Passion for the Ponte S. Angelo at Rome, now in S.

FIG. 207—BERNINI. COSTANZA BUONA-RELLI. BARGELLO, FLORENCE. (PHOTO. ALINARI)

Andrea delle Fratte, even the most loyal apologist for Bernini must admit a certain exaggeration. His most pretentious sacred composition is the shrine for St. Peter's Chair that forms so garish but so impressive an accent at the extreme east end of S. Pietro in Vaticano (Fig. 208).

Bernini's followers. Bernini's immediate pupils, some of them men of considerable talent, by their assistance made possible the completion of his numerous gigantic schemes, and were instrumental in diffusing the new style in other parts of Italy and Europe. The most important of these disseminators was Ercole Ferrata (1610-1686).

The conservative tendency. There are two Italian sculptors who are usually asserted to have been the leaders of a more conservative tradition that was more faithful to the

antique and partially opposed to the innovations of Bernini. The elder was François Duquesnoy, a Fleming by birth, and

FIG. 208—BERNINI. SHRINE FOR ST. PETER'S CHAIR. ST. PETER'S, ROME

therefore called Il Fiammingo (1594-1643). The St. Susanna of S. Maria di Loreto, Rome, perhaps based upon an ancient Urania in the Palazzo dei Conservatori, shows that some-

times, at least, he did not indulge in such passionate expression as Bernini. He was renowned also for his gentle, Rubens-like *putti,* in which he was among the first, if not the first, in sculpture, to render adequately the peculiarly unformed quality of infantile anatomy (Fig. 209). But the St. Andrew of the crossing of St. Peter's betrays the fact that not even Duquesnoy could withstand the onsweeping stream of the baroque. By his multiplication of objects of virtu, he established the vogue of small terracottas, ivories, and bronzes in the seventeenth and eighteenth centuries. Philistinism towards the baroque is somewhat less palpable in Bernini's rival at Rome, Alessandro Algardi (1602-1654). He lacked Bernini's sense of imposing decorative composition, and he sometimes inclined towards a prettiness that is a foretaste of the rococo. His tomb of Leo XI in St. Peter's corresponds, in general, to Bernini's sepulchre of Urban VIII, although

FIG. 209—FRANÇOIS DUQUESNOY. CUPID CARVING A BOW. KAISER FRIEDRICH MUSEUM, BERLIN

the two allegorical figures are more coldly classical and not so well keyed to the emotional tone of the monument. His religious figures, such as those above the door in the interior of S. Ignazio, Rome, often follow prevailing fashion. In the bronze statue of Innocent X in the Palazzo dei Conservatori, Rome, and in certain other portraits, he surpassed his rival in forceful individualization. His most significant work, which exerted an enormous influence upon the develop-

ment of highly pictorial relief in the next two centuries, is
the altarpiece of St. Leo and Attila for the Cappella Leonina
of St. Peter's (Fig. 210), a more absolute transcription into
marble of a dramatic and agitated baroque painting than even
Bernini permitted himself.

FIG. 210—ALGARDI. ALTARPIECE OF ST. LEO AND ATTILA. ST. PETER'S, ROME.
(PHOTO. ANDERSON)

The eighteenth century. Generally speaking, the rococo
obtained little hold in Italy, and the baroque persisted, not
much modified, until the neoclassic revolution. Pietro Bracci
(1700-1773) may be taken as typical of the high eighteenth
century at Rome. His feminine forms and his angels have
that somewhat greater tenderness and sweetness which are
almost the only signs in Italy of the presence of the rococo.

The height of his achievement, under the inspiration of Bernini, is represented by the Neptune, Tritons, and sea-horses of the Fontana di Trevi (Fig. 211).

FIG. 211—FONTANA DI TREVI, ROME

III. FRANCE

A. THE SEVENTEENTH CENTURY

1. Introduction

Although in France the plastic style of the baroque obtained a hold in sacred subjects and in the tombs of the later seventeenth and the eighteenth centuries, the most significant French sculpture of the seventeenth century was of a different sort and constituted one of the manifestations of what is called French classicism. The triumph of classicism occurred during the personal rule of Louis XIV from 1661 to 1715; the earlier years of the seventeenth century led up to this consummation. The French classic manner in sculpture

was derived from the late Italian Renaissance and the antique, but it was impressed with a dryness, elegance, and formality that may be paralleled in French literature of the period. Inevitably it adopted certain baroque characteristics, such as the addiction to movement and to pictorial accessories, accommodating them to its more sedate and ordered harmonies. The centralization of power in the monarch tended to localize artistic effort about the court, to confine its themes to the glorification of the King and his circle, to bestow upon it a certain pompousness, and to reduce it to a more or less monotonous unity that partially suppressed artistic individuality. The general evolution was assisted, as early as 1648, by the foundation of the Academy of Painting and Sculpture, which followed the trend of the times in subjecting art to a system of definite rules. The old Gallic naturalism persisted, indeed, in the portraits and sepulchral effigies, but even here it was often muffled, to a certain extent, by the tyranny of classicism.

2. The Reign of Henry IV

The accession of the Bourbons with Henry IV (1589-1610) began a period of transition from the Renaissance proper to the style of Louis XIV. Under Henry IV a considerable influence was exercised by the works of Giovanni Bologna, whose mannered follower, the Italianized Fleming, Pierre Franqueville (c. 1550-1615), was then enjoying a great vogue in France. The most prominent sculptor of this reign was Barthélemy Prieur (c. 1540-1611). The three allegorical figures from the monument for the heart of Anne de Montmorency, now in the Louvre, suggest not so much the highly personal treatment of women by Goujon and Pilon as the rather frigid and mannered treatment by Giovanni Bologna. The kneeling Marie de Barbançon-Cany, also in the Louvre, shows how sculptors were losing something of their grip upon incisive characterization in sepulchral effigies. The figures of Fame, or, as the French then called them, *Renommées,* and the four little genii of human activities, that he did for the exterior of the Petite Galerie of the Louvre, betray

the increasing tendency to a more arid and heavier class-
icism.

3. The Reign of Louis XIII and the Minority of Louis XIV

From the death of Henry IV to Louis XIV's personal
assumption of rule in 1661, the advance towards classicism
became more perceptible, largely through the centralizing
measures of the ministers Richelieu and Mazarin. The sculp-

FIG. 212—F. ANGUIER. TOMB OF JACQUES DE SOUVRÉ. LOUVRE, PARIS.

tors of the time were good, honest masters, but rarely in-
spired. Jacques Sarrazin (*c.* 1588-1660) is important in the
history of French tombs for stressing, as in the monument
for the heart of Henri de Condé, now in the chapel of Chan-
tilly, the use of the allegorical figures that were the fad of
the seventeenth and eighteenth centuries. Although the
naturalistic tradition has reasserted itself in his kneeling
Cardinal de Bérulle of the Louvre, he generally cultivated
the rather cold and rhetorical classicism that is well illus-
trated by his caryatides for the attic of the Pavillon de
l'Horloge of the same building. In the productions of the
Anguier brothers little mediæval realism is left. François

Anguier (1604-1669) made a specialty of tombs, usually classicizing now even the portraits, as on the elaborate monument of Henri de Montmorency in the chapel of the Lycée at Moulins. The effigies, such as the Jacques de Souvré (Fig. 212), may even be represented nude or semi-nude, agonizing like dying Gauls and foreshadowing the later dramatic conceptions of the tomb. In contrast to his brother, Michel Anguier (1612-1686) found his talent to lie in the direction of architectural adornment. His embellishment of the ceilings of Anne of Austria's apartments in the Louvre, of the Parisian church of Val-de-Grâce, and of the Porte St. Denis constitutes a French classic interpretation of baroque decoration, in which he has retained much Gallic feeling for femininity and for grace of drapery.

4. The Reign of Louis XIV

Introductory. Louis XIV carried centralization to such a point that he made his chief palace of Versailles, and not Paris, the capital of France, and he lavished works of art upon it in order to raise it to the dignity of such an honor. Even the sculpture of the period was dominated by the favorite painter and æsthetic arbiter of the court, Charles Le Brun, who often drew the designs from which the sculptors worked. Particularly in sepulchral monuments, his influence united with that of Bernini to produce the dramatic and pictorial effects which did not attain their full development until the eighteenth century.

Coysevox. The most characteristic sculptor under Louis XIV was Antoine Coysevox (1640-1720). Within the limits of classicism, he possessed vigor, invention, high technical ability, and a lively sense of personal beauty. Of his many mythological and allegorical creations, the most familiar are the mounted Fame and Mercury, now at the entrance to the gardens of the Tuileries. According to contemporary taste, in his representations of the sovereign, such as the standing bronze in the Hôtel Carnavalet, Paris, he used the pompous costume of a Roman conqueror; but in his portrait busts of other persons (Fig. 213) and in his sepulchral effi-

FIG. 213—COYSEVOX. BUST OF LE BRUN. LOUVRE, PARIS. (PHOTO. GIRAUDON)

gies, the power of the characterization is scarcely dimmed by the tendencies of the times. He was employed on a large number of tombs, usually collaborating with others and working u p o n others' sketches; the most pretentious example is the mausoleum of Mazarin, now in the Louvre.

Girardon. The art of François Girardon (1628-1715), Le Brun's favorite sculptural agent, does not differ essentially from that of Coysevox. It is somewhat less heroic, more graceful, and therefore more French. Characteristic are his stucco embellishments of the Galerie d'Apollon in the Louvre and his productions for fountains at Versailles, especially the leaden relief of bathing Nymphs in the Bain de Diane, surprising in their easy freshness and naturalism

FIG. 214—GIRARDON. SECTION OF RELIEF OF BATHING NYMPHS. BAIN DE DIANE, VERSAILLES

(Fig. 214). His most famous work is the tomb of Richelieu, in the church of the Sorbonne, where the different figures are brought together in greater unity than by Bernini. After the precedent of François Anguier's agonizing effigies, the top of the sarcophagus is now conceived as the bed of death, and the dying Cardinal is upheld by Religion and lamented by Science at his feet.

The Coustou. Of Coysevox's nephews and pupils, Nicolas and Guillaume Coustou I, the former (1658-1733) was little more than a gifted follower of his uncle, attaining at times a certain magnificence and animation of pose (Fig. 215). Nicolas began and Guillaume finished the relief of Louis XIV crossing the Rhine in the vestibule of the chapel at Versailles, one of those pompous allegorical representations of the king that were the delight of classicism. Guillaume Coustou I [1] (1677-1746) was less bound by the classic traditions, and already revealed the effects of the resuscitation of realism in the eighteenth century. His masterpieces are the prancing horses and their nude tamers on the Place de la

FIG. 215—NICOLAS COUSTOU. DUKE DE VILLARS. HÔTEL DE VILLE, AIX-EN-PROVENCE. (PHOTO. GIRAUDON)

Concorde (Fig. 216), opposite to the equestrian groups of Coysevox, to which they are superior in modelling and movement. Lady Dilke has pointed out that the use of horses as principal *motifs* denotes a return from the realm of mythology and allegory to an interest in nature. The

[1] So-called to distinguish him from his son, also a sculptor, Guillaume Coustou II.

FIG. 216—GUILLAUME COUSTOU I. HORSES OF MARLY. CHAMPS ÉLYSÉES, PARIS. (PHOTO. GIRAUDON)

FIG. 217—PUGET. MILO OF CROTON. LOUVRE, PARIS. (PHOTO. GIRAUDON)

statue of Louis XV's queen, Marie Leczinska, as Juno, in the Louvre, has already the sprightliness of the eighteenth century. The bust of his own brother, Nicolas, in the same Museum, has sloughed off the haughty idealization of the seventeenth century in favor of the growing naturalism.

Puget. Living for the most part away from the court and its classicism and making long sojourns in Italy, Pierre Puget of Marseilles (1622-1694) became the only thoroughly baroque sculptor among great French masters; but he was characterized by a more pronounced addiction to the colossal and muscular than the Italians of the seventeenth

century and by a less highly developed sense of physical beauty. In modelling he achieved the most naturalistic accuracy. As in the case of Giovanni Bologna, there is sometimes an unpleasant incongruity between the huge forms and the exquisite gestures. His most renowned works, all now in the Louvre, are the Milo of Croton (Fig. 217), the Perseus delivering Andromeda, and the relief of Alexander and Diogenes.

B. THE EIGHTEENTH CENTURY

1. Introductory

Sporadically, the classic tradition remained undisturbed; but, very generally, especially by the middle of the century, the staidness of the style of Louis XIV yielded to the rococo. The generalizing sentiment of the statuary of the former century gave way to a certain "individualization and even intimacy" of feeling and to the desire for sensitiveness in art. By a strange paradox, in the midst of the factitious civilization under Louis XV, the tendency to return to real nature also manifested itself, inspired in some degree by the writings of Rousseau. Shaking off the hampering pomposity of Louis XIV's age, the portrait busts and statues often avoided even the mannerisms of the rococo, so that, as direct, simple, and vigorous likenesses, they vie with the best that the world has produced. Sometimes the increased naturalism took the shape of a sensuality in accord with French life of the epoch. Another influence made for greater freedom. The court and the Academy lost something of their monopoly upon art and were obliged to share their æsthetic interests with the enlightened Parisians. The painter Boucher succeeded Le Brun in the artistic dictatorship, but he ruled less absolutely. Even religious production conformed to the general gaiety and sweetness of the rococo. In its vivacity and elegance, in its appreciation of femininity, in its marvellous skill in reproducing different fabrics and the texture of the skin, the sculpture of the eighteenth century is one of the most characteristic expressions of French genius. To the

more archæological and quieter form that the French rococo
assumed in the second half of the century at the approach
of neoclassicism, the term, the style of Louis XVI, is some-
times applied.

The tombs. During this century the dramatization of the
tomb was consummated. The allegorical figures were knit
together in some action glorifying the character of the de-
ceased, or some event in his life was reproduced allegor-
ically. Most interesting are the several tombs in which
Death is one of the actors, now summoning the victim, now
struggling with the victim's husband or wife, or with a repre-
sentative of Immortality. However false the theatrical agi-
tation may seem to our eyes, however unsuited to the so-
lemnity of death, yet it must be admitted that the age
showed astounding ingenuity in devising and surprising power
in executing its conceptions.

2. The First Generation of the Eighteenth Century

FIG. 218—LEMOYNE. BUST OF GABRIEL.
LOUVRE, PARIS. (PHOTO. GIRAUDON)

The standard of the old
classicism was chiefly up-
held by Edme Bouchardon
(1698-1762), although in
his admiration for ancient
art he was influenced also
by the theories of neoclas-
sicism. One gets the im-
pression that his work
tended to be labored, con-
scious, and theoretical.
The destroyed bronze
equestrian statue of Louis
XV, known to us in engrav-
ings and in two small
bronzes of the Museums of
the Louvre and Versailles,
was still severely aca-
demic; but at the same time it followed the fashion of the
slimmer steeds of the eighteenth century. The fountain of

the Rue de Grenelle, Paris, is likewise classically restrained in architectural composition and in the style of the three central figures of Paris, the Seine, and the Marne; but the French rococo has claimed its own in the mannered poses and realistic nudes of the adolescent genii of the Seasons and in the softness, naturalism, and playfulness of the accompanying reliefs of *putti*. Although the idea of the Cupid cutting himself a bow from Hercules's club, now in the Louvre, is in accord with the mincing temper of the rococo, its execution foreshadows the archæology of neoclassicism.

Jean Baptiste Lemoyne (1704-1778) inaugurated the style of Louis XV more definitely. His Bathing Flora has the daintiness and feminine charm so peculiar to the period; but it is his long series of busts (Fig. 218) that in their directness, liveliness, and lack of affectation best proclaim the new age.

3. The Second Generation of the Eighteenth Century

Pigalle. The most comprehensive plastic exponent of the period was Jean Baptiste Pigalle (1714-1785), although he did not illustrate all its aspects in their most pronounced form. His masterpiece is the Mercury attaching his sandals, the first terracotta sketch of which may be seen in the Metropolitan Museum. The choice

FIG. 219—PIGALLE. CHILD WITH CAGE. LOUVRE, PARIS. (PHOTO. GIRAUDON)

of a kinetic rather than a static moment, the other pictorial elements, the complication of attitude, the *svelte* grace of the body, the anatomical science, and technical dexterity—all these qualities make the Mercury a touchstone by which we may prove the art of the eighteenth century. Throughout

9 A HISTORY OF SCULPTURE

his life Pigalle sporadically devoted himself to such typically rococo themes as the Amour and Amitié of the Louvre, and he appealed to the taste of his contemporaries also in his forms of children engaged in pretty little activities (Fig. 219). Since, however, he possessed a vigorously masculine character, his feminine figures are less successful than his representations of men, they are less bewitching than the women of Falconet and Clodion, and they do not accord quite so thoroughly with the standards of the time. It is rather the trend

of the eighteenth century towards realism that is uppermost in his production. His nudes and his *putti* depend more directly upon the living model than do those of his contemporaries. A misunderstanding of ancient practice and a desire for the heroic combined with his anatomical enthusiasm to provoke the anomaly of representing Voltaire as nude in the statue now in the entry of the Library of the Institute, Paris, and of using an old soldier as the model for the body. Although in realism his busts outdo those of Houdon, he was not the greatest portraitist of his

FIG. 220—PIGALLE. TOMB OF THE COMTE D'HARCOURT. CATHEDRAL, PARIS

day. In his tombs he incorporated the noblest development of the sepulchral drama, and attained that grandeur of style which was often suppressed in him by the tyranny of the rococo. The most famous example was erected for the Comte de Saxe in the church of St. Thomas at Strassburg. The illustration (Fig. 220) is taken from the monument of another great Marshal of France, the Comte d'Harcourt.

Falconet. Étienne Maurice Falconet (1716-1791) repre-
sents for us the highest possibilities of the French style of
the eighteenth century, freed from its more pronounced and
extravagant phases. In the Music of the Louvre (Fig. 221)
he calmed and restrained the fashionable flutterings and
involutions; the Bathing Girl of the same Museum tran-
scends the standards of the time in its truth to nature and
is disembarrassed of Lemoyne's rococo mannerisms in the
treatment of the same sub-
ject. Like the majority of
his contemporaries, he fur-
nished models for the man-
ufacture of Sèvres china,
and his larger works were
also repeated in that me-
dium. The drawings of the
painter Boucher often were
forced upon the sculptors
as the basis for their Sèvres
models, but Falconet some-
times managed to adapt
them to his own ideas. His
most important object of
virtu is the clock of the
three Graces, existing in
marble in the Louvre and
also in a number of Sèvres
repetitions. In the cul-
minating work of his ca-

FIG. 221—FALCONET. MUSIC. LOUVRE,
PARIS. (PHOTO. GIRAUDON)

reer, the bronze equestrian statue of Peter the Great at Petro-
grad, in accordance with the proclivities of contemporary
art and with the precedent set by Tacca, both rider and
horse are represented in activity, the emperor blessing his
people and the splendid animal prancing in the air.

Caffieri. Jean Jacques Caffieri (1725-1792) lays a claim
upon our consideration principally because of his portrait
busts (Fig. 222). Although somewhat idealized, they are
withal excellent characterizations; but he endeavored to give
them the effect of decorative sculptures by turning the drap-

ery and even the hair in pretty rococo swirls, and he endowed
them with a gaze that is instinct with the nervousness and
alertness of the rococo.
Most famous are the ten
examples of literary and
theatrical celebrities in the
foyer of the Théâtre Fran-
çais.

FIG. 222—CAFFIERI. BUST OF THE
SCULPTOR VAN CLÈVE. LOUVRE, PARIS.
(PHOTO. GIRAUDON)

4. The Third Generation of the Eighteenth Century

Pajou. Like the other
masters who lived through
the beginning of the nine-
teenth century, Augustin
Pajou (1730-1809) was
only slightly affected by
neoclassicism, which had
developed before he died.
He remained a confirmed
devotee of the rococo until
the latter part of his life,
stressing pleasantly its
sweetness and soft sensuality. The frequent slovenliness of
modelling is due to his own too great productive facility and
to the extensive participation of assistants in his commis-
sions; the somewhat greater dryness of his style, as compared
with the general output of the eighteenth century in France,
possibly betokens the approach of neoclassicism. Character-
istic specimens of his achievement are the Bacchante and the
Queen Marie Leczinska as Charity in the Louvre and, among
his many productions as architectural decorator, the plastic
embellishment of the Opéra at Versailles, where he employed
as his chief material wood. The work in which he made most
concessions to neoclassicism is the Psyche of the Louvre. A
certain dryness intruded also into his statues of celebrities,
emptying them partially of life (with the exception of the
Pascal of the Institute) and setting in its place pompousness.

According to that false archæological taste of the time which is illustrated by Pigalle's undraped Voltaire, he represented Buffon as semi-nude, in the statue of the Museum of Natural History, Paris, conceiving him as an ancient philosopher and surrounding him with attributes. Pajou's defects are happily absent from his many portrait busts, which constitute his most precious bequest to posterity. One may gauge the high measure of his ability in this phase of his art by the Lemoyne and Buffon of the Louvre, the Hubert Robert of the École des Beaux Arts, and his several versions of Madame du Barry (Fig. 223).

Clodion. It is curious that the French rococo should have waited until the moment of its dissolution to find in Claude Michel, called Clodion (1738-1814), its most pronounced exponent. He realized the full possibilities of its daintiness and playfulness. He treated his abundant nudes with more fresh naturalism than any of his predecessors or contemporaries, often turning sensuality into licentiousness. No other attained to such a degree the briskness of movement demanded by the æsthetic ideals of his day.

FIG. 223—PAJOU. BUST OF MADAME DU BARRY. BLUMENTHAL COLLECTION, NEW YORK. (COURTESY OF MR. GEORGE BLUMENTHAL)

The supreme dexterity with which he met the exigencies of this animation and of other aspects of his art is another token of the times. His subjects of predilection were nymphs and satyrs, bacchantes, sports of Nereids, and romps of *putti*, employed in decorative friezes for houses, as on the Hôtel de Chambrun, Paris, but especially in small statuettes and groups of terracotta, a medium in which his facile hand and his genius for

improvisation expressed his conceptions most characteristically (Fig. 224).

Houdon. Jean Antoine Houdon (1741-1828) impresses us as very modern because his production is more or less independent of any æsthetic movement or century. Enrolling himself in the school of nature, he followed her as a preceptress with far more absolute devotion than could have been inspired by the timid naturalism of his day, already half suppressed by embryonic neoclassicism. In a few of his imaginative statues, he inevitably paid homage to the tastes of his fellows. The Vestal Virgin, formerly in the Morgan Collection, is somewhat neoclassic; and in the Baigneuse of the Metropolitan Museum he surpassed Falconet in Falconet's own manner. A celebrated instance of his own artistic principles is afforded by the early Diana, the most accessible replica of which is the bronze of the Louvre: classical only in subject and rococo only in its love of femininity, the statue is, in reality, a superb and

FIG. 224—CLODION. NYMPH AND SATYR. METROPOLITAN MUSEUM, NEW YORK. (COURTESY OF THE METROPOLITAN MUSEUM)

naturalistic study of the nude. It is, nevertheless, rather his vast number of portrait busts (Fig. 225) and his few portrait statues that have made his fame secure. No other sculptor, except a few of the greatest Italian masters of the fifteenth century, and perhaps Bernini, has realized so well the aim of true portraiture, the emphasis upon the most characteristic traits of the sitter, to the exclusion of the irrelevant, the attainment of a just balance between individualization and generalization, and the ennoblement and beautification of the

whole so that the portrait becomes an enduring work of art, the perpetuation of a type as well as of a single personality. The most renowned example is the seated Voltaire in the Théâtre Français (Fig. 226), in which he followed contemporary taste so far as to admit the costume of an ancient sage but rejected the archæological caprice of the nudity or semi-nudity of Pigalle's and Pajou's similar portraits. Our own country is fortunate enough to possess another portrait statue by Houdon, the Washington in the Capitol at Richmond.

FIG. 225.—HOUDON. BUST OF LOUISE BRONGNIART. LOUVRE, PARIS.

IV. BELGIUM

A. THE SEVENTEENTH CENTURY

The transition. In the first half of the century, the field was occupied by the Italian style that was transitional from the late Renaissance to the baroque. With the exception of the expatriated François Duquesnoy, the most talented sculptor of the period was Artus Quellin I of Antwerp (1609-1668). He reminds us of contemporary French classicists, but he had more respect for nature and a more pronounced inclination towards the baroque. His greatest undertaking, in conjunction with his assistants, was the elaborate decoration of the exterior and interior of the Town Hall, now the Royal Palace, at Amsterdam. His masterpiece is the east wall of the court-room in this edifice.

FIG. 226—HOUDON. VOLTAIRE. THÉÂTRE FRANÇAIS, PARIS. (PHOTO. GIRAUDON)

The symbolic reliefs reveal a moderate form of baroque pictorial treatment. The allegorical caryatides, the opulence of whose forms is derived from Rubens, possess the

surprising naturalism in the modelling of the nude that is characteristic of Quellin.

The developed style of the seventeenth century. In the second half of the century, Belgian sculpture took two forms: it was either an adaptation of the Italian baroque or was based upon Rubens's interpretation of the baroque. The great painter sometimes provided sketches upon which the sculptors worked, and even the more Italianate group were affected by his fashionable style. His buxom feminine figures were peculiarly popular. Now and then an inclination towards French classicism manifested itself; in particular, the dramatic and allegorical tombs of France were occasionally imitated. Wood continued to hold sway as a favorite medium, but baroque contrasts of black and white marble were also much in vogue. The sculptor who most faithfully transcribed the mode and ideas of Rubens into plastic expression was Luc Faydherbe of Malines (1617-1697). A convincing example of this relationship is the relief of the Road to Calvary on a pendentive of the dome in Notre Dame de Hanswyck at Malines, embodying the extreme form that, because of his dependence upon Rubens, the pictorial tendencies of the baroque took in Faydherbe. His most important work is the partially dramatized tomb of the Archbishop Cruesen in the cathedral of Malines. He also did small ivories after Rubens's designs, for instance, a relief of a satyr and *putti* in the Prado, Madrid, repeated almost exactly in a terracotta of the Musée du Cinquantenaire, Brussels. The chief representative of the more Italianate style was Bernini's pupil, Jean Delcour, active principally in Liége (1627-1707). Though he throws his draperies into an even more confused agitation than Bernini, he was endowed with a noble sense of personal beauty. In addition to his essentially religious work, he was in demand for the erection of fountains and tombs. The monument of the Bishop Eugène d'Allamont in the cathedral of Ghent is like the first dramatic tombs of France, except that the sacred figures are much more Italian. The bronze sepulchral bust of Lambert de Liverloo in the Archæological Museum at Liége has the power of Bernini's and Algardi's portraits.

FIG. 227—JAN FRANS VAN GEEL AND JAN VAN HOOL. PULPIT OF CHURCH OF ST. ANDRÉ, ANTWERP. CALLING OF STS. PETER AND ANDREW. (PHOTO. THILL)

B. THE EIGHTEENTH CENTURY

The baroque continued to reign, now with extreme license, until the classical revival, but the sacred figures often assumed the rococo modifications. The most peculiarly Belgian expression of the style is found in the wooden pulpits (Fig. 227). The lower part or even the whole pulpit becomes a bower of landscape or a rocky grotto, in the midst of which a religious or allegorical episode is enacted by large figures in the round. The canopy over the pulpit is also treated in the elaborate pictorial manner, carved with clouds and *putti*, with a sacred figure among baroque appurtenances, or with a continuation of the landscape from below. Scarcely less sensational are the wooden confessionals, notably those of the church of Ninove by Theodor Verhaegen (1701-1759) and one of his pupils.

V. HOLLAND

Introductory. During the baroque and rococo periods, it was only in the seventeenth century that Holland produced important sculpture. Protestantism entailed a proscription of religious art, which was the principal field of the baroque. Sculpture was therefore largely confined to the adornment of secular edifices and tombs, and the decorative figures of these were executed rather in a dry classic style developed from the precedents of the late Italian Renaissance. The baroque manifested itself in little else than the pictorial accessories and, occasionally, the pathetic spirit of the mausoleums. The Dutch were much more concerned with painting than with sculpture, and some of the best carving in Holland was done by Belgians. The spirit of contemporary *genre* painting dared to intrude even by the side of the classic figures, and a homely but not very penetrating or powerful realism, perhaps even before it showed itself in painting, often appeared in the reliefs on buildings and in the sepulchral effigies. In the second half of the seventeenth century, here and there a tendency to adopt French classicism asserted itself. The tombs were

the most notable assemblies of sculpture, especially those of the great admirals, which were usually adorned with a relief of the battle in which each was killed and with emblems of maritime activity. In the most magnificent examples, the effigy of the deceased was set in the midst of a kind of stately temple, more or less richly embellished with statues and reliefs.

FIG. 228—VERHULST. PURCHASE OF BUTTER. CITY WEIGH HOUSE, LEYDEN. (COURTESY OF DR. JAN KALF)

De Keyzer. The most important native Dutchman was Hendrik de Keyzer (1565-1621). Uniting to his Italianism a certain degree of Dutch realism, he became an estimable exponent of the modest virtues that we have allowed to Dutch sculpture. His great work is the temple-mausoleum of William the Silent in the Nieuwe Kerk, Delft, suggested perhaps by the tomb of Henry II in St. Denis. The decoration of public buildings with reliefs from everyday life is illustrated by the three panels from the House of Charity, Amsterdam, now in the Museum, probably to

be ascribed rather to one of Hendrik's sons, Willem and Pieter.

Verhulst. The other significant sculptural personality in the seventeenth century was a Belgian of Malines, Rombout Verhulst (1624-1698), who, having come as an assistant of Artus Quellin, remained in Holland. Like De Keyzer, however, he stood for a more naturalistic strain in the art of the Low Countries than the classical Quellin. This quality was immediately apparent in the colloquial reliefs that he did for the City Weigh House and Butter Market of Leyden, representing the testing of packed merchandise and the purchase of butter (Fig. 228). The rest of his production consisted of many sepulchral monuments and of several portrait busts. In both of these fields he evinced an endowment of technical skill, a sensitiveness to style, and an ability to impart life, that were unusual in Holland. In the modelling of the forms of the decorating *putti* he vied with the best masters of the century. His two masterpieces are the similar monuments of Willem van Lyere and of Karel van Inn-ende-Knyphuisen, the former in the church at Katwijk-Binnen, the latter in the church at Midwolde south of Groningen.

VI. ENGLAND

A. THE SEVENTEENTH CENTURY

During the seventeenth and eighteenth centuries sculpture in England recuperated somewhat from the decline into which it had fallen in the Renaissance, but the credit for the recovery was due almost wholly to Dutch practitioners or to Englishmen who had been trained in Belgium and Holland. The prevalent style of the seventeenth century was similar to the Dutch adaptation of the dry, classic manner of the late Renaissance, enlivened sporadically, especially in the second half of the century, by elements of the baroque. It found a typical exponent in Nicholas Stone (1586-1647), who had been trained at Amsterdam under Hendrik de Keyzer. Although Inigo Jones

employed him to carry out his architectural and sculptural conceptions, it is possible that Stone himself not only executed but actually designed the famous south porch of St. Mary the Virgin's at Oxford with its twisted baroque columns and figures of the Virgin and angels. His production, however, was largely confined to tombs, in the effigies of which, almost inevitably, he betrayed himself a rather stiff and lifeless portraitist. One of the best known examples is the monument of Thomas Sutton in Charterhouse Chapel, London. The tombs of Sir George Holles and Francis Holles in Westminster Abbey emphasize the antiquarian aspect of classicism. As Nicholas Stone labored for Inigo Jones, so Francis Bird (1667-1731) decorated the architecture of Sir Christopher Wren. His chief work on St. Paul's cathedral, the Conversion of St. Paul that occupies the west pediment, is thoroughly baroque in movement, in dramatic postures, and in pictorial setting of buildings, clouds, and rays. A much less commonplace

FIG. 229—GIBBONS. PART OF DECORATION OF REREDOS, ST. JAMES, PICCADILLY, LONDON. (COURTESY OF J. TIRANTI AND CO., LONDON)

master than either Stone or Bird was Grinling Gibbons (1648-1721), chiefly remembered as a decorative sculptor in wood. He exemplified the general return of the seventeenth century to naturalism by the liveliness, faithfulness to actuality, and beauty with which he carved ornamentation of flowers, foliage, birds, and *putti* (Fig. 229). But he also turned his hand successfully to other phases of the plastic art and stood forth as a representative of the more decidedly baroque fashion of England in the later seventeenth cen-

tury. His marble font in St. James, Piccadilly, resembles
the Belgian pulpits of the eighteenth century in its pictorial
treatment. The Adam and Eve of this font and the Roman-
ized statue of James II in St. James's Park, London, prove
that he was no mean figure-sculptor.

<center>B. THE EIGHTEENTH CENTURY</center>

Introductory. Even more commissions were now assigned
to foreigners; but because these foreigners came principally
from Belgium and France rather than from Holland, the
baroque of Italy and the rococo of France tended to sup-
plant in England the enervated manner of the late Dutch
Renaissance. The French type of dramatized tomb enjoyed
special favor. In the second half of the century, the move-
ment toward neoclassicism was scarcely less pronounced
than in France. The most distinguished plastic productions
of the English eighteenth century were perhaps the portrait
busts.

Foreign sculptors. Peter Scheemakers (1691-*c.* 1770) and
John Michael Rysbrack (1693-1770), both from Antwerp and
both employed chiefly on tombs of the contemporary Bel-
gian and French types, imported a fresher style and a more
skilful craftsmanship than had been achieved in the English
work of the preceding century. These Flemings, as well as the
English sculptors of the epoch, were eclipsed by the French-
man Louis François Roubillac (1695-1762), who displayed
to the admiring eyes of the British the superior technique,
ease, and *élan* of the French rococo. Popular as a builder
of mausoleums, he created such masterly specimens of the
elaborate French dramatic type as the monuments of the
Duke of Argyll and of Lady Nightingale in Westminster
Abbey. He perpetuated his memory also by several busts
which vie with the best French specimens of the time and
possess much more dash, style, and sense of personal beauty
than any English sculptor was able to attain. The Händel
and the Hogarth of the National Portrait Gallery are good
examples.

Native sculptors. The only prominent native sculptors were active in the second half of the century, and all, to a greater or less extent, were forerunners of neoclassicism. The most distinguished English executer of mortuary commissions was John Bacon the Elder (1740-1799). The monument to the first Pitt in Westminster is the best instance of the pretentious allegory and rhetorical patriotism that he affected. The most flourishing business in busts was plied by Joseph Nollekens (1737-1823), whose fame rests upon many such

excellent but unsparing characterizations as the portraits of Fox and the younger Pitt in the National Portrait Gallery. The sometimes incorrect and always uninteresting style of Joseph Wilton (1722-1803) would not deserve mention at all in this book, if he had not had a certain connection with America. In Westminster, his tomb of General Wolfe, on which an angel rewards the dying hero, has the cluttered detail and "fussiness" of the rococo (Fig. 230). He also executed the first three sculptural monu-

FIG. 230—WILTON. TOMB OF GENERAL WOLFE. WESTMINSTER ABBEY. (PHOTO. MANSELL)

ments erected in this country: to the elder Pitt at Charleston and in Wall St., New York, and to George III on Bowling Green in the latter city. The Romanized equestrian George III and the Pitt at New York perished during the Revolution, except for the fragments gathered in the New York Historical Society. The Pitt at Charleston, slightly mutilated, has been set up once more; the antique draperies treated with rococo elaboration bear witness to the conflicting tendencies in Wilton's style.

VII. Germany

A. THE SEVENTEENTH CENTURY

The devastation wrought by the Thirty Years' War (1618-1648) tended to reduce the plastic output, especially in the Protestant sections of the country, and it was instrumental also in preventing the appearance of any German sculptors of the first rank. During the first half of the seventeenth century the style of the late Belgian and Dutch Renaissance that lingered on in Germany developed of itself into a kind of baroque without any influence from Italy. Though tending to multiplication of small detail and lacking the largeness and monumentality of the contemporary Italian style, this early German baroque has the characteristic qualities of pictorialism, agitation, capriciousness, opulence, and greater naturalism. A typical exponent of the movement in the north was Ludwig Münsterman of Oldenburg (d. *c.* 1639); one of the principal names in the south was that of Hans

FIG. 231—DEGLER. ALTAR. CHURCH OF ST. ULRICH AND ST. AFRA, AUGSBURG. (PHOTO. DR. FR. STOEDTNER)



Degler (d. 1637), who belonged to a group of Bavarian sculptors in wood (Fig. 231). The invasion of artists from the Low Countries still continued, though in less force. They conquered a position especially at the court of the Great Elector of Brandenburg, Frederick William, who now raised Prussia into a centre for northern German art.

B. THE LATER SEVENTEENTH AND EIGHTEENTH CENTURIES

Introductory. It was not until the latter part of the seventeenth century that the influence of Italian developments was superimposed upon the native tendencies towards the baroque. In northern Germany, it was rather the Belgian and Dutch aspects of the Italian baroque that still played the preponderant rôle. In the south, the relationships with Italy were more direct. Many distinguished native masters joined with the constantly present foreigners in the development from the baroque to the utmost centrifugal license of the rococo and to neoclassicism. The cultural ascendancy of France during the epoch expressed itself in the frequent patronage given to French masters, in the imitation of the French form of the rococo, particularly for secular and sepulchral sculpture, and in the occasional adoption even of the classicism of Louis XIV.

Schlüter. In the first generation of native masters, the name of Andreas Schlüter (1664-1714) is most familiar. Educated in Italy and among the Flemings and Dutchmen then enjoying favor in northern Germany, he became the architect and sculptor of the Hohenzollern at Berlin. His style is baroque, but his Teutonism asserted itself in greater realism and in the Herculean strength of his figures. He possessed also a true sense of monumentality that was usually denied to baroque artists. Now and again, he shows a dependence upon the classicists of France. One of the landmarks of Berlin is his bronze equestrian statue of the Great Elector on the Long Bridge (Fig. 232), infused with a tremendous and essentially German energy. The rider and horse seem to have been suggested by Girardon's non-extant equestrian monument of Louis XIV, which was then being made

but had not yet been unveiled. The realistic side to Schlüter's personality is uppermost, in a ghastly phase, in the colossal masks of expiring warriors adorning the arches of the court in the Arsenal. The virtues of the series are the technical skill, the inventive range in age, mood, and kind of agony, and the heroic vigor that gives the heads the required monu-

FIG. 232—SCHLÜTER. MONUMENT OF THE GREAT ELECTOR. BERLIN.
(PHOTO. PHOTOGRAPHISCHE GESELLSCHAFT, BERLIN)

mentality. The most celebrated example of his religious work is the pulpit in the Marien-Kirche, an instance of the baroque magnificence which was bestowed upon these objects by the Germans and especially the Saxons as early as the end of the seventeenth century and which was only less than that in which the Flemings revelled. The lower part is derived from Bernini's structure for St. Peter's Chair. The two allegorical and dramatic bronze tombs in the cathedral

of Berlin that he executed for King Frederick I and his Queen are free adaptations of Girardon's monument for Richelieu.

Other native masters. The first important native manipulator of the baroque was Balthasar Permoser (1651-1732), active principally at Dresden. He embodied the baroque in its most pronounced form, whether his works are viewed from the standpoint of pictorial accessories or of violent agitation; but he managed to invest his feminine figures with great charm. His chief productions, mythological and allegorical, decorate the palace of the Zwinger at Dresden. His best known religious work is the pulpit of the Court Church, adorned with the soaring Evangelists and flights of *putti* holding the instruments of the Passion. By entangling his statue of Prince Eugene of Savoy (in the Belvedere, Vienna) in an intricate mesh of symbolical figures, he created one of the extreme manifestations of the baroque spirit. Like so many sculptors of the epoch, he did not feel it beneath him to busy himself with the minor arts, especially ivories. In southern Germany Johann Peter Alexander Wagner (1730-1809) occupied as important a position at the episcopal court of Würzburg as Schlüter at Berlin or Permoser at Dresden. His lot, however, was cast in the days when the rococo had taken the place of the baroque, and he even began to walk timidly over the road to neoclassicism. His ability may be measured by the statuary and vases on the staircase of the Episcopal Palace at Würzburg and by .his sculptured embellishment of the gardens of the castle at Veitshöchheim. His *putti*, which constitute his chief claim to renown, are modelled in the naturalistic fashion set by Duquesnoy.

VIII. Austria

Donner. The greatest Austrian sculptor of the epoch was Georg Raphael Donner (1693-1741). He had a baroque foundation, but he soon became a prophet of neoclassicism. He was endowed with high technical skill and with a respect for ideal and noble beauty of person unusual at the period. His principal medium was lead. His more baroque phase

may be illustrated by such superior and spirited examples of the style as the mounted St. Martin and the beggar in the cathedral, Pressburg, and (from the same altar) two angels in the National Museum, Budapest. His masterpiece is the Fountain in the New Market, Vienna (Fig. 233). Bronze copies have now been substituted for the original lead figures, which have been removed to the Städt-isches Depot. The achievement represents the most beautiful expression of that happy moment when incipient neo-classicism was not yet beclouded by too much archæology but still illumined by the brilliancy and originality of the baroque. Donner's statue of Charles VI in the Belvedere, Vienna, though accompanied by a fluttering feminine personification, is quieter and less disturbed by centrifugal effects than Permoser's Eugene.

FIG. 233—DONNER. FIGURES (BRONZE) ON FOUNTAIN. NEW MARKET, VIENNA. (FROM DEHIO AND VON BEZOLD, "DIE DENKMÄLER DER DEUTSCHEN BILD-HAUERKUNST")

Other sculpture of the period. The Austrian "Trinity Columns," erected usually as thank-offerings for deliverance from the plague, constitute as extreme manifestations of the baroque feeling as the pulpits of Belgium. The specimen in the Graben at Vienna, due to the collaboration of several sculptors, exhibits a multiplicity of figures ensconced on high-heaped, pictorial accessories of rocks and clouds. The most eminent exponent, at Vienna, of the naturalism of the rococo in portraiture was the Swabian, Franz Xaver Messerschmidt

(1732-1783), who has been called the Hogarth of sculpture. A good example of his unconditioned characterization is the bust of Van Swieten in the Public Hospital, Vienna. His interest in the studies of Mesmer and of the physiognomist, Lavater, led him to execute his even more startling series of heads of eccentric characters, represented at moments of physical and psychic excitement.

IX. SPAIN

A. THE SEVENTEENTH CENTURY

Introductory. In this, its Golden Age, Spanish art owed less to the Renaissance than did the contemporary output of other peoples. It retained certain things that it had learned from the antique and from Italianism, such as classically beautiful dispositions of the drapery; but in general it shook off all imitation, reasserted its originality, and became more truly national even than in the Middle Ages. Spanish sculptors did not continue to study in Italy like the masters of other countries, and they were therefore much less under the spell of Bernini and his *entourage*. The plastic production of Spain during this period was almost exclusively religious. The enthusiastic Catholicism of the country, which was the great stronghold of the Counter-Reformation, bestowed a more than usual fervor of Jesuitical piety upon the statuary, but the fervor expressed itself in an inner emotional intensity rather than in the usual outward agitation of the baroque. The gravity of the Spanish temperament avoided the Italian riots of movement, although the separate statues of saints were usually represented in some form of not too violent activity. The Spanish masters departed from the usual standard of the baroque also by indulging less in pictorial effects. They showed little fondness for the great pictorial compositions of architecture and statuary to which Bernini was addicted, and preferred single figures. The naturalism which has been typical of the whole history of Spanish art now appeared in its most decided manifestation, approach-

ing close to verism.[1] The old Spanish medium of wood
was almost universally retained. The polychromy was often
executed, not by the carvers themselves, but by painters, and
one of the expressions of naturalism was the greater faithful-
ness of the color scheme to actuality. In general quality the
sculpture of this period was only less distinguished than the
more famous painting of Velázquez, Ribera, Zurbarán, and
Murillo.

FIG. 234—GREGORIO FERNÁNDEZ. PIETÀ. MUSEUM, VALLADOLID. (PHOTO
LACOSTE)

The School of Valladolid. The master who led the way in
the repudiation of the Italian Renaissance and in the resusci-
tation of the indigenous tradition was Gregorio Fernández
(or Hernández) (*c.* 1567-1636). He retained enough of the
tutelage of the Renaissance to invest his naturalism with a
certain elegance of posture and drapery, particularly in his
retables, as in that of the cathedral of Plasencia; but discard-
ing the premature baroque violence of Berruguete and Juan

[1] Cf. below, p. 476.

de Juni, he reasserted the spirit of Spanish gravity. His
Virgin of Sorrows in the church of Santa Cruz at Valladolid
demonstrates how emotional piety expressed itself in Spain in
concentrated intensity and a veristic approximation to reality
rather than in baroque gesticulation. His naturalism mani-
fested itself especially in his utterly faithful and unclassical

treatment of the nude, as in
his many effigies of the
dead Christ, which exhibit
an almost poignant feeling
for the beauty and softness
of the flesh and the lines
of the undraped body. He
was also the champion of
the reaction against the
vivid polychromy that had
reached its climax in Juan
de Juni. The various as-
pects of his achievement
are well illustrated by the
Baptism of Christ and the
Pietà (Fig. 234) in the Mu-
seum of Valladolid.

The School of the South.
At Seville, the southern fo-
cus of Spanish art during
this period, the outstanding
name in sculpture is that
of Juan Martínez Mon-
tañés (*c.* 1564-1649). He
gives the same curious im-
pression of a combined

FIG. 235—MONTAÑÉS. VIRGIN. MU-
SEUM, SEVILLE. (PHOTO. LACOSTE)

idealism and naturalism that is the distinctive mark of Mu-
rillo's maturity, and like Murillo, he best embodied this
style in the subject of the Immaculately Conceived Virgin.
Of several repetitions, perhaps the greatest is the example
in the church of the Sagrario, annexed to the cathedral at
Seville. Montañés sublimated his naturalism also by be-
stowing monumentality upon his figures, especially, like

FIG. 236—PEDRO DE MENA. VIRGIN AND CHILD. STO. DOMINGO, MALAGA.
(COURTESY OF THE JUNTA DE AMPLIFICACIÓN DE ESTUDIOS, MADRID)

Benedetto da Maiano, through the device of great sweeps
of enveloping drapery (Fig. 235). A comparative restraint
in religious expression made for the same end. Even over
the celebrated Crucifix of the cathedral there rests that
calm sobriety which ensured to Montañés greater success

in single figures than in animated compositions. The painter and sculptor Alonso Cano of Granada (1601-1667) was influenced in his plastic production by Montañés. Though he did not hold his pious passion so firmly in check as the Sevillan master, he aimed at a more idealized beauty than his rivals, and, choosing gentler forms, he treated their details with a technical delicacy that, as in his paintings, distantly recalls Florentine art of the Quattrocento. Characteristic examples of his style at Granada are the Magdalene in the Cartuja and the Immaculate Conception in the sacristy of the cathedral. The most interesting, if not the greatest, Spanish sculptor of the century was Cano's pupil, Pedro de Mena of Granada (1628-1688). During the earlier part of his career, which is best represented by the carving of the choir-stalls in the cathedral of Malaga, the naturalistic side of his genius was dominant; and yet the idealistic inheritance from Cano somewhat tempered his anatomical zeal and made his nudes the most beautiful examples produced by Spanish sculptors at this epoch. The moderated naturalism of the *tondo* of the Virgin and Child in Sto. Domingo, Malaga, one of the most winning pieces of all Spanish sculpture (Fig. 236), again demonstrates the partial persistence of Cano's influence, and, like his master's work, suggests Florentine art of the fifteenth century. His *putti*, also, continue the best traditions for the modelling of the forms of children. In his maturity he added to his gifts spiritual expressiveness. The St. Francis in the cathedral of Toledo proves that Mena embodied his pious ardor best in the forms of ascetics, and that in the representation of monks and friars he has few rivals in the world's history.

B. THE EIGHTEENTH CENTURY

The sculptors of Spain in this period may be divided into four groups. There were, first, those who betrayed an unmistakable decadence from the high standards of the preceding century. The decadence often manifested itself in an adoption and even exaggeration of the baroque of Italy in its most wanton forms. This style appeared principally in architectural decoration and is called Churrigueresque

from the man who, rightly or wrongly, has been reckoned its most outrageous exponent, José Churriguera. Never has ornamentation been so overladen, so ostentatious, and so ugly in detail. A notorious example is Narciso Tomé's embellishment of the screen behind the high altar of the cathedral of Toledo, called the *Trasparente* because of the opening that admits light from the ambulatory. The taste was as bad in separate statues of saints. The mere artisans who now largely monopolized the plastic market broke all bonds in their naturalism, delighting in horror and putrefaction and endowing the figures with real hair and nails, glass eyes, and apparatus for moving the several parts of the body. A second group was constituted by the few sculptors who managed to maintain to a certain degree the good old traditions of the seventeenth century. Chief among these was Francisco Salzillo or Zarcillo of Murcia (1707-1781). The workshop that he organized with his brothers and sister is principally remembered for its *pasos* or sets of figures representing episodes from the Passion to be carried in the processions of Holy Week. The most notable examples are in the Ermita de Jesús at Murcia. Such essentially Spanish subjects, which had exercised the skill of great artists at least as early as Gregorio Fernández, were treated with a pronounced naturalism that sought to give the illusion of actual scenes; but Salzillo was never guilty of the realistic aberrations of the majority of his contemporaries. He sometimes conformed, however, to the now established practice of avoiding the labor of modelling anything but the head and extremities by concealing the rest with a real garment. A third group was formed by the French sculptors imported by Philip V, the first of the French Bourbon dynasty, to adorn the gardens of the palace of La Granja which he began in 1719 at San Ildefonso in direct imitation of Versailles. To a fourth group may be assigned the members of the Academy of San Fernando founded in 1752 and those inspired by the reform that the Academy was created to champion. Ferdinand VI's purpose was to rescue Spanish art from the degradation into which it had sunk, but the effort was only partially successful. The Academy banished extravagances, to be sure, but it

produced no better masters than Felipe de Castro (1711-1775) to direct and give strength to its energies. The chief element in the resulting style, despite a frequent admixture of naturalistic and baroque tendencies, was French classicism, much affected by the closer study of the antique that was general in Europe during the second half of the eighteenth century.

BIBLIOGRAPHICAL NOTE

The revived interest in the baroque has finally produced an adequate book on the European sculpture of the period in A. E. Brinckmann's *Barockskulptur*, Berlin, 1919, notable alike for its complete, up-to-date information and for its enlightened criticism; at the end even a brief résumé of the eighteenth century is included. One of the most active and capable modern investigators of the Italian baroque is A. Muñoz, among whose articles on the subject may be mentioned *La scultura barocca e l'antico, L'Arte,* XIX (1916), pp. 129-160, and *La scultura barocca, Rassegna d'arte,* July, 1916, pp. 158-168. The most comprehensive monograph on Bernini is by S. Fraschetti, Milan, 1900; M. Reymond's (Paris) and M. von Boehn's (Leipzig) books of 1911 and 1912 respectively should also be consulted; in *Bernini and Other Studies,* New York, 1914, R. Norton indulges in a dithyrambic rehabilitation of the baroque and its chief exponent. Algardi is thoroughly treated by H. Posse in the *Jahrbuch der preussischen Kunstsammlungen,* XXVI (1905), pp. 169-201. Bracci is the subject of volumes by K. von Domarus, Strassburg, 1915, and by C. Gradara, Milan, 1920.

The general spirit of French classic art is set forth with Gallic lucidity and elegance in H. Lemonnier's two works, *L'art français au temps de Richelieu et de Mazarin,* Paris, 1893, and *L'art français au temps de Louis XIV,* Paris, 1911. F. Ingersoll-Smouse's book, *La sculpture funéraire en France au XVIIIe siècle,* Paris, 1912, covers more than the title implies: it is a clear and penetrating examination of the evolution of the French tomb in the classic as well as the rococo period. Monographs on individual artists are furnished by: H. Stein, *Les frères Anguier,* Paris, 1889; H. Jouin, Paris, 1883, and G. Keller-Dorian, Paris and Lyons, 1920, both on Coysevox; P. Auquier, *Pierre Puget,* Paris, 1903; and Lady Dilke (E. F. Strong), *Les Coustou, Gazette des Beaux Arts,* 1901, I, pp. 5-14 and 203-214. Lady

Dilke has also written a pleasant, anecdotal book on the rococo in *French Architects and Sculptors of the XVIIIth Century,* London, 1900. The following are the standard monographs for the French eighteenth century: A. Roserot, *Edme Bouchardon,* Paris, 1910; S. Rocheblave, *Jean Baptiste Pigalle,* Paris, 1919; Louis Réau, *E. M. Falconet,* Paris, 1922; J. Guiffrey, *Les Caffiéri,* Paris, 1877; H. Stein, *Augustin Pajou,* Paris, 1912; H. Thirion, *Les Adam et Clodion,* Paris, 1885, and J. Guiffrey, *Le sculpteur Claude Michel dit Clodion, Gazette des Beaux Arts,* 1892, II, pp. 478-495, and 1893, I, pp. 164-176 and 392-417; and on Houdon, C. H. Hart and E. Biddle, Philadelphia, 1911, and, more comprehensive and final, with an elaborate catalogue of his works, G. Giacometti, Paris, 1918-1919, in three volumes.

A summary but useful book on the Belgian baroque is H. Rousseau's *La sculpture aux xviiᵉ et xviiiᵉ siècles,* Brussels, 1911. Laurent Delvaux is studied by G. Willame in a book published at Brussels in 1914. The greatest sculptor active in Holland during the epoch is well treated by M. van Notten in *Rombout Verhulst,* The Hague, 1908. E. B. Chancellor's *Lives of the British Sculptors,* London, 1911, though undiscriminating as well as too discursive and biographical, contains valuable data on the production of the seventeenth and eighteenth centuries. For monographs on English sculpture of the period, the student is referred to: A. E. Bullock, *Some Sculptural Works of Nicholas Stone,* London, 1908, and *Grinling Gibbons and his Compeers,* London, 1914; and to L. Rosenthal, *Un sculpteur français en Angleterre au xviiiᵉ siècle, Roubillac, Revue d'histoire moderne et contemporaine,* I (1899-1900), pp. 593-605. Further reading on German and Austrian sculpture may be found in: C. Gurlitt, *Andreas Schlüter,* Berlin, 1891; H. G. Lempertz, *Johann Peter Alexander Wagner,* Cologne, 1904; and E. Tietze-Conrat, *Oesterreichische Barockplastik,* Vienna, 1920. R. de Orueta has contributed splendid studies to the Spanish baroque in his *La vida y la obra de Pedro de Mena,* Madrid, 1914, and in his *Gregorio Hernández,* Madrid, 1920.

CHAPTER XIII

NEOCLASSICISM

I. General Characteristics

The cardinal principle of neoclassicism, which dominated all of Europe during the last few years of the eighteenth and the first quarter of the nineteenth century, was the imitation of the masterpieces of classic antiquity. The tendencies were brought to a head in no small degree by the propaganda of the German *savant* Winckelmann and the German painter Anton Raphael Mengs; but the movement may be viewed also as a spontaneous reaction against the extravagancies of the baroque and rococo. Almost any sculptor of the period would probably have proclaimed a formal allegiance to nature, but only in so far as her multifarious aspects might be verified in ancient statues; and the practical consequence was that he was satisfied to learn no more of actuality than what he found in these prototypes. The imitation was much more absolute even than in the Cinquecento. Since at first the productions of the best ancient periods were not known, the works of the pupils of Praxiteles and of the Hellenistic epoch were taken as the supreme models, with the result that charm and grace, softness, and sometimes even sensuality became the great desiderata. Although the sculptures of the Parthenon and the Æginetan temple were revealed to Europe at the beginning of the nineteenth century, they really had very little influence. Thorvaldsen and other later neoclassicists flattered themselves that they had attained a more essentially Greek manner than Canova and the earlier generation, dignifying it with the name of Hellenism; but as a matter of fact the whole output of neoclassicism was very much the same. Like all imitators, the neoclassicist exag-

gerated the traits of his prototypes, omitting the modelling, for instance, as far as possible in his effort after the idealized and generalized beauty of antiquity. The aims that he set himself were Hellenic repose of body, classic impassivity of countenance, and simplicity of composition; but occasionally, in a last homage to the baroque or in a frantic effort to break the cold spell of the neoclassic style, he dared to indulge in extravagant gesticulation, all the more obvious and painful because unfitted to the forms that he had borrowed from the past. Pictorial perspective was banished from reliefs. The Christian subjects were deemed less capable of the highest artistic expression than those of classical mythology and history. By the strictest theorists, portraits were tabooed; but patronage demanded them, and their executers salved their consciences by generalizing the features, by approximating them to those of some Greek or Roman figure, and by clothing the forms in ancient costume or ancient nudity or at least by somewhat concealing contemporary dress in a classically draped mantle. All themes were oppressed by rhetorical sentimentality. Yet even neoclassicism had its virtues, and one of them was a partial recovery of the sculptural sense in distinction from baroque pictorialism.

II. ITALY

Canova. The first great exponent of the style in sculpture was an Italian, Antonio Canova (1757-1822), born at Possagno in the province of Treviso but active chiefly at Rome. He tinged the neoclassic manner with other characteristics, but he also exemplified its typical features. The close dependence of the Perseus, in the Vatican, upon the Apollo Belvedere (cf. Fig. 71) reveals how sometimes he indulged in an almost exact reproduction of antiques. At other times the relation, though indubitable, is not so tangible: for instance, the group of Cupid and Psyche, in the Louvre, seems to have been suggested by a painting of a faun and a nymph from Herculaneum. The conception of Pauline Bonaparte (Fig. 237) as a Venus Victrix may serve as an example of

his adaptation of portraits to classic figures. He embodies
likewise the neoclassic standards of Praxitelean grace and
softness. One of the reasons was that these qualities were
attuned to his own personality, and there is, indeed, a more
subjective note in Canova's sculpture than in the average
output of the movement. He possessed a sense of physical
beauty, the inalienable heritage of his race, which even the
tyranny of neoclassicism could not utterly dull. In a word,

FIG. 237—CANOVA. PAULINE BONAPARTE. VILLA BORGHESE, ROME

his works have more warmth than those of his rivals. The
elegance and sweetness of many of his productions are linger-
ing echoes of the rococo. Another phase of his personality
is exhibited by the Hercules and Lichas in the National
Gallery of Modern Art at Rome, one of his occasional and
successful attempts to reproduce the colossal and forceful as-
pects of the antique. Here, as in some other instances, the
baroque sense was still potent enough to make him choose
the passing moment for representation. Nor could he be quite

so oblivious to nature as the severest theorists required. The best proof is afforded by some of his portraits, such as the Lætitia Bonaparte at Chatsworth, England. The contemporary tendencies to simplification, placidity, allegory, and sentiment are well illustrated by his series of mortuary monuments. In the two tombs of Clement XIV and Clement XIII, the former in the church of the SS. Apostoli, the latter in St. Peter's, Rome, he reduced the baroque type of sepulchre to greater tranquillity. His most pretentious mausoleum, the monument of the Archduchess Maria Christina in the Augustinian Church, Vienna, is a subdued example of the French dramatic tomb of the eighteenth century.

III. Denmark

The boasted Hellenism of Bertel Thorvaldsen of Copenhagen (1770-1844) manifested itself chiefly only in a greater profusion of Greek subjects and in an affectation of greater archæological correctness and detail. Having established himself at Rome, he developed into an absolute slave of the antique. It was a foregone conclusion that his respect for nature would be reduced to the minimum. One misses in his sculpture the impress of personality that Canova managed to retain. When unassisted by the ideas of others and when not reproducing antique conceptions, he was simple and unimaginative almost to the point of stupidity, nor did he compensate by any emotional qualities. It is all very well to say that he purposed this simplicity and this suppression of passion as incongruous with the tranquillity of the antique; but had he not been very phlegmatic in temperament, he would surely have chafed under neoclassic restrictions and at times and to a certain extent he would have shaken off these fetters. He was even technically less fine than Canova. The principal æsthetic quality with which he was concerned was probably composition, and here he was almost always good. His constant dependence upon the antique it hardly seems necessary to demonstrate. One or two examples will serve the purpose. Like the Perseus of Canova, his Jason is merely a transcript of the Apollo Belvedere. In the frieze of Alexander's triumph, existing in the plaster model in its original

position in the Quirinal Palace, Rome, and in finished marble, with some modifications, in the Villa Carlotta on Lake Como, the horsemen are suggested by the Parthenon frieze and the Asiatics by the barbarians on Trajan's column. Like Canova he was more at home in the gently elegant than in the heroic, and for this reason perhaps he preferred relief to statues in the round. But even in his best works in this manner, such as the renowned allegorical *tondos* of Morning and Night (Fig. 238), he did not approach so close to Praxitelean grace as his Italian rival. The nearest that he ever got to natural-

ism was in three of his four *tondos* of the Seasons, the rather charming Spring re-maining antique in concep-tion. His portraits he was likely to translate com-pletely into ancient terms, until little suggestion of the individual was left. The Count Potocki in the ca-thedral of Cracow, for in-stance, is a highly idealized classical warrior. His best portrait is perhaps the seated effigy of Pius VII on the tomb in St. Peter's, a monument of the more tranquil type employed by

FIG. 238—THORVALDSEN. NIGHT.
VILLA ALBANI, ROME

Canova. In the latter part of his life, he was forced to sac-rifice his principles somewhat and do homage to the Ro-mantic movement; but with his lack of any historic sense, he was here out of his element, and even in the best of his statues in romantic costume, such as the equestrian Maxi-milian I in the Wittelsbacher-Platz, Munich, he was able to attain no incisiveness or force.

IV. FRANCE

Neoclassicism was peculiarly fostered in France by the Revolutionary ideals of ancient republics and by Napoleon's

visions of a Roman empire. The artistic dictatorship that in the past had been enjoyed by such men as Le Brun and Boucher was now wielded by the painter, Louis David, who exercised his confirmed antiquarian influence in sculpture as well as in his own sphere. Since the ancient borrowings, however, were colored with an unmistakable "Frenchiness," they were never so absolute as those of Canova and Thorvaldsen. One group of sculptors cultivated the Praxitelean grace exhibited by Antoine Denis Chaudet (1763-1810) in his kneeling Eros with a butterfly (Fig. 239). Pierre Cartellier (1757-1831) may be taken as representative of another, more austere coterie, who found success in the decoration of architecture and in other monumental undertakings. Basing himself upon an ancient coin or gem, for instance, he executed a rather impressive relief in his Triumphal Quadriga over the central door of the Colonnade in the east façade of the Louvre. Less hidebound than the majority of neoclassicists, he revealed in his statue of Vergniaud

FIG. 239—CHAUDET. EROS. LOUVRE, PARIS. (PHOTO. BRAUN)

at Versailles qualities of portraiture that even his archæological enthusiasm and the antique costume could not completely nullify. Certain sculptors ventured a somewhat more decided rebellion, daring, in some degree, to study nature and to bestow at least a modicum of warmth upon their creations. Joseph Chinard of Lyons (1756-1813), in the soft outlines of his favorite terracotta, preserved much of the light and graceful charm of the rococo. His Three Graces in the Museum, Lyons, are a typical instance of the dainty and fanciful mode in which the eighteenth century treated

mythological themes. His fame rests upon his delicate
busts of young women (Fig. 240). Although he sometimes
so far catered to existing
standards as to garb them
in classical costume, he vio-
lated the neoclassic theo-
ries by making them real
portraits, and perhaps more
than anyone else in the
period he invested them
with French sensibility to
feminine charm.

FIG. 240—CHINARD. MME. RÉCAMIER.
(PHOTO. GIRAUDON)

V. GERMANY AND AUSTRIA

The naturalistic tradi-
tion was too inbred in Ger-
man art ever to be so far
eradicated by neoclassicism
as it was in other countries.
Dannecker. The transi-
tion from the rococo to neo-
classicism was embodied in Johann Heinrich Dannecker of
Stuttgart (1758-1841). The charming Sappho of the Stutt-
gart Museum illustrates how his rococo education left a pleas-
ant aftermath through all his earlier production both in his
preference for subjects allowing him to treat the feminine
figure and in his predilection for somewhat slighter and more
graceful forms than those cultivated by the more heroic
among the neoclassicists. As he grew more neoclassic, al-
though definite ancient prototypes for his works may occa-
sionally be found, the effect of classical art upon him may
be sought in fused impressions of several antiques or, even
less specifically, in original imitations of the ancient manner.
So it is rather the spirit of the antique that breathes through
his Girl with a Bird, probably suggested by Catullus's poem
on Lesbia and the dead sparrow (Fig. 241). His most re-
nowned achievement is the Ariadne in Bethmann's Museum,

Frankfort. The enduring significance of Dannecker consists in the pleasing union of a moderate naturalism with the ancient principles of rhythm and harmony. The best instances of naturalism, are, as usual, the portrait busts. He was particularly the portraitist of Schiller. Of several examples, the earliest, in the Library at Weimar, is the most memorable, despite the fact that the hair is treated with antique conventionalism.

FIG. 241—DANNECKER. GIRL WITH BIRD. MUSEUM, STUTTGART. (COURTESY OF MUSEUM, STUTTGART)

Schadow. The greatest German sculptor of the neoclassic period was Johann Gottfried Schadow of Berlin (1764-1850). It is necessary to describe Schadow as "of the neoclassic period," and not as essentially neoclassic himself, since, although inevitably influenced by the rococo style of his youth and by the prevalent antiquarianism, he was independent of any movement, and recognized as his guides only nature and his own conceptions. If he must be assigned to some tendency, his naturalism would be more in harmony with the rococo. He approached closest to the neoclassic in his decoration of the Brandenburg Gate, Berlin, and in his last work in marble, the recumbent maiden in the National Gallery, Berlin. Perhaps the most striking instances of his realism, all with contemporary military uniforms, are the statues of Frederick the Great in the Provinzial-Landhaus, Stettin, and of the generals Ziethen and Von Dessau in the Kaiser Friedrich Museum. His most popular work is the standing portrait group of the two sisters, the princesses Louise and Friederike of Prussia, in the Palace at Berlin

(Fig. 242). In a greater degree than Dannecker, he has attained an agreeable fusion of naturalism, of rococo loveliness, and of that classic grace which was much assisted by the similarity of the fashionable Empire costume to the dress of ancient Rome.

FIG. 242 — SCHADOW. PRINCESSES LOUISE AND FRIEDERIKE. ROYAL PALACE, BERLIN. (PHOTO. PHOTOGRAPHISCHE GESELLSCHAFT, BERLIN)

VI. ENGLAND

The English sculptors of this period sought to atone for a kind of provincial dullness and for the general coldness of the neoclassic style by a more liberal resort to rhetoric than even their continental rivals allowed themselves. The first important neoclassicist was John Flaxman (1755-1826), who was much more distinguished in his drawings than in sculpture. He himself never learned how to handle marble successfully, and usually modelled or designed for others to execute, setting little value on careful finish. His private sepulchres have the strained sentiment of the epoch. In these he was accustomed to give concrete form to some Biblical text, and in general he was characterized by more religious interest than the average English neoclassicist. His well-known Michael overcoming Satan at Petworth House is curiously baroque in spirit. His monuments of Nelson in St. Paul's, London (Fig. 243), and of Lord Mansfield in the Abbey are mild examples of the pompous and sentimental allegory relished by the British of that time in public com-

memorations. The best known immediate successor of Flax-man was Sir Francis Chantrey (1781-1841). If he had been a greater artist, he might have become an English Schadow, for he was more at home in realistic sub-jects, such as portraits, than in imaginative themes or sepulchral monuments. As a sculptor of busts, he was the most sought after master of the day, but it is doubtful whether his like-nesses are any better than those by Flaxman. The bust of Scott in the Na-tional Portrait Gallery, London, is typical. The Washington of the State House, Boston, is a char-acteristic specimen of his portrait statues, in which he was famous for concen-trating attention upon the head and for imparting to it intellectuality.

FIG. 243—FLAXMAN. MONUMENT OF NELSON. ST. PAUL'S, LONDON. (PHOTO. MANSELL)

VII. THE UNITED STATES

The early period. The plastic manifestations of neoclassicism in Austria, Belgium, and Spain are not so dif-ferent from those in other countries nor of such universal sig-nificance as to demand separate treatment; nor would the meagre beginnings of sculpture in the United States call for special discussion, if this were not an American book. Puri-tanic aversion to art and the simple condition of the colonists were unfavorable to any production or even importation until the middle of the eighteenth century. Several European sculp-

tors who obtained orders here subsequent to this date have already been mentioned; but native production had already begun on a humble scale. The work of the earliest American sculptors did not definitely belong to any school but was the result of the poor conglomerate artistic education that they

FIG. 244—RUSH. WASHINGTON. INDEPENDENCE HALL, PHILADELPHIA.
(COURTESY OF MR. WILFRED JORDAN)

could pick up in this remote country from prints, casts, or the very few examples of European sculpture that they chanced to see. Yet even in the United States they fell more or less under the influence of neoclassicism. In these first endeavors, with their comparative rudeness, American sculpture passed through a phase which was, in a way, as truly "primitive" as archaic Greek or Romanesque sculpture and which pos-

sesses the charm of primitive sincerity and hard effort. The outstanding figure of this early stage of American sculpture was William Rush of Philadelphia (1756-1833), who confined himself to the materials of wood and clay and all of whose performances betray clearly the wood-carver's methods. His feminine allegorical figures are as neoclassic as they are anything, but the wood-carver's technique gives them a rococo "fussiness" and projection of the folds. The Nymph of the Schuylkill, carved in wood for a fountain and preserved for us in a bronze replica in Fairmount Park, Philadelphia, proves, in its grace of form and pleasantly clinging drapery, that almost all of these tyros managed through sheer innate talent to create one or two memorable works. The statue of Washington in Independence Hall (Fig. 244) is a simple and impressive likeness, unspoiled by too close a contact with neoclassicism. It is an epitome of Rush's style, even to the difficulty that the sculptor encountered in essaying an easy posture.

FIG. 245—HORATIO GREENOUGH. WASHINGTON. SMITHSONIAN INSTITUTION, WASHINGTON. (COURTESY OF THE COMMISSION OF FINE ARTS)

Developed neoclassicism. With the increasing cultural development of the United States came the habit of study in Italy and the consequent absolute surrender to neoclassicism. The chief sculptors in the generation after Rush were Greenough, Powers, and Crawford. All three, having once established themselves in Italy, remained there for a large part of their lives, shipping their orders to America. Their activities extended far into the nineteenth century, beyond the chronological but not the stylistic limits of neoclassicism. Horatio Greenough of Boston (1805-1852)

exhibits his dull average of neoclassic mythology in such works as the Cupid Bound of the Boston Museum. His seated Washington (Fig. 245) is tricked out as a Phidian Zeus; but its faults are more the faults of the epoch. The bust of J. Q. Adams in the New York Historical Society betrays the fact

that Greenough floundered even more than the usual neoclassicist in portraiture. Hiram Powers (1805-1873) owed his fame largely to the sensation created, in untutored America, by the nudity of his feminine figures. The most celebrated example is the Greek Slave (Fig. 246), derived from the Medicean Venus. In works like the Daniel Webster in front of the State House, Boston, he achieved a slightly more veracious portraiture than Greenough. Thomas Crawford of New York City (1813-1857) was more original and imaginative than either of his rivals, initiating the American tradition of themes for national glorification. His most interesting legacy is his decoration of the Capitol at Washington. The bronze Armed Freedom, which crowns the dome, is a conception of real majesty, almost inspired. Although his pediment of the Senate Wing is a disjointed composition, some of the separate forms are not to be forgotten, especially the America, conceived in the same high mood as the Armed Freedom, and the

FIG. 247—CRAWFORD. BRONZE DOORS, CAPITOL, WASHINGTON. (PHOTO. L. C. HANDY)

431

seated and dejected Indian chieftain. His bronze doors of the Senate Portico, representing the terrors of war and the blessings of peace (Fig. 247), were another innovation in our country. In many respects, as in the simplicity of composition, lucidity of narrative, and pleasantly conceived and executed figures, they constitute Crawford's masterpiece.

BIBLIOGRAPHICAL NOTE

The standard monographs on Canova and Thorvaldsen are: A. G. Meyer, *Canova*, Leipzig, 1898; V. Malamani, *Antonio Canova*, Milan, 1911; E. Plon, *Thorvaldsen, sa vie et son œuvre*, Paris, 1874; S. Müller, *Thorvaldsen, hans Liv og hans Vaerker*, Copenhagen, 1893; and A. Rosenberg, *Thorwaldsen,* Leipzig, 1896. With their usual ability at illuminating generalization, the French have produced three important books on the temper and production of French neoclassicism, which are also essential for an understanding of the epoch throughout Europe: F. Benoît, *L'art français sous la révolution et l'empire*, Paris, 1897; L. Bertrand, *La fin du classicisme et le retour à l'antique,* Paris, 1897; and M. Dreyfous, *Les arts et les artistes pendant la période révolutionnaire*, Paris, 1906. More detailed information upon Chinard may be sought in C. Saunier's article in the *Gazette des Beaux Arts*, 1910, I, pp. 23-42. The German exponents of neoclassicism are studied by A. Spemann in *Dannecker*, Berlin, 1909, and by K. Eggers in *Johann Gottfried Schadow und Christian Daniel Rauch* (in R. Dohme, *Kunst und Künstler der ersten Hälfte des 19. Jahrhunderts,* vol. I, Leipzig, 1886). For English sculptors of the epoch, the interested may turn to J. Doin, *John Flaxman, Gazette des Beaux Arts*, 1911, I, pp. 233-246 and 330-342, and A. J. Raymond, *Life and Works of Sir Francis Chantrey*, London, 1904. The period just preceding native production in America is investigated by F. Kimball in *The Beginnings of Sculpture in Colonial America, Art and Archæology*, VIII (1919), pp. 185-189; the same periodical, XI (1921), pp. 245-247, contains a good article on Rush by W. Jordan.

CHAPTER XIV

MODERN SCULPTURE

I. Introductory

General characteristics. Despite the freer play permitted to individual proclivities in modern times and despite the consequent premium set upon originality, it is possible to observe one or two qualities that have been pursued with a fair degree of unanimity, and to discern several very general and consecutive movements. Throughout the nineteenth century there was a constantly increasing tendency to reproduce nature more accurately than ever before in the world's history. This characteristic, which came partly as a reaction against neoclassic aloofness from actuality, may be described, for want of a more specific term, as a kind of *realism.* It has culminated in our own day in that unsparing faithfulness to the model which marked Rodin's first period and which constitutes the ambition of many eminent artists of the present generation. With another large group of sculptors, however, the turn of the century has brought an organized opposition in the shape of a reversion to the ideals of archaic Greek, Romanesque, and oriental art. Clearly perceptible, also, has been the tendency in sculpture to the cultivation of form for form's sake; and this propensity, instead of succumbing, has even been accentuated by the return to the primitive. A statue or relief no longer has to enshrine some idea or passion of its author or represent a dead or living personage. It has very commonly been enough that it be nothing more than the study of a posture as an æsthetic end in itself. The results have been an inordinate devotion to that condition in which form and motion are best exhibited, the nude, and a feverish search after ever new and therefore

433

often fantastic attitudes and activities of the body, which reached its climax in Rodin.

Evolution of modern sculpture. In the second quarter of the nineteenth century there was developed throughout Europe and the United States a style which, though for ideal subjects it still abided pretty closely by neoclassic precedent, yet for its numerous portrait busts and statues adopted a moderate realism. The modelling included further and better definition of the object than in the neoclassic period, but the surfaces remained hard and dry. Contemporary costume was allowed; but very commonly a purely decorative mantle was still thrown over the shoulders, and even to the present day ancient garb has been revived in sporadic cases in the feeling that it enhances the impression of the heroic. Romanticism, which matured during this period, affected the themes of sculpture much less than those of painting. It was then also that there began to manifest itself in full force the passion for plastic commemoration which has made the last hundred years an age of public monuments. After the middle of the century another tendency gained general European and American acceptance—a renewed interest in the Renaissance, to which was soon added an enthusiasm for the baroque and rococo, especially the baroque as embodied by Rubens. The imitations consisted in the imposition of rather superficial borrowings from these periods upon forms thoroughly modern in substance and in feeling. From this time on, France definitely assumed the leadership; and even though there may be at least some slight ground for the accusation, occasionally brought against French sculpture, of a velleity for the melodramatic, it has always maintained a technical supremacy and exhibited a vitality in new developments that have exerted a great influence upon European and American art.

The pictorial tendency in sculpture, assisted by the enthusiasm for the baroque, became general by the last quarter of the century and culminated in Rodin's importation of pictorial impressionism into sculpture. Not only, as in the baroque, did the sculptor choose transitory and violent phases of movement and cast his draperies in great sweeps that would

be the delight of the painter's brush; but he gradually forsook the shining smoothness of neoclassicism, and broke up his surfaces into a succession of bosses and depressions for the purpose of superinducing upon them an uninterrupted play of pictorial light and shade. The more modern style of the later nineteenth century was first evolved in France and Germany and then spread to the other countries of Europe and to America. The impressionistic proclivity in sculpture was much influenced by the school of impressionists in painting, among whose aims was the desire to reproduce the chiaroscuro of nature. The impressionistic sculptors summarized the unessentials and modelled clearly only the significant details. One of the results was that the finished marble or particularly the finished bronze preserved the rough expanses and lines of the clay sketch; and this "sketchiness" has been much valued by modern sculptors under the conception that it gives to the work the freshness and the casual quality of a first "impression." Parts of the figures were sometimes hidden in the rough marble block in order to attain in sculpture the effect of the blurred and fading outlines of impressionistic painting. The end of the nineteenth and the beginning of the twentieth century brought a reaction from the pictorial attitude. Its protagonists have sought to revive the sense of strongly felt and powerfully outlined form, and thus to restore to sculpture its truly sculptural quality. Almost inevitably they were led to an imitation of the past eras in which the sculptural attitude was most pronounced, the archaic Greek and the Romanesque. Indeed, for this and other reasons, perhaps the most characteristic note of the sculpture of today is the imitation of the primitive. One of the other reasons is the reaction from that realistic reproduction of nature which marked the nineteenth century. There is now a very general tendency to adopt the standpoint of more primitive art which sacrificed accurate representation to the feeling for design and strongly defined form, to other æsthetic exigencies, and to expressiveness. We are living in an age of artistic stylization, and it has only needed an exaggeration of this attitude to produce Post-Impressionism.

II. France

The Progressives

The overthrow of the barriers of neoclassicism was begun for sculpture in France by Rude, David d'Angers, and Barye. They found themselves somewhat at loggerheads with the Academy, which, reëstablished in 1816, still upheld more or less rigidly the rules of neoclassicism against Romanticism and embryonic realism; but even the conservatives henceforth modelled more naturalistically than the earlier and stricter neoclassicists.

Rude. The leading figure among the harbingers of modern conceptions in sculpture was François Rude of Dijon (1784-1855), active chiefly at Paris. He always remained more or less of a formal believer in the theories of neoclassicism, and at the beginning and end of his career exemplified them; but when he allowed his natural instincts to have their play, he abided by his Burgundian birthright of a straightforward realism, with an addiction to accessories of *genre*, and a certain practicality that somewhat stifled imaginative afflatus. The phase of his art in which he most obviously violated the restrictions of the neoclassicists was the infusion of his forms with animation. The first premonitions of this new manner appear in the Neapolitan Fisher Boy in the Louvre. The unusual pose, the accessories of cap, net, scapulary, and tortoise, above all the opening of the mouth into a captivating smile, are certainly a break with tradition. In his most renowned achievement, the group of the Departure of the Volunteers on the Arc de l'Étoile, Paris, tradition was strong enough to exclude contemporary costume and to admit only nudes and antique armor; but the closely knit composition is instinct with movement, the most superb embodiment of which is the goddess of war shouting the Marseillaise. He represented in some characteristic activity even his commemorative statues (Fig. 248), and, although he occasionally retained the decorative mantle, he clothed these figures in the

costume of the period to which they belonged. He did not possess enough imagination to raise his ideal subjects above the ordinary standard, and almost all of his few religious works are worse than negligible. It was rather the impetuosity of patriotism that lent force to the Departure of the Volunteers. A true Burgundian, he usually excelled only when he clung to the rendering of a definite personality.

David d'Angers. Less radical and therefore more popular than Rude was Pierre Jean David of Angers (1788-1856), called David d'Angers to distinguish him from the painter of the same name. His aim was to make sculpture "national," that is, to represent the subjects that were up-

FIG. 248—RUDE. MONUMENT OF MAR-SHAL NEY. PLACE DE L'OBSERVATOIRE, PARIS. (PHOTO. BULLOZ)

permost in the French popular mind of the moment and to treat them in such a way that they would appeal to the ordinary intellect of the period. Such an attitude turned him naturally to the execution of the monuments of famous men that the epoch craved. He was enough of an innovator to clothe them in the costume of their period; but occasionally, as in the Racine at La Ferté-Milon, he reverted to classic dress, and he was much addicted to the enveloping mantle. In his characterizations he was less powerful and incisive, drier and more pompous than Rude. He did not ordinarily choose some typical moment of activity but endeavored to compress into the portrait the sum of his subject's permanent characteristics. To the number of his best achievements belong the Corneille at Rouen, the Drouot at Nancy (Fig. 249), the Thomas Jefferson in the Capitol, Washington, and the pediment of the Panthéon at Paris,

which reveals France honoring civic and military heroes. He tried his hand, of course, at the customary pieces of neoclassic mythology, history, and allegory; but, like his other achievements, they are wanting in charm and magnetism, because of what was perhaps the most fatal deficiency in his artistic make-up, the lack of any adequate sense of physical beauty. His æsthetic reputation must rest ultimately upon his many medallions of past and contemporary celebrities.

FIG. 249—DAVID D'ANGERS. STATUE OF DROUOT. NANCY

Barye. Much bolder in his innovations than either Rude or David d'Angers but less accredited in his day, because of the sphere of expression that he chose, the life of animals, was Antoine Louis Barye of Paris (1796-1875). Animal life was first made by him a principal subject for sculpture, whereas hitherto in western art it had been exalted to such a position only in a few isolated instances. Working both in the large and for the minor arts, he ran the gamut of the emotions that could be evoked from his themes, sometimes humorous, as in the standing Bear, sometimes epic, as in the superb Lion at the entrance to the Pavillon de Flore of the Louvre; but the subjects of his predilection were groups of two beasts engaged in a terrible life and death struggle. These bloody scenes from the jungle he could never have witnessed in the Zoo, and it was here that his imagination came chiefly into play. His works are full of such bits of naturalistic observation as the cruel twisting of the feline's tail as it crushes or devours. With the forms of beasts he sometimes

introduced human beings, but he tended to consider them
only as members of the animal kingdom. The bodies
are of a sturdy, almost brutish type in his most preten-
tious undertaking with the human form, the four groups,
in stone, of War, Peace, Force, and Order, for one of
the inner faces of the Carrousel courtyard of the Louvre,
repetitions of which have been set up in Mount Vernon
Square, Baltimore. The other innovation for which Barye

FIG. 250—BARYE. JAGUAR DEVOURING HARE. LOUVRE, PARIS. (PHOTO.
ALINARI)

was important was the broad treatment which is a form of
sculptural impressionism. He began with the old, precise
technique of realism, but he gradually developed the other
method, suppressing small details, as of the mane or skin,
and emphasizing only the great planes and masses, as of the
limbs and major muscles. A comparison of two groups in
the Louvre, the early Tiger and the Gavial and the late
Jaguar and the Hare (Fig. 250), will show the difference.
Another interesting factor in his technique was the lively

sense of color and the craftsman's skill exhibited in patinas for his bronzes, including great varieties of greens and browns and sometimes even red and frosted silver.

The Conservatives

Pradier. The most characteristic works of James Pradier (1790-1852), the champion of the academic coterie, were mythological or allegorical. He treated them in such a way as not to shock the *bourgeois* taste of Louis Philippe's reign by novelties or passages of genius, and on the other hand he never disturbed his patrons by falling technically below the level of respectable mediocrity. In his numerous feminine nudes, as in the Psyche of the Louvre, he ventured just enough of the fleshly as not to hurt the prudishness and yet to appeal to the sensuality that lay hidden beneath the smugness of the French middle class. Although his style at times becomes ponderous, his smoothness and his somewhat dignified grace may even please modern students in their less energetic moods. His best monumental achievements include the figures of Lille and Strassburg in the Place de la Concorde, Paris, and the four Victories with sinuous draperies in the spandrels of the Arc de l'Étoile.

B. THE PROGRESSIVE SCULPTORS OF THE SECOND EMPIRE

Carpeaux. The master who chronologically and spiritually belonged most thoroughly to the Second Empire was Jean Baptiste Carpeaux of Valenciennes (1827-1875). Two early works done at Rome and now in the Louvre reveal the most significant influences that helped throughout his life to mould his personality as an artist. The Neapolitan Fisher Boy listening to a sound in a shell is derived from the prototype. of Rude, but its proportions and contortion already bear witness to his fervid admiration for Michael Angelo. The realistic bronze group of the Death of Ugolino and his Sons, a subject taken from the thirty-third canto of Dante's *Inferno*, exhibits everywhere the dependence upon the great Florentine, even in the fact that it is an attempt to translate the contortions of the Laocoön group into a modern theme. Car-

peaux expressed himself most characteristically and en-
duringly in the crouching Flora and rollicking *putti* for the
Pavillon de Flore (Fig. 251) and in the group of the Dance
on the right of the entrance to the Opéra at Paris. It was
in these productions that he incorporated with the greatest
abandon the license and feverish thirst for pleasure of the
Second Empire. The Flemish blood that he derived from
Valenciennes perhaps contributed to his creation of buxom,

FIG. 251—CARPEAUX. DECORATION OF THE PAVILLON DE FLORE, LOUVRE,
PARIS. (PHOTO. GIRAUDON)

frankly carnal, and agitated feminine forms which shocked
even his contemporaries and constitute a violent break with
academic tradition. The faces are animate with expression,
and the glance is almost painful in its intensity. Often he so
gives the impression of momentary activity that his works
seem like improvisations. All these qualities show Carpeaux
to have been influenced by the baroque; the centrifugal ef-
fects of hair, drapery, and accessories, the intricate composi-
tion, and the cult of the sensual are even reminiscent of the

rococo. He also stood in the vanguard of those who intro-
duced pictorial impressionism into sculpture, and he was
largely responsible for the fashion of breaking up the surfaces
with bosses and cavities for the sake of chiaroscuro. In the
same nervous, alert, and sketchy style are his vividly char-
acterized portraits, again strongly influenced by the rococo,
especially in the loose sweeps of drapery. Masterful speci-
mens are the Princess Mathilda and the Mlle. Fiocre of the
Louvre and the Admiral Tréhouart at Versailles.

Frémiet. Emmanuel Frémiet (1824-1910), a nephew and
pupil of Rude, although he did his best work after the fall
of Napoleon III, may be assigned to the Second Empire be-
cause he came into prominence in this period and was inti-
mately connected with its activities. Until the establish-
ment of the Second Empire he was chiefly a sculptor of ani-
mals, and continued to work in this phase of art, rivalling
Barye in naturalistic skill. His most familiar achievement
as an *animalier* is perhaps the young Pan playing with cub
bears in the Luxembourg. Despite his productiveness in these
themes and despite his success in standing figures of con-
temporaries and of ideal personages, Frémiet will be chiefly
remembered as the creator of a long series of superb eques-
trian statues drawn from the history of earlier centuries, in-
cluding such masterpieces as the Jeanne d'Arc of the Place
de Rivoli, Paris,[1] the Lantern-carrier of the Hôtel de Ville,
Paris, the Du Guesclin at Dinan, and the Colonel Howard in
Mount Vernon Square, Baltimore (Fig. 252). It was no doubt
partially the Romantic movement in his youth that caused
him to devote himself to this successful evocation of the
past; and it was the prevalent enthusiasm for the Quattro-
cento that led him to adopt a precise realism especially in
archæological details of costume and trappings of the horses,
which he sought to make scrupulously correct. The classicist
would certainly blame the multiplication of accessories and
the effect of "fussiness" thus created; but here again Frémiet
aimed at the decorative effects of the Renaissance. He also

[1] One of the replicas is in Fairmount Park, Philadelphia.

infused his men and horses with the pride and strength that emanate from the portraits of the Quattrocento. The various kinds of horses, all exhibiting an expert knowledge of equine anatomy, play important rôles in the characterization, and are among the very greatest in the history of art.

FIG. 252—FRÉMIET. COLONEL HOWARD. BALTIMORE. (COURTESY OF PEABODY INSTITUTE, BALTIMORE)

C. THE THIRD REPUBLIC.
THE ELDER GENERATION

THE PROGRESSIVES

Dalou. The man who most thoroughly embodied the propensities of the earlier Third Republic was Jules Dalou (1838-1902). After the Commune of 1871 he had to escape to London, and it was here that he first asserted one of the cardinal features of his style and of modern art, a pronounced naturalism. The most significant products of his eight years' sojourn in England were a series of statues and statuettes of women engaged in some domestic activity, which may be illustrated, in this country, by the seated mother soothing a baby in the Metropolitan Museum. On his return to Paris in 1879 he led the way in the resuscitation of the baroque. His admiration for Rubens induced him not only to arrange his figures in compositions that are sometimes confused in their manifest effort after the pictorial, but also to cultivate anatomical realism and feeling for the quality of flesh. The first and most renowned achievement of this kind was the monument called the Triumph of the Republic in the Place de la Nation. The allegory of the French ideal of Fraternity, in the Petit Palais, Paris, in that it is a relief and is framed

like a painting, seems all the more a translation of one of
Rubens's pictures. The bronze group of Silenus accompanied
by other Bacchanalian figures, in the Luxembourg Gardens
(Fig. 253), is an even more pronounced reversion to the
Flemish master both in theme and execution. Dalou was
one of the first, if not the first, to construct memorials to
famous men of the type in which the effigy is surrounded,

FIG. 253—DALOU. SILENUS. LUXEMBOURG GARDENS, PARIS. (PHOTO.
BULLOZ)

usually at a lower level, by large related allegorical or histori-
cal figures, often too loosely associated with the artistic com-
position. Among the best examples is the Alphand monu-
ment in the Avenue du Bois de Boulogne, Paris; but in the
memorial to the painter Delacroix in the Luxembourg Gar-
dens, the allegorical figures are arranged in a composition
that outdoes the baroque in an altogether unjustified violence

of movement and difficulty of equilibrium, and the idea of
Time lifting Fame to offer a palm to the artist, while Apollo
applauds beneath, approximates a bathos of conception that
Dalou did not always succeed in avoiding. The most modern
phase of his interest had always been the peasant and the
workman, and, a socialist in politics, he had introduced
laborers into his monuments wherever it had been possible.
In his last years he returned to his predilection with re-
newed ardor, doubtless encouraged by the example of
Meunier. Forsaking the pompousness of allegory and reviv-
ing the unaffected naturalism of his English period, he exe-
cuted various sketches
and left many clay mod-
els of figures of workmen,
now in the Petit Palais,
for a great monument to
Labor, but he died before
the magnanimous scheme
was realized.

Falguière. Alexandre
Falguière (1831-1900),
the oldest of a Parisian
coterie of sculptors from
Toulouse, takes a distinct
position in the evolution
of French art chiefly
through his feminine
nudes, which usher in the
modern sensual treatment
of the undraped human
figure and the modern de-
votion to the physical
form as an æsthetic end
in itself. Going farther
along the same natural-

FIG. 254—FALGUIÈRE. THE WOMAN WITH
THE PEACOCK. MUSEUM, TOULOUSE.
(FROM "ALEXANDRE FALGUIÈRE" BY LÉ-
ONCE BÉNÉDITE)

istic road as Dalou, he modelled carnal types of nude women
with a literalness that to some may be shocking and was cer-
tainly prior to this date unparalleled (Fig. 254). His other

works were principally portrait statues and monuments. The former, such as the Corneille of the Théâtre Français, are vigorous pieces of characterization, obtained, as is the case with Rude, partly through telling postures and gestures which are unexpectedly restrained when we remember his passion for movement. He was generally incapable of any good imaginative compositions on a large scale, and, when his monuments consist of assemblies of figures, they are likely to err on the side of theatricality. One of the least objectionable (in collaboration with Mercié) is the memorial to Lafayette in Lafayette Square, Washington.

Mercié. Falguière's favorite pupil, Antonin Mercié (1845-1916), really belongs to the later generation but may be considered here since he was a member of the Toulousan group. His works have greater absolute worth than his master's, but he was less of a roadbreaker. He first won recognition with a frank imitation of the Quattrocento, the bronze David of the Luxembourg, consciously based upon Donatello's prototype. The memorial to Gounod in the Parc Monceau, Paris, is typical of his monuments of celebrities, which are very much in the manner of Falguière's, and neither better nor worse, except that what poetic material there is, however melodramatic, is more sincerely felt. His portrait figures, such as the equestrian Lee at Richmond, Virginia, do not generally seize upon one with the compelling force of Falguière in similar themes. His claim upon the attention of posterity rests rather upon two patriotic groups, in which, as so often happened in the history of French sculpture, love of country helped him to surpass his ordinary style of average excellence. These are the "Gloria Victis" of the courtyard of the Hôtel de Ville, Paris, which represents Fame carrying the dead body of a nude young soldier, and the "Quand Même" in the Place d' Armes, Belfort, which represents an episode of the siege of Belfort in 1870-1871, when an Alsatian woman seized the gun of a dying French soldier and herself assumed the defence of her country. The best that can be said of Mercié is that he rose to the height of both themes, in conception, composition, and forceful in-

spiration, exalting the poetic gift that appears in a minor degree in his other productions.

The Conservatives

Even the conservatives were now very much affected by the radical achievements of their day.

Chapu. Henri Chapu (1833-1891) penetrated the real secret of Greek beauty, and while never becoming a neoclassic copyist, he ennobled his modern forms and ideas by accommodating them to many Hellenic standards. He devoted his art especially to sepulchral monuments. He excelled in ideal feminine figures, in which realism is tempered by a study of the harmony and repose of ancient art, a restrained degree of spiritual expression is attained, and a healthy sweetness is coupled with a proper elegance. The most celebrated of the series are the sitting Jeanne d'Arc of the Louvre (Fig. 255) and the personification of Youth represented as decorating

FIG. 255—CHAPU. JEANNE D'ARC. LOUVRE, PARIS. (PHOTO. BRAUN)

the bust of Henri Regnault, on his monument in the Cour du Mûrier of the École des Beaux Arts. Chapu's poetic gifts and sense of classic beauty did not hinder him from producing finely characterized portraits in medals and such impressive portrait statues, marked by a sane realism, as the Berryer of the Palais de Justice, Paris. His popularity as a teacher and the example of his own works were cogent factors in disseminating that more reasonable imitation of

the antique which has distinguished so much European and American sculpture of the nineteenth century.

Dubois. More tangibly than any other French sculptor of the period, Paul Dubois (1829-1905) revealed the effect of the revived interest in the Renaissance, but he translated his imitations into terms of individual good taste and origi-

nality. He first attracted attention by producing, in the manner of the Quattrocento, the St. John Baptist (Fig. 256) and the Florentine Singer, both bronzes and in the Louvre. Subsequently he broadened his scope to include the Cinquecento, most notably in the tomb of General Lamoricière in the cathedral of Nantes, suggested by the sepulchres of the French Renaissance and influenced, in its allegorical personifications, by Michael Angelo. His equestrian Jeanne d'Arc in front of the cathedral of Reims, distinguished by the spirituality and delicacy that he had culled from the Italian sculpture of the fifteenth century, is less heroic and more visionary than the statue by Frémiet.

FIG. 256—PAUL DUBOIS. ST. JOHN BAPTIST. LOUVRE, PARIS. (PHOTO. BRAUN)

D. THE THIRD REPUBLIC. THE YOUNGER GENERATION

Rodin's style. The tendencies toward naturalism, pictorialism, and impressionism that had been maturing in the more advanced coteries of sculptors during the nineteenth century culminated in Auguste Rodin (1840-1917). So far as such a superlatively individualistic artist can be said

to be indebted to any predecessor, he owed most to a study of the realistic phases of late Gothic sculpture and the works of Michael Angelo and Carpeaux. His first productions are simply pieces of audacious naturalism, rendered with a supreme technical skill adequate to the difficult problems that he set himself. Chief among his early works are the youth waking to consciousness, known as the Age of Bronze, the St. John Baptist, both in the Luxembourg, and the six Burghers of Calais in the Jardin Richelieu of Calais. In these achievements, all of which are executed in bronze, impressionism had already begun, but in his second manner it was developed to a degree never dreamed of before in sculpture. He fully conformed to his oft repeated statement that sculpture should consist only of successive bosses and hollows. He so far neglected the modelling of non-significant parts and sought for the blurred outlines of impressionistic painting that he first allowed large portions of the body to remain concealed in the block of stone and later even left in the rough certain sections that emerged. This trick he doubtless learned from Michael Angelo, and, like him, he delighted in the effect of mysticism. He also loved to represent all kinds of postures and instantaneous movement, which had hitherto been believed suited only to painting, and thus, with his emphasis upon chiaroscuro, he became the chief exponent of the modern pictorial character of sculpture. The injection of movement by Rodin into a figure or group did not usually result in wild gesticulation or projection of arms and legs; rather, he preserved a closed contour and obtained his effect by the tremendous strain of muscles and nerves within the contour, creating the impression of concentrated energy. Despite his skill as a composer, the tendencies of his art, especially his pictorialism, precluded the attainment of monumentality. All of these qualities would have made of a lesser man a cultivator of form merely for form's sake, and indeed Rodin was again a protagonist of the modern attitude in ordinarily avoiding anything like the classical norms of physical loveliness. But in distinction from many of his imitators he vitalized this supreme interest in form by impressing his own powerful

individuality upon all his productions and by often making
them vehicles for ideas. These ideas, however vague and
however inferior to the noble inspirations of greater periods
in the world's history, yet have a real existence. Rodin's
creations are apt to express sexual or domestic love and the
will to power. His contortions, like those of Michael Angelo,

FIG. 257—RODIN. THE KISS. MUSÉE RODIN, PARIS. (PHOTO. BRAUN)

incorporate and even beautify sincere passion, in his case the
tragedy of modern doubts, uncertainties, and discontents, the
struggle within the modern soul.

Rodin's works. Of the more pretentious undertakings of
his second manner may be mentioned: the monument to
Victor Hugo now set up in the garden of the Palais-Royal;
the statue of Balzac in the Musée Rodin, Paris; and the
never completed doors for the entrance to the Palais des Arts

Décoratifs, known as the Gate of Hell, the conceptions of which were first derived from the Divine Comedy but were gradually extended to include a general setting forth of human sorrows and suffering. Several of the many studies that he made for the doors amidst his ever changing designs, he dissociated in the course of time and developed into separate works. Among these are: the Ugolino group

FIG. 258—RODIN. BUST OF HENRI ROCHEFORT. LUXEMBOURG, PARIS.
(PHOTO. BULLOZ)

in the Musée Rodin; the statues of the conscience-stricken Adam (bronze original in the Metropolitan) and Eve (replica in the Metropolitan); the Kiss (Fig. 257), originally intended for the Paolo and Francesca of the Fifth *Inferno;* and the Thinker, in front of the Panthéon at Paris. His other studies of form and movement in single figures and groups are well-nigh countless because, never handling the marble himself or undertaking the casting in bronze, he

needed to do only the small clay sketches and saved time by turning them over to assistants to be enlarged by a mechanical process and to be translated into more permanent material. In his portrait busts (Fig. 258) his usual technique is united to high power of characterization and to emphasis upon the noblest traits of his subjects.

Maillol. At the head of the French return to the primitive stands Aristide Maillol (b. 1861). Instead of the pictorial proclivity of Rodin, he seeks to be more truly sculptural. Instead of the violent movement of Rodin and Dalou, he strives for heavy repose, with which are combined strength, substantiality, and massiveness of form. Instead of Rodin's torturing of the surface for effects of light and shade, he models as little as possible, producing great, simple planes, but with his rugged, primitive types and dependence upon the archaic Greek, achieving results that are quite different from the smooth and elegant simplification of neoclassicism. His comparatively few works, consisting principally of the same powerful feminine physique in different poses (Fig. 259), reveal his desire to make his figures look like solid pieces of architecture.

Bartholomé. The third outstanding figure in this generation is Albert Bartholomé (b. 1848), a thorough modern in his independence of any schools, in his rejection of classic canons, and in his extreme originality of conception. The closest relative of his style is the pronounced and thoroughly unclassical naturalism of Rodin's early period. Possibly because he devoted himself wholly to painting until 1886, he has become one of the most unmistakable exponents of modern sculptural pictorialism both in composition and in modelling; but although he seeks a subtle chiaroscuro, especially in the countenance, he avoids Rodin's broken and sketchy surfaces. Like Rodin, he stands out from the crowd of Beaux-Arts sculptors by having created a physical type, particularly in feminine figures, peculiarly his own. His most celebrated work is the monument to the nameless dead at the end of the principal avenue of Père Lachaise, Paris (Fig. 260). The fundamental idea is mankind's horror of the universal phenomenon of death and the (non-Christian)

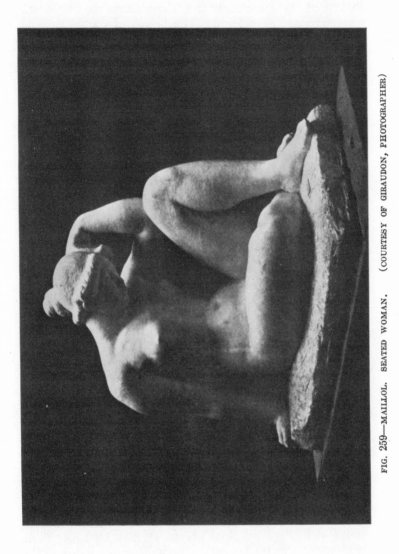

FIG. 259—MAILLOL. SEATED WOMAN. (COURTESY OF GIRAUDON, PHOTOGRAPHER.)

solution to this problem, the victory of earthly love over death and the consolation that comes from meeting death together with the beloved. The height of conception and execution here exemplified Bartholomé has never been able to attain again. In comparison, the tomb of Rousseau in the Panthéon is commonplace; the undeniable exaltation of his allegorical figure representing the Defence of Paris, in the Place du Carrousel, falls below the greatness of the theme

FIG. 260—BARTHOLOMÉ. MONUMENT TO THE DEAD. PÈRE LACHAISE, PARIS. (PHOTO. BRAUN)

and is obscured by his manifest interest in the modelling of a feminine body. Indeed, much of his recent output has consisted in feminine nudes, which, in their varying postures, look like plastic translations of paintings by Degas and the chief purpose of which is apparently the study of form.

Other French sculptors of today. The most prominent French pupil of Rodin is Émile Antoine Bourdelle (b. 1861), among whose characteristic works are the eccentrically posed Heracles in the National Gallery of Modern Art, Rome, and

the bust of Beethoven in the Luxembourg. In the reliefs for the Théâtre des Champs-Élysées, Paris, he has passed, for architectural decoration, into an even more archaistic style than that championed by Maillol. Paul Landowski (b. 1875), in adopting the frank naturalism of Bartholomé and of Rodin's first period, has turned usually for his subjects to the primitive types of humanity that appear in his Hymn to Dawn in the garden of the Petit Palais, Paris. Henri Bouchard, born the same year and Landowski's collaborator in the monument to the Reformation at Geneva, has ordinarily devoted himself, in the fashion set by Meunier, to the representation of laborers, as in the Blacksmith of the Metropolitan Museum, or to the powerful and archæological realism of Frémiet, as in the Claus Sluter of the Ducal Palace at Dijon. He applies a certain degree of impressionism to his chosen subjects but has succeeded in avoiding Rodin's spasmodic movements.

III. GERMANY AND RELATED COUNTRIES

A. THE FIRST HALF OF THE NINETEENTH CENTURY

For portraiture, German sculpture now adopted the characteristic realism of the period, but in a less vigorous and incisive form than was achieved in France. The plastic attainments of Germany during the period were summed up, at their best, by Daniel Christian Rauch of Berlin (1777-1857), who exercised a dominating influence upon the Teutonic sculptural output of the age. His most important productions are his long line of portrait statues and busts, in which he incorporated somewhat less realism than his German predecessor, Schadow, or the Frenchman whom he in so many respects resembled, David d'Angers. Although he usually confined himself to static attitudes for characterization, he employed contemporary costume; but he accommodated its lines as far as possible to classical garb, and he enhanced this effect by a very liberal use of the enveloping mantle. The most celebrated example of his portraiture, the equestrian monument of Frederick the Great at Berlin (Fig. 261), exhibits his practice of decorating his pedestals with related histor-

ical and allegorical statuettes and reliefs. In the six Victories in the Walhalla or Temple of Fame at Ratisbon, he partially transcended the ordinary style of the epoch for ideal creations. They are well individualized in different moods, such as joy for triumph or sorrow for the fallen, and they are marked not only by real Hellenic, in distinction from neo-

FIG. 261—RAUCH. MONUMENT OF FREDERICK THE GREAT. BERLIN. (PHOTO, PHOTOGRAPHISCHE GESELLSCHAFT, BERLIN)

classic, feeling, but also by an adaptation of classical precedents to a partially German and almost modern type of womanhood.

B. THE SECOND HALF OF THE NINETEENTH CENTURY

Introductory. The outstanding trait of Teutonic sculpture in the second half of the nineteenth century was a very pronounced form of the European return to the baroque. The

loud strains of the baroque, indeed, were well fitted to cele-
brate Teutonic pride in the victories of the epoch and in the
establishment of the German empire. In Germany, as in
France, there was an "opposition," here taking the form
especially of a reaction to the employment, in monuments, of
the huge, simple, and impressive, with a predominance of
architecture over sculpture.

FIG. 262—BEGAS. MONUMENT TO KAISER WILLIAM I. BERLIN

Berlin. The roadbreaker in the revival of the baroque, in
the renunciation of the dry semi-realism of the Rauch
tradition for a greater naturalism, and in the adoption of
pictorial compositions, surfaces, and draperies, was Reinhold
Begas of Berlin (1831-1911). His monument to Kaiser
William I at the west of the Royal Palace, Berlin (Fig. 262),
is a complete baroque outburst which has sacrificed the com-
pactness that Rauch and his followers managed to maintain
in composition. The fountain to the southeast of the palace

is a thorough-going imitation of Bernini's fountains at Rome. The most tangible proof of his naturalism is his treatment of the feminine nude in a series of separate figures and groups. He reproduced with moderate success the softness of the flesh and the texture of the skin, bestowing on his forms a mild sensuality; but in distinction from Dalou and other contemporary Frenchmen who were experimenting in the same plastic translation of Rubens, he represented a rather Teutonic type of womanhood, in which an abundance of fatty tissue tends to conceal the bony frame. Despite his innovations, there is a certain deadness about the style of Begas. Like the neoclassic sculptors against whom he protested, he was, after all, himself an imitator; the only essential difference was that his models were baroque rather than ancient. His portrait busts, such as that of the painter Menzel in the National Gallery, Berlin, will remain his most enduring works, since they are much livelier characterizations than his commemorative statues.

Among the sculptors at Berlin who were still educated in the Rauch tradition, Rudolf Siemering (1835-1905) may be singled out for mention because he did the huge Washington Monument at the entrance to Fairmount Park, Philadelphia. It is strange that this should be the only instance in which he exhibited to any marked degree the influence of Begas's complicated baroque conceptions for memorials.

The reaction from the baroque. The leader of the reaction from the way in which the modern baroque monuments were broken up into a number of convulsed parts was the architect Bruno Schmitz (b. 1856). He returned to architecture as the chief medium for commemorative monuments, and he gave to this architecture a colossal, massive, rough, primitive character, often derived from Romanesque precedents but marked by a bizarre modernity in detail as well as in the general structure. Sculpture ordinarily played only a subordinate rôle in the vast architectural assemblies. These gigantic piles of masonry embodied better than the baroque or any other one thing the pride of the Germans and the Hohenzollern. The most celebrated achievement of Bruno Schmitz is the monument near Leipzig commemorating

Napoleon's defeat in the Battle of the Nations (Fig. 263). The United States possesses a memorial designed by Schmitz, the huge obelisk of the Soldiers' and Sailors' Monument at Indianapolis, on which a slightly greater importance is given to the sculptural embellishment.

Munich. The guide at Munich along the new paths was perhaps Michael Wagmüller (1839-1881); but the much more

FIG. 263—INTERIOR OF LEIPZIG MONUMENT. ARCHITECT, BRUNO SCHMITZ;
SCULPTOR, FRANZ METZNER

highly individualistic production of Rudolf Maison (1854-1904) has a greater interest. He often exaggerated to the most impossible degree the piecemeal composition and pictorial proclivities of the baroque, but he broke sharply with his contemporaries' habit of depending, for their forms, on the baroque of the past, and studied his own forms directly from actuality. He thus evolved an intense naturalism, and he augmented this naturalism by an extremely veristic polychromy. His naturalism is most strikingly embodied in his statuettes of curious types of humanity; the combination of

this naturalism with a frenzied form of the baroque appears in his Teichmann fountain at Bremen (Fig. 264). This monument is marked also by that German tendency to the bizarre in conception, which, although he executed a number of works in a more rational style, is yet one of his constant traits.

FIG. 264—MAISON. TEICHMANN FOUNTAIN, BREMEN. (PHOTO. NEUE PHOTOGRAPHISCHE GESELLSCHAFT, STEGLITZ)

Austria. During the seventies and eighties of the nineteenth century, the Austrians continued to be satisfied with a style only slightly in advance of that compromise between realism and neoclassicism which they had adopted in the first half of the century. The leader in this slight advance was a foreigner, the Westphalian, Kaspar Zumbusch (1830-1915), who even developed a partial addiction to the baroque in the composition of his monuments and the postures of their subordinate figures. One of the most spirited statues

that he left behind him at Munich is the Count Rumford in the square called the Forum, a replica of which has been set up at Woburn, Mass., where Rumford was born. His principal works at Vienna are the memorials to Maria Theresa and to Beethoven in the squares of the same names.

In the last quarter of the nineteenth century a real change

FIG. 265—TILGNER. MOZART MONUMENT. VIENNA. (PHOTO. STENGEL AND CO., DRESDEN)

took place, production passed into the hands of native masters, and the general style was somewhat differentiated by an Austrian rather than a German tone. The separate character of Austrian sculpture consists in a greater lightness and gaiety, consonant with the volatile sensuality and traditional spirit of Viennese life. In accordance with these qualities, artists turned more to an imitation of the rococo than of the baroque. The chief representative of this new

phase of Austrian sculpture was Viktor Tilgner (1844-1896),
who typified his day by a general stylistic eclecticism. His
most celebrated monument, the memorial to Mozart in the
Albrechts-Platz, Vienna (Fig. 265), is absolutely and, con-
sidering the subject, properly rococo in treatment; his foun-
tains, for instance the example in front of the theatre at
Pressburg, recall the prototypes of Versailles; and his embel-
lishment of public buildings, as of the Natural History
Museum at Vienna, smacks of the eighteenth century. In
some of his decoration, however, as in that of the Hofburg-
Theater, Vienna, he successfully essayed Frémiet's specialty,
figures and busts of eminent personages of the past; and in his
sepulchres, he even tried his hand at the chastity of the
antique, introducing mourning feminine figures after the
fashion of Chapu. His many portrait busts, in which he has
caught and crystallized all aspects of contemporary Viennese
life, are brilliant characterizations, rococo in spirit and execu-
tion.

C. THE PRESENT GENERATION

Hildebrand. If one seeks for a distinctive quality in the
most recent sculpture produced in Teutonic territory and in
countries, such as Hungary and the smaller Slavic states,
which have been somewhat influenced by the modern German
æsthetic spirit, he will probably find it in an even more
tangible proclivity for the bizarre than is to be met with in
other lands. Yet the greater part of this sculpture depends
for its basic principles upon Adolf Hildebrand (1847-1921),
who was not himself betrayed into the ways of the abnormal.
The German city with which his activity was chiefly con-
nected was Munich. He owed the conception of his new
style to the German painter, Hans von Marées, who revolu-
tionized German art by representing man as the human
animal and by studying the pictorial effects of his figures in
space. Hildebrand took the same attitude towards the nude
form and thought it the only theme really worthy of repre-
sentation. Such a conception at once directed him towards
the antique. He led the way in a reaction against the turbu-

lence and subjective char-
acter of the prevalent imi-
tations of the baroque to
the repose and objective
character of Greek sculp-
ture; but, a true modern,
he went much farther than
the Greeks in his natural-
ism. By emphasizing the
bony structure and joints
of the body, by setting it
solidly upon the ground, by
occasionally choosing a
somewhat Polyclitan phys-
ical type, he laid the
foundations for the recent
sculptural tendency which
is represented in France by
Maillol. More than any
other German sculptor
hitherto considered, he fell
in with the modern cult of
form for form's sake. His
typical productions are
male nudes (Fig. 266). He
did not confine himself,
however, to static poses.
He studied the body in
many phases of activity,
but even upon these he be-
stowed ancient calm and
compositional compactness.
His works of this kind in-
clude a series of nude
youths, the comparative

FIG. 266—HILDEBRAND. YOUTHFUL
MASCULINE NUDE. NATIONAL GAL-
LERY, BERLIN. (PHOTO. DR. FR. STOEDT-
NER, BERLIN)

thinness of whose bodies affords one of the occasional proofs,
in Hildebrand's output, of a not very vital influence
of the Quattrocento. The application of his peculiar manner
to monumental undertakings may be studied in the Wittels-

bach Fountain of the Maximilians-Platz, Munich. The equestrian Bismarck at Bremen is not only an epitome of his style, but itself constitutes a prime example of the marvellous compression of force and character into a single figure or group which is perhaps Hildebrand's most memorable attainment. His portraits also inaugurated a new era in German sculpture by their direct naturalism and characterization, by their simplicity, by the objective approach from which the sculptor excludes his own interpretation, and by the study, even in such subjects, of form. Among many examples may be mentioned the bust of Böcklin in the National Gallery, Berlin, and of Otto Ludwig in the English Garden at Meiningen.

Hildebrand's circle. Hildebrand embodied his æsthetic propaganda in a book, "The Problem of Form," which has exerted a wide influence, especially in a definite school of pupils at Munich. Some of his imitators have returned to antique costume or the nude even for portraits. His most faithful follower at Munich is perhaps Hermann Hahn (b. 1868), who is rather unfairly represented in this country by the nude Goethe in Lincoln Park, Chicago. Louis Tuaillon of Berlin (1862-1917) was as much indebted directly to Hans von Marées as to Hildebrand. His most celebrated works are the mounted Amazon in the National Gallery, Berlin, one of the most praiseworthy examples of the infusion of modern naturalism into a noble antique mould, and the equestrian Kaiser Frederick near the railway station at Bremen, in which he has dared the atavism of a Roman emperor's military garb, clinging so tight as to give the effect of a nude. The Swiss, Hermann Haller (b. 1880), whether consciously affected by Hildebrand or not, bids fair to prove the most talented perpetuator of his principles; but he brings to this task a highly personal conception of physical beauty. He usually prefers rather lank bodies, the main lines of which are based upon modern naturalism but the modelling of which is partially simplified. The most prominent German sculptors who have been influenced by Maillol are Bernhard Hoetger (b. 1874) and Wilhelm Lehmbruck (1881-1919). The latter, after a beginning in the ordinary style of the

academies, aligned himself with Maillol and executed stocky feminine nudes of the kind represented by his statue in the Museum of Duisburg; then, giving his allegiance to the general principles of Post-Impressionism rather than only to Maillol's interpretation of them, he turned, with vague reminiscences of the Romanesque and of Donatello, to the other extreme of leanness and elongation. Characteristic examples are the figures of a kneeling woman (National Gallery, Berlin) and a stepping youth. In all this he was doubtless affected by the achievements of the Belgian Minne, and he has, indeed, something of Minne's sombre outlook on life.

Klinger. At the other pole from the tendencies sponsored by Hildebrand and Maillol stands the sculpture of the painter and engraver, Max Klinger of Leipzig (1857-1920), who evolved one of the most personal styles in the annals of art. In contrast to the objective standpoint assumed by Hildebrand and his circle, Klinger's creations are intensely subjective. They are crystallizations of his own ideas, and since these ideas are peculiar, the resulting statues are to the ordinary mind forbiddingly peculiar. His later compositions, especially, tend to desperate intricacy, and defy the interpretative faculties of a normal mentality. A second difference from Hildebrand may be discerned in Klinger's addiction to the pictorial and decorative in sculpture. He often revealed, particularly in his nudes, an unexpected sense of plastic form, but his compositions, multiplication of accessories, and above all his polychromy are merely a transfer of the principles of his paintings into his sculpture. His polychromy is the most *recherché* that we have hitherto encountered. Not only did he tint his marbles, but he travelled all over Europe in search of stones of strange and delicate hues, and with combinations of these in a single work he was likely to employ also metals and here and there, for accents, as in the eyes, even precious gems. A famous instance of his extraordinary conceptions is the Beethoven of the Museum at Leipzig. The musician is represented as an Olympian Zeus, almost nude, upon a cloud-borne throne, before which cowers the eagle and upon the sides of which the

fall of man and his spiritual and carnal redemption are symbolized by reliefs of Biblical and mythological content. The intention was to suggest the fusion of paganism and Christianity that Beethoven meant to embody in a tenth symphony, as the decorative heads of children incorporate

FIG. 267—KLINGER. DRAMA. ALBERTINUM, DRESDEN. (PHOTO. E. A. SEEMANN)

the scherzos. His extraordinary poses may be illustrated by the Bathing Maiden of the Leipzig Museum. The employment of portraits largely as themes for his own improvisation is exemplified by the powerful bust of Liszt in the same collection. In his later works, as in the so-called Drama of the Albertinum, Dresden (Fig. 267), and the monument to Brahms in the Music Hall, Hamburg, the involved grouping of the figures and the renunciation of finish at certain points are partially due to the influence of Rodin.

Austria. The most distinguished recent sculptor whom, though he was born in Bohemia, Austria has a right to claim is Franz Metzner (1870-1919). With him the modern sacrifice of realism to æsthetic purposes took the shape of an arbitrary treatment of the human form in order to bestow upon it architectural lines and to force it into given architectural spaces. His attitude was very like that of the Romanesque sculptor, except that he exhibited greater anatomical knowledge. The glyptic and heroic qualities of his style fitted him better than any other to execute the adornment of Bruno Schmitz's architecture, for instance, the Rheingold Wine House at Berlin, and, still more important, the Leipzig Monument (cf. Fig. 263). He also designed, for his own monuments, impressive structures that recall Schmitz's achievements. In the memorial to Stelzhamer at Linz, both the head, as usually in his portraits, and even the modern costume are conventionalized into architectural lines and masses.

IV. BELGIUM

A. THE SCHOOL OF 1850

It was not until Belgium acquired her independence in 1831 that her sculptors began to grow restive under an unusually debilitated form of neoclassicism. A group of them, who attained the maturity of their powers about 1850, struggled heavily on towards truth of representation, attaining in portrait statues that average of moderate realism which was then international. Good examples at Brussels are the Count Belliard in the Rue Royale by Guillaume Geefs (1805-1883) and the group of Counts Egmont and Hoorn in the Place du Petit Sablon by Charles Auguste Fraikin (1817-1893).

B. THE LATER NINETEENTH CENTURY

Introductory. Partly because of frequent contact with France, but more largely because of the personal genius of a

few great innovators, modern Belgian sculpture has achieved greater results than were promised by the school of 1850. The most tangible quality of the new Belgian school is a fresh and emphatic manifestation of the naturalism that had always run in Flemish veins. The sculptors of the second half of the century may be divided into those who found their chief inspiration in this naturalism, and those who, though profiting by it, yet were more closely related to the group of masters in France who maintained a modernized and sensualized classicism or were influenced by the Renaissance.

The Naturalistic Group

Meunier. The naturalistic group, influenced doubtless by the achievements of the French painter Millet, preferred to find their themes in the life of the lower classes. The first few instances began to appear in the early eighties, but such subjects did not obtain a definite vogue until they were given the stamp of the authority of Constantin Meunier (1831-1905), the undisputed protagonist of modern Belgian sculpture. After a discouraging début in the old academic tradition, he forsook sculpture for painting and eventually became interested in depicting themes drawn from an observation of the intense industrial activity of Belgium. Feeling instinctively the inadequacy of painting for rendering the workman's form and perhaps stimulated by the timid beginnings of others in such subjects, he returned again in 1885 to sculpture, and by his genius justified and popularized the cult of labor as an artistic *motif* throughout the world (Fig. 268). He discerned better than any other sculptor the æsthetic values of the laborer's body, moulded, muscularized, made lithe, and hardened by toil; but he ascended far above the regions of a literal naturalism and, within certain limits, simplified and idealized the workman's form until it took on the lines of an heroic and almost classic beauty. Carrying his training as an impressionistic painter into his sculpture, he purposely modelled in a rather summary fashion, relying for characterization very much upon the general pose and

FIG. 268—MEUNIER. RETURN OF THE MINERS. (COURTESY OF MONSIEUR JACQUES-MEUNIER)

gestures. In the classes of laborers that he represented, costume was already reduced to its lowest terms, a pair of light and close-fitting trousers, occasionally accompanied by as tight a jerkin or a leathern apron, so that the muscular forms are clearly outlined underneath and can be treated as if nude. It has often been pointed out that he

stressed the burden of the workman's lot, and we are apt to forget that he never neglected to emphasize also the dignity of labor, the happiness in physical exertion, and the strength of character that results from honest toil. His most congenial medium was bronze. He began with statuettes and continued to work at times on a small scale for the rest of his life; but he conceived even these figures in a monumental mood and often developed them afterwards into large statues. Despite the high merit of his separate figures, his greatest work perhaps is to be sought in his reliefs. It was here, of course, that his modern pictorial proclivities

FIG. 269—LAMBEAUX. "LA FOLLE CHANSON." AVE. PALMERSTON, BRUSSELS. (FROM "LA SCULPTURE BELGE CONTEMPORAINE" BY EGON HESSLING)

had their fullest play, but in his backgrounds he did not indulge in deep pictorial perspective and only indicated rather than defined details. Although his preëminence is witnessed by the wide distribution of his works in Europe and America, the different phases of his production may still best be studied in the Museum of Brussels.

The circle of Meunier. The two Belgian sculptors whose

production is most analogous to that of Meunier and who have apparently been influenced by him are Pierre Braecke (b. 1859) and Guillaume Charlier (b. 1854). The former, in his representation of laborers and the downtrodden, aims at sentimental pathos rather than at æsthetic effect. The latter may have anticipated Meunier by one or two instances of the favorite Belgian themes; but since the series of his most typical productions began at about the same time that Meunier achieved his first successes, it is likely that he was led to continue in this vein by the vogue that his rival was creating for a similar repertoire. His most characteristic subjects are fisher-folk and the peasant life of Italy. He usually clothes his men and women so heavily that he misses Meunier's opportunity for introducing the interest of the nude. Although he borders almost always upon the pathetic, he is less poignant than Braecke.

Other members of the group. Naturalism of quite a different species from that championed by Meunier and his fellows is

FIG. 270—LAGAË. BUST OF LÉON LEQUIME. (FROM "LA SCULPTURE BELGE CONTEMPORAINE" BY EGON HESSLING)

embodied in the output of Jef Lambeaux (1852-1908). He set himself to the task of transferring to sculpture the art of the great painters of Antwerp in the seventeenth century, Rubens and Jordaens (Fig. 269); and he went far beyond the Frenchmen who worked in the same spirit and at times beyond Rubens and even Jordaens in the corpulency of his feminine forms, in the muscularity of his masculine forms, and in the impassioned baroque intricacy of his com-

positions. Of plain, straightforward naturalism, unadorned either by the idealizations of Meunier or the archaisms of Lambeaux, the chief exponent is Jules Lagaë (b. 1862), whose most notable contributions have been a long series of vigorously realistic and direct portrait busts (Fig. 270).

The Modern Academic Group

Paul de Vigne (1843-1901) partly owed what advance he achieved to his admiration for Rude. Charles van der Stappen (1843-1910) was more forceful and original. His nudes are more sensual, and as he grew older he accepted more of the naturalistic principles. The group of resting workmen called the Builders of Cities in the Parc du Cinquantenaire, Brussels, reveals the influence of Meunier. Thomas Vinçotte (b. 1850) has made a specialty of human or mythological figures combined with spirited horses, and in these groups he reverts more or less consciously to the style of the French seventeenth century. The best known instances are the Horse Tamer of the Avenue Louise, Brussels, and (reminiscent of Versailles) two groups of Tritons with steeds in the park of the royal castle of Ardenne. With the possible exception of Lagaë, who is more penetrating in his characterization, he is also the most distinguished portraitist that the modern Belgian school has produced. In his busts, as in the example on the memorial to De Nayer at Willebroeck, he casts aside his modern classicism and employs a degree of naturalism which, in conjunction with a frequent decorative treatment of the drapery, recalls the baroque and rococo. Victor Rousseau (b. 1865), although his modes of conception and the thoughts contained in his statues are academic, indulges in bodies that are more realistic. He has a characteristically modern enthusiasm for the nude for its own sake, and, doubtless bewitched by Rodin, he likes to bestow upon it perversely eccentric postures. As frank studies of form these works would be interesting, for he has much technical skill; but he almost spoils them by trying to make them express modern abstract ideas that are vague and futile. For instance, he creates a group of three love-sick, nude women of different

ages and dignifies it with the high-sounding title of "Sisters of Illusion" (Fig. 271). The nearest that he ever gets to sincerity in idea is unfortunately when he is sensual, and he often becomes unwholesome in a disagreeable harping upon the thought of the birth of passion in youths and maidens.

FIG. 271—VICTOR ROUSSEAU. SISTERS OF ILLUSION. MUSEUM, BRUSSELS. (FROM "LA SCULPTURE BELGE CONTEMPORAINE" BY EGON HESSLING)

Stylization in Belgium

Of the recent tendency to stylization the chief Belgian representative is George Minne (b. 1867). Although he preserves certain harshly realistic touches and although he usually works in small dimensions, he simplifies the human form into stiff, architectonic lines, he exaggerates elongation and emaciation, and he stresses the *Weltschmerz*, the general sorrow of man's lot (Fig. 272). It cannot be denied that he possesses a kind of power, but, as with Ibsen, it is the power

of the mere presentation of tragedy without the suggestion of a remedy or without imparting to his characters, like Meunier, the strength to sustain the burden. His characters are morbid mental or physical wrecks of humanity; they are not the definite personalities of Meunier's oppressed laborers

FIG. 272—MINNE. FOUNTAIN. FOLKWANG MUSEUM, HAGEN, WESTPHALIA.
(PHOTO. DEUTSCHES MUSEUM, HAGEN)

but generalized types of humanity, often nude. The spirit that breathes through his production is the dreamy sadness of his compatriot, Maeterlinck.

V. ITALY

A. THE REBELS AGAINST NEOCLASSICISM

Perhaps because foreign artists considered Italy a kind of vast studio for the absorption of inspiration from the antique,

the native sculptors did what was expected of them and clung
to neoclassicism with amazing tenacity. The first of the
malcontents is traditionally Lorenzo Bartolini (1777-1850);
but he still held largely by the neoclassic style and proved a
greater champion of naturalism as a preacher than as an
actual performer. In his group called Charity in the Pitti
Gallery, Florence, it may be possible to discern something of
that *morbidezza* in the rendering of the flesh which he is
said to have restored to sculpture, and the types of the
mother and the infant are sufficiently near to the people to
have displeased the older school. The only really striking
piece of realism in his output is the recumbent effigy of the
aged Countess Zamoyska for her tomb in S. Croce, Florence.
Although in his portraits he generally eschewed costumes of
the period in question, the heads are adequate characteriza-
tions, and occasionally, as
in the Machiavelli of the
Portico of the Uffizi, Flor-
ence, he admitted other
than Roman garb when its
romantic nature might con-
done it. What Bartolini
barely hinted was defi-
nitely achieved by Giovan-
ni Duprè (1817-1882). His
early statue of the slain
Abel, now in the Gallery
of Modern Art, Florence,
already announces his gos-
pel of a harmonious fusion
of the beautiful and the
real. The lovely Sappho
in the National Gallery of
Modern Art, Rome, reveals
a distinctly naturalistic ad-

FIG. 273—VELA. NAPOLEON. VER-
SAILLES. (PHOTO. BRAUN)

vance in the treatment of the feminine nude. It is in his re-
ligious sculpture, as in the Pietà of the Cemetery of the
Misericordia, Siena, that an appreciation of the real and a
chaste æsthetic sense manifest themselves most attractively

in just proportions; and this sculpture has the additional charm of issuing from the heart of a fervid believer. Since he had little feeling for the monumental, his public statuary, as in the case of the Cavour memorial at Turin, is less felicitous. The third stage in the advance to naturalism was represented by Vincenzo Vela (1820-1891), but in certain respects he overstepped the safety line in this quality and led many Italian sculptors after him into the pitfall of *verism*, i.e., a photographic realism. In his most characteristic works, the approximation to the actual model and the elaboration of minutiæ, especially in the costumes, have gone very far, and are accentuated, as in the seated Cavour of the Loggia dei Banchi, Genoa, by the adoption of casual poses. For nobility of imagination and for Duprè's idealism, he was apt to substitute bathos and sentimentality: the relief on the base of the monument to Donizetti in S. Maria Maggiore, Bergamo, represents seven *putti*, as symbols of musical notes, stricken with grief and breaking their lyres! The best instance of his occasional penetration beneath a labored superficial naturalism to the inner character of his subject is the seated statue of the dying Napoleon in the Museum at Versailles (Fig. 273).[1]

B. MORE RECENT ITALIAN SCULPTURE

Introductory. Modern Italian sculpture has been much impaired not only by a verism that is partly to be laid at Vela's door but also by a velleity for mere prettiness and for cluttering with sweet detail. Another influence in provoking the unfortunate tendencies has doubtless been the incredible virtuosity of the marble-workers at Carrara in an almost absolutely illusive rendering of stuffs, laces, flowers, and the like. It is, of course, these marble-workers or sculptors of an only slightly higher tone of mind who have been the chief sinners and who, commercializing their craft, have found a ready market in many parts of the world; but even the greatest Italian masters have not always kept their skirts free from the failings of Vela and from

[1] Replica in the Corcoran Gallery, Washington.

pettiness. The cemeteries of Italy are crammed with this futile statuary, appalling in its sentimentality and strewn with accessories too domestic to be included in any æsthetic

FIG. 274—GEMITO. WATER-CARRIER. ROBINSON HALL, HARVARD UNIVERSITY

system; the most notorious instance is the Campo Santo at Genoa. Naples and Turin have probably been the most significant centres of modern Italian sculpture.

Naples. The Neapolitan school is fundamentally naturalistic both in its themes, often taken from the wonderful

FIG. 275—BISTOLFI. BRIDES OF DEATH. VOCHIERI TOMB, FRASCAROLO LOMEL-LINA. (COURTESY OF MR. BISTOLFI)

popular life of the city, and in its technique, which betrays, however, no particular tendency to the veristic form assumed by naturalism in Vela and his numerous imitators. The sculpture, like the life, of Naples has more spontaneity and vivacity than depth of thought. Of several prominent masters, the most celebrated is Vincenzo Gemito (b. 1852), who has usually confined himself to bronze statues of small dimensions. He has shown his talent most characteristically in representations of the nude or semi-nude urchins of the Neapolitan streets, docks, and coast (Fig. 274) and in busts of girls of the people. He gives in these themes, as in all his sculpture, his momentary, objective impressions; but, true Neapolitan, he goes no further, not able or not caring to elevate his work into the realm of lofty imagination or thought. Like other Neapolitans and like so many other modern sculptors, he has been much influenced by painting and he seeks for effects of chiaroscuro rather than of form. Although he prefers sketchy surfaces, each of his productions is elaborated

with a charming delicacy, and the number of his works is small.

Turin. The most original and on the whole the best sculptor of Turin is Leonardo Bistolfi (b. 1859). He is renowned chiefly as the introducer of a sad and wistful symbolism into the mortuary monuments of Italy, which, even if it were false and badly done, would be better than the usual sentimental photographs in stone. But it is neither false nor badly done (Fig. 275). The dimly outlined, mystically evanescent, and fluid lines of his forms and their merging into one another give the effect of music. Always a painter working in marble and bronze, he has a passion for flowers, crowding them into his spaces with an Italian taste for pretty detail. His influence has been so great that much of the most recent Italian sculpture is hardly more than a weak imitation of his peculiar style of symbolic themes expressed in gentle female personifications, flowing and agitated lines, and *rilievo schiacciato.*

Medardo Rosso. Italy has given birth to one distinguished follower of Rodin, Medardo Rosso (b. 1858), who has developed pictorial impressionism even to a further point than his master. Actually suppressing so far as possible the bosses and indentations which were almost the only sculptural attributes retained by Rodin, he avoids all sharp contrast between planes and passes from one to the other by the gentlest transitions. He delights in blurring the outlines (taught perhaps in this instance by the French painter Carrière) so that one part of a figure may merge into another and the whole figure melt into space. His works are mere fragments—a head, a face, the front of a bust—the slight and fleeting impressions of the moment; and he prefers carrying them no further than the original wax. Well-known specimens of his style may be seen in the Gallery of Modern Art, Rome, especially the face of a laughing girl, the head of a book-maker at the races, and the hazy bust of a woman seen on a Parisian boulevard towards evening.

VI. Great Britain

A. introductory

Great Britain did not effectually shuffle off neoclassicism until the beginning of the last quarter of the nineteenth century, and then adopted the universal style of which France was the radiating centre. In this more recent sculpture, however, the British ethnic type is always unmistakable, and the agitated *tempo* of France is much retarded. The general affection for the Quattrocento that actuated European sculpture in the latter part of the nineteenth century was all the more natural to England because of the previous efforts of the Pre-Raphaelites in painting. The nearest approach to true originality may be sought in a more pronounced sympathy for the "Arts and Crafts" movement, which has run a broader and more successful course in Great Britain than elsewhere. English sculptors have not only often turned to the production of articles of the minor arts, but they introduce jewels, enamels, colored stones, and other materials into their large works and cover them with accessories of that highly elaborated ornament which is an example of the fundamentally decorative interests of this school. All such emphasis upon detail and upon polychromy is part and parcel of the pictorial tendency that had marked British sculpture even from Gothic times.

B. the break with neoclassicism

The first master to grow restless under the restrictions of neoclassicism and to approximate moderate realism in portraiture was the Irishman John Henry Foley (1818-1874), whose achievements, however, did not equal those of his continental contemporaries. Alfred Stevens (1817-1875) was an isolated phenomenon, whose very few works were apart from the customary style of this period of English sculpture. In a modern sense of beauty, in composition, and in imaginative conception, if not in realism, he had few rivals

of his own age in Europe. Largely self-taught, he remained impervious to neoclassicism and anticipated the general European return to enthusiasm for the Renaissance. While maintaining his own originality, he imitated Raphael and especially Michael Angelo and looked forward to the achievement of the French sculptor, Paul Dubois. His attainments as a sculptor can now best be studied in the crouching carya-

FIG. 276—STEVENS. CARYATIDES. DORCHESTER HOUSE, LONDON. (COURTESY OF THE TATE GALLERY)

tides of a mantelpiece in Dorchester House, London (Fig. 276), and in the mausoleum of the Duke of Wellington in St. Paul's cathedral.

C. MANIPULATORS OF THE MORE MODERN STYLE

The first lines of a new and definite sculptural communication between the island and the continent were established in the sixties by the Austrian Sir Joseph Edgar Boehm (1834-1890), whose *forte* was realistic portraiture, and in the seventies by the long exile of Dalou at London.

Brock, Wood, and Thornycroft. The most prominent
sculptor of the old school elastic enough to profit by the
novelties was Sir Thomas Brock (b. 1847). He has attained
tremendous popularity as a portraitist who will always give
satisfaction by the combination, in his busts or figures, of a
high degree of faithfulness to life with a suitable conception
and execution, and who will never shock English sensibility
by an æsthetic or imaginative extravagance. Although not

highly endowed with poetic
invention, he compensates
by a strong sense of truly
sculptural monumentality,
gained often in his portrait
statues, as in the Gladstone
of Westminster Abbey, by
enveloping them in the
robes of their office and by
a large and simple manipu-
lation of the folds. Like all
English sculptors of the
period, he has done his
stint of representations of
Queen Victoria, the most
accessible among which is
the seated effigy of the
great National Memorial in
front of Buckingham Pal-
ace, accompanied by nu-
merous allegorical figures.
Derwent Wood (b. 1871),

FIG. 277—THORNYCROFT. TEUCER. TATE
GALLERY, LONDON

who was once Brock's assistant, is shown by his statue of
the elder Pitt in the National Gallery, Washington, to be
a keener portraitist. In other words, belonging to the
younger generation, he has gradually adopted the more un-
conditioned realism of modern days. His Dancer at Bur-
lington House, London, is one of his characteristic feminine
nudes, which vie in the frankness of their naturalism with
the figures of Bartholomé and Landowski. Brock had been
preceded in the adoption of the new style by Sir W. Hamo

Thornycroft (b. 1850), who had never owed any special allegiance to the old school. He is a classicist only in the sense in which the word can be applied to such sculptors as Chapu: the mythological themes and suggestions from the antique are treated in a modern way. His Teucer in the Tate Gallery (Fig. 277), for instance, is modelled with that fresher realism and that imaginative force which distinguish his production from that of Brock. In the Mower of 1884 (Liverpool Gallery) and the Sower of 1886, he even anticipated with unexpected closeness Meunier's popularization of the semi-nude workman. The Dean Colet of St. Paul's School, London, is a good example of his staid but lifelike portraiture.

FIG. 278—WATTS. PHYSICAL ENERGY. KENSINGTON GARDENS, LONDON

Watts. The sculpture of the painter, George Frederick Watts (1817-1904), because of a pictorialism almost equal to that of Rodin, seems amazingly more modern in style than the work of even his younger English rivals. His two superb equestrian figures, the Hugh Lupus in front of Eaton Hall near Chester and the Physical Energy in Kensington Gardens, London (Fig. 278), look as if they had just ridden out of a painting, and the large planes as well as the small bosses are calculated as a mesh to entrap the light and shade. The principal attraction of his sculpture, as of his pictures, is an imaginative originality and an ability to express this originality powerfully.

Drury. The Englishman who succumbed most completely
to the influence of Dalou was Alfred Drury (b. 1859).
Many sculptors among his compatriots of the last half cen-
tury have been little more than interpreters, to their country-
men, of the Parisian cult of the nude; and Drury, though he
has distinctly more force and somewhat more originality, is
their chief representative. He has a Frenchman's ability to
turn to any subject that is ordered from him, by his facile
technique always to please his patrons, and occasionally to
approximate a masterpiece. He has affected a rather robust
type of femininity, as in the Circe of the City Art Gallery,
Leeds, and he has clung to the long sweeping expanses of
Dalou's baroque draperies thrown into a few largely con-
ceived and vigorously projecting folds. The plastic adorn-
ment of the New War Office, London, is one of many in-
stances in which he has been called upon to employ the
French style for the decoration of squares and buildings. His
portrait statues, such as the Dr. Priestley in City Square,
Leeds, and his busts are distinguished performances. The
Griselda of the Tate Gallery is one of several examples of
tender, ideal busts of young girls, the production of which he
has chosen as an avocation.

Ford. E. Onslow Ford (1852-1901) inaugurated his career
in a rather exceptional way by studying under Wagmüller
at Munich. It was here perhaps that he gained the stimulus
that caused him to conform to the general pictorial tendency
of British sculpture. At home the influence of the Arts and
Crafts movement showed itself particularly in the decora-
tion of his pedestals. Like Drury, he worked upon every
kind of commission that the conditions of the nineteenth
century provided, and in all of them he satisfies but does
not thrill the spectator. The category of commemorative
portraiture is well represented by the Queen Victoria at Man-
chester; the busts, by the General Gordon in the Abbey;
mausoleums, at Oxford, by the Jowett Memorial in Balliol
College, in the manner of the Renaissance, and by the cen-
otaph of Shelley in University College, which foreshadows
Gilbert's highly peculiar, ornate, and symbolical creations.
The Egyptian Singer and the Folly of the Tate Gallery be-

long to a series of youthful feminine nudes, his most individualistic productions, whose charm is only slightly and occasionally impaired by their too boyish anatomy.

D. THE SCULPTORS OF THE ARTS AND CRAFTS MOVEMENT

The chief sponsor of the typically English union of sculpture with the minor arts is Alfred Gilbert (b. 1854). His

FIG. 279—GILBERT. DETAIL OF TOMB OF DUKE OF CLARENCE. ST. GEORGE'S CHAPEL, WINDSOR. (COURTESY OF MR. GILBERT)

Perseus [1] is one of three statuettes of nude youths which show how he began by paying homage to the Renaissance; and he has continued to the end to feel himself a Florentine sculptor-goldsmith. He prefers bronze and in this medium expresses himself more satisfactorily. Much of his time he has gladly

[1] Replica in the Metropolitan Museum, New York.

devoted to small, figured objects belonging exclusively to the minor arts, but even in his larger monuments decoration by pure design and by statuettes is employed to such an extent as to constitute a peculiarity. The two most important instances are the memorial to Victoria at Winchester and the tomb of the Duke of Clarence in St. George's Chapel, Windsor (Fig. 279). It might be supposed that his interest in the meticulous though lovely elaboration of detail would stand in the way of any adequate conception of the whole or in the way of spiritual values; but although Gilbert's style is always more pictorial than sculptural, he possesses great powers of large, original, and even poetic imagination and a superior sensitiveness to beauty of form and line. The one deterrent to a complete enjoyment of his achievements is that, a victim of the modern passion for far-fetched symbolism, he has chosen the accessories for symbolical reasons that are rather prosaic. The reredos of St. Alban's cathedral is an instance of the manner in which his unique conceptions sometimes border on the eccentric.

FIG. 280—FRAMPTON. DAME ALICE OWEN. OWEN SCHOOL, ISLINGTON, LONDON. (COURTESY OF MR. R. F. CHOLMELEY)

The master who stands closest to Gilbert in the accommodation of sculpture to the Arts and Crafts movement is Sir George J. Frampton (b. 1860). His hobby has been polychrome sculpture, which ordinarily means with him a combination of different materials in a single figure or monument, such as ivory, marble, and bronze; and he has fre-

quently turned to themes from the Middle Ages and Renaissance, to which polychromy was chronologically suited (Fig. 280). His most beloved achievement, the Peter Pan of Kensington Gardens, stands on a pedestal that recalls Gilbert's ornate compositions. Few names in modern British sculpture are deservedly ranked so high; and yet, perhaps because he is one of the most prolific of artists, he has neither taken the time to attain such distinction in technique as Gilbert nor found the leisure necessary for the play of so poetic a fancy as that of his rival.

E. STYLIZATION IN ENGLAND

Though an American by birth, Jacob Epstein (b. 1880) is identified with the English aspects of the most recent developments in sculpture. He harks back to the primitive less often and less emphatically than Meštrović or Manship, and when he does, as in his Christ, the head of his wife, or the tomb of Oscar Wilde in Père Lachaise, it is rather Egyptian art that he has in mind. Sometimes he is even so old-fashioned (!) as to adopt the broken, highly shaded surfaces of Rodin. Usually, with no archaic models very definitely in mind, his method is little more than a simplification and overstatement in order to gain his effects. Some of his best work is a mere intensification of telling traits in portraiture.

VII. SPAIN

Introductory. During the first half of the nineteenth century, the few men who essayed the typical moderate realism of the epoch in portraiture did not rise above the level of second-rate provincials. The new and fresher style, which, as elsewhere in Europe, was evolved in the latter half of the nineteenth century, was a reflection of Parisian fashions, and except for a very occasional and factitious reversion to the polychrome statuary of the seventeenth century, native characteristics were, for Spain, strangely indistinct. It was often not the genuine French manner that the Spaniards absorbed but rather its modifications in Italy. A verism like that of Italy, indeed, has often infected Spanish mortuary art.

The modern masters. The prophet of the new style, probably through French inspiration, was Ricardo Bellver (b. 1845), whose achievements definitely signalize in Spain the transfer of allegiance from the models of antiquity to those of the Renaissance. His two great mausoleums, of the Cardinal Lastra in the cathedral of Seville and of the Cardinal Siliceo in the cathedral of Toledo are based in structure, ornament, and elegance upon sepulchral precedents of the Spanish sixteenth century. The Fallen Angel of the Park of the Buen Retiro, Madrid, and his religious works show that he very definitely cast his lot also with the general resurrection of the baroque.

Agustín Querol (1863-1909) achieved an international reputation through consciously struggling for the unusual and catering to the modern taste for extreme realism rather than through any intellectual or technical superiority to his Spanish rivals. The group of Tradition in the Museum of Modern Art, Madrid, an old woman instructing two children, is perhaps the most celebrated example of his realism. One of his most singular excursions into the field of the unusual is the whole pseudo-mystic conception of the tomb of Antonio Cánovas in the Panteón de Atocha, Madrid, which suggests the sepulchral ideas and methods of the contemporary Italian, Bistolfi.

FIG. 281—BLAY. LABORERS ON MONUMENT TO CHAVARRI. BILBAO. (FROM "ESCULTURA EN MADRID" BY E. SERRANO FATIGATI)

Miguel Blay (b. 1866) has more skill, true originality, and real life, and at the same time he belongs by his conceptions

to more recent developments in art. His "Eclosión" in the Museum of Modern Art, Madrid, embodies the typically modern concept of the unfolding of the sexual instinct. The portrait group of Señora de Iturbe and her daughter in the family's residence at Madrid is like an enlargement of some work of Troubetzkoi. But it is his predilection for figures of laborers, as on the monument to Chavarri at Bilbao (Fig. 281), that most conclusively classifies him with the *dernier cri*. He treats them with an almost photographic realism and fails to elicit from their forms the beauty that Meunier discerned. For his statue of St. Francis Solano at Santiago del Estero in the Argentine Republic, his realistic proclivities led him to revert to the national style of the seventeenth century.

FIG. 282—CLARÁ. "DIVINITY." (COURTESY OF MR. CLARÁ)

The most celebrated name of the younger generation is perhaps that of José Clará (b. 1878), a pupil of Rodin. He has adopted his master's cult of form for form's sake, but his feminine nudes make it clear that, as in the case of Landowski and Derwent Wood, it is rather the extreme naturalism of Rodin's first period that has interested him (Fig. 282). Now and then he exhibits a potent influence of Greek sculpture of the fifth century.

VIII. SCANDINAVIA

Modern Scandinavian sculpture has adhered closely to the artistic trends of the great European centres, especially Paris, but at the same time has impregnated its productions with a considerable amount of indigenous feeling. Inevitably

the first generation of sculptors after Thorvaldsen in Norway, Sweden, and Denmark did little else than attempt to repeat his achievements. The next development was the adoption of the moderate realism generally prevalent in Europe about 1850. Of the new Parisian style of the second half of the nineteenth century, the chief representative was Stephan Sinding (1846-1922), a Norwegian by birth but a Dane by citizenship. The Frenchmen who most influenced him were

Falguière and particularly Ernest Barrias (1841-1905). The critic Bigeon has pointed out that Sinding in his maturity incorporated two different interests in his works, human sorrow and the feminine nude. It is especially in the former phase that one senses the Scandinavian note. Sometimes, as in his celebrated equestrian Valkyr, in Langelinie Park, Copenhagen, he even turned to Norse mythology. His other interest does not seem to the present writer so much the feminine nude as the "problem" of sex, for he ordinarily groups a masculine with a feminine nude, and, like Victor

FIG. 283—VIGELAND. SECTION OF FOUNTAIN FOR CHRISTIANIA. (COURTESY OF THE AMERICAN SCANDINAVIAN FOUNDATION)

Rousseau and Blay, morbidly stresses the first budding of love in youth. Impressionism has been represented, in a manner resembling that of Troubetzkoi, by the Swede, Carl Milles (b. 1875), and, in a manner resembling that of Rodin, by the Norwegian, Gustav Vigeland (b. 1869). Indeed, it is perhaps not too much to say that the works of Vigeland's first

period, such as the many amorous groups, the bronze relief of Hell in the National Gallery at Christiania, and the monument to the mathematician Abel in the same city, reveal him as the most faithful and at the same time the most gifted of Rodin's followers. The cult of eccentric posture, the slimness and litheness of form, the pictorialism, the extreme naturalism in the nude and in gripping portraiture, the passionate intensity, the modern eroticism,—all these qualities are manipulated by the Norwegian disciple with almost as great distinction as by the French master; and yet a certain ruggedness, an individuality of type, a northern gloom of sentiment, bestow upon Vigeland's productions an indelible original and Scandinavian character. In parts, however, of his most recent commission, the fountain for the space in front of the royal palace at Christiania (which, when completed, will constitute, with its scores of groups and

FIG. 284—TROUBETZKOI. TOLSTOI. DETROIT INSTITUTE OF ARTS. (COURTESY OF DETROIT INSTITUTE OF ARTS)

figures, one of the most colossal sculptural enterprises of modern times), he has partially forsaken the manner of Rodin, and, while always retaining his originality, has adopted something of the primitive simplifications and solidity of Maillol or even Archipenko. In the delightful bronze forms in the midst of the sculptured trees and in their attitudes (Fig. 283), the influence of Rodin is still evident, and the more sculptural style properly shows itself especially in the more ponderous stone of the outermost groups on the monument.

IX. Russia

The more modern phase of European sculpture has been exemplified by a Russian of great distinction, Prince Paul Troubetzkoi (b. 1866). A thorough cosmopolitan, he was born and trained in Italy and has resided at Moscow and Paris. He adopts a mild form of Rodin's pictorial impressionism, and carries to an extreme the tendency to preserve in the finished bronze the rough texture of the clay model. He stands at the head of the whole group of sculptors in various countries whose most characteristic works are small sketches recording momentary impressions of persons and things. In his attitude towards art he has been very much influenced by Tolstoi; in its practice he has revealed high gifts of keen observation, vividness, force of expression, and crispness of style. Among his statuettes of various themes, it is perhaps his portraits (Fig. 284) that have won most applause.

X. Jugoslavia

The Jugoslav representative of stylization is Ivan Meštrović (b. 1883). He has taken his stand with the group who have sought to make the technical knowledge and content of modern art conform to the mould of archaic Greek sculpture (Fig. 285). Like Maillol he aims at glyptic bulk, and like Manship, at decorative composition; yet, the chief intention of his simplifications and conventionalizations often seems to be primitive brute force. The contemporary whom he most suggests is his teacher, Metzner, especially in the bestowal of architectural lines upon the body; but the latter's models are rather Romanesque, whereas those of Meštrović are Hellenic. He has gained the reputation of an exponent of an essentially Jugoslav æsthetic tendency. His themes are often a glorification of Jugoslav history, such as the sculptures for his projected temple to commemorate the Battle of Kossovo; but there is nothing distinctive in the forms or methods to label them as Jugoslav, unless Meštrović would have us believe that the fierceness of his style reflects a

Jugoslav barbarism. His portraits, such as the Rodin, he
hacks more or less into the same rugged, formal designs.
His numerous religious sculptures, often in wood, are in-
tensified modernizations of Byzantine prototypes in the same
way as his secular figures are adaptations from the ancient
Greek. Although, in his whole production, like the others

FIG. 285—MEŠTROVIĆ. THE MAIDEN OF KOSSOVO. (COURTESY OF MR.
MEŠTROVIĆ)

who have resurrected the primitive, he exaggerates the
idiosyncrasies of his models, he succeeds as well as, if not
better than, any of his rivals in the coveted decorative and
emotional effects, and undeniably realizes his purpose of
rude power.

XI. The United States

A. THE TRANSITION FROM NEOCLASSICISM TO MODERNISM

1. Introductory

Until about the time of the Centennial of 1876, American sculptural aspirants did not cease to get their training, especially for ideal themes, from the tradition of Canova and Thorvaldsen in Italy. More and more, however, the progressive masters and to a lesser extent the conservatives began to rely upon their own inspiration, particularly for portraits, and they approximated the moderate realism generally characteristic of European sculpture in the first half of the nineteenth century. The peculiar nature and costume of the celebrities whom they were called upon to portray was already forming something like a separate American tradition in sculpture. The passions of the Civil War gave rise to themes more truly felt and essentially national than the mythological or related artificialities of neoclassicism. A distinctive type of Soldiers' and Sailors' monument was evolved, apparently without French influence, consisting of a lofty and massive base crowned by some such allegorical figure as Victory or Liberty and with other allegorical personifications and statues of soldiers and sailors ranged at lower levels.

2. The Progressives

The early neoclassic pieces of Henry Kirke Brown of New York (1814-1886) gave but little promise of his really interesting work as a conscientious portraitist. His standing portraits, such as the Lincoln in Union Square, New York, are less important than his equestrian figures, among which the Washington of the same square is an almost inspired conception (Fig. 286). Thomas Ball of Boston (1819-1911), in his portraits, manifested less feeling than Brown for that vague thing which we call "style." It is curious that his masterpiece, also, should have been an equestrian figure, the Washington of the Public Garden, Boston. In representing

personages of less remote times, like Brown in his Lincoln, Ball sought to offset the prose of modern costume by the poetic mantle. Rather unexpectedly, he revealed in gentle, idealistic productions something of that imagination which he seems partially to lack in his standing portraits. The group of the Genius of Death unveiling the personification

of Faith for the Chickering monument in Mount Auburn Cemetery, Cambridge, is an expression of a mild, Victorian fancy that is not unpleasant. His pupil, Martin Milmore (1844-1883), was a sculptor of less renown but greater gifts. Cut off in the flower of his promise, he has never received his due meed of honor as an artist who, with little to guide him but his own instinct, forestalled the æsthetic developments of the subsequent generation. It is true that he is

generally given the credit of having established the vogue of the typical Soldiers' and Sailors' monument by the success of the specimen that he erected in the Boston Common in 1874. But he makes greater demands upon our recognition than this. He anticipated Saint-Gaudens in at least two respects. In what to others were arid themes, commemorative statues of northern soldiers and sailors, he partially broke through the customary hard style of the period by his feeling for surfaces and by extracting a certain beauty

even from the forbidding costume of coat and trousers; and he had a sense of grave poetry that is well illustrated by the angel of the Coppenhagen monument in Mount Auburn (Fig. 287). The greater impress of the artist's personality that appears in the production of Ball and Milmore as compared with the ordinary neoclassic output is found likewise in the work of Erastus D. Palmer of Albany (1817-1904), above all in his Angel at the Sepulchre in Albany Cemetery. The White Captive of the Metropolitan Museum exhibits also his other contribution to the development of American sculpture, a more truthful and warmer treatment of the feminine nude.

FIG. 287—MILMORE. COPPENHAGEN MONUMENT. MOUNT AUBURN CEMETERY, CAMBRIDGE, MASS.

Ward. John Quincy Adams Ward (1830-1910) was somewhat affected by the advance of American sculpture subsequent to the Centennial, particularly in a very occasional and slight predilection for pictorial surfaces; but, broadly speaking, his art belongs to the earlier, transitional period, of which it is usually deemed the best product. A pupil of

Brown for seven years, he was wholly trained in this country, and rightly boasted that his art was essentially American. He scouted altogether the mythologies of neoclassicism, and his few idealistic subjects, such as the Indian Hunter of Central Park, New York, are inspired by our own history and culture. If we may arrogate to ourselves a sturdier manliness than other nations, then Ward was American in

FIG. 288—WARD. WASHINGTON. SUB-TREASURY, NEW YORK. (PHOTO. BOGART)

his strong masculinity. He consistently avoided the adventitious, the pretty, and the affected; he sought a general monumentality rather than delicacy of execution; he was satisfied with the great simple lines of quiet postures and gestures. He may be studied at his best in the Garfield memorial at Washington, in the Beecher monument at Brooklyn, and in the Washington on the steps of the Sub-Treasury,

New York (Fig. 288), perhaps the noblest setting forth of this frequent American theme.

Rimmer. In the judgment of certain critics, William Rimmer of Boston (1816-1879) more than disputes Ward's preëminence in the transitional period. This opinion deserves consideration if for no other reason than because it has

FIG. 289—RIMMER. FALLING GLADIATOR. MUSEUM OF FINE ARTS, BOSTON.

recently been championed by one of our greatest living sculptors, Gutzon Borglum, who has sought to rescue him from oblivion by the most unqualified superlatives of praise. Self-trained, an eccentric of enigmatic ancestry, the creator of but a few pieces of sculpture, painter, lecturer on artistic anatomy, and physician as well, he certainly stood quite apart from the plastic tradition of his time. Like Milmore, he anticipated later artistic developments. B o r g l u m has compared him to Rodin at Rodin's best; and whether or not we accept this dictum in regard to a man who produced so little and in whom sheer genius cannot quite hide the shortcomings of defective training and environment, it must be acknowledged that his work presents many analogies to the French master's achievement. His Falling Gladiator (Fig. 289) and Dying Centaur in the Boston Museum and especially his many drawings reveal the same interest in form in curious postures for form's sake, and he also was able to maintain, as particularly in the Fighting Lions of the Boston Art Club, a wonderful concentration of composition. Even

so phenomenally youthful a work as the figure of Despair in the Boston Museum, a strangely direct ancestor of Rodin's Thinker, shows that his naturalism prophesied the twentieth century: it was thought that the Gladiator, like Rodin's Age of Bronze, was merely a cast from a living model. But he was able to pour into his creations a spiritual content, often bespeaking, as in the case of Rodin, an inner strife of his own emotions. With Rimmer it was the struggle for existence, the many disappointments at lack of appreciation and of opportunity for the development of his gifts, the hopeless effort of a great nature to express itself in a cramped atmosphere. The head of St. Stephen in the Boston Museum is the most astounding example of his embodiment of anguish. His power of expression is extraordinary even in other fields: not even Barye has attained the fierceness of his Fighting Lions. The statue of Alexander Hamilton on Commonwealth Avenue, Boston, is a typical instance of the way in which, like Max Klinger, he always made his productions crystallizations of his own unusual ideas and conceived each commission in an absolutely individual manner.

3. The Italianates

The conservative sculptors of the transitional period do not vary much, one from the other, in their manipulation of the neoclassic style. William Wetmore Story (1819-1895) was clever enough to choose from the classical repertoire a vein that appealed to Victorian taste, sorrowing females of the kind represented by his Cleopatra and Medea of the Metropolitan Museum. In his portrait statues, which inevitably lack the strength of Brown, Ball, and Ward, he had a predilection for men whom he could drape in flowing gowns, such as the statue of his father, Chief Justice Story, in the vestibule of the Mount Auburn Chapel. Randolph Rogers (1825-1892) tried his hand with tolerable results at the several kinds of sculpture popular at the time, but all his many productions suffer from a blight of dullness. Yet he has a place in American annals as the author of the bronze

doors for the Rotunda of the Capitol, Washington. If, in distinction from Crawford, he had not been so unwise as to provoke by imitation a comparison with Ghiberti, the absence of any highly developed artistic quality might be condoned and the doors accepted for their clearly told stories and for the romantic characters embodied in the statuettes; but even as it is and even from the purely æsthetic standpoint, they are better than the ordinary critic will admit. William H. Rinehart of Maryland (1825-1874) is not only superior to the others of his coterie in every technical aspect, but he shows more refinement and warmth in the use of the human body as a vehicle of plastic expression. In the Clytie (Fig. 290), a feminine nude, the naturalism just falls short of the more modern treatment by Palmer.

FIG. 290—RINEHART. CLYTIE. PEA-BODY INSTITUTE, BALTIMORE. (COURTESY OF THE PEABODY INSTITUTE)

B. THE MODERN PERIOD

1. General Characteristics

Lorado Taft has demonstrated that about the time of the Centennial of 1876 the whole nature of sculpture in the United States was changed. America was drawn into the surge of the more modern style that had already gained force in France and Germany and was then spreading to the other

countries of Europe. Turning from Italy to France, virtually all of our sculptors now obtained their training largely or partly in Paris. Some of them used the Parisian elements as contributory material out of which to build an essentially American school; others, while tinging their borrowings with some degree of Americanism, imitated more closely the styles of France. What they acquired in particular was not only a much greater technical facility than the old school but also a predilection for the broken surfaces of the new pictorial style. It does not seem likely that the rather meagre exhibit of foreign sculpture in the new style at the Centennial could have had much to do with stimulating the desire for emulation. Certain of our sculptors, such as Warner and Saint-Gaudens, had already inaugurated the practice of studying at Paris, and perhaps the whole modern sculptural movement in America should be largely ascribed to the precedent of their initiative. The last quarter of the nineteenth century, moreover, witnessed, in this country, a general elevation of culture and taste. Another reason for the development of an indigenous movement was the higher sense of nationality that resulted from the reassertion of unity after the Civil War. The most distinctive qualities of American sculpture are its moderation and seriousness of purpose. Little patronage has been afforded to ideal sculpture as an end in itself, that is, ideal sculpture not designed for decoration of monuments, except in the case of "exposition sculpture"; and even the greater part of this has been done by foreign craftsmen. Now and again there crops out in American sculpture that sentimentality which Europeans, with their false conceptions of our materialism, will never believe lies at the foundation of the American character. Not only the portraits but also the ideal figures reflect the national ethnic type, which unhappily lacks the clean-cut definiteness of feature that is the heritage of purer races. One of the peculiar virtues of our native school, largely due to the great influence of Saint-Gaudens, has been a stronger tendency than elsewhere to construct emphasized architectural settings, especially exedras, for commemorative figures.

2. The First Generation

The More American Group

Warner. Olin Levi Warner (1844-1896) may be assigned
to the more American group because his imaginative figures
as well as his portraits already conform to our ethnic type,
and he may be considered first because, although he studied
at Paris at the same time as Saint-Gaudens, he was four
years his senior. Even from the standpoint of absolute
æsthetic merit, were it not for Saint-Gaudens, one would be
hard put to it to discover another who more justly deserves
the place of honor. Without descending to neoclassic
plagiarism, he exemplified both the feeling for physical beauty
and the moderation of antiquity, retaining vague reminis-
cences of Hellenic loveliness of line and form. He modelled
with conscientious exactitude, but he never sacrificed a proper
sculptural monumentality to realistic detail. His portraits,
such as the Garrison on Commonwealth Avenue, Boston, al-
though vivid embodiments of individualities, are never lack-
ing in a Greek emphasis upon the beauty of spiritual char-
acteristics. His art has been compared to that of his French
contemporary, Chapu, and it is possible that the pose of his
best feminine nude, the Diana, was suggested by Chapu's
Jeanne d'Arc. Studying when he did at Paris, he was bound
to be somewhat influenced also by the Renaissance. His
most precious legacy from the fifteenth century was the art
of delicate bas-relief, which he vied with Saint-Gaudens in
recovering for the United States. The various aspects of
his achievement are perhaps most readily appreciated in his
bronze doors for the Congressional Library, symbolizing the
idea of Tradition (Fig. 291).

Saint-Gaudens. The most generally representative and, on
the whole, the greatest American sculptor was Augustus
Saint-Gaudens (1848-1907). Born at Dublin, Ireland, of a
French father and an Irish mother, he was brought by his
family as an infant to New York. His period of study
abroad, at Paris and in Italy, extended from the years 1867
to 1875. In coming from French art to Saint-Gaudens, per-

FIG. 291—WARNER. BRONZE DOORS. CONGRESSIONAL LIBRARY, WASHING-
TON. (PHOTO. L. C. HANDY)

503

haps the thing that strikes one as most American is his
sobriety. Even those figures which are represented in move-
ment, such as the Deacon Chapin at Springfield, Mass., and
the equestrian Sherman on Fifth Avenue, New York, have
what we like to think is an American staidness. This
sobriety, however, does not mean either that his modelling
is dry or that his figures are dead. He possessed the incom-
parable gift of pouring such life into his most static figures
that even the best of what had gone before in American sculp-
ture seems torpid by contrast. Not only are his portraits
among the most gripping characterizations of modern times,
but the poise which is among his most precious American
traits enabled him to soften their realism by evoking from
the subject as much sedate poetry as possible and by de-
veloping still further Ward's ability to make the subject
representative of an epoch or movement. The poetry of his
nature emerges more clearly in his idealistic figures, which
are discreetly adapted to the American conception of feminine
beauty—gravely sweet poetry in the Amor Caritas of the
Luxembourg, more serious and solemn in the mysterious
brooding and mourning woman leaning against the monument
of Mrs. Henry Adams in Rock Creek Cemetery, Washington.
Although his temperance kept him, like Warner, from the
audacious chiaroscuro of Carpeaux, his modelling is mildly
pictorial. It is particularly in low relief that he inclines to a
moderate impressionism, elaborating only the significant lines
and planes and merely indicating the others broadly. Per-
haps we may claim, without conceit, that his hostility to any
meretricious appeals is American. Above all, in his long
series of great portraits of our fellow-countrymen, he brought
vividly forth what are traditionally the highest American
characteristics—a simple nobility and hardihood, the rough
naturalness that belongs to a young nation, the curious
fusion of reticence and frankness. The apotheosis of this new
type of manhood that Saint-Gaudens introduced into the art
of the world is the standing Lincoln of Lincoln Park, Chicago
(Fig. 292).

He was so much of an innovator that he might almost be
said to have created modern American sculpture. He col-

FIG. 292—SAINT-GAUDENS. LINCOLN. LINCOLN PARK, CHICAGO. (COUR-
TESY OF MR. J. H. POWERS)

505

laborated with the architect Stanford White in evolving a
new kind of base, an exedra from the centre of which rises
the statue; the earliest example is the Farragut of Madison
Square, New York. In such works as the memorials to Bel-
lows in All Souls Unitarian Church, New York, and to
Stevenson in the cathedral of Edinburgh, he popularized an-
other type of monument in which the effigy appears in high
or low relief against a background decorated with ornamental
detail, especially lettering. This type is only an outgrowth
of his use, in portraiture, of bronze or marble plaques instead
of the traditional busts. He was original in his fundamental
conceptions; the most notable important example is the great
monument to Colonel Shaw, Boston, in which the commander
of the first colored Massachusetts regiment of the Civil War
is shown riding beside his marching troops, presided over by
a floating feminine personification, who, pointing onward,
carries the poppies of death and the laurel for victory after
death.

French. Daniel Chester French (b. 1850) is much more
American than Saint-Gaudens. For this first period he had
no other training than a month with Ward at Brooklyn, the
excellent lectures on artistic anatomy by Rimmer at Boston,
and later a year at Florence under Ball. The works of this
period, such as the John Harvard in front of University Hall,
Cambridge, are respectable examples of the "dry" manner of
the progressive group in the transitional stage of American
sculpture. He did not adopt the more modern style of the
Parisian ateliers until his journey to Paris in the later
eighties, from which date begins the series of his most char-
acteristic creations. The achievement of no other sculptor
is harder to evaluate. He has produced a series of works
which indubitably deserve the adjective "great" and in which
an enviable technical ability is equalled by large powers of
poetic and spiritual expression. He is always, indeed, a pre-
eminent and facile craftsman, and, as in the Memory of the
Metropolitan Museum, a past master of the human form,
especially the feminine nude. In the list of his best works,
the following should be accorded a prominent place: the
monument of John Boyle O'Reilly in the Back Bay Fens,

FIG. 293—FRENCH. MELVIN MONUMENT. SLEEPY HOLLOW CEMETERY, CONCORD, MASS. (PHOTO. BOGART)

507

Boston; the Death and the Sculptor as a memorial to Martin Milmore in Forest Hills Cemetery near Boston; the Melvin monument in Sleepy Hollow Cemetery, Concord, Mass. (where he resorted to his favorite and impressive device of sinking the symbolic figure in the stele) (Fig. 293); the allegorical personifications of the bronze doors of the Boston Public Library; and the standing Lincoln at Lincoln City, Nebraska, which only suffers by comparison with the standing effigy by Saint-Gaudens. There are, however, too large a number of other works which tend towards the commonplace and are likely to detract from the high esteem accruing to him from the series of more creditable productions. Their faults are due to two interlinked causes, an excessive Americanism and a tremendous fecundity, which, resulting from the popular appeal of his Americanism, has often caused him to drop to the level of what, were it not for the distinguished quality of the execution, would be little better than hackwork. The penalty of the American virtue of sobriety is the possibility of lapsing into dullness, and in his conceptions French has not infrequently fallen victim to this danger. Nor is he absolutely immune from our national sentimentality. He adds the youthful male figure to the American repertoire of ideal forms, but he is likely so to approximate this as well as the feminine figure to our racial type that they lose the nobility suited to imaginative and exalted themes. His many portraits for public commemoration, standing, seated, and equestrian, are not permeated by the force and vitality of Saint-Gaudens, and they, as well as his ideal figures, reproduce too closely the indefiniteness and softness of American features, occasionally becoming even vacuous. It must be. acknowledged that some of these defects are not altogether absent even from his best achievements.

Adams. Having fallen, at Paris, under the prevalent spell of the Renaissance, Herbert Adams (b. 1858) reveals a predilection for the kind of subject done by his Florentine predecessors, for their sensitive, pictorial treatment of surfaces, for their exquisite floral borders, and for polychromy. The most notable products of this imitation of the Renaissance, which is relieved by the Americanism of the types, are

a series of feminine busts. Like his portrait statues, however, they lack the Florentine power of incisive characterization. His distinctive note is an agreeable sweetness that reminds one of the "sentimental" coterie of sculptors in the Quattrocento. Among his most delightful achievements in this vein are his imitation of the Della Robbia in the tympanum for his doors of St. Bartholomew's Church, New York, and the McMillan Fountain, Washington. In the fashion of Story, he sometimes seeks majesty in his series of portrait statues, as in the Bryant on the west side of the Library, New York, by enveloping them in robes, beneath which the form is not always strongly felt.

Niehaus. Of German extraction but born in Cincinnati in 1855, Charles Henry Niehaus obtained his foreign training in the Royal Academy, Munich. There is something of German stolidity about all of his production, but especially about his ideal figures, and one misses occasionally a sufficient sense of humor. His imaginative conceptions fall rather flat. The nude Driller, on the monument at Titusville, Pennsylvania, to Edwin L. Drake, though it lacks the vibrant energy of Barnard's Hewer, is a partial exception to these strictures. Possibly owing to a period of study at Rome, he has done a series of more frankly classic subjects, though with inevitable modernizations, than any other American sculptor of the epoch. To this class belongs the Orpheus as a memorial to the author of the "Star Spangled Banner" at Fort McHenry, Baltimore, in which, as in the Drake monument, he has wisely had recourse to symbolism in place of the wearisome practice of commemoration through portrait statues. But he has also done his stint of portraits for monuments. If simplicity is really an American trait, then in these he is somewhat more American than the majority of his contemporaries. They are good though not vivid likenesses. With the partial exception of his best work of this kind, the Garfield on Race Street, Cincinnati, the simplicity is seen particularly in the postures and gestures. He has also been much in requisition as a sculptor of historical panels, in which he is likely to approximate the kind of relief, with the foremost figures almost detached, that Amadeo frequently es-

sayed. The most familiar examples are his six panels for one of the three sets of the Astor Memorial Doors of Trinity Church, New York.

Boston. The name of Bela Lyon Pratt (1867-1917) brings us to the modern sculptural output of Boston. The only reasons for placing him in the more American group are that he was called upon to commemorate so many American worthies and events and that, generally speaking, his art was soberer or, more properly, duller than the usual Gallic outbursts. His heads are usually vacuous. Among much slovenly modelling, the lank draperies often have the unfortunate appearance of loosely flung sheets. Otherwise, his long series of ideal subjects are quite French in manner. Among the most acceptable members of this series should be mentioned the Peace restraining War of the Butler Memorial at Lowell, Mass., and the medallions of the Four Seasons in the Congressional Library; among the least acceptable, the seated personifications of Science and Art in front of the Boston Library. His portraits, for which he is fond of adopting Saint-Gaudens's fashion of relief, are somewhat vitiated by a vacant stare and by the partial looseness and flabbiness which disfigure the majority of his productions. The rectors of Trinity parish, Boston, will have to take their places at the foot of this class —the statue of Phillips Brooks in front of the Boston Museum and the relief of Dr. Donald in the church itself. Gross exaggeration, however, of Pratt's shortcomings is now the vogue among artistic snobs and bluestockings. There is a certain exaltation and even spirituality about almost all of his figures, and his technique, however deficient, remains that of a master. In addition, he made important contributions to the repertoire of our national art. The Nathan Hale at Yale is one of several similar works in which he has attained much of the spirit of young American manhood. A number of bewitching studies of the adolescent feminine nude, well exemplified in the Boston and Worcester Museums, show that he was best when he was least pretentious.

Chicago. Of Lorado Taft (b. 1860), who enjoys the distinction of being in a very real sense the Vasari of American sculpture, it might be expected that his own art would be

decidedly imitative and eclectic; and it is true that now and again his work is reminiscent of those styles of his colleagues in Europe as well as in this country which he himself has so well defined. According to the fashion of the day fathered by Rodin, he likes to represent forms, as in his Solitude of the Soul in the Art Institute of Chicago, emerging from a mass of stone. His Soldiers' Monument at Oregon, Ill., with its architectural exedra, is suggestive of Daniel Chester

FIG. 294—TAFT. FOUNTAIN OF TIME. MIDWAY PLAISANCE, CHICAGO

French. His group of the blind, based upon Maeterlinck's play, very properly recalls the manner of Charlier and Bouchard. His symbolism, which is a sign of the times, may strike some critics as rather perfunctory. But perhaps he is no more subject to extraneous influences than other contemporary masters. Certain it is that he has the great credit of overcoming the handicap of his historical and educational interests and of evolving an original mode of expression. His most palpable characteristic, quite in harmony with the atmosphere of America and particularly Chicago, is a largeness

of conception. Like Barnard, he imagines huge plastic enter-
prises, most notably the new adornment of the Midway
Plaisance with sculptured bridges and vast fountains, of
which the Fountain of Time (Fig. 294) is already in place.
It has fallen to his lot to be the creator especially of gran-
diose fountains, such as the Fountain of the Great Lakes in

FIG. 295—DALLIN. SIGNAL OF PEACE. LINCOLN PARK, CHICAGO. (PHOTO.
W. H. PIERCE)

front of the Art Institute, Chicago, and the Columbus Me-
morial at Washington. Although his compositions are pro-
nounced examples of the pictorialism that developed in sculp-
ture in the nineteenth century, yet the arrangements have a
sculptural compactness, and the separate figures, however
Americanized in type, are likely to be conceived monu-
mentally.

Indian subjects. One of the best exponents of the very general American proclivity for Indian themes is Cyrus E. Dallin of Boston (b. 1861). To his connoisseurship in Indian types he often unites an expression of the inner nature of the Red Man, although he keeps well away from melodrama and false pathos and conceives his subjects with sculptural restraint. His equestrian statues (Fig. 295) are the most celebrated of his long series of Indian subjects. His success in his chosen field does not mean that he lags behind his fellows when he tries more usual themes. He is particularly felicitous, like Fré-
miet, in evocations from the past, ordi-
narily from the co-
lonial period; a re-
cently completed in-
stance is the Anne Hutchinson in front of the State House, Boston. Solon H. Borglum (1868-1922) found inspiration in the life of the cow-
boy as well as of the Indian. He caught and ennobled that ro-
manticism of the

FIG. 296—SOLON BORGLUM. ON THE BORDER OF THE WHITE MAN'S LAND. METROPOLITAN MUSEUM, NEW YORK. (PHOTO. BOGART)

western plains which affords material for so many of the scenarios of our moving pictures. His earlier groups, such as the Lassoing Wild Horses in the Cincinnati Museum, although sometimes too frantic in movement for the ordinary canons of art, are yet superb examples of craftsmanship and of expert sympathy with the subjects. Later in life he strove also for spiritual content, and he found it in the note of pathos (Fig. 296). Perhaps for the sake of enhancing pathos by a kind of mysticism, he tended to adopt, together with more compact composition, the broad impressionism of Rodin, towards which he had leaned from the first.

The Less American Group

Barnard. George Grey Barnard (b. 1863), despite his long
sojourns in France, is so independent that he is much less
closely allied with the trends of modern Gallic sculpture than
are the other members of this group. A relationship to Rodin
might seem to be postulated by certain aspects of his work,
such as the choice of primitive themes and types, the natural-
istic modelling of the nude, and the concealment of parts of
the bodies in the unhewn stone; but it may be that each
sculptor developed these analogous traits separately, and in
many other essential ways, especially in an avoidance of the
corrugation of surfaces for the sake of pictorial impressionism,
Barnard differs from his great French contemporary. In a
recent work, however, the Lincoln in Lytle Park, Cincinnati,[1]
he does, for the nonce, change his manner and adopt Rodin's
impressionism and extreme realism in portraits. The align-
ment of a large number of nudes in a serious philosophic
composition reminds one vaguely of Bartholomé, and very
occasionally, like Bartholomé, he has departed from his usual
earnestness of purpose to amuse himself, as in the Maiden-
hood of the Metropolitan Museum, with studies of the
feminine nude for their own sake. His chief formative in-
fluence, however, was Michael Angelo; and yet he is able to
maintain his originality because of the modernism of his
ideas and the modern and personal character with which he
has invested forms partially derived from the Italian proto-
types. Like the great Florentine, he has found in the nude
his chosen mode of expression, and he has forced it, even
contorted it, into a vehicle for abstract ideas. In a cele-
brated composition in the Metropolitan Museum, he repre-
sents, for instance, the conflict of the good and bad natures
within a human being. The colossal Hewer at Cairo, Illinois,
was intended as one of the constituents of a tremendous as-
semblage meant to embody the History of Humanity but
never realized. Of the groups at the entrance to the Capitol
at Harrisburg, that on the right symbolizes the Burden of
Life, that on the left the relief from the Burden in labor and

[1] Replica in Manchester, England.

brotherly love (Fig. 297). He is again like Buonarroti in his fondness for the heroic and in his planning of vast plastic projects. He is truly a sculptor, in distinction from a painter working in clay, bronze, or stone, and he himself does as much as possible of the actual execution, so that his creations tend to have the warm, personal touch of Michael Angelo.

FIG. 297—BARNARD. GROUP AT LEFT OF ENTRANCE, CAPITOL, HARRISBURG.
(PHOTO. MUSSER)

MacMonnies. A greater contrast could not exist than between Barnard and Frederick MacMonnies, who was born the same year. He is perhaps the most French among the more prominent sculptors of the earlier generation. So far as such catch-phrases have any value, he is an American Falguière, though a lighter, gayer Falguière, taking passion less seriously. His feminine nudes, the Bacchante, the Truth beside the entrance to the Library, New York, and especially the

Diana, are in the manner of Falguière, but somewhat less voluptuous. Although he does not pass into the more definite impressionism of Rodin, he carries the pictorial in technique, postures, and accessories as far as or farther than any of Rodin's predecessors. As in the work of Carpeaux, his

FIG. 298—MACMONNIES. BATTLE MONUMENT. PRINCETON. (PHOTO. ROSE AND SON)

modelling is crisp and nervous and retains the sensitiveness of the clay sketch. One must not look for any deep significance in his productions; what significance there is Caffin has well described as imaginativeness rather than imagination. A technique that can cope with any problem has enabled him to rival the modern Frenchmen among whom he was trained in the variety of subjects in which he has given

satisfaction. The Stranahan of Prospect Park Plaza, Brooklyn, is a gauge of his talent as a commemorative portraitist. Evocations from the past, such as the Nathan Hale of City Hall Park, New York, by the very nature of the romantic themes, clamored for a pictorial treatment. The Horse Tamers at the Ocean Avenue entrance to Prospect Park demonstrate his ability in intricate movement. The enormous groups symbolizing the Army and Navy on the Memorial Arch of Prospect Park Plaza and the Princeton Battle Monument (Fig. 298) constitute a curious species of sculpture of which he is peculiarly fond—masses of forms like huge carved pictures, exhibiting his skill in compactness of large and difficult compositions. His most recent works have been disappointing in their diminished sense of beauty of form and in an exaggeration of his characteristic unsculptural "fussiness" of detail. It is for these reasons, rather than for its theme, that one might perhaps wish that the protests against the Civic Virtue in City Hall Park, New York, had been efficacious.

Bartlett. Paul Wayland Bartlett (b. 1865) is as much an American Frémiet, as MacMonnies an American Falguière. He inaugurated his career with animal subjects, like the Bohemian Bear Trainer of the Metropolitan Museum, and he excels in such romantic evocations from the past as the Michael Angelo of the Rotunda of the Congressional Library and the equestrian Lafayette at Metz.

Gutzon Borglum. Solon Borglum's elder brother, Gutzon (b. 1867), is probably the most pronounced American exponent of sculptural impressionism. Exercising also the profession of painter, he has manifested this style in a treatment of the surfaces of his sculpture with chiaroscuro and in a definition only of essentials. This sketchiness sometimes creates a parallelism to Troubetzkoi, especially in his statuettes, as in the seated Ruskin of the Metropolitan Museum. He has given his allegiance to the most modern form of unsparing faithfulness to actuality, and he has Rodin's and Troubetzkoi's ability in accomplishing his purpose. The seated Lincoln at Newark reveals that for his statues on monuments, as in all his productions, he is likely to choose the most casual

pictorial postures. The symbolical group called "I Have Piped and Ye Have Not Danced" illustrates his adoption of the mannerism of submerging parts of the forms in the unhewn stone. The pictorialism of his Mares of Diomedes in the Metropolitan Museum does not shrink from a frenzy of movement that beggars Rodin; but even here, as in many other works, he clings to Rodin's closed contours. Apart from his mere studies of varied poses of the feminine form, which he tags with the characteristic modern sentimental titles, he utilizes impressionism to clothe conceptions that are often instinct with originality and power.

Philadelphia. Philadelphia has been chiefly represented in sculpture by Charles Grafly (b. 1862), who, however, since 1917 has taught also in Boston. His art has two phases. With a treatment as realistic as Falguière's and with an expert knowledge of anatomy, he has followed many modern Europeans in a devotion to the human body for its own sake; and he endows his nudes with the usual cast of vague modern symbolism. The second phase in which he has distinguished himself is lifelike portraiture.

3. The Younger Generation

One cannot delude himself into believing that our sculptors born in the seventies or eighties have as yet equalled the achievements of the generation who established American sculpture on a new plane after the Centennial. Little has been added to our national heritage through the cult of the nude form by Robert I. Aitken (b. 1878) and Sherry Edmundson Fry (b. 1879). Such a work as the Fountain of the Earth for the San Francisco exposition indicates that Aitken has apparently been influenced by Barnard, though he is more naturalistic. Both he and Fry, on the other hand, have recently indulged somewhat in primitive simplifications. A capital instance, in the case of Fry, is the Barrett Memorial Fountain at St. George, Staten Island. Fry has also done distinguished work in the ordinary kind of American memorial, as in the Abbey Monument at Tompkinsville, Conn. The achievement of Albin Polasek (b. 1879), like that of Grafly,

is twofold: he has produced studies of the nude of more than ordinary physical loveliness, and he has made busts of that modern vividness which one finds again in Grafly as well as in Hildebrand. Of a number of women who have chosen the sculptural vocation, two are preëminent for their originality. Anna Vaughn Hyatt (b. 1876) first attracted attention as an excellent modeller of animals; but recently she has not only widened her range of subject but at the same time she has set herself a standard by a continued realization of which she will become one of our greatest sculptors. The equestrian Jeanne d'Arc on Riverside Drive, New York, presents the happy union of equine knowledge, archæological accuracy, and compositional beauty with keen characterization and high power of spiritual expression. The same unusual combination of vigor, technical mastery, charm of arrangement, emotional content, and originality of conception is exhibited in a work from quite another sphere, the nude Diana. It might have been expected that the very general interest in kinetic poses created by Rodin would have early turned for themes to the plentiful source of the Russian dance; but it required the artistic intuition of Malvina Hoffman (b. 1887) to seize upon the opportunity. As a pupil of Rodin, it was almost inevitable that she should concern herself with the pictorial rather than the truly sculptural aspects of her themes and should crystallize the fleeting instant of the performer's extreme activity; but *pace* the æsthetic purists, her talent for perception of the beautiful and her mastery over modern naturalistic anatomy and over other phases of the plastic art have enabled her to perpetuate some of the loveliest moments of the dance. Her representation of Pavlowa in the Gavotte has already become one of the best known of American statuettes; and her Bacchanale has been deemed worthy of a place in the Luxembourg Gardens. She has proved herself, indeed, equal to the several kinds of commissions that today fall to the lot of a sculptor, though with a tendency toward modern sentimental symbolism that is as yet pleasantly absent from the production of Miss Hyatt. The Bacon memorial to the Harvard men who died in the War is an impressive reversion to the type of mediæval tomb with recumbent knight; it is

enough praise for the kneeling personification of grief at the head to observe that, in features and drapery, it recalls, perhaps unconsciously, the feminine figures of the "atelier de la Ste. Marthe."

Stylization. The greatest product of the return to the primitive in this country is Paul Manship (b. 1885). One could well be pardoned for resting content with his imitation

FIG. 299—MANSHIP. DANCER AND GAZELLES

of the achievements of former ages, for he brings to this task vitalizing freshness and a perfection of craftsmanship in reproducing the style desired that affords the same justifiable pleasure as the pyrotechnics of a Caruso. Especially remarkable are his ability in delicate low relief and the decorative sense manifested in the embellishment of his creations. The small bronze of the Centaur seizing upon a Dryad is a masterpiece in the archaic Greek style. A dependence upon India is illustrated by the panels of the four personifications of the

elements for the Western Union Building, New York. The marble half-length of his infant daughter, Pauline, in the Metropolitan Museum is an astonishing performance in the mode of the realistic portraiture of the Quattrocento. Nor does he quite stop at imitation. His conceptions, though merely pleasant fancies, emanate largely from his own mind (Fig. 299). One can discern also, beginning to emerge dimly from all this imitation, an æsthetic and somewhat modern ideal for the human form that is quite personal, especially in the Briseis and other feminine figures. After all, nevertheless, these are only intimations of individuality, and Manship cannot yet claim the title of a great artist, because hitherto he has not shown himself much more than an unparalled imitator and a most accomplished technician. We must demand of him a further development and expression of his own personality, further technical originality, and a profounder spiritual content. We must ask of him what we find in Minne, Metzner, and Meštrović, however disagreeable their message and however inferior to his their skill.

XII. Post-Impressionism

So far as definition goes, Post-Impressionism is a very poor term for the latest movement in western art. It means no more than the movement that succeeded the development in European and American art known as impressionism. Critics have pointed out that a better title would have been Expressionism. The exponents of the tendency sacrifice representation not only to an expression of their own and others' emotions, sensations, and personalities, but also to purely æsthetic purposes. The Roumanian Constantin Brancusi may be taken as typical, in his earlier phases, of those who, without any carefully elaborated system, go no farther than a neglect of definition of certain details and an exaggeration of the characteristics that they wish to emphasize. In Brancusi's bust of a Muse, for instance, the attention is concentrated upon the accentuated effect of rapt dreaming in the face by reducing to the lowest terms the modelling of the parts that would not contribute to this result. The

Cubists and Futurists have concocted intricate æsthetic theories for the sake of creating a purpose for their sacrifice of reality. In order to render evident the mathematical basis that the former conceive to underly reality, they simplify the sections of the body into geometrical shapes. An example is afforded by the group called Family Life (Fig. 300), the work

FIG. 300—ARCHIPENKO. FAMILY LIFE

of the Russian Alexander Archipenko. The Post-Impressionists tend to intrude upon one another's specialties. Brancusi, in such productions as the Kiss, has lately turned towards Cubism; Archipenko, in the above-mentioned group, has adopted Brancusi's intensification of reality, choosing for his sphere of emphasis the impression of sculptural bulk. He therefore feels it necessary to leave his heads and here and

there other sections of the anatomy as mere lumps of stone, to cut off all extremities, such as hands and toes, that would project from the dense mass, and to exaggerate the robustness of physique. The compactness is doubtless meant also to serve a spiritual end, the emphasis upon the union of the family. Archipenko has likewise worked in the extreme sort of Cubism cultivated by the painters of the coterie. The cardinal principle of the Futurists is the accumulation, in the same work, without regard for the verities of space and time, of all significant connotations of the object, scene, or idea—its different temporal and kinetic phases, the other things and conceptions suggested by the theme, the emotional associations that it arouses. For sculpture they add the mandate to employ all kinds of materials and actual articles as accessories in the same work. In Umberto Boccioni's (d. 1916) colossal bust entitled "Head—Houses—Light," many objects that fell within the vision of the sculptor are heaped upon the Buddha-like form: sections of distant houses, for instance, upon the head; bits of wooden railing, an iron grill, a balcony, and an actual toy representing a woman upon one shoulder; and the modelling of one side of the head is obscured (!) by a congeries of lines signifying rays of light.

The sacrifice of veristic representation to the dictates of interpretative or æsthetic ends is no new thing in art. Indeed, no art is anything but photographic that does not make such a sacrifice. The distinctive characteristic of Post-Impressionism is that the sacrifice has proceeded so far that little or nothing of the body is still left upon the altar. The principal argument against this cult is the achievement of such men as Francesco Laurana, Maillol, Botticelli, and the Japanese. They have demonstrated that it is possible to conform to the representative and story-telling function, which is one of the legitimate phases of art, and at the same time, within the limits of this restriction, to attain as much of an emotional and æsthetic effect as the Post-Impressionists with all their pretty theories. Whatever be the verdict upon the intrinsic merits of this new sculpture and painting, few would deny the salutary influence of the movement upon less revolutionary phases of art in diverting them still farther from a mere literal reproduction of nature.

BIBLIOGRAPHICAL NOTE

Germany has provided us with two good, general books on the art of the nineteenth century: M. Schmid, *Kunstgeschichte des 19. Jahrhunderts,* Leipzig, 1904, and F. Haack, *Die Kunst des 19. Jahrhunderts,* fifth edition, Esslingen, 1918. J. Meier-Graefe's *Modern Art* (English translation by F. Simmonds and G. W. Chrystal, New York, 1908) is a lengthy discussion of recent æsthetic tendencies with a characteristically German treatment from the philosophical standpoint, including brief passages on sculpture, especially on Rodin and his school. The plastic art of the twentieth century has been described by L. Taft, with his usual geniality of style, in *Modern Tendencies in Sculpture,* Chicago, 1921, and, with some inaccuracy and indecisiveness, by K. Parkes in *Sculpture of Today,* 2 vols., London, 1921. W. Radenberg in *Moderne Plastik,* Leipzig, 1912, furnishes a good collection of illustrations, chiefly of German sculpture.

The following is a list of monographs on modern French sculptors:[1] on Rude (all at Paris), A. Bertrand, 1888, L. de Fourcaud, 1904, and J. Calmette, 1920; on David d'Angers, H. Jouin, Paris, 1878; on Barye, A. Alexandre, Paris, and C. de Kay (H. Eckford), New York, both of 1889; on Carpeaux, L. Riotor, Paris, 1905, P. Vitry, Paris, 1912, Florian-Parmentier, Paris, and A. Mabille de Poncheville, Brussels, 1921; on Frémiet, J. de Biez, Paris, 1910; on Dalou, M. Dreyfous, Paris, 1903; on Falguière, L. Bénédite, Paris, 1902; on Chapu, O. Fidière, Paris, 1894; on Rodin, O. Grautoff, Leipzig, 1908, J. Cladel, Brussels, 1908, M. Ciolkowska, Chicago, 1912, and G. Coquiot, Paris, 1915; on Maillol, O. Mirbeau, Liége, 1921; on Bartholomé, P. Clemen in *Die Kunst,* VII (1903), pp. 33-53; on Bourdelle, A. Castell in *Die Kunst,* XXIX (1914), pp. 218-227; and on Bouchard, H. Marcel in the *Gazette des Beaux Arts,* 1913, I, pp. 236-252.

Any list on German sculpture should include: on Rauch, in addition to the book mentioned in connection with Schadow, F. and K. Eggers, Berlin, 1873-1891; on Begas, A. G. Meyer, Leipzig, 1897; on Siemering, B. Daun, Leipzig, 1906; on Maison, F. von Ostini in *Die Kunst,* III (1900-1901), pp. 131-142; on Hildebrand, A. Heilmeyer, Leipzig, 1902, and A. L. Mayer in *Die Kunst,* XXXVII (1917-1918), pp. 61-66; on Hahn, G. J.

[1] With such an abundance of bibliographical material on modern sculpture, only the most significant books and articles can be here included; for a fuller list, cf. the bibliography at the end of *A History of European and American Sculpture,* by C. R. Post.

Wolf in *Die Kunst*, XXIX (1913-1914), pp 289-298; on Hoetger, G. Biermann, Munich, 1913; on Lehmbruck, P. Westheim, Potsdam, 1922; and on Klinger, M. Schmid, Leipzig, 1899, G. Treu, Leipzig, 1900, F. Servaes, Berlin, 1904, P. Kühn, Leipzig, 1907, and W. Pastor, Berlin, 1918. The general evolution of Austrian sculpture is treated by L. Hevesi in *Oesterreichische Kunst im neunzehnten Jahrhundert*, Leipzig, 1903, and by H. Haberfeld in *The Art Revival in Austria*, special summer number of the *Studio* for 1906. A collection of photographs of Tilgner's works was published by L. Hevesi in 1897 (Vienna); Metzner is the subject of a monograph by O. Stoessl, Prague, 1905.

The best general works on modern Belgian sculpture are: O. G. Destrée, *The Renaissance of Sculpture in Belgium, The Portfolio*, XXIII (1895); E. Hessling, *La sculpture belge contemporaine*, Berlin, 1903 (with magnificent illustrations); H. Hymans, *Belgische Kunst des 19. Jahrhunderts*, Leipzig, 1906; and P. Schumann, *Belgische Bildhauer der Gegenwart* in *Die Kunst*, XV (1906-1907), pp. 57-70 and 81-97. The student should consult also the following monographs: on Meunier, K. Scheffler, Berlin, 1903, and W. Gensel, Leipzig, 1905; on Braecke, V. Pica in *Emporium*, XIX (1904), pp. 3-19; on Charlier, S. Pierron, Brussels, 1913; on Lambeaux, H. Teirlinck, Antwerp, 1909; on Lagaë, V. Pica in *Emporium, XXXV* (1912), pp. 163-176; on Vinçotte, P. Lambotte and A. Goffin, Brussels, 1913; on Rousseau, M. des Ombiaux, Brussels, 1908; and on Minne, A. Fortlage in *Die Kunst*, XXVII (1913), pp. 347-353.

Discussions of the sculpture are included in the two standard works, A. R. Willard, *History of Modern Italian Art*, London, 1902, and L. Callari, *Storia dell'arte contemporanea italiana*, Rome, 1909. The chief monographs are: H. S. Frieze, *Giovanni Duprè*, London, 1888; R. Manzoni, *Vincenzo Vela*, Milan, 1906; S. di Giacomo, *Vincenzo Gemito*, Naples, 1905; and G. Cena, *Leonardo Bistolfi* in *Nuova Antologia*, IV series, 117 (1905), pp. 1-20. Allusion should be made also to the little manuals on modern Italian art, with copious illustrations, compiled by F. Sapori and published at Turin.

M. H. Spielmann's *British Sculpture and Sculptors of Today*, London, 1901, is less incisive in distinguishing the styles of the different masters than it is rich in material. In addition to the book of W. C. Monkhouse on Foley, London, 1875, the following articles are among those that will assist in obtaining a more detailed knowledge of modern British attainments in sculpture: the three articles by W. Armstrong in the *Portfolio* on Stevens,

1890, pp. 127-133, Thornycroft, 1888, pp. 111-115, and Ford, 1890, pp. 67-71; W. K. West, *The Work of F. Derwent Wood, International Studio,* XXIV (1904-1905), pp. 297-306; M. S. Watts, *George Frederic Watts,* London, 1912; A. L. Baldry, *A Notable Sculptor, Alfred Drury, Studio,* XXXVII (1906), pp. 2-18; J. Hatton, *Alfred Gilbert, London Art Journal, Easter Art Annual,* 1903; H. C. Marillier, *Die Kunst George Framptons, Die Kunst,* X (1904), pp. 369-377, and W. K. West, *Some Recent Monumental Sculpture by Sir George Frampton, Studio,* LIV (1911-1912), pp. 35-43.

In addition to the general works listed at the end of Chapter I, those who wish to pursue modern Spanish sculpture further may read C. Rudy, *Modern Spanish Sculpture, The Work of Agustín Querol* in the *International Studio,* XXVIII (1906), pp. 300-306, and J. Francés's monograph on Clará, Madrid, 1923. The general works on Scandinavian art include: E. Hannover, *Dänische Kunst des 19. Jahrhunderts,* Leipzig, 1907; G. Nordensvan, *Schwedische Kunst des 19. Jahrhunderts,* Leipzig, 1904; chapters in H. G. Leach's *Scandinavia of the Scandinavians,* New York, 1916; and rather inadequate chapters in *Scandinavian Art,* New York, 1922, a book due to the collaboration of C. Laurin, E. Hannover, and J. Thiis. The monographs and articles on Scandinavian sculptors include: M. Bigeon, a chapter on Sinding in *Les révoltés scandinaves,* Paris, 1894; G. Grappe, *Stephan Sinding,* Paris, 1911; V. Pica, *Carl Millès, Emporium,* XXIX (1909), pp. 3-19; J. Thiis, *Gustav Vigeland, Ord och Bild,* XIII (1904), pp. 99-116; H. Dedekam, *Vigelands Fontæne,* in the same periodical, XXVII (1918), pp. 401-421; and *The Vigeland Fountain, The American Scandinavian Review,* VIII (1920), pp. 28-32. For the two great Slavic sculptors, the student is referred to C. Brinton's introduction to a *Catalogue of Sculpture by Prince Paul Troubetzkoy* (exhibited by the American Numismatic Society), 1911, and to the monograph on Meštrović compiled by M. Ćurčin, London, 1919.

L. Taft's already listed book on American sculpture can best be supplemented by C. H. Caffin's essays in *American Masters of Sculpture,* New York, 1913, by the large, illustrated Catalogue of the highly representative Exhibition of American Sculpture at the Hispanic Society, New York, in 1923, valuable for biographies and lists of works, especially of our younger masters, and by A. Adams's chatty little book, *The Spirit of American Sculpture,* written for the same occasion. From the large amount of material on individual American sculptors, the following titles

may be selected: W. O. Partridge, *Thomas Ball, New England Magazine*, N. S., XII (1895), pp. 291-304; A. Adams, *John Quincy Adams Ward*, New York, 1912; the two apologies for Rimmer, T. H. Bartlett, *The Art Life of William Rimmer*, Boston, 1882, and G. Borglum, *Our Prophet Unhonored in Art*, *New York Evening Post*, June 18, 1921; M. E. Phillips, *Reminiscences of William Wetmore Story*, Chicago and New York, 1897; W. C. Brownell, *The Sculpture of Olin Warner, Scribner's*, XX (1896), pp. 429-441; on Saint-Gaudens, the books by R. Cortissoz, Boston, 1907, and C. L. Hind, New York, 1908; S. Brinton, *An American Sculptor, Daniel Chester French, International Studio*, XLVI (1912), pp. 211-214, and *The Recent Sculpture of Daniel Chester French* in the same periodical, LIX (1916), pp. 17-24; R. Armstrong Niehaus, *The Sculpture of Charles Henry Niehaus*, New York, 1901; on Pratt, articles by W. H. Downes in the *International Studio*, XXXVIII (1909), pp. iii-x, and by L. M. Bryant in the same periodical, LVII (1915-1916), pp. cxxi-cxxv; on Taft, articles by R. H. Moulton in the *Architectural Record*, XXXVI (1914), pp. 12-24, and in *Art and Archæology*, XII (1921), pp. 242-252; on Dallin, A. Seaton Schmidt in the *International Studio*, LVIII (1916), pp. 109-114; on Solon Borglum, C. H. Caffin's introduction to the Catalogue of the exhibition of his works at New York; on Barnard, P. Clemen in *Die Kunst*, XXIII (1910-1911), pp. 385-405; on MacMonnies, F. Strother in the *World's Work*, XI (1905-1906), pp. 6965-6981, and C. H. Meltzer in the *Cosmopolitan*, LIII (1912), pp. 207-211; on Gutzon Borglum, L. Mechlin in the *International Studio*, XXVIII (1906), pp. xxxv-xliii, and the book of photogravures of his works published at Stamford; Connecticut, in 1913; on Grafly, V. C. Dallin in the *New England Magazine*, N. S., XXV (1901-1902), pp. 228-235; on Aitken, A. Hoeber in the *International Studio*, LIV (1914-1915), pp. xv-xviii; and on Manship, M. Birnbaum's introduction to the Catalogue of the exhibition of his works at New York, 1916, and the monograph by A. E. Gallatin, New York, 1917.

The available books on Post-Impressionism vary in their usefulness. C. L. Hind's *The Post-Impressionists*, London, 1911, is rather vague and inarticulate in its sympathy for the movement. A. J. Eddy's *Cubists and Post-Impressionism*, second edition, Chicago, 1919, is more lucid. P. Fechter in *Der Expressionismus*, third edition, Munich, 1919, treats his theme with German thoroughness.

CHAPTER XV

THE SCULPTURE OF THE ORIENT

I. Introductory

In comparison to occidental sculpture, the most palpable characteristic of oriental sculpture is its conservatism. There are minor æsthetic variations between the successive periods in the art of each country, but generally speaking, except for degrees of superiority or inferiority, the style remains much the same from the beginning to the end of each national tradition. One of the causes of conservatism was the dependence of art upon a hieraticism that continued to prescribe for sacred figures unchanging canons as rigid as those of neoclassicism in Europe. The forms and draperies were treated with a conventionalization that recalls the Romanesque. The images of the more austere gods and saints started with frontality, and, because of conservatism, never got very far away from it. The stationary nature of oriental sculpture, however, had its compensations. The endless repetitions of the same themes in the same manner facilitated the frequent achievement of a perfection that may well be envied by occidental rivals. The possibility of depending upon precedent for the principal constituents of a statue coöperated with the general oriental proclivity for design on a small rather than a large scale to allow the artist to concentrate much of his attention upon decorative detail and thus to attain an exquisite supremacy in its rendering. The custom of polychromy was universal.

The two great hearths of oriental sculpture are India and China. From the former were derived the schools of Ceylon, Java, Burma, Siam, and Cambodia; from the latter, the schools of Corea and Japan. Indeed, one who has a mania

for tracing origins would be perfectly right in asserting that, with the exception of the unimportant production of the early Han dynasty, the sculpture of China, however free from slavish imitation and however superior to its models, was partially based upon Indian precedent.

II. INDIA

Introductory. Indian sculpture and its tributaries are even more petrified by tradition than the output of the Chinese æsthetic group. Personality and individual initiative are so lacking that almost no craftsman has stood out sharply enough from his fellows to leave us his name, and it has seriously been questioned whether any of the vast production of India should be dignified by the term Fine Art in distinction from Industrial Art. Few critics would now be so chary of the former epithet as to confine it to works embodying an intense expression of personality. Almost all critics would admit within the charmed circle of Fine Art at least the best Indian carvings; the number would vary greatly according to one's æsthetic and racial prejudices. Writers on Indian sculpture always feel it necessary to apologize for or at least to explain two of its characteristics that might discourage the beginner. First, the omission of the modelling to which the westerner is accustomed and the consequent smoothness and roundness of the forms may be ascribed not only to the less apparent muscularity of the Hindu body but also to a religious proscription of realism. The same characteristic occurs in a less degree in Mongolian sculpture. The narrow waist the Indians shared with Cretan, Egyptian, and archaic Greek art. The concomitant phenomenon of impassivity in the countenance may be traced to a similar pious reason. Furthermore, Indian taste has always set less value upon correctness of form and of perspective than upon movement, rhythm, and expression through posture. Second, whether one accepts the monstrous forms that occur in Brahmanical in distinction from Buddhist art will depend upon whether he is enough of an oriental enthusiast to discern in them a sufficient religious significance to bestow upon

them a spiritual value that obliterates the impression of grotesqueness and even enhances the æsthetic appeal. Certainly the enjoyment of the uninitiated will be impaired by the multiplication of arms and faces and by the capping of human bodies with bestial heads. Indian art is distinguished from Chinese and Japanese by a greater sensuality in the treatment of the feminine form and by a greater profusion of ornamental accessories. It turns more readily to relief than to figures in the round and reveals little architectural sense in adapting the lines of its carvings to their function in the decoration of buildings.

The history of sculpture in India may be divided into five periods. Of the three religions of India, Buddhism inspired the sculpture of the three medial periods, the Aśokan, the Græco-Buddhist, and the Gupta, although during the last epoch Brahmanism had already encroached somewhat upon its domain. In the fifth or mediæval period, which began roughly in the seventh century after Christ, the revived and more essentially Hindu religion of Brahmanism was, with a few provincial exceptions, the directing force. Within this fifth period falls also the comparatively unimportant part played by Jainism. The invasion and occupation by the Mohammedans, since their doctrines were hostile to sculpture, need not concern us.

The "archaic" period. It is only the most recent criticism that has proposed to assign to as remote a date as the sixth and fifth centuries B.C. a few monumentally ponderous and impressive statues, chiefly, it is likely, portraits of monarchs, in the Mathurā and Calcutta Museums, and thus to create for Indian sculpture an earlier period of extant production than had hitherto been established. If we accept this chronology, which now may be said to be favored by the best opinion, we have discovered an epoch of Indian sculpture with a splendid æsthetic tradition independent of any foreign influence and of such advanced technical ability that it is necessary to presuppose a long history of previous, non-extant carving.

The Aśokan period. Although "Aśokan" applies properly only to the reign of the emperor and propagandist of

Buddhism, Aśoka (273-232 B.C.), under whom all but the extreme south of India was united, the term, for the sake of convenience, may be extended to include the production, in a similar style, of the two succeeding centuries before Christ. A certain degree of influence from Mesopotamia, Assyria, and Persia upon Aśokan art is now generally assumed. It has even been proposed to discern already a slight Hellenistic strain in the later output of this period, subsequent to Aśoka but long before the days of Græco-Buddhist art; but to many critics such factors as the habit of narrative bas-relief, bits of technical adroitness, and remote analogies in the composition of certain sacred *motifs* will not constitute adequate evidence. The fact that the reliefs are pictorial rather than sculptural in their conception makes it just as likely that they were based upon painted Indian prototypes. In any case, the foreign borrowings from one source or another have been so thoroughly acclimatized and combined with preponderant indigenous

FIG. 301—BUDDHIST SPRITE. GATEWAY, SĀNCHĪ. (PHOTO. JOHNSTON AND HOFFMAN)

elements as to imply that the sculptures are a continuation of the native tradition now apparently established for the archaic period or that the hands of the sculptors had been previously trained to work in wood, clay, ivory, or metals in objects that have perished. Despite a few conventions, especially in the drapery and in the foreshortening of limbs, and despite occasional primitive crudities of modelling, the period was marked by a fresh naturalism that was very rare in later epochs of Indian sculpture. Upon this

naturalism was often pleasantly superimposed the usual oriental nicety of execution. The mere delight in rapid story-telling, however, sometimes caused the sculptor to treat details rather hastily. Practically the only extant plastic relics of Aśoka's reign are a number of monolithic columns crowned by symbolic animals. The best specimen is at Sārnāth near Benares. Of Post-Aśokan work, which, in general, is less vigorous and crisp than that of the third century, the most familiar examples are the sculptured stones from the ruins of Bharhut, in the Museum of Calcutta, representing various Buddhist sprites, scenes from the life of Buddha, and a multitude of animals, and the similar but more delicately executed subjects on the gateways at Sānchī (Fig. 301).

The Græco-Buddhist period. The Græco-Buddhist movement was at its height from the first through the third century after Christ. The intermediaries between the Greeks and the Asiatics of India and China in its dissemination were the Scythians of central Asia, who were converted to Buddhism. The movement centered in the extreme northwestern section of India and flourished under the dynasty of the Indo-Scythian tribe of the Kushāns who had occupied that region around their capital Peshāwar. Since this region was formerly known as Gandhāra, the term, school of Gandhāra, is in very general usage. The position of Gandhāra on the northwestern frontier made possible a contact with Hellenistic art, especially the art of that outpost of Greek civilization northwest of India, Bactria, and the probable importation of Hellenistic artists. The result was a harmonious fusion of some of the characteristics of Greek art with the already established Indian types and style. The heads took on an Hellenic cast, the bodies became sturdier and were the recipients of more realistic, muscular modelling, and the draperies fell in folds approved by Greek precedent. The period witnessed what were probably the first representations of Buddha himself (though non-extant images may very well have been carved before). The most common mode of representing him was the one that henceforth became traditional in oriental art: he is conceived as seated with crossed feet and hands in the posture that the Indian ascetic or *yogī*

finds easy when he wishes to withdraw into himself for medi-
tation. In Gandhāra art he sometimes wears moustaches.
Among the most important examples of sculpture produced
in great quantity in the Gandhāra district proper are: a large
number of well characterized heads of sacred effigies, in clay,
stucco, or terracotta, about forty of which may be seen in
the British Museum; a seated, moustached Buddha in the
Ethnographical M u -
seum, Berlin (Fig. 302);
a seated, smooth-faced
Buddha with unadorned
halo in the British Mu-
seum; the relief of In-
dra's visit to Buddha in
the Calcutta Museum;
and the Kuvera or god
of riches in the Lahore
Museum (formerly be-
lieved to be the portrait
of an Indo-Scythian
king), remotely sug-
gested by the type of the
Phidian Zeus. To what
an extent the rest of In-
dian territory fell under
the Hellenic spell is a
moot point. In any case,
outside of Gandhāra the
national traits greatly
preponderate over the
foreign borrowings. The

FIG. 302—BUDDHA OF THE GANDHĀRA STYLE.
MUSEUM, BERLIN. (FROM "A HISTORY OF
FINE ART IN INDIA AND CEYLON" BY VIN-
CENT A. SMITH)

chief sites are Sārnāth and Mathurā south of Delhi; the
sculpture from the latter site has been gathered in the
Museum at the place and in the Museum at Calcutta.
The lively, highly imaginative, and beautifully decorative
carvings from the stūpa (Buddhist chapel) at Amarāvatī, the
majority of which are distributed between the Central Mu-
seum, Madras, and the British Museum, are so thoroughly
nationalized in manner that it is a question whether there

is any Greek influence, and, if so, whether it sifted in from Gandhāra or drifted in from maritime routes.

The Gupta period. The next period is styled Gupta from the dynasty (320-480 A.D.) which finally managed to gain control over a zone stretching across all northern India from central Bengal on the east to Kāthiāwār on the west, but the term is usually extended to include the art of India to the middle of the seventh century. From one standpoint the epoch may be viewed as transitional between the partly Hellenized art of Gandhāra and the thoroughly nationalized art of the Indian Middle Ages. Although a certain number of Brahmanical themes began to be executed in lasting materials, Buddhism still dominated the field of sculpture. The definitive qualities of the Gupta style are a frequent luscious amplitude of form, a soft elegance, the use of tight-fitting, diaphanous garments, and a general emotional restraint. Among the finest specimens of Buddhist inspiration are the carvings at Ajantā in western India, the seated Buddha with elaborate halo and two flying siddhas in the Sārnāth Museum, and the standing Buddha also with a highly ornamented halo in the Mathurā Museum.

The mediæval and modern period. It is usual to subdivide the Middle Ages into an earlier period from the middle of the seventh to the middle of the eighth century A.D., sometimes called classic because the most essentially Indian characteristics then found their highest expression, and a later period which betrays a very gradual artistic decline, which passes into modern art at no very definite date, but which, for the sake of convenience, may be considered to have ended with the beginning of the British rule in 1761. The triumph of Brahmanism, except in a few districts, crushed out the genial representation of episodes from every-day life that had distinguished Buddhist art, and covered India with a luxuriance of ascetic or weirdly fantastic themes. Western India now for the first time assumed an important position in the history of sculpture: the carvings in its cave temples, as at Elūrā near Aurangabad and on the island of Elephanta off Bombay, are among the greatest examples of monumental sculpture in stone during the classic age. The south now also

loomed larger in the general prospect of Indian art, more for its bronzes than for its stone sculpture, and in stone sculpture more for abundance and chimerical profusion than for intrinsic merits of modelling and naturalism. Of the earlier period, however, the work at Māmallapūram, just below Madras, vies with the achievements of Elūrā and Elephanta.

The sculptural manner patronized by the powerful emperors who, with their capital at Vijayanagar, dictated to the whole south from the fourteenth to the sixteenth centuries is best represented in the temples at that place and on the gateways at Tārpatri near Anantapur in Madras. It leads slowly into the grotesque and often *gauche* art that has been lavishly employed to deck the temples of Drāvida (extreme southern India) from the sixteenth century to the present day.

Bronzes. It is for its small figures in bronze or copper that southern India has particularly attracted the attention of connoisseurs. They are distinguished by a lively sense of general design, by ability to embody impressively the desired idea, and by technical delicacy, especially in the hands, to the modelling of which, in lieu of naturalistic accuracy in other parts of the body, the Indian artist has always devoted himself and in the characterization by which he has always excelled. Masterpieces of this style are statuettes, now scattered through several museums, of Śiva engaged in the cosmic dance (Fig. 303).

Orissa. In Orissa, where the art was chiefly Brahmanical, the Mohammedan conquest did not succeed in crushing plastic production until the end of the thirteenth century. The greatest assemblage of sculpture in this region was not done until this very century, at Konārak. The decorative reliefs are disfigured by an extreme phase of the obscenity so often encountered in Indian art; the most interesting pieces of sculpture are the seven colossal horses which are conceived to be drawing the temple, in the guise of the Sun's chariot, and in which anatomical accuracy is sacrificed to a superb monumentality.

III. Ceylon

The most important and beautiful school of Indian sculpture, outside of India itself, was the Sinhalese. The art of Ceylon, with its religion, remained Buddhist. It may be divided into two periods: the first, while the capital was still at Anurādhapura, corresponding roughly to the Gupta epoch in India; the second, when from the eighth to the thirteenth century, the capital was at Pollonāruwa, corresponding to the Middle Ages in India. Typical Gupta works at or from Anurādhapura are: the seated Buddha coming from the vicinity of the Jetavanārāma dāgaba or chapel and now in the Colombo Museum, exhibiting the tendency to the colossal so often met with in Ceylon and perhaps surpassing any example on the mainland in contemplative majesty; and the standing Buddha, with the characteristic crimped and trans-

parent drapery of the period, at the Ruanveli dāgaba.
Specialties of Sinhalese sculpture are: the flat, semi-circular
"moonstones" set at the foot of staircases and adorned in
low relief with curving bands of delightfully rendered ani-
mals; and figures at entrances, especially misshapen dwarfs,
to avert evil spirits. The stone sculpture of the mediæval
period is well represented by the colossal sage or King
Parākrama Bāhu at Pollonāruwa, belonging to a type of
fairly realistic portraiture much affected throughout the his-
tory of Sinhalese art. Far more interesting are the mediæval
bronzes. It is still a moot point whether they were produced
in Ceylon itself or simply imported from southern India;
in any case, they rival, if they do not surpass, the continental
specimens. The Boston Museum possesses one of the loveliest
specimens in the seated Avalokiteśvara.

IV. JAVA

Javanese art did not begin before the fifth century after
Christ, it reached its height in the ninth century, and came to
an end with the Mohammedan conquest of the fifteenth. Both
Buddhism and Brahmanism are given expression, but the
products of the latter religion are inferior. Critics are still
investigating the problem of the region of India from which
the Javanese sculptors first drew their inspiration, inclining
perhaps, in harmony with certain Indian traditions, to favor
the West. The forms have the fullness of the Gupta period,
with less slender limbs and less narrow waists than the usual
Indian or Sinhalese figure. The most celebrated monument
is the series of 1600 reliefs relating Buddhist hagiology on
the pyramidal temple of Bōrōbudur. They are distinguished
by a naturalistic knowledge, an imaginative variety, an ap-
preciation of the human side of life, a technical skill, and a
sensitiveness to facial beauty that cannot be paralleled in
the narrative sculpture of India itself. An explanation has
been sought even in a hypothetical Chinese influence. The
American student may obtain a good idea of Javanese sculp-
ture from the relief of Durgā slaying the demon Mahisa, in
the Boston Museum.

V. Cambodia

The Indian art that flourished in Cambodia from the ninth to the twelfth century was likewise chiefly Buddhist and naturally embodied in its sacred effigies a more Mongolian ethnic type. Its ornamental carvings, the best known specimens of which may be seen on the temples at Angkor, are marked by somewhat greater realism in detail, by a more playful spirit, and by a truer decorative sense than those of India proper. The head of Buddha in the Fogg Museum at Harvard proves that in contemplative figures a more evident dreaminess was obtained by still further closing the eyes.

VI. China

Introductory. Chinese sculpture, together with its dependent schools of Corea and Japan, was more conscious than Indian sculpture of its profession as a Fine Art; it therefore has a nobler spiritual content and developed a finer technique, especially a greater crispness and accuracy of modelling. In contrast to the rather lackadaisical style of India, it was more virile and dignified both in inspiration and in execution. Its superiority may be partially due to the fact that it was the more humanly sympathetic type of Buddhism from northern India which was imported into the Mongolian countries. Unfortunately the scarcity of the extant or at least discovered and excavated monuments makes the study of Chinese sculpture proper very difficult. In China itself only monuments in stone remain, and even these are in remote places. For our knowledge of works in bronze and other materials we have to rely upon specimens in Japan, more or less hypothetically ascribed to Chinese provenience, or upon Corean and Japanese adaptations of the Chinese types.

The archaic period. The numerous carved slabs, found in the caves of the Han dynasty (206 B.C.—220 A.D.) in the province of Shantung need not concern us, for, produced at first by incision or later by the lowest kind of relief, they are scarcely sculptural at all, but rather translations of painting into stone. Some good specimens may be seen in

the Boston Museum. Chinese sculpture did not really begin until the essentially plastic religion, Buddhism, had thoroughly established itself in the fourth century. The archaic period may be considered to have extended from the fourth century to the accession of the Tang dynasty in 618. During this period until 589, the country was separated

FIG. 304—WEI STELE. FENWAY COURT, BOSTON. (COURTESY OF MRS. JOHN L. GARDNER)

into two parts, a northern kingdom with its capital at Tatung under the Wei dynasty, and a southern kingdom with its capital at Nanking under a succession of short-lived dynasties; in 589 the cleavage was healed under the royal house of Sui. Among the most important extant specimens in the north are the carvings in the living rock near Tatung and at Longmen near Honan. The demand for the same Buddhist themes as in India naturally entailed a partial adoption of

the Indian sculptural style, especially, at Tatung, of the Indian slimness of physique, and there seems to be also indisputable evidence of at least a slight interest in the Græco-Buddhist movement. The channel by which Hellenic influence reached China was the region of Turkestan, where the Indo-Scythian conquerors had practised since the third century after Christ a style allied to that of Gandhāra but somewhat more Greek. The most significant remains in Turkestan have been found in the vicinity of Khotan. The most beautiful examples of Wei sculpture are a number of stelæ and similar slabs (Fig. 304), carved with Buddhistic figures in the round and in relief that is often very low, and embodying at its noblest the uniquely Chinese fusion of monumental austerity with technical exquisiteness and luxuriance of detail. Of the more indigenous sculpture of the southern Chinese kingdom, the most interesting examples were produced in the eastern section of southern China called Go (which thus sometimes gives its name to the style), and were executed in bronze. The heavy, architectural forms of this style, with their rectangular contours and almost fearful severity of expression, may be studied at present in the tentatively attributed specimens exported to Japan and in their Japanese and Corean imitations.

The Tang period. The Golden Age of Chinese art, the Tang period, is usually taken to cover the years from 618 to the accession of the Sung dynasty in 960. The first part of the period, the seventh century, witnessed the greatest flourishing of the Græco-Buddhist style, owing to Chinese military conquests, diplomatic negotiations, and pilgrimages in Turkestan. It should be acknowledged at once, however, that one school of critics seeks to reduce the Hellenic influence to even lower terms than in the greater part of India, and thus is forced to emphasize the importance of the indigenous evolution. Perhaps the most striking proof of the relationship to the art of Khotan is afforded by the statue of the divine hero of Turkestan, Bisjamon, now in the Kiovogo-Kokuji Temple at Kioto, Japan, in all probability a Chinese work of the seventh or eighth century. Among the finest specimens of this phase of Chinese sculpture, in which the

conventionalism of oriental art is relieved by a partial natu-
ralism, are a small torso of a Bodhisattva (saint on the way
to become a Buddha) in the Boston Museum, and at Long-
men, pictorial reliefs representing processions, on the tomb
of the Emperor Taitsong six high reliefs of his favorite horses,
and at the entrance to the temples figures of keepers of the
gates. A comparison of these Tang sculptures at Longmen
with those of the archaic epoch at the same place will illus-
trate the much increased influence of Hellenism. Although
the Greek lessons in a more correct treatment of the human
form and in a greater nobility of spiritual content continued
to act as a leaven in all later Chinese art, the specific imita-
tion gradually ceased in the eighth, ninth, and tenth cen-
turies. The sculpture of this subsequent phase of Tang was
less numerous and less distinguished, yielding in popular
favor to painting; and yet it would be impossible to recog-
nize a falling off if we could with any surety follow certain
critics in assigning to this later date the five wonderful
Chinese figures in wood, representing Bodhisattvas (?)
mounted on symbolical animals, in the temple of Toji, Kioto,
Japan, instead of, with other critics (as seems to the present
writer more logical) to the Go school of the archaic period.
There are analogies between the later manner of Tang and
the Gupta art of India. The subsequent eras have little im-
portance for sculpture.

VII. Corea

With the possible exception of a few small and somewhat
rude bronzes, chiefly in Prince Yi's Household Museum,
Seoul, the estimate of Corean sculpture has still to be based
almost wholly upon the hypothetical ascription to that coun-
try of certain works now in Japan. It has been conjectured
that there was a flourishing period of sculptural production in
Corea at the end of the sixth or the beginning of the seventh
century after Christ, deriving its inspiration apparently from
the Chinese style of Go, modified by qualities that may be
tentatively designated as Corean, such as a much increased
delicacy, a pronounced attenuation of form, a roundness of

general shape that suggests derivation from a column, and a noble sensitiveness to rhythmical beauty of line and composition. The favorite medium was probably wood, and it may be by reason of its perishable nature that, except for one or two rock carvings, so little sculpture has been discovered in the country itself. The most beautiful statue that has been claimed by some critics as Corean is the standing figure, in wood, of the compassionate Bodhisattva Kwannon in the Yumedono of the Horyuji temple at Nara; but it is quite as likely that this masterpiece is the work of Japanese hands. A few statues of the second half of the seventh century in Japan have appeared to certain students of oriental art to be Corean, to afford evidence of a significant Corean Græco-Buddhist or at least Tang movement, and to prove a persisting vitality in Corean sculpture after the sixth century; but here the basis for attributions is much more dubious than in the earlier period.

VIII. JAPAN

The Suiko period. Japanese sculpture throughout its history has consisted in an indigenous adaptation and modification of the successive styles of China. It began with the introduction of Buddhism and with the civilization of the country in the second half of the sixth century after Christ. The earliest monuments come from the end of the sixth or the beginning of the seventh century; but no very marked national characteristics were evolved until the Fujiwara period of the tenth to the twelfth centuries. The first period, of the seventh century, is known as the Suiko from the name of the great empress who inaugurated the epoch, but it is sometimes subdivided. Its style, though following a century later, is based upon that of the archaic era in China and upon Corean translations of Chinese prototypes. The bronze Trinity of a central seated Buddha and two lateral Bodhisattvas on the altar of the Kondo of Horyuji, executed by the sculptor Tori, represents a more strictly Chinese phase of the Suiko style, possessing a meditative monumentality and a ponderous tranquillity. In other works, as in the

wooden statues of the four heavenly kings or guardians of the points of the compass set at the corners of the square altars of the Kondo of Horyuji, the Corean influence seems to be uppermost; and in the more developed art of the middle of the century this influence resulted in a partial enlivenment of the draperies and of the expression in head and hands and in a more pictorial treatment of the surfaces. The imitation of Chinese models in which there is a slight Græco-Buddhist influence possibly accounts for a perceptible increase of naturalism and for a modelling in higher relief of details of costume. One of the masterpieces of this developed art is the seated Kwannon of the nunnery of Chuguji at Nara.

The Hakuho period. The Suiko period is sometimes considered to have ended with the first half of the seventh century, and the second half is separated and designated as the Hakuho period. In any case, it was marked by the introduction of another style from China, the early Tang, perhaps with Corean modifications. The Græco-Buddhist influence is more probable than in the first half of the century. Although the religious monumentality and contained gravity still remain, the bodies have more correct proportions; the anatomy is further indicated; the activities and draperies suggest reality. The favorite medium is bronze. The most wonderful specimen is the Trinity in the Kondo of Yakushiji at Nara (Fig. 305). Certain productions of this period reveal a fondness for opulent and exquisite decorative detail; they aim at delicacies of modelling rather than large effects; they sacrifice the depth of Buddhist seriousness to charm and a desire for tenderness and sweetness; in a word, they indicate the first glimmer of a distinctive Japanese sculpture. The finest example is a small Buddhist Trinity enclosed in a wooden shrine in the Kondo of Horyuji. In many respects the Hakuho period in Japan, like the Tang in China, represents the greatest sculptural achievement of which the country was capable.

Later periods. The succeeding epochs of Nara (700-800) and of Jogan (800-900) witnessed no essentially new sculptural developments except an increase in the repertoire of subjects. Instances of such thematic amplification are the

FIG. 305—FIGURE AT LEFT IN BUDDHIST TRINITY. KONDO OF YAKUSHIJI MONASTERY, NARA. (FROM "JAPANESE TEMPLES AND THEIR TREASURES" WITH THE COURTEOUS PERMISSION OF THE JAPANESE DEPARTMENT OF EDUCATION)

forms of women and children, either conceived as divinities or as mere portraits, and especially the grotesques, whether consisting of new themes or of the old themes treated in a new way. This tendency to the grotesque may be studied at Nara in its most interesting phases in the twelve heavenly kings of clay in the Shin Yakushi monastery. The Fujiwara era, extending from the tenth through the twelfth centuries, fostered for the first time the marked development of the essentially Japanese characteristics (in distinction from Chinese) of an almost mannered grace, exquisiteness, gentleness, and ornamental splendor. The favorite religious subjects were the kindlier divinities, Kwannon and Amida (the Buddha of boundless light). The Kamakura or Feudal epoch (1190-1337) was emphatically the age of individualism, and in art individualism is likely to mean portraiture. Sculptured portraits had not been unknown in the previous periods, but their great vogue belongs to the days of Kamakura. The inception

FIG. 306—PATRIARCH OF THE HOSSO SECT. MUSEUM OF FINE ARTS, BOSTON

of this realistic portraiture is traditionally connected by the Japanese with the names of two sculptors, Wunkei and Tankei. Wood as a medium now enjoyed almost a monopoly. The great collection of oriental art in the Boston Museum is again fortunate enough to include a masterpiece of this portraiture in the figure of the Patriarch of the Hosso sect (Fig. 306). The grotesques, such as the Lantern Bearer by Kobun, the third son of Wunkei, in the Kofukuji monastery, Nara, seek a similar individualization and are

marked by an almost baroque violence of movement. The sacred sculpture of the Ashikaga (1337-1582) and Tokugawa (1603-1868) periods traversed the same downward path towards stiff conventionalization and obtuseness to any real religious feeling as the output of the contemporary Ming and Manchu dynasties in China. The most memorable plastic products of these centuries in Japan were the dramatic masks.

BIBLIOGRAPHICAL NOTE

The classic work on Indian art, however obsolete in certain points, is still V. A. Smith's *A History of Fine Art in India and Ceylon,* Oxford, 1911. A. K. Coomaraswamy's introduction to his *Catalogue of the Indian Collection in the Museum of Fine Arts, Boston,* 1923, constitutes a succinct history of Indian and related sculpture with more recent information, with an analysis of the religion of the country, so important to an understanding of the art, but sometimes without sufficient clearness in the definition of the styles of the several epochs. Among other works by the same author, the student is referred especially to *The Arts and Crafts of India and Ceylon,* London, 1913, and, particularly for illustrations, *Viśvakarmā, Examples of Indian Sculpture,* London, 1914. E. B. Havell's *A Handbook of Indian Art,* London, 1920, is a somewhat ecstatic discussion of Indian culture and religion rather than a manual of the art. More useful, so far as it goes, is W. Cohn's *Indische Plastik,* Berlin, 1921. The new hypothesis of an earlier, archaic period of Indian sculpture may be studied in K. P. Jayaswal's articles in the *Journal of the Bihar and Orissa Research Society,* V (1919), and in O. C. Gangoly's article in the *Modern Review,* Calcutta, October, 1919.

For Chinese and Japanese sculpture, E. F. Fenollosa's *Epochs of Chinese and Japanese Art,* New York, 1911, though much less systematic and final than Smith's history of Indian art, remains of fundamental significance. There is little of additional value on the sculpture in O. Münsterberg's German histories of Chinese (Esslingen, 1910) and of Japanese (Brunswick, 1904) art. E. Chavannes's publication in the *Ars Asiatica,* II (1914), *Six monuments de la sculpture chinoise,* is important for the slab at Fenway Court. K. With's *Buddhistische Plastik in Japan,* Vienna, 1919, with many excellent illustrations, is perhaps the best general history of Japanese sculpture yet written; but, for

the investigation of a single epoch, Langdon Warner has set a
new standard of distinguished oriental scholarship in his *Jap-
anese Sculpture of the Suiko Period*, New Haven, 1923. The
defect of O. Kümmel's *Die Kunst Ostasiens*, Berlin, 1921, is its
brevity.

GLOSSARY

Ambo.—A pulpit for the singing of the Gospel or the Epistle.

Archivolt.—A moulded band carried around a curved opening

Baldacchino.—The Italian word for an architectural canopy.

Bodhisattva.—The Buddhistic term for a saint on the way to become a Buddha.

Caryatid.—A female figure used as a support.

Chiaroscuro.—The distribution of lights and shadows in a work of art.

Ciborium.—Used in this book in the sense of a receptacle for the Sacrament and not of a *baldacchino* above the altar.

Cinquecento.—The Italian word for the sixteenth century.

Contrapposto.—The turning of the body upon its axis. Cf. p. 340.

Détente.—A French term for the relaxation of Gothic realism at the end of the fifteenth century.

Epitaph.—A mortuary relief on a wall. Cf. p. 223.

Frieze.—The architectural term for a longitudinal band of considerable length, often decorated with sculpture in relief.

Frontality.—The placing of a figure so that a plumb-line dropped from the centre of the forehead would divide it into two equal parts. Cf. p. 22.

Iconography.—The traditional mode of representing a subject in religious art.

Illusionism.—A term much used by recent writers to define the attempt in sculpture or in painting to suggest depth, as well as height and width. Cf. p. 155.

Metope.—In a Doric frieze, the rectangular block between two triglyphs.

Misericord.—"A shelving projection on the under side of a hinged seat in a choir-stall, so arranged that, when turned up, it gave support to one standing in the stall" (Murray).

Pediment.—A low, triangular gable, with cornices above and below.

Pietà.—The Italian term for the dead Christ held by his Mother. Cf. p. 221.

Predella.—A narrow panel under an altarpiece.

Putto.—The Italian term for the nude child as an artistic *motif.*

Quattrocento.—The Italian word for the fifteenth century.

Reredos: See Retable.

Retable.—Used in this book in the sense more usually imparted in English by the word reredos, *i.e.,* sculptured or painted decoration above an altar; an altarpiece.

Schrein.—The German term for the centre of a retable.

Stele.—The Greek name for a slab of stone set on end to form a monument.

Strigil.—"A slightly curved vertical fluting" (Sturgis).

Tondo.—The Italian term for a panel of circular shape.

Trecento.—The Italian word for the fourteenth century.

Tympanum.—A space above a doorway or a window, bounded above by an arch or a curved moulding.

INDEX OF SCULPTORS

In cases where there are two or more entries after a name, the figures in Italics indicate the pages on which the principal discussions of the sculptors in question may be found; for masters who are mentioned only incidentally, the Italic type has not been used.

Adams, Herbert, 508f.
Agasias of Ephesus, 145f.
Agelaidas of Argos, 72, 95.
Agesander of Rhodes, 144.
Agoracritus of Paros, 102.
Aitken, Robert Ingersoll, 518.
Alberti, Leon Battista, 307.
Alcamenes of Athens, 92, 102.
Algardi, Alessandro, *378f.*, 397.
Amadeo, Giovanni Antonio, *323ff.*, 326, 327, 329, 509.
Anguier, François, *383*, 385.
Anguier, Michel, 383.
Antelami: *see* Benedetto of Parma.
Antenor of Athens, 83f.
Antonianus of Aphrodisias, 162.
Apollonius, son of Archias, of Athens, 147.
Apollonius of Tralles, 144.
Arca: *see* Bari, Niccolò da.
Archermus of Chios, 64.
Archipenko, Alexander, 491, *522f.*
Arfe, Juan de, 366.
Arnolfo of Florence (di Cambio?), *285f.*, 288.
Athenodorus of Rhodes, 144.

Bacon, John, the Elder, 404.
Balduccio, Giovanni di, 290.

Ball, Thomas, *494f.*, 496, 499, 506.
Bandinelli, Baccio, 341f.
Bandini, Giovanni, 342, 347.
Bari, Niccolò da, 328.
Barisanus of Trani, 214ff.
Barnard, George Grey, 509, 512, *514f.*, 518.
Barrias, Ernest, 490.
Bartholomé, Albert, *453f.*, 455, 482, 514.
Bartlett, Paul Wayland, 517.
Bartolini, Lorenzo, 475.
Barye, Antoine Louis, 436, *438ff.*, 440, 442, 499.
Beaugrant, Guyot de, 357.
Beauneveu, André, *232f.*, 245.
Becerra, Gaspar, 368f.
Begarelli, Antonio, 329.
Begas, Reinhold, 457f.
Bellver, Ricardo, 488.
Benedetto of Parma, 212f.
Bernini, Giovanni Lorenzo, *373ff.*, 378, 380, 383, 385, 394, 397, 407, 410, 458.
Berruguete, Alonso, *367f.*, 411.
Bird, Francis, 402.
Bistolfi, Leonardo, *479*, 488.
Blay, Miguel, 488ff.
Blondeel, Lancelot, 355, 357.
Boccioni, Umberto, 523.

551

Boehm, Joseph Edgar, 481.
Boethus of Chalcedon, 140.
Bologna, Giovanni, *345ff.*, 354, 362, 363, 381, 387.
Bonannus of Pisa, 215f.
Borglum, Gutzon, 498, *517f.*
Borglum, Solon Hannibal, *513*, 517.
Borreman, Jan, 248.
Bouchard, Henri, *455*, 511.
Bouchardon, Edme, 388f.
Bourdelle, Émile Antoine, 454f.
Bracci, Pietro, 379f.
Braecke, Pierre, 471.
Brancusi, Constantin, 521f.
Bregno, Andrea, 314, *329ff.*
Brock, Thomas, 482f.
Broeucq, Jacques du, 354f.
Brown, Henry Kirke, *494*, 495, 497, 499.
Brüggemann, Hans, 260.
Brunelleschi, Filippo, 306.
Bryaxis of Athens, 124f.
Buon, Bartolommeo, 325.
Buon, Giovanni, 325.
Buonarroti, *see* Michael Angelo.

Caffieri, Jean Jacques, 391f.
Calamis of Athens, 87, 102.
Calcagni, Tiberio, 339.
Camaino, Tino di, 288.
Cambio, Arnolfo di: *see* Arnolfo of Florence.
Campionesi, the, 291, 323, 326.
Canachus of Sicyon, 72.
Candido, Pietro, 363.
Cano, Alonso, 414.
Canova, Antonio, 418, *419ff.*, 422, 423, 494.
Carpeaux, Jean Baptiste, *440ff.*, 449, 504, 516.
Cartellier, Pierre, 423.
Castro, Felipe de, 416.

Cellini, Benvenuto, 342, *343ff.*, 346.
Chantrey, Francis, 427.
Chapu, Henri, *447f.*, 462, 483, 502.
Charlier, Guillaume, *471*, 511.
Chaudet, Antoine Denis, 423.
Chinard, Joseph, 423f.
Clara, José, 489.
Cleomenes of Athens, 147.
Clodion, 390, *393f.*
Coecke, Peeter, 356f.
Colin, Alexander, 359.
Colombe, Michel, *240ff.*, 349.
Colotes of Heraclea, 102.
Colyns de Nole, Jacob, 357.
Coustou, Guillaume I, 385f.
Coustou, Guillaume II, 385.
Coustou, Nicolas, 385.
Coysevox, Antoine, *383f.*, 385.
Crawford, Thomas, *429f.*, 500.
Cresilas of Cydon, 101f.
Critius of Athens, *83f.*, 105, 108.
Cruz, Diego de la, 281.

Dallin, Cyrus Edwin, 513.
Dalou, Jules, *443ff.*, 452, 458, 481, 484.
Damophon of Messene, 141f.
Dannecker, Johann Heinrich, 104, *424f.*
Dauher, Adolf, 360f.
Dauher, Hans, 361.
David d'Angers, *436ff.*, 455.
Degler, Hans, 405f.
Delcour, Jean, 397.
Desiderio da Settignano, *311ff.*, 317, 318, 319, 333, 364.
Donatello, 6, 10, *298ff.*, 306, 307, 309, 311, 312, 314, 315, 316, 320, 322, 324, 339, 446, 465.
Donner, Georg Raphael, 408f.

Douwermann, Heinrich, 260.
Drury, Alfred, 484.
Dubois, Paul, *448*, 481.
Duccio, Agostino di, 314f.
Duprè, Giovanni, 475f.
Duquesnoy, François, *377f.*, 395, 408.

Epstein, Jacob, 487.
Eutychides of Sicyon, 129.

Falconet, Étienne Maurice, 390, *391*, 394.
Falguière, Alexandre, *445f.*, 490, 515, 516, 517, 518.
Fancelli, Domenico, *364f.*, 367.
Faydherbe, Luc, 397.
Fernández, Gregorio, *411f.*, 415.
Ferrata, Ercole, 376.
Fiammingo Il: see Duquesnoy.
Flaxman, John, 426.
Flötner, Peter, 360.
Floris de Vriendt, Cornelis, 356.
Foley, John Henry, 480.
Ford, Edward Onslow, 484f.
Forment, Damián, 366f.
Fraikin, Charles Auguste, 467.
Frampton, George James, 486f.
Franqueville, Pierre, 346, *381*.
Frémiet, Emmanuel, *442f.*, 448, 455, 462, 513, 517.
French, Daniel Chester, *506ff.*, 511.
Fry, Sherry Edmundson, 518.

Geefs, Guillaume, 467.
Geel, Jan Frans van, 398.
Gemito, Vincenzo, 478f.
Gerhaert, Nicolaus. 266.
Gerhard, Hubert, 362f.
Gérines, Jacques de, 246f.

Ghiberti, Lorenzo, 289, 297, 302, 304, *305ff.*, 319, 320, 344, 500.
Gibbons, Grinling, 402f.
Gilbert, Alfred, 485ff.
Giotto, 287f.
Girardon, François, *384f.*, 406, 408.
Giusti: see Juste.
Glycon of Athens, 147.
Goujon, Jean, *349ff.*, 381.
Grafly, Charles, *518*, 519.
Grasser, Erasmus, 265f.
Greenough, Horatio, 429f.
Guglielmo, Master, 210f.
Guido da Como, 214.

Hahn, Hermann, 464.
Haller, Hermann, 464.
Hans of Gmünd, 279.
Hernández: see Fernández.
Hildebrand, Adolf, *462ff.*, 465, 519.
Hoetger, Bernhard, 464.
Hoffman, Malvina, 519f.
Hool, Jan van, 398.
Houdon, Jean Antoine, 390, *394f.*
Huerta, Jean de la, 237.
Hyatt, Anna Vaughn, 519.

Juni, Juan de, *368*, 412.
Juste family, 349.

Keyzer, Hendrik de, 400f.
Keyzer, Pieter de, 401.
Keyzer, Willem de, 401.
Klinger, Max, *465f.*, 499.
Kobun, 545.
Krafft, Adam *261ff.*, 357.
Krumper, Hans, 363.

Lagaë, Jules, 472.
Lambeaux, Jef, 471f.

Landowski, Paul, *455*, 482, 489.
Laurana, Francesco, *331ff.*, 523.
Le Bouteillier, Jean, 232.
Le Brun, Charles, 383, 384, 387, 423.
Lehmbruck, Wilhelm, 464f.
Le Moiturier, Antoine, 237.
Lemoyne, Jean Baptiste, *389*, 391.
Leochares of Athens, 124, 125, 132.
Leoni, Leone, 365f.
Leoni, Pompeo, 366.
Lombardo, Antonio, 327.
Lombardo, Pietro, 327.
Lombardo, Tullio, 327.
Lomme, Janin, 279f.
Lycius, 102.
Lysippus, 112, *120ff.*, 129, 131.

MacMonnies, Frederick, 515ff.
Maiano, Benedetto da, 318, *319f.*, 413.
Maillol, Aristide, *452f.*, 455, 463, 464, 465, 491, 492, 523.
Maison, Rudolf, 459f.
Maitani, Lorenzo, 288f.
Manship, Paul, 487, 492, *520f.*
Mantegazza, Cristoforo and Antonio. *323*, 326, 327, 329.
Marville, Jean de, *234*, 237.
Masegne, Jacobello and Pier Paolo dalle, 291.
Matthew, Master, 275.
Mazzoni, Guido, 328.
Meit, Konrad, 361f.
Mena, Pedro de, 414.
Menelaus, 149.
Mercadante, Lorenzo, 278.
Mercié, Antonin, 446f.
Messerschmidt, Franz Xaver, 409f.

Meštrović, Ivan, 487, *492f.*, 521.
Metzner, Franz, *467*, 492, 521.
Meunier, Constantin, 445, 455, *468ff.*, 472, 474, 483, 489.
Michael Angelo Buonarroti, 6, 331, *335ff.*, 345, 367, 368, 372, 440, 448, 449, 450, 481, 514, 515, 517.
Michel, Claude: see Clodion.
Michelozzi, Michelozzo, 298, 307.
Mikkiades of Chios, 64.
Millán, Pedro, 278.
Milles, Carl, 490.
Milmore, Martin, *495f.*, 498.
Minne, George, 465, *473f.*, 521.
Mino da Fiesole, *312ff.*, 318, 329, 331.
Mone, Jean, 355f.
Montañés, Juan Martínez, 412ff.
Moral, Lesmes Fernández del, 366.
Münsterman, Ludwig, 405.
Myron of Eleutheræ, *87ff.*, 102, 105, 108.

Nesiotes of Athens, *83f.*, 105, 108.
Niccolò, Master, 211f.
Nicola d'Apulia, 210, 216, *281ff.*, 284, 285, 290, 297, 320.
Niehaus, Charles Henry, 509f.
Nollekens, Joseph, 404.

Onatas of Ægina, 72.
Opera, Giovanni dell': see Bandini.
Orcagna, Andrea, 287f.
Ordóñez, Bartolomé, *367*, 368.

Pæonius of Mende, 92, *101.*
Pajou, Augustin, 351, *392f.,* 395.
Palmer, Erastus Dow, *496,* 500.
Pasiteles, 148f.
Pasti, Matteo dei, 315.
Permoser, Balthasar, 408f.
Phidias, 81, 82, *96ff.,* 102, 105.
Pigalle, Jean Baptiste, *389f.,* 395.
Pilon, Germain, *351f.,* 364, 381.
Pisano, Andrea, *286ff.,* 305f.
Pisano, Giovanni, 210, 281, *283ff.,* 287, 297.
Pisano, Nicola: *see* Nicola d'Apulia.
Polasek, Albin, 518f.
Pollaiuolo, Antonio, *315f.,* 317, 365.
Polyclitus, 82, *95f.,* 147, 153.
Polydorus of Rhodes, 144.
Powers, Hiram, 429f.
Pradier, James, 440.
Pratt, Bela Lyon, 510.
Praxias of Athens, 102.
Praxiteles, 112, *113ff.,* 131, 147, 418.
Prieur, Barthélemy, 381f.
Primaticcio, Francesco, *348,* 351, 352.
Puget, Pierre, 386f.
Pythagoras of Rhegium, 87.

Quellin, Artus I, *395f.,* 401.
Quercia, Jacopo della, 297, 304, *320f.*
Querol, Agustín, 488.

Rauch, Daniel Christian, *455f.,* 457, 458.
Ravy, Jean, 232.
Regnault, Guillaume, 242.
Renier de Huy, 207.

Rhœcus of Samos, 7.
Richier, Ligier, 353f.
Riemenschneider, Tilman, 259, *263f.*
Rimmer, William, *498f.,* 506.
Rinehart, William Henry, 500.
Rizzo, Antonio, 325f.
Robbia, Andrea della, *309f.,* 311, 320.
Robbia, Giovanni della, 311.
Robbia, Luca della, 287, *308f.,* 312.
Rodin, Auguste, 433, 434, *448ff.,* 453, 455, 472, 479, 483, 487, 489, 491, 492, 493, 498, 499, 511, 513, 514, 516, 518, 519.
Rogers, Randolph, 499.
Rossellino, Antonio, 318f.
Rossellino, Bernardo, *307,* 312, 318, 319.
Rosso, Medardo, 479.
Roubillac, Louis François, 403.
Rousseau, Victor, *472f.,* 490.
Rude, François, *436f.,* 438, 440, 442, 446, 472.
Rush, William, 429.
Rysbrack, John Michael, 403.

Saint-Gaudens, Augustus, 496, 501, *502ff.,* 508, 510.
Salzillo, Francisco, 415.
Sansovino, Andrea, *335,* 342.
Sansovino, Jacopò, 342f.
Santi, Andriolo, 291.
Santi family, 291.
Sarrazin, Jacques, 382.
Schadow, Johann Gottfried, *425f.,* 427, 455.
Scheemakers, Peter, 403.
Schlüter, Andreas, 406ff.
Schmitz, Bruno, 458f., 467.
Scopas, 112, *118ff.,* 124, 125.

Siemering, Rudolf, 458.
Siloé, Gil de, 280f.
Sinding, Stephan, 490.
Sluter, Claus, *234ff*., 266, 298.
Stappen, Charles van der, 472.
Stephanus, 148.
Stevens, Alfred, 480f.
Stone, Nicholas, 401f.
Story, William Wetmore, 499.
Stoss, Veit, *261ff*., 357.
Strongylion of Athens, 102.
Styppax of Cyprus, 102.
Syrlin, Jörg, the Elder, 265.

Tacca, Pietro, *347f*., 391.
Taft, Lorado, 500, *510ff*.
Tankei, 545.
Tatti, Jacopo: *see* Sansovino, Jacopo.
Tauriscus of Tralles, 144.
Theodorus of Samos, 7.
Thornycroft, William Hamo, 482f.
Thorvaldsen, Bertel, 72, 418, *421f*., 423, 490, 494.
Tilgner, Viktor, 461f.
Timotheus of Athens, 124, 125.
Tomé, Narciso, 415.
Tori, 542.
Torrigiano, Pietro, 364, 365.
Traù, Giovanni da, 314, 329.
Tribolo, Niccolò, 345.
Troubetzkoi, Prince Paul, 490, *491f*., 517.
Tuaillon, Louis, 464.

Ugolino, Andrea di: *see* Pisano, Andrea.

Vallfogona, Pere Johan de, 278f.
Vela, Vincenzo, *476f*., 478.
Verhaegen, Theodor, 399.
Verhulst, Rombout, 401.
Verrocchio, Andrea del, 315, *316ff*., 339.
Vigarni, Felipe, *366*, 368.
Vigeland, Gustav, 490f.
Vigne, Paul de, 472.
Vinci, Leonardo da, 347, 348.
Vinçotte, Thomas, 472.
Vischer, Peter, the Elder, *357ff*., 364.
Vischer, Peter, the Younger, 359f.
Vriendt, Cornelis Floris de: *see* Floris de Vriendt, Cornelis.
Vries, Adriaen de, 363.

Wagmüller, Michael, *459*, 484.
Wagner, Johann Peter Alexander, 408.
Ward, John Quincy Adams, *496ff*., 499, 504, 506.
Warner, Olin Levi, 501, *502f*., 504.
Watts, George Frederick, 483.
Werve, Claus de, 236f.
Weyden, Roger van der, 246.
Wilton, Joseph, 404.
Witte, Peeter de: *see* Candido, Pietro.
Wolvinius, 186.
Wood, Derwent, *482*, 489.
Wunkei, 545.

Zarcillo: *see* Salzillo.
Zumbusch, Kaspar, 460f.

INDEX OF MONUMENTS AND PLACES

In this index monuments are listed primarily by the places where they are now to be found. An asterisk indicates that an illustration is given.

Abu Simbel, colossi of Ramses II, 27.*

Abydos, Egypt, relief of Seti I, 29.*

Ægina marbles, 72-75*, 418, 422.

Agias, statue, 121-123.*

Aix-en-Provence, statue by Nicolas Coustou, 385.*

Ajantā, India, Gupta carvings, 534.

Albany, N. Y., cemetery, angel by Palmer, 496.

Alcalá de Henares, church of La Magistral, tomb by Ordóñez, 367.

Aldworth, church, tombs of knights, 271.*

Alexander sarcophagus, 133f.*

Amarāvatī, India, carvings from, 533.

Amboise, relief of 15th century, 238.

Amiens, cathedral,
choir-stalls, 239.
portals, west, 226ff.*
Porte Dorée, 230.

Amsterdam,
Royal Palace, sculpture by Quellin, 395f.
Ryks Museum,
effigies by Jacques de Gérines, 247.

Amsterdam,
Ryks Museum (Continued)
organ panels, 248.
panels for House of Charity, 400f.
Visitation, 248.

Angkor, carvings, 538.

Angoulême, St. Pierre, façade, 202, 205.

Annaberg, church, high altar, 360.

Antwerp,
cathedral, Virgin, 244.
Hôtel de Ville, fireplace, 356.*
St. André, pulpit, 398f.*

Anurādhapura, standing Buddha, 536.

Aphrodite of Cnidus, 115f.,* 147.

Aphrodite of Melos, 131f.*

Apollo Belvedere, 132f.,* 374, 419, 421.

Apollo of Melos, 61f.*

Apollo Sauroctonus, 116.

Apollo from temple of Zeus at Olympia, 91.*

Apollo from Veii, 151f.*

"Apollos," archaic Greek, 61f.,* 79.

Apoxyomenus, 121f.*

Ara Pacis Augustæ, 153ff.,* 158.

Ardenne, royal castle, sculpture by Vinçotte, 472.
Arles, St. Trophime, façade, 200f.,* 212.
Artemis of Versailles, 132.
Ashurbanipal, reliefs of, 46ff.*
Ashurnasïrpal, statue, 40f.;* reliefs of, 42ff.*
Assisi, S. Maria degli Angeli, altarpiece by Andrea della Robbia, 310.*
Astorga, cathedral, retable by Becerra, 368.
Athena Parthenos, 97ff.*
Athens,
 Acropolis Museum,
 archaic female figures, 75ff.*
 Calfbearer, 65,* 76.
 Heracles and the Old Man of the Sea, 68.
 Man mounting chariot, 77f.*
 "Typhon," 67f.,* 70.
 Victory tying her sandal, 109.*
 Athena Nike temple and balustrade, 108,* 125, 351.
 Erechtheum, 107f., 351.
 National Museum,
 Apollo of Melos, 61f.*
 heads from the temple of Athena Alea at Tegea, 118f.*
 Nicandra statue, 60f.,* 79.
 sculptures from Lycosura, 142.
 sculptures from the temple of Asclepius at Epidaurus, 125.
 Varvakeion Athena, 97f.*
 Victory of Delos, 64f.*

Athens (Continued)
 Parthenon, 102ff., 418, 422.
 "Theseum," 108.
Attalus I, dedications of, 134ff.*
Augsburg,
 cathedral, doors, 206, 215.
 church of St. Ulrich and St. Afra, retable by Degler, 405f.*
 fountains of Augustus, Hercules, and Mercury, 363.*
Augustus of Prima Porta, 153.*
Aulnay, St. Pierre, Romanesque sculpture, 202.
Autun, St. Lazare, portal, 200,* 225.
Avignon,
 cathedral, tombs of the popes, 233.
 St. Didier, relief by Laurana, 332f.
Avila,
 Sto. Tomás, tomb by Fancelli, 365.
 S. Vicente, portals, 275.

Babylon, Gate of Ishtar, reliefs, 48f.*
Baltimore, Md.,
 Clytie by Rinehart, 500.*
 Colonel Howard by Frémiet, 442f.*
 groups by Barye, 439.
 monument by Niehaus, 509.
Bamberg,
 cathedral, Gothic sculpture, 251, 253,* 254.
 Pfarrkirche, retable by Stoss, 263.
Barcelona,
 Casa Consistorial, archangel, 279.

Barcelona (Continued)
Casa de la Diputación, frieze of heads, 279.
medallion of St. George, 279.
cathedral,
reliquary of St. Eulalia, 277.
sculptures by Ordóñez, 367.
Bar-le-Duc, St. Pierre, sepulchral figure by Ligier Richier, 353.
Barletta, portrait statue (Theodosius?), 180.
Basel, cathedral, portal, 205.
Bassæ, temple of Apollo Epicurius, 109f.
Belfort, Place d'Armes, group by Mercié, 446.
Benevento, cathedral, doors, 215f.*
Bergamo, S. Maria Maggiore, façade and tombs by Amadeo, 323ff.*
monument to Donizetti by Vela, 476.
Berlin,
Arsenal, masks of dying warriors by Schlüter, 407.
Brandenburg Gate, sculpture by Schadow, 425.
cathedral, tombs by Schlüter, 407f.
Ethnographical Museum, Buddha of Gandhāra style, 533.*
Kaiser Friedrich Museum, bust by Desiderio, 312.
bust by Meit, 362.
Cupid by Duquesnoy, 378.*
sculpture by Giovanni Pisano, 284.

Berlin,
Kaiser Friedrich Museum (Continued)
stalls by A. Dauher, 360.
statues by Schadow, 425.
Long Bridge, Great Elector by Schlüter, 406f.*
Marien-Kirche, pulpit by Schlüter, 407.
National Gallery,
Amazon by Tuaillon, 464.
bust of Böcklin by Hildebrand, 464.
bust of Menzel by Begas, 458.
kneeling woman by Lehmbruck, 465.
recumbent maiden by Schadow, 425.
statue by Hildebrand, 463.*
New Museum,
Ikhnaton and his queen, 30.*
reliefs from the Great Altar of Pergamum, 136ff.*
Old Museum, Meleager after Scopas, 119.
Rheingold Wine House, sculpture by Metzner, 467.
Royal Palace,
Princesses by Schadow, 425.*
fountain by Begas, 457f.
monument to William I by Begas, 457.*
Unter den Linden, Frederick the Great by Rauch, 455f.*
Bewcastle, cross, 183f.*
Bilbao, monument by Blay, 488f.*

Blutenburg, wood-carvings, 266.

Boghaz-Keui, rock-cut reliefs 50.

Bologna,
fountain by Giovanni Bologna, 345.
S. Domenico, shrine of the saint, 290.
S. Maria della Vita, Pietà by Niccolò da Bari, 328.
S. Petronio, sculpture by Jacopo della Quercia, 320f.*

Bordeaux,
cathedral,
north portal, 231.
St. Anne, 242.*
statues on the apse buttresses, 231.
St. Seurin, porch, 230.

Borghese Warrior, 145f.*

Borgo San Donnino, cathedral, sculpture by Benedetto of Parma, 212.

Bōrōbudur, Buddhist carvings, 537.

Boston, Mass.,
Art Club, lions by Rimmer, 498.
Back Bay Fens, monument to O'Reilly by French, 506.
Common, Soldiers' Monument by Milmore, 496.
Commonwealth Avenue,
Garrison by Warner, 502.
Hamilton by Rimmer, 499.
Fenway Court,
bust by Cellini, 345.
Chinese stele, 539f.*
Romanesque sculpture, 202.

Boston, Mass. (Continued)
Forest Hills Cemetery, monument to Milmore by French, 508.
Museum of Fine Arts,
Avalokiteśvara (Sinhalese), 537.
Boddhisattva (Tang), 541.
bronze Śiva, 535f.*
Cupid by Greenough, 430.
Egyptian reliefs, 23.*
Han slabs, 538f.
head of Zeus, 99f.*
Javanese relief, 537.
Menkure and his Queen, 20f.*
Patriarch, Japanese, 545.*
Saite portrait head, 31.*
sculptures by Pratt, 510.
sculptures by Rimmer, 498f.*
Snake Goddess, 54f.*
three-sided relief, Greek, 93f.*
Public Garden, Washington by Ball, 494.
Public Library,
doors by French, 508.
Science and Art by Pratt, 510.
State House,
Anne Hutchinson by Dallin, 513.
Washington by Chantrey, 427.
Webster by Powers, 430.
(opposite State House),
Shaw monument by Saint-Gaudens, 506.
Trinity Church,
Dr. Donald by Pratt, 510.

Bourg, church of Brou, tombs, 362.

Bourges,
 cathedral, tympanum of
 Last Judgment, 230,
 276.
 house of Jacques Cœur,
 carvings, 239.
Boy and Goose, 140.*
Branchidæ, seated statues
 from, 63f.*
Breda, Protestant Church,
 choir-stalls, 247.
Bremen,
 Bismarck by Hildebrand,
 464.
 fountain by Maison, 460.*
 Kaiser Frederick by Tuail-
 lon, 464.
Breslau, Kreuz-Kirche, tomb
 of Duke Henry IV, 256.
Bristol, England, Mayor's
 Chapel, knight, 270.
Brooklyn, N. Y.,
 Beecher monument by Ward,
 497.
 sculptures by MacMonnies,
 517.
Brou: see Bourg.
Bruges,
 Hospital of St. John, tym-
 panum, 244.
 Palais de Justice, fireplace,
 357.
Brunswick,
 bronze lion, 206.
 cathedral, tomb of Henry
 the Lion, 257.
Brussels,
 Avenue Louise, Horse Tamer
 by Vinçotte, 472.
 Avenue Palmerston, La folle
 chanson by Lambeaux,
 470f.*
 Musée du Cinquantenaire,

Brussels,
 Musée du Cinquantenaire
 (Continued)
 retable by Borreman,
 248f.*
 terracotta by Faydherbe,
 397.
 Musée Royale,
 sculpture by Meunier,
 470.
 Sisters of Illusion by Rous-
 seau, 473.*
 Parc du Cinquantenaire,
 monument by Van der
 Stappen, 472.
 Place du Petit Sablon, monu-
 ment by Fraikin, 467.
 Rue Royale, monument by
 Geefs, 467.
Budapest, angels by Donner,
 409.
Burgos,
 cathedral,
 Gothic sculpture, 275f.*
 reliefs by Vigarni, 366.
 St. Jerome by Becerra,
 368.*
 church of Miraflores, sculp-
 ture by Gil de Siloé,
 281.
 Museum, tomb by Gil de
 Siloé, 281.

Cairo, Egypt, Museum,
 head of Harmheb, 27f.*
 Khafre seated, 21.
 Sesostris I, 25.*
 Sheikh-el-Beled, 18f.*
Cairo, Ill., Hewer by Barnard,
 509, 514.
Calais, group by Rodin, 449.
Calcar, retable by Douwer-
 mann, 260.

Calcutta, Museum,
 archaic Indian statues, 530.
 Gandhāra relief, 533.
 sculptures from Bharhut, 532.
 sculptures from Mathurā, 533.
Calf-bearer, 65*, 76.
Cambridge, England, King's College, choir-stalls, 364.
Cambridge, Mass.,
 Fogg Museum,
 Burgundian capitals, 200.
 Cambodian head, 538.
 Meleager, 119.*
 Harvard College Yard, John Harvard by French, 506.
 Harvard University, Robinson Hall, Water-carrier by Gemito, 477f.*
 Mount Auburn Cemetery,
 Chickering monument by Ball, 495.
 Coppenhagen monument by Milmore, 496.*
 Story by Story, 499.
Candia, Museum, ivory "Divers" from Cnossus, 54.
Capua, Museum, arch of Frederick II, fragments, 216f.*
Champmol (Dijon), monastery,
 portal, 234.
 pedestal for well, 234ff,* 298.
Chantilly, chapel, monument of Henri de Condé by Sarrazin, 382.
Chaource, Holy Sepulchre, 243.
Charité-sur-Loire, La, tympana, 202.

Charleston, S. C., Pitt by Wilton, 404.
Chartres, cathedral,
 west portal, 200, 212, 224ff.,* 251, 267, 275.
 lateral portals, 226, 253, 255, 268.
Châteaudun, saints, 239.
Chatsworth, Lætitia Bonaparte by Canova, 421.
Chester,
 cathedral, stalls, 271.
 Eaton Hall, Hugh Lupus by Watts, 483.
Chicago,
 Art Institute, sculpture by Taft, 511f.
 Lincoln Park,
 Goethe by Hahn, 464.
 Lincoln by Saint-Gaudens, 504f.*
 Signal of Peace by Dallin, 512f.*
 Midway Plaisance, fountain by Taft, 512f.*
Christiania, sculpture by Vigeland, 490f.*
Cincinnati,
 Garfield by Niehaus, 509.
 group by S. Borglum, 513.
 Lincoln by Barnard, 514.
Cividale, saints in stucco, 184.
Clermont-Ferrand, Notre Dame du Port, portal, 202.
Cleve, retable by Douwermann, 260.
Cluny, capitals, 199.
Cologne,
 cathedral, choir-pillars, 257.
 St. Cecilia, tympanum, 205.
 St. Gereon, Virgin, 14th Century, 258.

Colombo, Museum, seated Buddha, 536.

Como, Lake, Villa Carlotta, frieze by Thorvaldsen, 422.

Concord, Mass., Sleepy Hollow, Melvin monument by French, 507f.*

Conques, Ste. Foy, tympanum, 202.

Constantine, arch of, reliefs, 161f., 165f.*

Constantinople, Ottoman Museum, Alexander sarcophagus, 133f.*

Copenhagen, Valkyr by Sinding, 490.

Courtrai, Notre Dame, St. Catherine, 245.

Cracow,
cathedral, Potocki by Thorvaldsen, 422.
St. Mary's, retable by Stoss, 261f.*

Cremona, cathedral, Prophets, 212.

Cuéllar, S. Esteban, tombs, 277f.*

Cuenca, tombs, 279.

Cyprus, sculpture from, 50.

Delft, Nieuwe Kerk, tomb of William the Silent by De Keyzer, 400.

Delphi, Museum,
Agias, 121ff.*
Charioteer, 86f.*
Siphnian Treasury, 69ff.*

Detroit, Mich., Tolstoi by Troubetzkoi, 491f.*

Dijon,
Champmol, monastery: see Champmol.

Dijon (Continued)
Ducal Palace, Sluter by Bouchard, 455.
Museum,
bust of Christ by Sluter, 236.
tombs, 236ff.,* 266, 280.

Dinan, Du Guesclin by Frémiet, 442.

Dinton, England, tympanum, 208.*

Discobolus by Myron, 87f.

Dordrecht, Groote Kerk, choirstalls, 357.

Dresden,
Albertinum,
Bacchante after Scopas, 119.
Drama by Klinger, 466.
Court Church, pulpit by Permoser, 408.
Palace of the Zwinger, decoration by Permoser, 408.

Duisburg, statue by Lehmbruck, 465.

Durham, cathedral, Romanesque reliefs, 209.

Dying Gladiator, 135f.*

Edinburgh, cathedral, Stevenson by Saint-Gaudens, 506.

Elephanta, mediæval Indian carvings, 534f.

Elgin marbles, 102ff.

Elūrā, mediæval Indian carvings, 534f.

Ely, cathedral,
choir-stalls, 270.
stone seats, 270.

Escorial, sepulchral figures by Pompeo Leoni, 366.

Exeter, England, cathedral, façade, 270.

Farnese Bull, 144f.*
Farnese Heracles, 147.
Ferrara, cathedral, portal, 211f.
Ferté-Milon, La,
 Racine by David d'Angers, 437.
 relief on castle, 238.
Fiesole, cathedral, altar by Mino, 313.
Florence,
 Academy, David by Michael Angelo, 335, 339, 340, 341.
 Badia,
 altar by Mino, 313.*
 tomb by Mino, 314.
 baptistery,
 doors by Andrea Pisano, 286f.,* 305f.
 doors by Ghiberti, 305ff.*
 Magdalene by Donatello, 300.
 Bargello,
 Bacchus by Jacopo Sansovino, 342f.*
 Bacchus by Michael Angelo, 335, 340.
 bust by Benedetto da Maiano, 320.
 bust by Bernini, 376.
 bust by Cellini, 345.
 bust by Laurana, 332.
 bust by Antonio Rossellino, 319.*
 bust by Verrocchio, 318.
 David by Donatello, 301f., 316, 339, 446.
 David by Verrocchio, 316, 339.
 group by Pollaiuolo, 315f.*
 Madonna by Luca della Robbia, 308f.*
 Madonna by Michael Angelo, 335, 341.

Florence,
 Bargello (Continued)
 Madonna by Verrocchio, 318.*
 Mercury by Giovanni Bologna, 345.
 Oceanus by Giovanni Bologna, 345.
 Perseus by Cellini, 344f.*
 reliefs by Brunelleschi and Ghiberti, 306.
 St. George by Donatello, 300.
 St. John by Antonio Rossellino, 319.
 Victory by Michael Angelo, 345.
 Virtue by Giovanni Bologna, 345.
 Boboli Garden, fountains by Giovanni Bologna, 345f.*
 Casa Buonarroti, Madonna by Michael Angelo, 335, 341.
 campanile,
 reliefs, 287.
 statues by Donatello, 298f.*
 cathedral,
 doors by Luca della Robbia, 309.
 Pietà by Michael Angelo, 339.
 statues by Donatello, 298f.
 Chapel of the Vanchetoni, bust by Desiderio, 312.
 Gallery of Modern Art, Abel by Duprè, 475.
 Hospital of the Innocents, reliefs by Andrea della Robbia, 309.
 Loggia dei Lanzi,
 Perseus by Cellini, 344.

Florence,
Loggia dei Lanzi (Continued)
Rape of the Sabine woman
by Giovanni Bologna,
346f.*
Opera del Duomo,
reliefs by Bandinelli and
Bandini, 342.
singing-gallery by Dona-
tello, 302.
singing-gallery by Luca
della Robbia, 309.
Or San Michele,
group by Verrocchio, 317.
statues by Donatello,
298.
tabernacle by Orcagna,
288.
Palazzo Panciatichi, Ma-
donna by Desiderio,
311f.*
Palazzo Vecchio,
Hercules and Cacus by
Bandinelli, 341f.
Putto by Verrocchio, 317.
Pazzi Chapel, reliefs by Luca
della Robbia, 309.
Piazza della Signoria, Cos-
imo I by Giovanni
Bologna, 346.
Pitti Gallery, Charity by
Bartolini, 475.
S. Croce,
Annunciation by Dona-
tello, 302, 304.*
pulpit by Benedetto da
Maiano, 319.
tomb by Bartolini, 475.
tomb by Bernardo Rossel-
lino, 307,* 312.
tomb by Desiderio, 312.
S. Lorenzo,
pulpits by Donatello, 301f.

Florence,
S. Lorenzo (Continued)
tabernacle by Desiderio,
312.
tombs by Michael Angelo,
338f.,* 340.
S. Miniato, tomb by Antonio
Rossellino, 319.
Uffizi Gallery,
Machiavelli by Bartolini,
475.
reliefs from the Ara Pacis
Augustæ, 153ff.*
Venus dei Medici, 147, 430.
Villa della Petraia, foun-
tain by Giovanni Bo-
logna, 346.
Frankfort on the Main,
Bethmann's Museum, Ari-
adne by Dannecker, 424.
Municipal Sculpture Gal-
lery, Athena after
Myron, 89.
Städel Art Institute, Ma-
donna by Riemenschnei-
der, 264.
Frascarolo Lomellina, tomb by
Bistolfi, 478f.*
Freiberg, cathedral, Goldene
Pforte, 244, 252.*

Geneva, monument to Refor-
mation, 455.
Genoa,
Camposanto, tombs, 477.
Loggia dei Banchi, Cavour
by Vela, 476.
University, reliefs by Gio-
vanni Bologna, 346.
Gerona, cathedral, tomb, 279.
Gheel, St. Dympna, tomb of
Jan III de Mérode,
356.

Ghent, cathedral, tomb by Delcour, 397.

Gizeh, Great Sphinx, 21, 27.

Gloucester, England, cathedral, choir-stalls, 271.

Gnesen, doors, 206.

Granada,
 cathedral,
 Immaculate Conception by Cano, 414.
 sculptures by Vigarni, 366.
 tomb of Ferdinand and Isabella by Fancelli, 365.
 tomb of parents of Charles V by Ordóñez, 367.
 the Cartuja,
 Magdalene by Cano, 414.

Gudea, statues of, 36f.*

Haarlem, Episcopal Museum, Epiphany, 248.

Hagen, Westphalia, fountain by Minne, 473f.*

Hal, Notre Dame,
 retable by Jean Mone, 355.
 Virgin, 245.

Halicarnassus, Mausoleum at, 118, 123ff.*

Hamburg, monument to Brahms by Klinger, 466.

Harrisburg, Pa., groups by Barnard, 514f.*

Hereford, cathedral, font, 209.

Hildesheim, cathedral,
 doors, 186ff.*
 Easter column, 186ff.
 font, 205ff.*

Hoogstraeten, St. Catherine, tomb of Count de Lalaing, 356.

Huy, Notre Dame, portal, 244.

Indianapolis, Soldiers' Monument, 459.

Innsbruck, Franciscan church, tomb of Maximilian, 359.

Isola Bella, tomb by Amadeo, 325.

Kampen, Stadhuis, fireplace, 357.

Karnak, reliefs of Seti I, 28f.*

Katwijk-Binnen, tomb by Verhulst, 401.

Khotan, carvings influenced by Hellenistic art, 540.

Kioto,
 Kiovogo-Kokuji temple, statue of Bisjamon, 540.
 Toji temple, figures on animals, 541.

Konārak, Indian sculpture, 536.

Lahore, Museum, statue of Kuvera, 533.

Laocoön group, 143f.,* 146, 339, 440.

Léau, St. Léonard, tabernacle by Floris de Vriendt, 356.

Leeds, sculpture by Drury, 484.

Leghorn, monument of Ferdinand I, 347.

Leipzig,
 Battle Monument, 458f.,* 467.
 Museum, sculpture by Klinger, 465f.

Leon, cathedral,
 choir-stalls, 279.
 portals, 276.
 tomb of Bishop Martin, 276.
Lerma, S. Pedro, tomb of
 Cristóbal de Rojas,
 365f.*
Leyden, reliefs by Verhulst,
 400f.*
Liége,
 Archæological Museum, bust
 by Delcour, 397.
 St. Barthélemy, font, 207.
Lierre, screen, 247.*
Lille, relief by Donatello, 302.
Lincoln, England, cathedral,
 angel-choir, 269.
 Judgment Porch, 268.
Lincoln, Neb., Lincoln by
 French, 508.
Linz, monument to Stelzhamer
 by Metzner, 467.
Liverpool, Mower by Thorny-
 croft, 483.
London,
 British Museum,
 bust by Meit, 362.
 Caryatid from the Erech-
 theum, 107f.*
 frieze from the temple of
 Apollo Epicurius at
 Bassæ, 109f.
 Indian sculptures, 533.
 P a r t h e n o n sculptures,
 102ff.,* 418, 422.
 portrait of Pericles, 101.*
 reliefs from the palace of
 Ashurbanipal, 46ff.*
 reliefs from the palace of
 Sennacherib, 45f.*
 sculptures from the Mau-
 soleum at Halicarnassus,
 123ff.*

London,
 British Museum (Continued)
 sculptures from the palace
 of Ashurnasirpal, 40ff.*
 seated statues from Bran-
 chidæ, 63.*
 Buckingham Palace, Victoria
 Monument, 482.
 Burlington House, Dancer
 by Wood, 482.
 Charterhouse Chapel, monu-
 ment to Sutton by
 Stone, 402.
 Dorchester House, caryatides
 by Stevens, 481.*
 Kensington Gardens,
 *Peter Pan by Frampton,
 487.
 Physical Energy by Watts,
 483.*
 Lansdowne House, Heracles,
 119.
 National Portrait Gallery,
 busts by Nollekens, 404.
 busts by Roubillac, 403.
 Scott by Chantrey, 427.
 New War Office, decoration
 by Drury, 484.
 Owen School, Islington, Alice
 Owen by Frampton,
 486f.*
 St. James church, Piccadilly,
 decorative carvings by
 Gibbons, 402.*
 font by Gibbons, 403.
 St. James's Park, James II
 by Gibbons, 403.
 St. Paul's cathedral,
 pediment by Bird, 402.
 tomb of Nelson by Flax-
 man, 426f.*
 tomb of Wellington by
 Stevens, 481.

London (Continued)
St. Paul's School, Dean Colet by Thornycroft, 483.
Tate Gallery,
bust by Drury, 484.
statues by Ford, 484.
Teucer by Thornycroft, 482f.*
Temple Church, tombs of knights, 270.
Westminster Abbey,
angels of transept-ends, 268f.*
bust of Gordon by Ford, 484.
chapel of Henry VII, 272.*
Gladstone by Brock, 482.
tomb of Aymer de Valence, 271.
tomb of Countess of Richmond, 364.
tomb of Edward III, 271.*
tomb of Henry III, 270.
tomb of Henry VII, 364.
tomb of Lord Mansfield by Flaxman, 426.
tomb of Pitt by Bacon, 404.
tomb of Queen Eleanor, 270.
tomb of Wolfe by Wilton, 404.*
tombs of Holles family by Stone, 402.
tombs by Roubillac, 403.
Longmen,
archaic Chinese carvings, 540f.
Tang carvings, 541.
Louvain,
Ste. Gertrude, choir-stalls, 247.

Louvain (Continued)
St. Jacques, tabernacle, 247.
Lowell, Mass., Butler Memorial by Pratt, 510.
Lucca,
carvings of lintels, 214.
cathedral,
Romanesque carvings, 214.
tomb of Ilaria by Jacopo della Quercia, 321.
"Ludovisi Throne," 93ff.,* 116.
Lycosura, fragments from, 142.
Lyons,
cathedral, reliefs on façade, 231, 287.
Museum, Graces by Chinard, 423.

Maastricht, St. Servatius, portal, 244.
Madras, Central Museum, carvings from Amarāvatī, 533.
Madrid,
house of Iturbe family, portraits by Blay, 489.
Museum of Modern Art,
group by Querol, 488.
"Eclosion" by Blay, 489.
Panteón de Atocha, tomb by Querol, 488.
Park of Buen Retiro, angel by Bellver, 488.
Plaza de Oriente, Philip IV by Tacca, 347.
Prado, ivory by Faydherbe, 397.
Magdeburg, cathedral,
tomb of Archbishop Ernest by Vischer, 357.
tomb of Archbishop Frederick I, 206f.*

Malaga,
cathedral, choir-stalls by Pedro de Mena, 414.
Sto. Domingo, Virgin by Pedro de Mena, 414.*
Malines,
cathedral, tomb by Faydherbe, 397.
Notre Dame de Hanswyck, sculpture by Faydherbe, 397.
Māmallapūram, mediæval Indian carvings, 535.
Manchester, England,
Lincoln by Barnard, 514.
Victoria by Ford, 484.
Marble Faun, 116f.*
Marcus Aurelius, column of, 164.
Marcus Aurelius, relief, 163.*
Marseilles, old cathedral, tabernacle by Laurana, 332.
Mathurā, India, Museum,
archaic statues, 530.
carvings of Gandhāra period, 533.
standing Buddha, 534.
Mayence, tomb of Konrad von Weinsberg, 258.*
Meiningen, English Garden, bust of Otto Ludwig by Hildebrand, 464.
Menkure and his Queen, 20f.*
Merseburg, cathedral, tomb of Rudolf of Swabia, 207.
Metz, Lafayette by Bartlett, 517.
Midwolde, tomb by Verhulst, 401.
Milan,
S. Ambrogio,
altar-canopy, 184.
altar-casing, 186.

Milan,
St. Ambrogio (Continued)
capitals, 210.
S. Eustorgio, shrine of St. Peter Martyr, 277, 290, 323.
statue of Sforza by Leonardo da Vinci, 347.
Modena,
cathedral,
Nativity by Mazzoni, 328.*
reliefs of the Passion, 212.
sculptures by Guglielmo and Niccolò, 210f.
S. Francesco, Deposition by Begarelli, 329.
S. Giovanni della Buona Morte, Holy Sepulchre by Mazzoni, 328.
S. Pietro, altarpiece by Begarelli, 329.
Moissac, St. Pierre, Romanesque sculpture, 198f., 203, 205, 225.
Monasterboice, cross, 184.
Monreale, Sicily, doors by Barisanus and Bonannus, 215.
Mons, sculpture by Du Broeucq, 354.
Montrottier, château, reliefs by Vischer, 359.
Moulins, tomb of Montmorency by F. Anguier, 383.
Munich,
Alte Residenz, fountain, 363.
Forum, Rumford by Zumbusch, 461.
Frauen-Kirche, choir-stalls, 265.

Munich (Continued)
Glyptothek,
relief, Peasant and Cow, 140ff.*
sculpture from the temple of Aphaia at Ægina, 72ff,* 418.
Marien-Platz, Virgin, 363.
Maximilians-Platz, fountain by Hildebrand, 464.
National Museum, Judith by Meit, 362.
Old Rathaus, statuettes by Grasser, 265f.
St. Peter's, tomb by Grasser, 265.
Wittelsbacher-Platz, Maximilian by Thorvaldsen, 422.
Münster, portal, 244, 252.
Murcia, Ermita de Jesús, groups by Salzillo, 415.
Mycenæ, Lion Gate, 53f.*

Nancy,
Drouot by David d'Angers, 437f.*
Franciscan church, tomb by Richier, 354.
Nantes, cathedral,
tomb by Colombe, 241f.*
tomb by Dubois, 448.
Naples,
cathedral, Romanesque reliefs, 217.
Monte Oliveto,
Annunciation by Benedetto da Maiano, 319.
Nativity by Antonio Rossellino, 319.
National Museum,
Doryphorus after Polyclitus, 95f.*

Naples,
National Museum (Continued)
Farnese Heracles by Glycon, 147.
Harmodius and Aristogiton after Critius and Nesiotes, 84ff.*
head of Doryphorus by Apollonius, 147.
S. Angelo a Nilo, tomb by Donatello, 302f.*
S. Maria Donna Regina, tomb by Tino di Camaino, 288.*
Triumphal Arch, sculpture by Laurana, 331.
Nara,
Chuguji nunnery, Kwannon, 543.
Horyuji temple,
Hakuho Trinity, 543.
Kwannon, 542.
statues of heavenly kings, 543.
Trinity by Tori, 542.
Kofukuji monastery, Lantern Bearer by Kobun, 545.
Kondo of Yakushiji, Trinity, 543f.*
Shin Yakushi monastery, heavenly kings, 545.
Narâm-Sin, stele of, 38f.*
Naumburg, cathedral, statues of benefactors, 254f.*
Newark, N. J., Lincoln by G. Borglum, 517.
New Haven, Conn., Yale University, Nathan Hale by Pratt, 510.
New York,
All Souls Church, Bellows by Saint-Gaudens, 506.

New York (Continued)

Blumenthal Collection, bust by Pajou, 393.*

Central Park, Indian by Ward, 497.

City Hall Park,
Civic Virtue by MacMonnies, 517.
Nathan Hale by MacMonnies, 517.

Fifth Avenue, Sherman by Saint-Gaudens, 504.

Historical Society,
fragments by Wilton, 404.
J. Q. Adams by Greenough, 430.

Madison Square, Farragut by Saint-Gaudens, 506.

Metropolitan Museum,
Bacchante by MacMonnies, 515.
Baigneuse by Houdon, 394.
Bear Trainer by Bartlett, 517.
Blacksmith by Bouchard, 455.
bust by Riemenschneider, 264.
Byzantine Crucifixion, 181f.*
early Gothic statue, 226.
English retable, 273.*
Flavian portrait, 158f.*
group by Clodion, 394.*
group by S. Borglum, 513.*
infant by Manship, 521.
Mares of Diomedes by G. Borglum, 518.
Memory by French, 506.
Mercury by Pigalle, 389.
Nativity by Antonio Rossellino, 319.

New York,
Metropolitan Museum (Continued)
Old Market Woman, 139.*
Perseus by Gilbert, 485.
relief by Hans Dauher, 361.*
reliefs by Flötner, 360.
Ruskin by G. Borglum, 517.
St. Anne, 243.
St. Catherine, 239.
St. John Baptist, 231.
sculpture from château of Biron, 243.
sculpture from Cyprus, 50.
sculptures by Barnard, 514.
sculptures by Rodin, 451.
Spanish predella, 279.
statues by Story, 499.
statuette by Dalou, 443.
White Captive by Palmer, 496.

Public Library,
Bryant by Adams, 509.
Truth by MacMonnies, 515.

Riverside Drive, Jeanne d'Arc by Hyatt, 519.

St. Bartholomew's, sculpture by Adams, 509.

Sub-Treasury, Washington by Ward, 497f.*

Trinity Church, doors by Niehaus, 510.

Union Square, statues by Brown, 494f.*

Western Union Building, reliefs by Manship, 521.

Ninove, confessionals, 399.

Norwich, England, cathedral, stalls, 272.

Noto, Madonna by Laurana, 331.

Novgorod, doors, 206.

Nuremberg,
Burgschmiet-Strasse, relief by Krafft, 263.
Germanic Museum,
reliefs by Krafft, 262f.*
sculpture of the 14th century, 257f.
St. James, Apostles, 258.
St. Lawrence,
Annunciation by Stoss, 262.
tabernacle by Krafft, 263.
tympanum, 258.
St. Sebaldus,
reliefs by Stoss, 263.
reliquary by Vischer, 358f.
tympanum, 258.

Olympia, Museum,
Hermes by Praxiteles, 113ff.*
sculptures from the temple of Zeus, 90ff.*
Victory by Pæonius, 100f.*

Oregon, Ill., monument by Taft, 511.

Orvieto,
cathedral, carvings on façade, 288f.*
S. Domenico, tomb by Arnolfo, 286.

Oviedo, cathedral, Romanesque sculpture, 275.

Oxford,
Balliol, Jowett Memorial by Ford, 484.
St. Mary the Virgin, porch by Stone, 402.
University College, cenotaph of Shelley by Ford, 484.

Padua,
Arena chapel, Virgin by Giovanni Pisano, 285.
church of the Eremitani, tombs by Andriolo Santi, 291.
S. Antonio, sculptures by Donatello, 298ff.,* 316.

Palermo, Museum,
bust by Laurana, 332.*
metopes from Selinus, 66f.*

Pampeluna, cathedral,
Gothic sculpture, 276.
tomb of Charles the Noble, 279.

Paris,
Arc de l'Étoile,
relief by Rude, 436f.
Victories by Pradier, 440.
École des Beaux Arts,
bust of Robert by Pajou, 393.
tomb of Regnault by Chapu, 447.
Bibliothèque Nationale, Psalter of Charles the Bald, 185f.*
Bois de Boulogne, Alphand monument by Dalou, 444.
Hôtel Carnavalet,
decoration by Goujon, 351.
Louis XIV by Coysevox, 383.
Place du Carrousel, statue by Bartholomé, 454.
cathedral,
portals, 227, 255.
reliefs on choir-screen, 232.
reliefs in east end, 231.
tomb by Pigalle, 390.*

Paris,
cathedral (Continued)
Virgin of 14th century, 231f.*
Hôtel de Chambrun, reliefs by Clodion, 393.
Place de la Concorde,
equestrian groups by G. Coustou, 385f.*
equestrian groups by Coysevox, 383.
statues by Pradier, 440.
Rue de Grenelle, fountain by Bouchardon, 389.
Hôtel de Ville,
group by Mercié, 446.
Lantern-carrier by Frémiet, 442.
Institute,
Pascal by Pajou, 392.
Voltaire by Pigalle, 390, 393, 395.
Louvre, Museum,
Amour and Amitié by Pigalle, 390.
Aphrodite of Melos, 131f.*
Artemis of Versailles, 132f.
Bérulle by Sarrazin, 382.
Birague by Pilon, 352.*
Borghese Warrior, 145.*
bust by Caffieri, 391f.*
bust by Houdon, 394f.*
bust by Lemoyne, 388f.*
Captives by Michael Angelo, 337f.,* 340.
Cupid and Psyche by Canova, 419.
Cupid by Bouchardon, 389.
Diana by Houdon, 394.
Eros by Chaudet, 423.*
Fisher Boy by Carpeaux, 440.

Paris,
Louvre, Museum (Continued)
Fisher Boy by Rude, 436, 440.
"Germanicus" by Cleomenes, 147.
groups of animals by Barye, 439.*
Gudea, 36f.*
Hera of Samos, 60f.*
Jeanne d'Arc by Chapu, 447,* 502.
Louis XV by Bouchardon, 388.
monument for the heart of Henry II, 351.
Nymph by Cellini, 344.
Psyche by Pradier, 440.
putti by Pigalle, 389f.*
relief of St. George by Colombe, 242.
relief by Desiderio, 312.
reliefs by Goujon, 351.
reliefs from palace of Sargon II, 45.*
sculptures by Carpeaux, 440, 442.
sculptures by Coysevox, 383f.*
sculptures by Dubois, 448.*
sculptures by Falconet, 391.*
sculptures by Pajou, 392f.
sculptures by Prieur, 381.
sculptures by Puget, 386f.*
sculptures by the Coustou, 386.
Seated Scribe, 20.*
Souvré by F. Anguier, 382f.*
statues of Charles V and queen, 232f.*
stele of Narâm-Sin, 38f.*

Paris,
 Louvre, Museum (Continued)
 tomb of Poncher, 242.
 Victory of Samothrace, 129f.*
 Vierge d'Olivet, 242.
 Vulture stele from Tello, 37ff.
 Louvre, Palace,
 caryatides by Sarrazin, 382.
 decorations by F. Anguier, 383.
 decorations by Girardon, 384.
 decorations by Prieur, 381f.
 Flora by Carpeaux, 441.*
 lion by Barye, 438.
 Quadriga by Cartellier, 423.
 sculpture by Goujon, 351.
 stone groups by Barye, 439.
 Luxembourg,
 Amor Caritas by Saint-Gaudens, 504.
 Beethoven by Bourdelle, 455.
 David by Mercié, 446.
 Pan by Frémiet, 442.
 sculpture by Rodin, 449ff.*
 Luxembourg Gardens,
 Bacchanale by Hoffman, 519.
 monument to Delacroix by Dalou, 444.
 Silenus by Dalou, 444.*
 Musée Rodin, sculptures by Rodin, 450f.*
 Place de la Nation, monument by Dalou, 443.
 Natural History Museum, Buffon by Pajou, 393, 395.

Paris (Continued)
 Place de l'Observatoire, Ney by Rude, 436f.*
 Opéra, Dance by Carpeaux, 441.
 Palais de Justice, Berryer by Chapu, 447.
 Palais-Royal, monument to Hugo by Rodin, 450.
 Panthéon,
 p e d i m e n t by David d'Angers, 437.
 Thinker by Rodin, 451.
 tomb of Rousseau by Bartholomé, 454.
 Parc Monceau, memorial to Gounod by Mercié, 446.
 Père Lachaise,
 monument by Bartholomé, 452ff.*
 tomb of Oscar Wilde by Epstein, 487.
 Petit Palais,
 Hymn to Dawn by Landowski, 455.
 sculpture by Dalou, 443ff.
 Porte St. Denis, decoration by M. Anguier, 383.
 Place de Rivoli, Jeanne d'Arc by Frémiet, 442, 448.
 St. Jean-St. François, St. Francis by Pilon, 352.
 Sorbonne, church of, tomb of Richelieu by Girardon, 385.
 Square of the Innocents, fountain by Goujon, 350f.*
 Théâtre des Champs-Élysées, reliefs by Bourdelle, 455.

Paris (Continued)
 Théâtre Français,
 busts by Caffieri, 392.
 Corneille by Falguière,
 446.
 Voltaire by Houdon, 395f.*
 Val-de-Grace, decoration by
 M. Anguier, 383.
Parma, carvings by Benedetto
 of Parma, 212f.*
Pavia,
 the Certosa, sculpture by the
 Mantegazza and Ama-
 deo, 322ff.*
 S. Lanfranco, shrine by Ama-
 deo, 325.
 S. Michele, façade, 210.
Persepolis, reliefs from the
 palaces of Xerxes and
 Artaxerxes, 50.
Perugia, S. Bernardino, sculp-
 tures by Laurana, 314f.*
Petrograd, Peter the Great by
 Falconet, 391.
Petworth House, St. Michael
 by Flaxman, 426.
Philadelphia,
 Fairmount Park,
 fountain by Rush, 429.
 Jeanne d'Arc by Frémiet,
 442.
 Washington monument by
 Siemering, 458.
 Independence Hall, Wash-
 ington by Rush, 428f.*
 University of Pennsylvania
 Museum, stele of Kri-
 nuia, 126.*
Pisa,
 baptistery, pulpit by Nicola
 d'Apulia, 282f.*
 cathedral,
 doors by Bonannus, 215.

Pisa,
 cathedral (Continued)
 sculpture by Giovanni Pi-
 sano, 284f.
Pistoia,
 carvings of lintels, 214.
 S. Andrea, pulpit by Gio-
 vanni Pisano, 283f.*
 S. Bartolommeo, pulpit by
 Guido da Como, 214.
Plasencia, cathedral, retable by
 Fernández, 411.
Poitiers, Notre Dame la
 Grande, façade, 202.
Pollonāruwa, colossal statue,
 537.
Prato,
 exterior pulpit, 302.
 interior pulpit, 313.
Pressburg,
 cathedral, St. Martin by
 Donner, 409.
 theatre, fountain by Tilg-
 ner, 462.
Princeton, N. J.,
 Battle Monument, 516f.*
 Museum, feminine saint,
 243.*

Quedlinburg, Abbey of, tombs
 of abbesses, 207.

Ratisbon,
 St. James, façade, 205.
 Walhalla, Victories by
 Rauch, 456.
Ravello, cathedral, doors, 215.
Ravenna,
 sarcophagi, 176ff.*
 throne of Maximian, 179f.*
Reims,
 cathedral, Gothic sculpture,
 227ff.,* 253ff.

Reims (Continued)
 Jeanne d'Arc by Dubois, 448.
Richmond, Va.,
 Lee by Mercié, 446.
 Washington by Houdon, 395.
Rimini, S. Francesco, decoration by Laurana, 315.
Ripoll, façade, 204.
Ripon, stalls, 272.
Rochester, England, cathedral, portal, 209.
Rome,
 Villa Albani,
 reliefs by Thorvaldsen, 422.*
 statue by Stephanus, 148f.*
 Piazza Barberini, fountain by Bernini, 374.*
 Villa Borghese,
 Apollo and Daphne by Bernini, 373f.
 Pauline Bonaparte by Canova, 419f.*
 Capitoline Hill, Marcus Aurelius, 301.
 Capitoline Museum,
 Boy and Goose after Boethus, 139f.*
 Dying Gaul, 135f.*
 "Marble Faun," 116f.*
 relief of Marcus Aurelius, 163f.*
 Palazzo dei Conservatori, Innocent X by Algardi, 378.
 Arch of Constantine, reliefs, 160f.,* 165f.*
 Lateran Museum,
 Christian sarcophagi, 173ff.*
 Good Shepherd, 178f.*
 Marsyas after Myron, 89.

Rome (Continued)
 Column of Marcus Aurelius, 164.
 Museo di Villa Papa Giulio, terracotta Apollo from Veii, 151f.*
 National Gallery of Modern Art,
 Hercules by Bourdelle, 454.
 Hercules and Lichas by Canova, 420.
 Sappho by Duprè, 475.
 sculptures by Medardo Rosso, 479.
 National Museum,
 Antinoüs as Silvanus, relief, 162.*
 Discobolus after Myron, 88.*
 group by Menelaus, 149.
 "Hellenistic Ruler," 140f.*
 Ludovisi Ares, 119.
 "Ludovisi Throne," 93ff.,* 116.
 reliefs from the Ara Pacis Augustæ, 153ff.*
 Piazza Navona, fountain by Bernini, 374.
 Papal Museum of Sculpture, tomb of Sixtus IV by Pollaiuolo, 316, 365.
 Quirinal hill, ancient statues of Horse-tamers, 339.
 Quirinal palace, frieze by Thorvaldsen, 421f.
 S. Andrea delle Fratte, angels by Bernini, 376.
 SS. Apostoli,
 tomb of Clement XIV, 421.
 tomb of Pietro Riario, 329.

Rome,
SS. Apostoli (Continued)
tomb of Raffaello della Rovere, 331.
S. Cecilia in Trastevere, *baldacchino* by Arnolfo, 285.
S. Ignazio, decoration by Algardi, 378.
S. Maria di Loreto, St. Susanna by Duquesnoy, 377.
S. Maria sopra Minerva, tombs by Bandinelli, 342.
S. Maria del Popolo,
tomb of Cristoforo della Rovere, 330f.*
tombs by Andrea Sansovino, 334f.*
S. Maria della Vittoria, St. Theresa by Bernini, 376.
S. Paolo fuori le Mura, *baldacchino* by Arnolfo, 285.*
St. Peter's,
Grotte Vaticane, Junius Bassus sarcophagus, 174f.*
Pietà by Michael Angelo, 335f.,* 339, 340.
relief of St. Leo by Algardi, 379.*
St. Andrew by Duquesnoy, 378.
shrine for St. Peter's chair, 376f.,* 407.
tomb of Alexander VII by Bernini, 375.*
tomb of Clement XIII by Canova, 421.
tomb of Leo XI by Algardi, 378.

Rome,
St. Peter's (Continued)
tomb of Pius VII by Thorvaldsen, 422.
tomb of Urban VIII by Bernini, 378.
S. Pietro in Vincoli, tomb of Julius II, 338, 340.
S. Sabina, doors, 180.
Arch of Titus, reliefs, 157ff.*
Column of Trajan, reliefs, 159f.,* 422.
Fontana di Trevi, 380.*
Vatican,
Aphrodite after Praxiteles, 115f.,* 147.
Apollo Belvedere, 132f.,* 374, 419, 421.
Apollo Citharœdus, 119.
Apoxyomenus after Lysippus, 121f.*
Augustus from Prima Porta, 153f.*
Christian sarcophagi of porphyry, 174.
Ganymede after Leochares, 125.
Laocoön group, 143f.,* 146, 339, 440.
Meleager after Scopas, 119.
Perseus by Canova, 419.
Tyche of Antioch after Eutychides, 129, 131f.*
Römhild, tomb by Vischer, 358.
Rothenburg, St. James, retable by Riemenschneider, 264.
Rouen,
cathedral,
Porte des Libraires, 231, 287.
stalls, 239.

Rouen (Continued)
 statue of Corneille by David
 d'Angers, 437.
Ruthwell, cross, 184.

St. Alban's, England, cathe-
 dral, retable by Gilbert,
 486.
St. Benoît-sur-Loire, Roman-
 esque sculpture, 202.
St. Denis, cathedral,
 tomb of Henry II, 351f.,
 400.
 tomb of Louis XII, 348f.
 tombs of 13th century, 230,*
 237.
 tombs of 14th century,
 233.
 west portal, 224.
St. George, Staten Id., foun-
 tain by Fry, 518.
St. Gilles, façade, 201, 212.
St. Mihiel, St. Étienne, Holy
 Sepulchre by Richier,
 353f.*
St. Omer, Notre Dame, tomb
 by Du Broeucq, 355.
Saintes, Ste. Marie aux Dames,
 Romanesque sculpture,
 202.
Salamanca, cathedral, tomb of
 Aparicio, 276.
Salerno, ambos, 216.
Salisbury,
 cathedral,
 tomb of Bishop Jocelyn,
 209.
 tomb of Bishop Roger,
 207.
 chapter-house, spandrels, 268.
Samothrace, Victory of,
 129ff.*

Sānchī, carvings on gateways,
 531f.*
S. Cugat del Vallés, capital,
 195f.*
San Francisco exposition,
 fountain by Aitken,
 518.
Santiago de Compostela, cathe-
 dral,
 Pórtico de la Gloria, 203,
 267, 274f.*
 Puerta de Platerías, 203f.,*
 212.
Santiago del Estero, Argen-
 tine, St. Francis Solano
 by Blay, 489.
Sto. Domingo de la Calzada,
 retable by Forment,
 367.
Sto. Domingo de Silos, reliefs
 in cloister, 203.
Saragossa,
 church of the Pilar,
 retable by Forment,
 366f.
 Seo,
 retable, 279.
 tomb of Archbishop de
 Luna, 277.
Sārnāth, India,
 Aśokan column, 532.
 carvings of Gandhāra period,
 533.
 seated Buddha, 534.
Schleswig, cathedral, retable by
 Brüggemann, 260.
Segovia, cathedral, entomb-
 ment by Juan de Juni,
 368.
Selinus, metopes from, 66f.*
Seoul, Prince Yi's Household
 Museum, Corean
 bronzes, 541.

Seville,
 cathedral,
 Crucifix by Montañés, 413.
 Immaculate Conception by Montañés, 412.
 lateral doors of façade, 278.
 retable, 279.
 tomb by Fancelli, 365.
 tomb of Lastra by Bellver, 488.
 Museum,
 statues by Torrigiano, 365.
 Virgin by Montañés, 412.*
Siena,
 baptistery,
 font and relief by Jacopo della Quercia, 320.
 putti and relief by Donatello, 302.
 cathedral,
 altar by Bregno and Michael Angelo, 331.
 pulpit by Nicola d'Apulia, 283.*
 cemetery of the Misericordia, Pietà by Duprè, 475.
 Fonte Gaia, 320.
 Palazzo Pubblico, fragments of Fonte Gaia by Jacopo della Quercia, 320.
Sigüenza, late Gothic tombs, 279ff.*
Solesmes, Holy Sepulchre, 240.
Souillac, portal, 198.
Springfield, Mass., Deacon Chapin by Saint-Gaudens, 504.
Stettin, Frederick the Great by Schadow, 425.

Strassburg,
 cathedral, sculpture of the 13th and 14th century, 255f.,* 268.
 Maison de Notre Dame, busts by Gerhaert, 266.
 Municipal Museum, head of Prophet by Gerhaert, 266.
 St. Thomas, tomb of Comte de Saxe by Pigalle, 390.
 Wilhelmer-Kirche, tomb of Philipp von Werd, 259.
Stuttgart, Museum, statues by Dannecker, 424f.*

Tārpatri, carvings on gateways, 535.
Tarragona, cathedral,
 capital, 195f.*
 main portal, 277.
 retable by Pere Johan de Vallfogona, 278f.*
Tatung, archaic Chinese carvings, 539f.
Titusville, Penn., Driller by Niehaus, 509.
Toledo, cathedral,
 choir-stalls, lower range, 279.
 choir-stalls, upper range, 368.
 Puerta de los Leones, 278.
 Puerta del Reloj, 277.
 retable, 279.
 screen, 277.
 St. Francis by Pedro de Mena, 414.
 tomb of Siliceo by Bellver, 488.
 Trasparente by Narciso Tomé, 415.
Tompkinsville, Conn., Abbey Monument by Fry, 518.

Tongres, Ste. Materne, retable, 248.

Tonnerre, Holy Sepulchre, 237f.*

Torcello, Byzantine reliefs, 182.

Toulouse,
 Museum,
 Nude by Falguière, 445.*
 Romanesque sculpture, 198f.*
 St. Sernin, south portal, 203.

Tournai,
 cathedral,
 façade, 244.
 screen by Floris de Vriendt, 355f.*
 Museum, epitaph of De Quinghien, 246.*

Trani, doors, 214.

Trèves, Diocesan Museum, tomb by Gerhaert, 266.

Troyes, church of the Magdalene, St. Martha, 243.

Turin, Cavour Memorial by Duprè, 476.

Ulm, cathedral, choir-stalls by Syrlin, 265,* 361.

Valladolid,
 Museum,
 Christ by Juan de Juni, 368.
 fragments of retable by Berruguete, 367f.*
 sculptures by Fernández, 411f.*
 sepulchral statues by Pompeo Leoni and assistants, 366.
 Santa Cruz, Virgin by Fernández, 412.

Veitshöchheim, sculpture by Wagner, 408.

Venice,
 campanile, statues by Jacopo Sansovino, 342.
 Colleoni by Verrocchio, 316f.*
 Ducal Palace, statues by Antonio Rizzo, 326.*
 church of the Frari, tomb of Tron by Antonio Rizzo, 326, 360.
 SS. Giovanni e Paolo, tomb of Mocenigo by Pietro Lombardo, 327.*
 S. Maria dei Miracoli, decoration by the Lombardi, 327.
 St. Marks,
 Apostles by the Masegne, 291.
 Byzantine reliefs, 182.
 doors by Jacopo Sansovino, 343.
 S. Salvatore, tomb of Venier by Jacopo Sansovino, 343.

Venus dei Medici, 147, 430.

Venus de Milo, 131f.*

Verona,
 cathedral, portal, 211f.
 S. Maria Antica, tombs of the Scaligers, 290f.*
 S. Zeno,
 doors, 206.
 portal, 210f.*

Versailles,
 decorations by Pajou, 392.
 fountains by Girardon, 384f.*
 Louis XV by Bouchardon, 388.
 Napoleon by Vela, 475f.*
 relief by the Coustou, 385.
 Tréhouart by Carpeaux, 442.

Versailles (Continued)
Vergniaud by Cartellier, 423.
Vézelay, portal, 199, 205, 225.
Vienna,
Albrechts-Platz, Mozart by
Tilgner, 461f.*
Augustinian Church, tomb
of Maria Christina by
Canova, 421.
Beethoven-Platz, monument
by Zumbusch, 461.
Belvedere,
Charles VI by Donner, 409.
Prince Eugene by Per-
moser, 408, 409.
Benda Collection, *putto* by
Desiderio, 312.
cathedral, tomb of Frederick
III, 266.
Figdor Collection, bust by
Adolf Dauher, 360.
Graben, Trinity Column,
409.
Hofburg-Theater, decoration
by Tilgner, 462.
Imperial Museum,
reliefs from Gjölbaschi-
Trysa, 110.
Imperial Treasury, salt-
cellar by Cellini, 343.
Maria-Theresien-Platz, mon-
ument by Zumbusch,
461.
Natural History Museum,
decoration by Tilgner,
462.
New Market, fountain by
Donner, 409.*
Public Hospital, bust by
Messerschmidt, 410.
Städtisches Depot, figures
from fountain by Don-
ner, 409.

Vijayanagar, carvings on tem-
ples, 535.
Villeneuve-l'Archevêque, Holy
Sepulchre, 243.

Washington,
Capitol,
Armed Freedom by Craw-
ford, 430.
doors by Crawford, 431f.*
doors by Rogers, 500.
Jefferson by David d'An-
gers, 437.
pediment by Crawford,
430ff.
Columbus Memorial by
Taft, 512.
Congressional Library,
doors by Warner, 501f.*
medallions by Pratt, 510.
Michael Angelo by Bart-
lett, 517.
Corcoran Art Gallery,
Greek Slave by Powers,
430.*
Napoleon by Vela, 476.
Garfield Memorial by
Ward, 497.
Lafayette Square, monument
by Falguière and Mercié,
446.
McMillan Fountain by
Adams, 509.
National Gallery, Pitt by
Wood, 482.
Rock Creek Cemetery, mon-
ument of Mrs. Adams
by Saint-Gaudens, 504
Smithsonian Institution,
Washington by Green-
ough, 429f.*
Weimar, Library, bust of Schil-
ler by Dannecker, 425.

Wells, façade, 267f.*

Willebroeck, bust of De Nayer by Vinçotte, 472.

Winchester, England, Victoria by Gilbert, 486.

Windsor, St. George's Chapel, Gothic angels, 272.
monument of Duke of Clarence by Gilbert, 485f.*

Wittenberg, tomb by Vischer the Younger, 359.

Woburn, Mass., Rumford by Zumbusch, 461.

Worcester, Mass., Museum of Art, sculpture by Pratt, 510.

Würzburg,
cathedral,
tomb by Riemenschneider, 263.

Würzburg,
cathedral (Continued)
tombs of Albert von Hohenlohe and Gerhard von Schwarzburg, 258.*
Virgin of 14th century, 258.
Episcopal Palace, decoration by Wagner, 408.
Historical Society, Adam and Eve by Riemenschneider, 264.*

Xanten, retable by Douwermann, 260.

York, Museum, statues from abbey of St. Mary, 267.

Zeus by Phidias at Olympia, 97, 99f.